FIN-DE-SIÈCLE VIENNA

CARL E. SCHORSKE

FIN-DE-SIÈCLE

VIENNA

POLITICS
AND CULTURE

Vintage Books · A Division of Random House · New York

VINTAGE BOOKS EDITION, January 1981

The following originally appeared as articles in the
American Historical Review:

"Politics and Patricide in Freud's Interpretation of Dreams,"
Vol. 78 (April 1973), pp. 328-47.

"The Transformation of the Garden: Ideal and Society in
Austrian Literature," Vol. 72 (July 1967), pp. 1283-320.

"Politics and the Psyche in Fin-de-siècle Vienna: Schnitzler and
Hofmannsthal," Vol. 68 (July 1961), pp. 930-46.

Grateful acknowledgment is made to the following for permission to
reprint from previously published material:

University of Chicago Press: "Politics in a New Key: An Austrian
Triptych," The Journal of Modern History, Vol. 39 (December 1967),
pp. 343-386. Copyright © 1967 by the University of Chicago.

Owing to limitations of space, all other acknowledgments for permission
to reprint previously published material, and all acknowledgments for
permission to reproduce illustrations, will be found following the index.

Library of Congress Cataloging in Publication Data
Schorske, Carl E Fin-de-siècle Vienna.
Bibliography: p. Includes index.
1. Vienna—Intellectual life—Addresses, essays, lectures.
2. Austria—Politics and government—1867-1918—
Addresses, essays, lectures.
I. Title.
DB851.S42 1981 943.6'13'04 80-11043
ISBN 0-394-74478-0

For Liz

Contents

Illustrations

Figure

Insert following page 222:

Color Plate

I. *Pallas Athena (G. Klimt)*

II. *Watersnakes II (G. Klimt)*

III. *Judith and Holofernes (G. Klimt)*

IV. *Portrait of Margaret Stonborough-Wittgenstein (G. Klimt)*

V. *Portrait of Fritza Riedler (G. Klimt)*

VI. *Portrait of Adele Bloch-Bauer (G. Klimt)*

VII. *Danae (G. Klimt)*

VIII. *The Kiss (G. Klimt)*

IX. *Death and Life (G. Klimt)*

Insert following page 350:

Color Plate

X. *The Red Stare (A. Schoenberg)*

XI. *Kunstschau poster (O. Kokoschka)*

XII. *Lithograph and text from* The Dreaming Boys *(O. Kokoschka)*

XIII. *Poster for* Murderer, Hope of Women *(Pietà) (O. Kokoschka)*

XIV. *Portrait of Herwarth Walden (O. Kokoschka)*

XV. *Portrait of Hans Tietze and Erica Tietze-Conrat (O. Kokoschka)*

XVI. *The Tempest (O. Kokoschka)*

XVII. *Portrait of the architect Adolf Loos (O. Kokoschka)*

Acknowledgments

EVEN THE MOST individual scholarly work, viewed in terms of the economic, intellectual, and psychological support necessary to its accomplishment, turns out to be a social enterprise. In the case of a work so slow to grow as mine, whose production resembled less the determined making of a book than the shaping of a record of continuing exploration, one becomes especially conscious of the magnitude of personal help and institutional sustenance received along the way.

A fellowship from the John Simon Guggenheim Foundation made possible a valuable year of initial reading and research in London. My three universities—Wesleyan, California at Berkeley, and Princeton—provided leave time and financial support for the work. Such release from teaching duties enabled me to accept the hospitality of the Center for Advanced Study in the Behavioral Sciences (Stanford), the Institute for Advanced Study (Princeton), and Wesleyan's Center for the Humanities. The American Council of Learned Societies also supported my writing at the Wesleyan Center.

Among the many scholars whom I wish to thank, Felix Gilbert

· xiii ·

must be among the first. He helped me early to define my field of inquiry and later guided me around many a pitfall with that gently emendatory spirit of erudite criticism which has made him the prime post-graduate educator of so many historians of my generation and the next. Professor Gilbert's sister, the late Mary Gilbert of King's College, London, introduced me to the poetry of Hofmannsthal and to his social circle, while Leopold Ettlinger and Ernst Gombrich at the Warburg Institute library gave me some preliminary guidance into the swampy world of Austrian *art nouveau*. My late colleagues Heinrich Schwarz and Heinz Politzer communicated not only their deep knowledge of Austrian art and literature respectively, but also their love of what they knew—in unforgettable evenings of picture-viewing, record-playing and intense conversation. Robert A. Kann of Rutgers University repeatedly placed at my disposal his matchless knowledge of Austrian political and intellectual history.

In Austria itself, scholars have been both intellectually generous and personally hospitable without exception. Among them, my special thanks are due to the late Friedrich Engel-Janosi, Fritz Fellner, Dr. and Mrs. Harald Leupold-Löwenthal, Gerald Stourzh, Adam Wandruszka, and Erika Weinzierl. Outside the academy, Dr. Otto Schulmeister, erstwhile editor of *Die Presse,* opened my eyes to the special light that Austria's post-Nazi present could throw upon her pre-Nazi past.

William J. Bouwsma, Arthur C. McGill, and William Slottman sensitized me to the distinctive characters of the religious traditions relevant to my interpretation of the special qualities of Austrian secular culture.

From Robert Clark, Robert Geddes, Henry Russell Hitchcock, Martin Meyerson, Adolf K. Placzek, and especially Anthony Vidler, I have received both basic ideas and specific criticisms in the area of architecture and urban planning, while Samuel M. Green, Irving and Marilyn Lavin, and Angelica Rudenstine contributed toward the essays on painting. John Barlow and, over many years, Richard Winslow, helped me with music, so easy to love, so hard to grasp. Hayden White offered careful and penetrating criticisms on the relation of musical and visual language in Essay VII, not all of which I could successfully meet.

My greatest intellectual debt is to five close friends. Despite radically divergent outlooks, they share a capacity for vital en-

gagement with ideas where they touch the life of society. Through years of discussion of their work and mine, they have enriched and sustained me, transmuting intellectual labor into deepest personal pleasure. Leonard Krieger has helped me most in sharpening the sense of the intellectual historian's task, showing by his own example as well as through criticism how to respect and integrate the often conflicting internal and external constituents of our branch of history. Norman O. Brown again and again has shaken me out of dogmatic slumbers, helping me with his classical learning and his powerful figurative imagination to recognize new meanings in the historical sources. Arno J. Mayer had as much to do with sustaining the political dimension in my analysis as Norman Brown with enriching the cultural one. Beyond his incisive and detailed criticisms— especially of Essay VII—Professor Mayer gave me needed help in bringing the whole work-plan down at last to realizable proportions.

Two younger friends freshened the enterprise with quite different kinds of contributions. Ann Douglas brought to bear her incandescent spirit, as a person and as an American cultural critic, on the later stages of the work. She both fortified and modified my sense of what I was doing in the light of American intellectual experience. Professors Douglas and Krieger both provided thorough criticisms for the improvement of the Introduction, though it still must fall short of their hopes for it and mine. William J. McGrath, for some years now a close fellow-worker in the same vineyard, has helped me so much in cultivating the ground that the yield should be accounted his as well as mine.

My wife, Elizabeth, brought to the task the crucial qualities of mind and spirit most needed to accomplish it. Those qualities came, as they had to, in polaric pairs, yet she always managed to keep them in fruitful balance: understanding and impatience; involvement and distance; resolution in large issues and selfless labor in small details—and, through it all, faith.

For her efficiency, care, and infinite patience, I am deeply grateful to Jean Wiggs, who typed the manuscript. And finally, for turning the last mile into an unexpected delight, my thanks to the many in the house of Knopf who have produced the book so understandingly— especially Robert Gottlieb and Jeffrey Seroy.

C. E. S.

Introduction

IN MOST FIELDS of intellectual activity, twentieth-century Europe has proudly asserted its independence of the past. As early as the eighteenth century, the word "modern" acquired something of the ring of a war cry, but then only as an antithesis of "ancient" —implying contrast with classical antiquity. In the last one hundred years, however, "modern" has come to distinguish our perception of our lives and times from all that has gone before, from history as a whole, as such. Modern architecture, modern music, modern philosophy, modern science—all these define themselves not *out* of the past, indeed scarcely *against* the past, but in independence of the past. The modern mind has been growing indifferent to history because history, conceived as a continuous nourishing tradition, has become useless to it.

This development is, of course, of serious concern to the historian, for the premises of his professional existence are at stake in it. But an understanding of the death of history must also engage the attention of the psychoanalyst. At the most obvious level, the latter would see the sharp break from a tie with the past as involving

generational rebellion against the fathers and a search for new self-definitions. In a more complex way, emergent "modernism" has tended to take the specific form of what Heinz Kohut has called in another connection a "reshuffling of the self." Here historical change not only forces upon the individual a search for a new identity but also imposes upon whole social groups the task of revising or replacing defunct belief systems. The attempt to shake off the shackles of history has paradoxically speeded up the processes of history, for indifference to any relationship with the past liberates the imagination to proliferate new forms and new constructs. Thus complex changes appear where once continuity reigned. Conversely, the consciousness of swift change in history-as-present weakens the authority of history as relevant past.

Vienna in the *fin de siècle*, with its acutely felt tremors of social and political disintegration, proved one of the most fertile breeding grounds of our century's a-historical culture. Its great intellectual innovators—in music and philosophy, in economics and architecture, and, of course, in psychoanalysis—all broke, more or less deliberately, their ties to the historical outlook central to the nineteenth-century liberal culture in which they had been reared. The essays in this volume probe the beginnings of that cultural transformation in its specific historical context.

I

BEHIND my selection of Vienna as a focus of inquiry lies no particular training or expertise as a historian of the Habsburg Empire. As is common with historians, I came to my problem out of a combination of professional, intellectual, and political experiences.

As a beginning teacher in the late 1940's, I set out to construct a course in modern European intellectual history, designed to help students to understand the large, architectonic correlations between high culture and socio-political change. In American college catalogues, this linkage commonly appeared in the course titles: "Social and Intellectual History of . . ."—a stamp of legitimation inherited from the Progressive generation. Its intellectual leaders—James Harvey Robinson, Charles Beard, John Dewey—had restated for twentieth-century America the faith of the Enlightenment in his-

tory as an interdependent progress of reason and society. The succeeding generation of the 1930's, to which I belonged, influenced by the experience of depression and the thought of Marx, placed more stress on the elements of struggle and crisis in social reality. But it retained its predecessor's confidence in the progress of society and the use of ideas both to explain and to spur that progress. For that task, the cultural historian had available the sweeping descriptive categories by which nineteenth-century intellectuals had charted the development of their own era: rationalism and romanticism, individualism and socialism, realism and naturalism, and so on. However broad and reductionist such categories might be, they served to establish a framework within which the concrete efforts of the producers of European higher culture to make meaning out of life might be analyzed in their particularity and yet related to a wider historical context.

With such conceptual premises, my course in intellectual history went well enough—until Nietzsche. Thereafter, it ran into trouble. In what seemed like ubiquitous fragmentation—Nietzsche and the Marxists agreed in calling it "decadence"—European high culture entered a whirl of infinite innovation, with each field proclaiming independence of the whole, each part in turn falling into parts. Into the ruthless centrifuge of change were drawn the very concepts by which cultural phenomena might be fixed in thought. Not only the producers of culture, but also its analysts and critics fell victim to the fragmentation. The many categories devised to define or govern any one of the trends in post-Nietzschean culture—irrationalism, subjectivism, abstractionism, anxiety, technologism—neither possessed the surface virtue of lending themselves to generalization nor allowed any convincing dialectical integration into the historical process as previously understood. Every search for a plausible equivalent for the twentieth century to such sweeping but heuristically indispensable categories as "the Enlightenment" seemed doomed to founder on the heterogeneity of the cultural substance it was supposed to cover. Indeed, the very multiplicity of analytic categories by which modern movements defined themselves had become, to use Arnold Schoenberg's term, "a death-dance of principles."

What was the historian to do in the face of this confusion? It seemed imperative to respect the historical development of each

constituent branch of modern culture (social thought, literature, architecture, etc.), rather than to hide the pluralized reality behind homogenizing definitions. I therefore turned for help to my colleagues in other disciplines. Their intellectual situation, however, only compounded the problem. In the fields of greatest importance to my concern—literature, politics, art history, philosophy—scholarship in the 1950's was turning away from history as its basis for self-understanding. At the same time, in a parallel movement, the several academic disciplines redefined their intellectual functions in ways that weakened their social relatedness. Thus, for example, the New Critics in literature, as they came to power in the academy, replaced the practitioners of literary historicism who had prevailed in English departments before World War II with scholars committed to an a-temporal, internalistic, formal analysis. In political science, as the New Deal receded, the normative concerns of traditional political philosophy and the pragmatic preoccupation with questions of public policy began to give way to the a-historical and politically neutralizing reign of the behaviorists. In economics, mathematically oriented theorists expanded their dominion at the expense alike of the older, socially minded institutionalists and of policy-oriented Keynesians. Even in such a field as music, a new cerebrality inspired by Schoenberg and Schenker began to erode musicology's historical concerns. Above all in philosophy, a discipline previously marked by a high consciousness of its own historical character and continuity, the analytic school challenged the validity of the traditional questions that had concerned philosophers since antiquity. In the interest of a restricted and purer functioning in the areas of language and logic, the new philosophy broke the ties both to history in general and to the discipline's own past.

In one professional academic field after another, then, the diachronic line, the cord of consciousness that linked the present pursuits of each to its past concerns, was either cut or fraying. At the same time as they asserted their independence of the past, the academic disciplines became increasingly independent of each other as well. Far from providing any unifying premises or principles of coherence for comprehending the multiplicity of contemporary culture, the autonomous disciplines reinforced the culture's pluralism with an academic specialization that was its analytic parallel. Discussions with colleagues in other fields convinced me that the historical

consciousness could expect little sustenance from either the humanistic or the social scientific disciplines in any direct or participatory way. They dispelled my idea, compounded of naïveté and a certain arrogant aspiration to universal comprehension, that a historian could find, with whatever support, a satisfactory general characterization of modern high culture. At the same time, they convinced me that the autonomous analytic methods of the several disciplines, however a-historical in general import, posed to the intellectual historian a challenge he could no longer ignore with impunity. Historians had been too long content to use the artifacts of high culture as mere illustrative reflections of political or social developments, or to relativize them to ideology. As long as both the makers of culture and the scholars who interpreted them conceived of their functions as acquiring meaning from a historical trajectory of socially shared values, the historian's traditional procedure had some legitimacy, however shallow it might be. A commonly accepted architecture of the historical process in the culture as a whole—especially one revolving around the idea of progress, as in the nineteenth century— allowed the historian also to appropriate cultural materials for those of their properties germane to his conception of the general direction of history. But now that new internal methods of analysis in the humanistic disciplines disclosed in works of art, literature, and thought autonomous characteristics of structure and style, the historian could ignore them only at the risk of misreading the historical meaning of his material.

Just as a knowledge of the critical methods of modern science is necessary for interpreting that science historically, so a knowledge of the kinds of analysis practiced by modern humanists is necessary for coming to grips with the makers of twentieth-century non-scientific culture. Only thus can one read a text—whether it be a drama, a city plan, a painting, or a treatise in psychology—in such a way that its content (of which its form is an important constituent) can be comprehended. The weaker the social consciousness of its creator, the greater the need for specialized internal analysis on the part of its social-historical interpreter. Yet the historian will not share to the full the aim of the humanistic textual analyst. The latter aims at the greatest possible illumination of a cultural product, relativizing all principles of analysis to its particular content. The historian seeks rather to locate and interpret the artifact temporally in a field where

two lines intersect. One line is vertical, or diachronic, by which he establishes the relation of a text or a system of thought to previous expressions in the same branch of cultural activity (painting, politics, etc.). The other is horizontal, or synchronic; by it he assesses the relation of the content of the intellectual object to what is appearing in other branches or aspects of a culture at the same time. The diachronic thread is the warp, the synchronic one is the woof in the fabric of cultural history. The historian is the weaver, but the quality of his cloth depends on the strength and color of the thread. He must learn something of spinning from the specialized disciplines whose scholars have in fact lost interest in using history as one of their primary modes of understanding, but who still know better than the historian what in their métier constitutes stout yarn of true color. The historian's homespun will be less fine than theirs, but if he emulates their method in its making, he should spin yarn serviceable enough for the kind of bold-patterned fabric he is called upon to produce.

What the historian must now abjure, and nowhere more so than in confronting the problem of modernity, is the positing in advance of an abstract categorical common denominator—what Hegel called the *Zeitgeist*, and Mill "the characteristic of the age." Where such an intuitive discernment of unities once served, we must now be willing to undertake the empirical pursuit of pluralities as a precondition to finding unitary patterns in culture. Yet if we reconstruct the course of change in the separate branches of cultural production according to their own modes, we can acquire a firmer basis for determining the similarities and differences among them. These in turn can bring us to the shared concerns, the shared ways of confronting experience, that bind men together as culture-makers in a common social and temporal space.

\gg II \ll

THE CONVICTION that, to maintain the analytic vitality of intellectual history as a field, I would have to approach it by a kind of post-holing, examining each area of the field in its own terms, determined the strategy of my inquiry. Hence these studies took form from separate research forays into distinct branches of cul-

tural activity—first literature, then city planning, then the plastic arts, and so on. But had I attended only to the autonomy of fields and their internal changes, the synchronic relations among them might have been lost. The fertile ground of the cultural elements, and the basis of their cohesion, was a shared social experience in the broadest sense. That ground was suggested to me by politics and cultural change in postwar America. My description of the history that follows draws upon American development, though it does not, of course, pretend to explain it.

In the decade after 1947, the historical and social optimism that had been associated with the New Deal and the struggle with the Nazis finally broke down. It is true that America had had its waves of pessimism and doubt in the past, with such eloquent spokesmen as Poe, Melville, or Henry Adams. But they had not cut very deep into the culture of a nation whose intellectuals were closely integrated into its public life. Now a mood of pessimism—sometimes of impotence, sometimes of rigid defensiveness, sometimes of sur-render—settled over an intelligentsia that, whether centrist or radical, liberal or Marxist, had for several decades been united in social optimism. Its shared Enlightenment premises were gravely weakened by a combination of political factors in the early postwar years: the deepening of the Cold War, the first Soviet coup in Czechoslovakia, new revelations of Stalinist iniquities, and the effects, so powerful and so astonishingly ramified throughout all social classes, of McCarthyism. It was not so much that these political developments caused the intellectuals to shift political positions or abandon politics entirely, though many did so. More fundamentally, the crisis seemed to force a shift in the general philosophic outlook in which liberal or radical political positions had been embedded. In short, the liberals and radicals, almost unconsciously, adapted their world-views to a revolution of falling political expectations. Some liberals who had spent their lives in religious indifference found themselves drawn to neo-orthodox Protestantism; Kierkegaard be-came a name to conjure with. To the intellectual tone-setters among college students, the resigned patrician wisdom of Jakob Burckhardt began to make more sense of the problems of culture and power than did the formerly engrossing ethical rationalism of John Stuart Mill, or the tough synoptic vision of Karl Marx. To young Ameri-canists, the virile moral realism of Perry Miller's Puritan fathers

spoke more strongly than the open democratic spirit of Vernon Parrington's pioneers.

Among the shifts from Promethean to Epimethean culture heroes, however, none was more striking than the turn from Marx to Freud. For here the search for and understanding of the ills that plague mankind tended to be translated from the public and sociological domain to the private and psychological one. Freud had, of course, long since established himself as a major figure in American thinking. His Old Testament preoccupation with the problems of guilt and responsibility, combined with his modern concern for the liberation of "healthy" sexual instincts, had won him well before 1930 a wide moral authority, both as therapist and as progressive theorist of human nature.[1] In the 1950's, however, the more somber side of Freud struck chords hitherto untouched in widely disparate sectors of American life. Scholars of the most varied outlook exemplified the change dramatically. The historian William Langer, growing discontented with the politics of interest as the dominant substance of historiography, turned to psychoanalysis to explain cultural and social change as collective trauma. Lionel Trilling, as his liberalism became embattled against the Left, fortified his humanistic rationalism with the controlled assimilation of the psychoanalytic underworld of instinct. Meanwhile, others on the left of the political spectrum, such as the philosopher Herbert Marcuse and the classicist Norman O. Brown, were redrawing the lineaments of Utopia, transferring their intellectual foundations from Marx to Freud. Though ranging in their political outlook from conservative to extreme radical, these four intellectual leaders played important parts in shifting—or at least broadening—the premises for understanding man and society from the social to the psychological realm. And they did so under the pressure of new, uncongenial turns in the world of politics.

Freud was of course an Austrian. But he was not the only man of his country at the turn of the century to whom Americans were drawn in the postwar era. Gustav Mahler, long regarded as a banal and rather tedious composer, suddenly became a popular staple of symphony programs. During the student "revolution" in Berkeley, a newly formed Mahler Society proclaimed its creed, in the fashion of the day, on a button: "Mahler Grooves." Schoenberg meanwhile extended his influence from the avant garde and its composers to the citadels of academia. Gustav Klimt, Egon Schiele, and Oskar

Kokoschka, Vienna's painters of the sensuous and psychic life, leapt from obscurity to what can only be called a vogue.

"History," Burckhardt once observed, "is what one age finds worthy of note in another." Where America between the wars found interest in Austria before 1918 as a multi-national state that failed, it now found "worthy of note" the intellectual products of the same period of Austria's history. Of course America made its cultural borrowings with little sense of the problems and experiences of that "other age" in which the ideas and art that attracted it were shaped. This naturally stimulated my interest in exploring within its political and social context the thought which drew my contemporaries. To understand the formation of those ideas as part of a wider historical process would of course neither validate them nor show their value for us today. That is not the historian's task. But historical analysis could at least reveal the characteristics with which history had endowed that culture at its conception and birth. Illuminating the genesis, meaning, and limitations of ideas in their own time, we might better understand the implications and significance of our affinities for them in our time.

<p style="text-align:center">➤ III ⬅</p>

IT WAS, then, a combination of factors that led to Vienna as a field of work. Having encountered through teaching the baffling problem of finding some related characteristics for pluralized, post-Nietzschean culture, I had been made aware of the need to proceed piecemeal, recognizing the autonomous analytic modes necessary to understanding the several strands of cultural innovation. At the same time, the political and intellectual life of post-war America suggested the crisis of a liberal polity as a unifying context for simultaneous transformation in the separate branches of culture. The fact that Freud and his contemporaries aroused new interest in America in itself suggested Vienna as a unit of study. Finally, to keep history's synoptic potential intact when both the culture itself and the scholarly approaches to it were becoming de-historicized and pluralized, a well-circumscribed social entity, reasonably small but rich in cultural creativity, was needed.

For such a multi-disciplinary inquiry on a political ground, Vienna in the *fin de siècle* offered unusual advantages. Almost simultaneously in one area after another, that city's intelligentsia produced innovations that became identified throughout the European cultural sphere as Vienna "schools"—notably in psychology, art history, and music. But even in fields where an international awareness of Austrian achievement dawned more slowly—in literature, architecture, painting, and politics, for example—the Austrians engaged in critical reformulations or subversive transformations of their traditions that their own society perceived as radically new if not indeed revolutionary. The term *Die Jungen* ("The Young Ones") as a common designation for innovative *révoltés* spread from one sphere of life to another. First employed in politics in the 1870's to denote a group of young rebels against classical Austrian liberalism, the term soon appeared in literature (*Jung-Wien*), and then among the artists and architects who first embraced *art nouveau* and gave it a special Austrian character.[2]

The new culture-makers in the city of Freud thus repeatedly defined themselves in terms of a kind of collective oedipal revolt. Yet the young were revolting not so much against their fathers as against the authority of the paternal culture that was their inheritance. What they assaulted on a broad front was the value system of classical liberalism-in-ascendancy within which they had been reared. Given this ubiquitous and simultaneous criticism of their liberal-rational inheritance from within the several fields of cultural activity, the internalistic approach of the special disciplines could not do justice to the phenomenon. A general and rather sudden transformation of thought and values among the culture-makers suggested, rather, a shared social experience that compelled rethinking. In the Viennese case, a highly compacted political and social development provided this context.

The era of political ascendancy of the liberal middle class in Austria, begun later than elsewhere in western Europe, entered earlier than elsewhere into deep crisis. By optimistic calculation, actual constitutional government lasted about four decades (1860–1900). Its victory had scarcely been celebrated when retreat and defeat began. The whole process took place in a temporal compression unknown elsewhere in Europe. In France, the post-liberal

question of "modernity" in culture arose in the wake of the Revolution of 1848 as a kind of avant-garde self-criticism of the bourgeoisie, and slowly spread, with many advances and retreats, from the era of the Second Empire to the eve of World War I. In Austria, however, the modern movements appeared in most fields in the 1890's and were fully matured two decades later. Thus the growth of a new higher culture seemed to take place in Austria as in a hothouse, with political crisis providing the heat. Backward Austria, in sudden travail, became, as one of its poets said, "the little world in which the big one holds its tryouts."[3] Could one find, as one analyzed the work of the cultural innovators, traces of the experience of liberal political eclipse and failure? Had it eroded their faith in the inherited high culture in a sense that was more than merely political?

The socially circumscribed character of the Viennese cultural élite, with its unusual combination of provincialism and cosmopolitanism, of traditionalism and modernism, created a more coherent context for studying early twentieth-century intellectual development than other major cities. In London, Paris, or Berlin— as my students and I learned from seminars exploring each as a cultural entity—the intellectuals in the various branches of high culture, whether academic or aesthetic, journalistic or literary, political or intellectual, scarcely knew each other. They lived in relatively segregated professional communities. In Vienna, by contrast, until about 1900, the cohesiveness of the whole élite was strong. The salon and the café retained their vitality as institutions where intellectuals of different kinds shared ideas and values with each other and still mingled with a business and professional élite proud of its general education and artistic culture. By the same token, the "alienation" of the intellectuals from other sectors of the élite, their development of an arcane or avant-garde subculture, detached from the political, ethical, and aesthetic values of the upper middle class, came later in Vienna than in other Western cultural capitals, though it was perhaps swifter and more sure. Most of the pioneering generation of culture-makers who appear in these studies were alienated along with their class in its extrusion from political power, not from and against it as a ruling class. Only in the last decade before World War I does there appear alienation of the intellectual from the *whole* society.

⇒ IV ⇐

SINCE THE STUDIES in this volume do not constitute a completed map of the historical landscape, they can each be read independently. Each one issued from a separate foray into the terrain, varying in scale and focus according to the nature of the problem. Only the fundamental motif of interaction between politics and culture runs through them all. The hope is that, as in a song cycle, the central idea will act to establish a coherent field in which the several parts can cast their light upon each other to illuminate the larger whole.

A few words on the focus and arrangement of the essays may help the reader on his way. The first piece, "Politics and the Psyche," provides a background for the whole series. It aims to define broadly the special character of the Austrian cultural inheritance—part aristocratic, Catholic, and aesthetic, part bourgeois, legalist, and rationalist, with which the makers of *fin-de-siècle* culture faced their crisis of function and meaning. Their dilemmas are crystallized in two major literary figures—Arthur Schnitzler and Hugo von Hofmannsthal—shown in the arduous task of adapting the legacy in their different ways to the problems of their social class.

The second essay, "The Ringstrasse . . . ," looks back to explore the liberal cultural system in its political ascendancy through the medium of urban form and architectural style. But it looks forward too; the critical responses to the liberal redevelopment of Vienna on the part of two leading participants in it—Otto Wagner and Camillo Sitte—reveal the emergence of conflicting tendencies, communitarian and functionalist, in modern thought about the built environment.

Essay III, "Politics in a New Key," enters directly into the realm of politics in the crucial area of anti-Semitism. Through the analysis of three leaders—two anti-Semites and a Zionist—it pursues the emergence of a politics of fantasy, in which the persistent power of the aristocratic cultural tradition is adapted by these erstwhile Austro-liberals to the modern pursuit of mass politics.

Essay IV plunges more deeply into the intellectual realm, exploring a single text, Freud's epoch-making work, *The Interpretation of Dreams*. Here psychoanalytic method is used in a modified way, by

appropriating the day-residues in Freud's dreams to reconstitute the personal historical experience that influenced his ideas of the psyche. In exploring the social and political content of those dreams and memories—materials which he recovered from his repressed past in his self-analysis—psychoanalysis as an a-historical system of thought is shown taking form under the trauma inflicted upon Freud by history.

Essay V, on the painter Gustav Klimt, widens the focus again, from a single text to the *oeuvre* of a lifetime. As a participant first in the high culture of liberalism, then in the revolt against it in search of the "modern," and finally in a withdrawal to purely decorative functions, Klimt registered in the style and ideas of his painting the changing nature and function of art amid the tensions of late Habsburg society.

The last two essays, "The Transformation of the Garden" and "Explosion in the Garden," offer a synoptic view of the gradual sea-change of art as it lost its orientation toward social reality during the half-century of liberalism's decline. The garden, traditional symbol of man's ordering power, serves as a vehicle for tracing the emergence of new, post-rationalist conceptions of the human condition over four generations. Essay VI, "The Transformation of the Garden," presents through specific examples from literature the often painful but creative reorganization of thought and feeling that emerged in the face of the dissolution of liberal power and of the historical perspectives that had sustained it. The final essay, "Explosion in the Garden," follows the process to the birth of Expressionist culture—a new, more drastic phase in which the destruction of the traditional cultural order reaches a climax and reconstitution begins. In an eruptive outburst against the aestheticism of the *fin de siècle*, Kokoschka and Schoenberg devised new languages in painting and music to proclaim the universality of suffering in transcendent negation of the professed values of their society. With the definition of modern man as one "condemned to re-create his own universe,"[4] twentieth-century Viennese culture had found its voice.

⇥ NOTES ⇤

[1] For a carefully nuanced analysis of Freud's reception in America before 1918, see Nathan G. Hale, Jr., *Freud and the Americans* (New York, 1971).

[2] For the first phase of this revolt and its cultural ramifications, see William J. McGrath, *Dionysian Art and Populist Politics in Austria* (New Haven, 1974), *passim*. For a brief survey of the whole development, see Carl E. Schorske, "Generational Tension and Cultural Change: Reflections on the Case of Vienna," *Daedalus* (Fall, 1978), pp. 111–122.

[3] Friedrich Hebbel, quoted in Heinrich Benedikt, ed., *Geschichte der Republik Oesterreich* (Munich, 1954), p. 14.

[4] Oskar Kokoschka, *Schriften, 1905–1955* (Munich, 1956), p. 403.

FIN-DE-SIÈCLE VIENNA

I

POLITICS AND THE PSYCHE: SCHNITZLER AND HOFMANNSTHAL

At the close of World War I, Maurice Ravel recorded in *La valse* the violent death of the nineteenth-century world. The waltz, long the symbol of gay Vienna, became in the composer's hands a frantic *danse macabre*. Ravel wrote: "I feel this work a kind of apotheosis of the Viennese waltz, linked in my mind with the impression of a fantastic whirl of destiny."[1] His grotesque memorial serves as a symbolic introduction to a problem of history: the relationship of politics and the psyche in *fin-de-siècle* Vienna.

Although Ravel celebrates the destruction of the world of the waltz, he does not initially present that world as unified. The work opens rather with an adumbration of the individual parts, which will compose the whole: fragments of waltz themes, scattered over a brooding stillness. Gradually the parts find each other—the martial fanfare, the vigorous trot, the sweet obligato, the sweeping major melody. Each element is drawn, its own momentum magnetized, into the wider whole. Each unfolds its individuality as it joins its partners in the dance. The pace accelerates; almost imperceptibly the sweeping rhythm passes over into the compulsive, then into the frenzied.

The concentric elements become eccentric, disengaged from the whole, thus transforming harmony into cacophony. The driving pace continues to build when suddenly caesuras appear in the rhythm; the auditor virtually stops to stare in horror at the void created when a major element for a moment falls silent, ceases to act. Partial paralysis of each element weakens the movement, and yet the whole is moving, relentlessly driving as only compulsive three-quarter time can. Through to the very end, when the waltz crashes in a cataclysm of sound, each theme continues to breathe its individuality, eccentric and distorted now, in the chaos of totality.

Ravel's musical parable of a modern cultural crisis, whether or not he knew it, posed the problem in much the same way as it was felt and seen by the Austrian intelligentsia of the *fin de siècle*. How had their world fallen into chaos? Was it because the individuals (in Ravel, the musical themes) contained in their own psyches some characteristics fundamentally incompatible with the social whole? Or was it the whole as such that distorted, paralyzed, and destroyed the individuals who composed it? Or again, was there perhaps never a rhythmic social whole at all, only an illusion of unified movement resulting from an accidental articulation of fundamentally incohesive, individuated parts? And if this last, could the illusion of unity be transformed into reality? These questions are not new to humankind, but to Vienna's *fin-de-siècle* intelligentsia they became central. Not only Vienna's finest writers, but its painters and psychologists, even its art historians, were preoccupied with the problem of the nature of the individual in a disintegrating society. Out of this preoccupation arose Austria's contribution to a new view of man.

Traditional liberal culture had centered upon rational man, whose scientific domination of nature and whose moral control of himself were expected to create the good society. In our century, rational man has had to give place to that richer but more dangerous and mercurial creature, psychological man. This new man is not merely a rational animal, but a creature of feeling and instinct. We tend to make him the measure of all things in our culture. Our intrasubjectivist artists paint him. Our existentialist philosophers try to make him meaningful. Our social scientists, politicians, and advertising men manipulate him. Even our advanced social critics use him, rather than the criterion of rational right, to judge the worth of a social order. Political and economic oppression itself we assess in

terms of psychological frustration. Ironically, in Vienna, it was polit-
ical frustration that spurred the discovery of this now all-pervasive
psychological man. His emergence out of the political crisis of
Viennese liberal culture provides my theme.

After delineating briefly the nature and background of the political
crises of the *fin de siècle*, this essay will sketch the principal
characteristics of nineteenth-century Viennese liberal culture.
Though sharing much with the liberal cultures of other European
countries, it had certain features all its own. Strangely divided into
ill-reconciled moralistic and aesthetic components, it provided the
fin-de-siècle intelligentsia with the intellectual equipment with which
to face the crisis of their time. Within that context one can under-
stand the different ways in which two leading literary figures,
Arthur Schnitzler and Hugo von Hofmannsthal, sought to orient
themselves in the crisis of liberal culture and to formulate concep-
tions of the relationship between politics and the psyche.

❧ I ☙

AUSTRIAN LIBERALISM, like that of most European nations,
had its heroic age in the struggle against aristocracy and baroque
absolutism. This ended in the stunning defeat of 1848. The chastened
liberals came to power and established a constitutional régime in
the 1860's almost by default. Not their own internal strength, but
the defeats of the old order at the hands of foreign enemies brought
the liberals to the helm of state. From the first, they had to share
their power with the aristocracy and the imperial bureaucracy.
Even during their two decades of rule, the liberals' social base re-
mained weak, confined to the middle-class Germans and German
Jews of the urban centers. Increasingly identified with capitalism,
they maintained parliamentary power by the undemocratic device
of the restricted franchise.

Soon new social groups raised claims to political participation: the
peasantry, the urban artisans and workers, and the Slavic peoples. In
the 1880's these groups formed mass parties to challenge the liberal
hegemony—anti-Semitic Christian Socials and Pan-Germans, So-
cialists, and Slavic nationalists. Their success was rapid. In 1895, the
liberal bastion, Vienna itself, was engulfed in a Christian Social tidal

wave. Emperor Francis Joseph, with the support of the Catholic hierarchy, refused to sanction the election of Karl Lueger, the anti-Semitic Catholic mayor. Sigmund Freud, the liberal, smoked a cigar to celebrate the action of the autocratic savior of the Jews. Two years later, the tide could no longer be stemmed. The emperor, bowing to the electorate's will, ratified Lueger as mayor. The Christian Social demagogues began a decade of rule in Vienna which combined all that was anathema to classical liberalism: anti-Semitism, clericalism, and municipal socialism. On the national level as well, the liberals were broken as a parliamentary political power by 1900, never to revive. They had been crushed by modern mass movements, Christian, anti-Semitic, socialist, and nationalist.

This defeat had profound psychological repercussions. The mood it evoked was one not so much of decadence as of impotence. Progress seemed at an end. The *Neue Freie Presse* saw the expected rational course of history as cruelly altered. The "culture-hostile mass" was victorious before the prerequisites of political enlightenment had been created. In the Mardi Gras of 1897, wrote the *Neue Freie Presse*, the liberals could wear "a false nose [only] to conceal an anxious face. . . . Instead of the gay waltz, one hears only the cries of an excited brawling mob, and the shouts of police trying to disperse [political] antagonists."[2] Anxiety, impotence, a heightened awareness of the brutality of social existence: these features assumed new centrality in a social climate where the creed of liberalism was being shattered by events.

The writers of the nineties were children of this threatened liberal culture. What were the values which they had inherited, and with which they would now have to face the crisis? Two groups of values can, I think, be loosely distinguished in the liberal culture of the last half of the century: one moral and scientific, the other aesthetic.

The moral and scientific culture of Vienna's *haute bourgeoisie* can scarcely be distinguished from garden-variety Victorianism elsewhere in Europe. Morally, it was secure, righteous, and repressive; politically, it was concerned for the rule of law, under which both individual rights and social order were subsumed. It was intellectually committed to the rule of the mind over the body and to a latter-day Voltairism: to social progress through science, education, and hard work. The achievements resulting in a few short decades from the

application of these values to Austria's legal, educational, and economic life are too often underestimated. But neither the values nor the progress made under them gave the Austrian upper middle class a unique character.

More significant for our concern is the evolution of the aesthetic culture of the educated bourgeoisie after the mid-century, for out of it grew the peculiar receptivity of a whole class to the life of art, and, concomitantly at the individual level, a sensitivity to psychic states. By the beginning of our century, the usual moralistic culture of the European bourgeoisie was in Austria both overlaid and undermined by an amoral *Gefühlskultur*. This development has not been closely studied, and I can only suggest its outline.

Two basic social facts distinguish the Austrian from the French and English bourgeoisie: it did not succeed either in destroying or in fully fusing with the aristocracy; and because of its weakness, it remained both dependent upon and deeply loyal to the emperor as a remote but necessary father-protector. The failure to acquire a monopoly of power left the bourgeois always something of an outsider, seeking integration with the aristocracy. The numerous and prosperous Jewish element in Vienna, with its strong assimilationist thrust, only strengthened this trend.

Direct social assimilation to the aristocracy occurred rarely in Austria. Even those who won a patent of nobility were not admitted, as in Germany, to the life of the imperial court. But assimilation could be pursued along another, more open road: that of culture. This too had its difficulties. The traditional culture of the Austrian aristocracy was far removed from the legalistic, puritanical culture of both bourgeois and Jew. Profoundly Catholic, it was a sensuous, plastic culture. Where traditional bourgeois culture saw nature as a sphere to be mastered by imposing order under divine law, Austrian aristocratic culture viewed nature as a scene of joy, a manifestation of divine grace to be glorified in art. Traditional Austrian culture was not, like that of the German north, moral, philosophical, and scientific, but primarily aesthetic. Its greatest achievements were in the applied and performing arts: architecture, the theater, and music. The Austrian bourgeoisie, rooted in the liberal culture of reason and law, thus confronted an older aristocratic culture of sensuous feeling and grace. The two elements, as we shall see in Schnitzler, could only form a most unstable compound.

The first phase in the assimilation to aristocratic culture was purely external, almost mimetic. The new Vienna built by the ascendant bourgeoisie of the sixties illustrates it in stone. The liberal rulers, in an urban reconstruction which dwarfed that of Napoleon III's Paris, tried to design their way into a history, a pedigree, with grandiose buildings inspired by a Gothic, Renaissance, or Baroque past that was not their own.*

A second avenue to aristocratic culture, even more striking than the building spree, lay through the patronage of the traditionally strong performing arts. This form of aristocratic tradition penetrated deeper into the middle-class consciousness than did architecture, for the traditional Viennese folk theater had prepared the ground for it. Vienna's new *haute bourgeoisie* may have begun its sponsorship of classical theater and music in emulation of the Lobkowitzes and Rasoumowskys, but no witness denies that, by the end of the century, it manifested more genuine enthusiasm for these arts than its counterparts in any other city in Europe. By the 1890's the heroes of the upper middle class were no longer political leaders, but actors, artists, and critics. The number of professional scriveners and amateur literati increased rapidly.

By the end of the century, the function of art for Viennese middle-class society had altered, and in this change politics played a crucial part. If the Viennese burghers had begun by supporting the temple of art as a surrogate form of assimilation into the aristocracy, they ended by finding in it an escape, a refuge from the unpleasant world of increasingly threatening political reality. In 1899 the critic Karl Kraus identified the widened interest in and the commercialization of literature as a political product, a product of "recent years, which have [seen] the sphere of action of Viennese liberalism constricted to the parquets of theaters on opening night."[3] Hofmannsthal saw the increased devotion to art as related to the anxiety resulting from civic failure. "We must take leave of a world before it collapses," he wrote in 1905. "Many know it already, and an indefinable [*unnennbares*] feeling makes poets out of many."[4] Elsewhere in Europe, art for art's sake implied the withdrawal of its devotees from a social class; in Vienna alone it claimed the allegiance of virtually a whole class, of which the artists were a part. The life of art became

* See Essay II, sections i and ii.

a substitute for the life of action. Indeed, as civic action proved increasingly futile, art became almost a religion, the source of meaning and the food of the soul.

One must not conclude that, in his absorption of aesthetic culture, the Viennese bourgeois absorbed the collective sense of caste and function which the aristocracy maintained even in its decadence. The bourgeois, whether as fop, artist, or politician, could not rid himself of his individualistic heritage. As his sense of what Hofmannsthal called *das Gleitende*, the slipping away of the world, increased, the bourgeois turned his appropriated aesthetic culture inward to the cultivation of the self, of his personal uniqueness. This tendency inevitably led to preoccupation with one's own psychic life. It provides the link between devotion to art and concern with the psyche. It can be illustrated in the style employed in the avidly read cultural section of the press, the *feuilleton*.

The *feuilleton* writer, an artist in vignettes, worked with those discrete details and episodes so appealing to the nineteenth century's taste for the concrete. But he sought to endow his material with color drawn from his imagination. The subjective response of the reporter or critic to an experience, his feeling-tone, acquired clear primacy over the matter of his discourse. To render a state of feeling became the mode of formulating a judgment. Accordingly, in the *feuilleton* writer's style, the adjectives engulfed the nouns, the personal tint virtually obliterated the contours of the object of discourse.

In an essay written when he was only seventeen, young Theodor Herzl identified one of the chief tendencies in the *feuilleton* writer: narcissism. The *feuilleton* writer, Herzl said, ran the danger of "falling in love with his own spirit, and thus of losing any standard of judging himself or others."[5] The feuilletonist tended to transform objective analysis of the world into subjective cultivation of personal feelings. He conceived of the world as a random succession of stimuli to the sensibilities, not as a scene of action. The feuilletonist exemplified the cultural type to whom he addressed his columns: his characteristics were narcissism and introversion, passive receptivity toward outer reality, and, above all, sensitivity to psychic states. This bourgeois culture of feeling conditioned the mentality of its intellectuals and artists, refined their sensibilities, and created their problems.

Let us now bring together the separate strands of culture and political development as they converged in the nineties. In its attempt at assimilation into the pre-existing aristocratic culture of grace, the educated bourgeoisie had appropriated the aesthetic, sensuous sensibility, but in a secularized, distorted, highly individuated form. Narcissism and a hypertrophy of the life of feeling were the consequence. The threat of the political mass movements lent new intensity to this already present trend by weakening the traditional liberal confidence in its own legacy of rationality, moral law, and progress. Art became transformed from an ornament to an essence, from an expression of value to a source of value. The disaster of liberalism's collapse further transmuted the aesthetic heritage into a culture of sensitive nerves, uneasy hedonism, and often outright anxiety. To add to the complexity, the Austrian liberal intelligentsia did not fully abandon the earlier strand in its tradition, the moralistic-scientific culture of law. The affirmation of art and the life of the senses thereby became, in Austria's finest types, admixed with and crippled by guilt. The political sources of anxiety found reinforcement in the individual psyche through the persistent presence of conscience in the temple of Narcissus.

II

In Arthur Schnitzler (1862–1931), the two strands of Austrian *fin-de-siècle* culture, the moralistic-scientific and the aesthetic, were present in almost equal proportions. Schnitzler's father, a prominent physician, destined Arthur for the solid medical career which the young man pursued for more than a decade. Sharing the Viennese enthusiasm for the performing arts, the senior Schnitzler proudly numbered Vienna's great performers among his patients and friends. But when Arthur contracted in his own home so severe a case of aesthetic fever that he felt the urge to a literary vocation, his father proved himself a mid-century moralist, violently opposing the young man's intentions.

Even as a medical student, Schnitzler was drawn to psychology. He served as assistant in the clinic of Freud's teacher, Theodor Meynert, and became expert in hypnotic clinical techniques. Like Freud, Schnitzler felt a profound tension between his paternal

inheritance of moralistic values and his modern conviction that the instinctual life demanded recognition as a fundamental determinant of human weal or woe. Again like Freud, he resolved his ambivalence by detaching the scientific outlook from its moralistic matrix and turning it boldly upon the life of instinct. Small wonder that Freud hailed Schnitzler on his fiftieth birthday (1912) as a "colleague" in the investigation of the "underestimated and much-maligned erotic."[6] Indeed, so strongly did Freud feel his affinity to Schnitzler that he consciously avoided the writer as his "double" (*Doppelgänger*).[7]

As a Viennese, Schnitzler could readily approach the world of instinct from the social types disclosed to the literary naturalist. Vienna's playboys and *süsse Mädel*, the debonair sensualists of the age, provided him with the characters of his early works. What he explored in them was the compulsiveness of Eros, its satisfactions, its delusions, its strange affinity to Thanatos, and—notably in *La ronde* (*Reigen*, 1896)—its terrible power to dissolve all social hierarchy. In the late nineties, after the clear victory of the Viennese anti-Semites, Schnitzler's concern and sympathy for the old moral world grew. He turned from the gay philanderers who mock at moralistic culture to the believing victims of that culture. In the plays *Paracelsus* (1897) and *Frau Berta Garlan* (1900), Schnitzler showed how fragile is the hold of morality even upon those most determined to repress their vital instincts in the interests of an orderly, ethical, and purposive social existence. Another play, *The Call of Life* (1905), explores the cruelly repressive aspect of conventional culture, but also the futility of the attempt to find satisfaction outside the world of convention in surrender to the instinct of love. The "call of life" is a call to a Dionysian existence, which involves a plunge into the torrent and is thus also a call to death. While Schnitzler inveighed against the moralistic tradition for its failure to understand the instinctual, he also showed, like Freud, the inevitable cruelty to the self and to others which instinctual gratification involves.

In the crisis of liberalism in the mid-nineties, Schnitzler turned to the problem of politics, or rather, to the psyche as manifested in politics. *The Green Cockatoo* (1898) is a brilliant satirical playlet in which the instinctual life of the characters becomes central to their fate in the French Revolution. Schnitzler did not take sides for or

against the French Revolution, which had lost its historical meaning
for him as for so many other late-nineteenth-century liberals. He
merely used the Revolution as a vehicle for irony about contem-
porary Austrian society in its current crisis. The upper-class charac-
ters of *The Green Cockatoo* are committed to the sensuous
existence: some as open sensualists, others as devotees of the
theatrical art. The scene and center of the play is a cabaret-theater,
where the performances aim at obliterating for the patrons the
distinction between play and reality, mask and man. Merely amusing
in normal times, in the revolutionary situation this game proves fatal
to its devotees. The corruption of art and the art of corruption
blend. Stage murder becomes real murder, real murder executed by
an actor out of jealousy appears as heroic political murder, the
lover-murderer becomes a hero of the irrational revolutionary mob.
Too much dedication to the life of the senses has destroyed in the
upper class the power to distinguish politics from play, sexual
aggression from social revolution, art from reality. Irrationality
reigns supreme over the whole.

In *The Green Cockatoo* Schnitzler approached the Austrian
problem of psyche and society abstractly, lightly, ironically. Almost
a decade later, he returned to the problem in a full-length novel, this
time treating it concretely, sociologically, seriously. The phe-
nomenon of the disintegration of Austrian liberal society under the
impact of anti-Semitism provides the specific historical ground of
this novel. Its title, *Der Weg ins Freie (The Road into the Open)*,
refers to the desperate attempt of the cultivated younger generation
of Viennese to find their way into the clear, their road out of the
morass of a sick society to a satisfactory personal existence. Each of
the young Jewish secondary characters represents an actual road
still open to the Jews when liberalism was being swept away. Each
has been diverted from the path which a just society might have left
open to him into another road less congenial and at times funda-
mentally incompatible with his personality. The man of political will
becomes a frustrated writer, turning his will inward upon himself to
his own destruction; the attractive young Jewess made for a life of
love becomes a militant socialist *passionaria*; the young Jew destined
by temperament to be an army officer of fine aristocratic cut becomes
a Zionist; and so forth. Like the themes in Ravel's *La valse*, each

character is distorted from his true self into eccentricity by the frenzied whirling of the whole.

A second group of characters represents the older generation, the purposive, moral, and scientific culture which is in its death throes. Schnitzler views them positively now. It is as if he had made peace with his father. Though their values are anachronistic, no longer relevant to the social-psychological facts of life, the older characters still offer an example of stability, a basis for engagement in constructive work, and even a certain ground for human sympathy. This generation, however, no longer possesses vitality. Schnitzler may view it, as Ravel views Johann Strauss, with nostalgia and warmth, but he sadly sees reality as involving its destruction. His novel shows that instinct has in fact been let loose in the sphere of politics, the parliament has become a mere theater through which the masses are manipulated, sexuality has become liberated from the moral code that contained it. Private dances of life whirl more boldly as the public dance of death gains power. Schnitzler is thus suspended between a renewed allegiance to traditional values and a scientific view of modern social and psychological reality which makes those values inapplicable.

It is from the now contradictory perspectives of old morality and new psychology that Schnitzler draws the hero of *Der Weg ins Freie*. Georg von Wergenthin, at once artist and aristocrat, represents the bourgeois culture hero of the Austrian *fin de siècle*. Through him, Schnitzler illuminates the slow death of an ideal.

Appropriately, Wergenthin is doubly lionized in the circle of Jewish upper bourgeois in which he moves: for his talent as a composer and for his aristocratic grace and pedigree. Although on the surface this society loves his person and encourages his art, it actually reinforces in him, by virtue of its hopeless pluralism, a sense of drift, isolation, and futility. The sensitive Wergenthin reflects in his psychic life the riven and driven condition that characterizes Schnitzler's social panorama. Where the society is a chaos of conflicting value orientations, Wergenthin is its general resultant—a value vacuum.

The incapacity for commitment paralyzes Wergenthin's existence. He dwells in the sterile marchlands of the conscious life: between work and play, between affirmation and negation of his inner drives,

between flirtation and love, between aristocratic wisdom and bourgeois rationality. He makes no choices. Schnitzler deftly shows how they are made for him by whatever pressures, social or instinctual, register most strongly upon his seismographic consciousness. In the love of a lower-middle-class girl, Wergenthin very nearly finds salvation. Withdrawing with her from Vienna to an isolated life in Lugano, he begins to compose once more. The commitment in love makes possible a commitment to creative work. But the disintegrating society soon breaks in upon his creative retreat, and Wergenthin returns from love and work to aimless drifting. Anna's child enters the world stillborn.

The novel has no real end, the hero no tragic stature. Schnitzler was a prophet without wrath. The scientist in him avenged itself on both the moralist and the artist. As social observer and psychologist he drew the world he saw as necessitous, but not—like the true tragedian—as justified. Morality and the dynamics of both instinct and history were incompatible. Schnitzler could neither condone nor condemn.

Yet, as a proclamation of the death of a cultural idea, his novel has power. The break-up of Georg and his artist-sweetheart symbolizes the end of a half-century's effort to wed bourgeoisie and aristocracy through aesthetic culture. Schnitzler shows that the historical force compelling recognition of this failure was the rise of anti-liberal mass politics. Appropriately, the pure and aesthetic Anna's own brother is a vicious anti-Semite. While she is doomed to a humdrum *petit bourgeois* existence by her aristocratic lover's weakness, her brother embarks on a promising if hideous political career. As for Georg, he is paralyzed by his own hypertrophied sensibilities, conscious of being driven by instincts within and an irrational society without. The social aristocrat can no longer control the reality; the aesthetic aristocrat cannot understand it. He can but feel his own impotence in a bourgeois world spinning out of orbit.

Aspiring to tragedy, Schnitzler achieved only sadness. One of his characters observes that there is no *Weg ins Freie* except into the self. Schnitzler, caught between science and art, between commitment to old morals and new feelings, could find no new and satisfying meaning in the self, as did Freud and the Expressionists; nor could he conceive a solution to the political problem of the psyche, as Hofmannsthal was to do. A despairing but committed

liberal, he posed the problem clearly by shattering illusions. He could not create new faith. As an analyst of Viennese high bourgeois society, however, Schnitzler had no peer among his literary contemporaries. Like Ravel, he understood not merely the traditions of the world of the waltz but also the psychology of its individuals in their increasingly eccentric relation to the dissolving whole. He described as no other has done the social matrix in which so much of twentieth-century subjectivism took form: the disintegrating moral-aesthetic culture of *fin-de-siècle* Vienna.

⇒ III ⇐

SCHNITZLER approached first the psyche, then politics, out of the moral-scientific tradition. His commitment to that legacy led him to paint the bankruptcy of the aesthetic-aristocratic ideal. Hugo von Hofmannsthal (1874–1929), in contrast to Schnitzler, was brought up in fidelity to the aristocratic tradition (as he later showed in his libretto for *Der Rosenkavalier*), reared in fact in the temple of art. From it he broke out into the world of politics and the psyche and sought to revitalize the dying moral and political tradition with the magic of art. Thus the two friends worked with the same problems and the same cultural materials, but from different approaches and with different results.

The Hofmannsthal family was the living embodiment of the bourgeoisie's aesthetic-aristocratic tradition. Hugo's father was a Viennese patrician of the purest dye, a true aristocrat of the spirit. Unlike Schnitzler's father, he had no *idée fixe* concerning his son's choice of career, his function in society. What alone mattered was that the boy cultivate his faculties for the optimum enjoyment of refined leisure. The gifted son was consequently reared in a virtual hothouse for the development of aesthetic talent.*

Small wonder that the adolescent Hofmannsthal became a young Narcissus, "early ripened and tender and sad."[8] Quickly absorbing

* Hermann Broch has drawn an illuminating comparison between the paternal education of Hofmannsthal, with its leisure orientation, and that of Mozart, whose father trained him in art as a social vocation. See his "Hofmannsthal und seine Zeit," in Hermann Broch, *Essays*, ed. Hannah Arendt (2 vols., Zürich, 1955), I, 111–13.

the fashionable poetic and plastic culture of all Europe, his language glowed darkly with purple and gold, shimmered with world-weary mother-of-pearl. Small wonder, too, that he became the idol of Vienna's culture-ravenous intelligentsia, young and old. Only Karl Kraus, the city's most acidulous moralist, poured contempt upon "that gem-collector" Hofmannsthal, who "flees life and loves the things which beautify it."[9]

How wrong Kraus was, as wrong as Hofmannsthal's admirers! All were deceived by the poet's diction. From the very beginning, the aesthetic attitude was problematical for Hofmannsthal. The dweller in the temple of art, he knew, was condemned to seek the significance of life purely within his own psyche. He suffered acutely from this imprisonment within the self, which permitted no connection with outer reality except that of the passive reception of sensation. In *The Fool and Death* (*Der Tor und der Tod*) (1893), Hofmannsthal explored the disastrous skepticism, devitalization, and ethical indifference that ensued for the devotee of the "gem-collecting attitude."

In *The Death of Titian* (*Der Tod des Tizian*) (1892), the poet presented in their own terms the cultists who made art the source of value, but also manifested for the first time his own urge to escape from the aesthetic attitude. A sort of *tableau vivant*, the playlet verges on a rite of the dying god of the cult of beauty. The disciples of Titian, in an atmosphere of stylized richness reminiscent of Walter Pater's *Renaissance*, converse on the aesthetic vision of life given them by the artist now nearing death. The disciples glorify the master for having, through his soul, transfigured nature and man for them. Were it not for him,

> We would live on in twilight,
> Our life devoid of meaning . . .*

as do the vulgar in the city. Although Hofmannsthal renders this cult of beauty with all the warmth of an initiate, his commitment is qualified. He senses danger and, even in this most "aesthetic" of his works, gives that danger voice: for the orthodox of the religion of art, the interpretation of life as beauty brings a terrible dependency.

* So lebten wir in Dämmerung dahin, Und unser Leben hätte keinen Sinn.

The genius can always see beauty; to him every moment brings fulfillment. But those who know not how to create "must helplessly await the revelation" of the genius. Meanwhile, life is drained of vitality:

> Our present is all void and dreariness
> If consecration comes not from without.*

The root of the difficulty is suspected only by the youngest of the disciples, the sixteen-year-old Gianino, to whose beautiful person, as to the young Hofmannsthal, "something maidenly" clings. In a "half-dream," the state in which so many of Hofmannsthal's own insights were born, Gianino has wandered in the night to a ledge below which sleeping Venice lies. He sees the city through a painter's eyes: an object of pure vision, "nestling whispering in the spangled cloak which moon and tide had cast about her sleep." Then there rises on the night wind the shattering secret that under this visual image life is pulsing—intoxication, suffering, hate, spirit, blood. For the first time, Gianino becomes aware of an active, emotionally rich and committed existence. "Life, alive and omnipotent—one can have it, yet be oblivious of it," if one separates oneself from the city.

Titian's other apostles rush to resurrect the glacis which separates art and life, and which Gianino's vision threatens to destroy. One explains that under the beautiful and seductive face of the city live ugliness and vulgarity, that distance wisely conceals from Gianino a hideous, dreary world, peopled with beings who do not recognize beauty, who even in their sleep are dreamless. To keep out this gross world, another avers, Titian has built the high fence, through whose luxuriously blooming vines the devotee of beauty shall not see the world directly, but only sense it dimly. Gianino speaks no more, but his attitude finds justification in the dying Titian. The master, in a final burst of insight, cries out, "The God Pan lives!" Fortified by his new dedication to the unity of all life, Titian paints on the eve of his death a canvas in which Pan is the central figure. The painter does not represent Pan the god of life directly, but only as a veiled

* Und unsre Gegenwart ist trüb und leer, Kommt uns die Weihe nicht von aussen her.

puppet in the arms of a young girl, a female counterpart of Gianino with his androgynous characteristics, a girl who feels the mystery of the life she holds. The master has pointed the way to the unification of art and life, but he has not passed beyond a traditional mythological representation of its possibility. For Gianino, though he does not say so, even this merely symbolic vision of vitality is not enough. He wants more than symbol. While the other followers of Titian become epigoni, losing the master's connection of traditional artistic achievement and life, Gianino intensifies the aesthete's vision until it drives him through the ornamented pale of beauty to a yearning for life itself, to the horror of his friends who find life outside the pale unthinkable. In the fragment, Gianino-Hofmannsthal's problem is not resolved, but the question that plagued the poet is clearly posed: How shall art transcend mere passive rendering of beauty to achieve a fruitful relationship to the life of the world? More simply put: Where was the escape from the temple of art?

For a decade Hofmannsthal quietly probed the temple walls to find a secret exit. In his myriad explorations, he discovered one of particular promise for his own intellectual development: art as the awakener of instinct.

In the poem "Idyll on an Ancient Vase Painting," Hofmannsthal tells of the daughter of a Greek vase painter who lives in dissatisfaction with her blacksmith husband. Her childhood memories of the sensuous mythological images drawn by her father arouse a longing for the life of feeling which the work-oriented blacksmith cannot satisfy. At last a centaur comes, and the flame of life leaps up in her. She tries to escape with the centaur and is speared by her husband in the attempt. That is all. Not a very moving story when wrenched from its poetic setting, and yet it has great significance. Hofmannsthal here inverts the attitude of Keats, whom he so much admired. Where Keats in his famous "Ode on a Grecian Urn" arrested and fixed the instinctual life in beauty, Hofmannsthal proceeded from the truth of beauty to reawaken the active instinctual life that had been frozen in art. The "Idyll" marks only the beginning of Hofmannsthal's concern with the life of instinct that led to such magnificent dramas as *Electra* and *Venice Preserved* in the first decade of our century.

I do not mean to imply that Hofmannsthal became some kind of champion of the libido. Far from it. The instinctual for him as for

Schnitzler was dangerous, explosive. His contribution was to show that beauty, which his culture had seen merely as an escape from the everyday world, pointed to another world—the ill-defined realm of the irrational. Because he viewed it as dangerous, Hofmannsthal rarely presented the instinctual world directly in contemporary terms, cloaking it rather in mythical or historical dress. What he said of Friedrich Hebbel's poetry is true of his own, that it "penetrates us in such a way that the most secret . . . inner depths stir in us and the actually demonic, the natural in us, sounds in dark and intoxicating sympathetic vibration."[10] With all its danger, the instinctual element in man, "the natural in us," provided the power whereby one could escape from the prison of aestheticism, from the paralysis of narcissistic sensibility. Engagement in life, Hofmannsthal felt, demands the capacity to resolve, to will. This capacity implies commitment to the irrational, in which alone resolution and will are grounded. Thus affirmation of the instinctual reopened for the aesthete the door to the life of action and society.

How did Hofmannsthal see the great world which he now entered? Modern society and culture seemed to him, as to Schnitzler, hopelessly pluralistic, lacking in cohesion or direction. ". . . [T]he nature of our epoch," he wrote in 1905, "is multiplicity and indeterminacy. It can rest only on *das Gleitende* [the moving, the slipping, the sliding], and is aware that what other generations believed to be firm is in fact *das Gleitende*."[11] This new perception of reality undermined the very efficacy of reason for Hofmannsthal. "Everything fell into parts, the parts again into more parts," says one of his characters, "and nothing allowed itself to be embraced by concepts any more."[12] Hofmannsthal saw it as the trial of the noblest natures to take into themselves "a wholly irrational mass of the non-homogeneous, which can become their enemy, their torture."[13] For the poet, this trial was actually the call to his proper function in the modern world: to knit together the disparate elements of the time, to build "the world of relations [*Bezüge*]" among them. The poet would do his unifying work not by imposing law, but by revealing the hidden forms in which the parts of life are bound to each other. Thus the poet, rather like the historian, accepts the multiplicity of things in their uniqueness and reveals the unity in their dynamic interrelationship. He brings the discordant into harmony through form.

Accordingly, Hofmannsthal abandoned lyric poetry for drama, a

literary form more appropriate to the sphere of action and therefore to ethics and politics. Action, grounded now in instinct and taking place in a human scene where no one law holds sway, implies both suffering for the self and becoming the cause of suffering to others. Each man is destiny to other men, and they to him. Thus ethics in Hofmannsthal becomes detached from traditional rational moral law and is subsumed under the life of feeling. Schnitzler's ambivalence between old morality and new reality is not shared by Hofmannsthal. The ethical life is for him a life of continually renewed sensibility, a life creating ever-new forms of relationship.

In the first years of the century, Hofmannsthal repeatedly experimented with approaches to politics in a series of dramas and dramatic sketches not all of which he completed. As in Schnitzler, the breakthrough of irrationality and demonism in politics posed his basic problem. For the first of his sketches, *Fortunatus and His Sons* (1900–1), Hofmannsthal explicitly stated his "basic historical-sociological motif: the decadence of parvenu families."[14] The rich ruler is demonically driven to make his power felt, to such a point that his subjects rebel. This relatively simple parable of the abuse of rulership gives place to a more complex approach in the next political sketch, *King Candaules* (1903). Candaules is a well-established monarch, whose relation to kingship is reminiscent of that of Gianino to art in *The Death of Titian*. Dissatisfied with the "airless, everyday character" of his existence, Candaules longs for the pulsing life of the multitudes in the city. In the attempt to reach it, he commits the "crime against his kingship: the dissolution of the mythical."[15] What had been redemption for Gianino the artist becomes perdition for Candaules the king. Great art, so Hofmannsthal seems to be saying, depends on recognizing the psychological realities of everyday life, which can then be embraced in poetic form. Great rulership, however, depends on continued recognition of the primacy of its aesthetic component, of "the form, 'king': the high-priestly, no-longer-human essence, the son of gods. . . ."[16] Thus Hofmannsthal, fighting off Schnitzlerian pessimism, strove to find a concept of rulership that could shape and canalize the irrational in politics. His clue he found in the temple of art. From it he brought to the sphere of political chaos the solution he had found for the problem of the poet's relation to the chaos of modern life—dynamic form.

What does the notion of dynamic form imply for politics? It starts from the assumption that the conflicting energies of individuals and groups must have an outlet. This outlet is not given in abstract rational justice, which merely quantifies; the whole psychological man must participate in the political process. Participation here signifies both more and less than the democratic vote of autonomous and equal individuals. It means partaking of what Hofmannsthal called "the ceremony of the whole." Only in a ritual form of politics from which none feels excluded can the inchoate energies of conflicting individuals be harmonized.

This ritualistic concept of politics bears the clear stamp of the Habsburg tradition. In the late Austrian Empire, the imperial office, with its aura of ceremonial formalism, was the only effective focus of civic loyalty. Hofmannsthal may have been inspired by this imperial tradition, but he was not limited by it. In his political plays and sketches he showed that hieratic form alone is not enough; the form must contain the living reality of a culture, or it is doomed to break. His message on the desublimation of art in the "Idyll on an Ancient Vase Painting" remained as a warning in his quest for a resublimation of politics.

Hofmannsthal expressed his mature thought on the relationship of politics and the psyche in his greatest drama, *The Tower* (*Der Turm*) (1927). For more than twenty-five years he worked on this tragedy and embodied in it his experience of the decline and fall of the Habsburg Empire. The central psychological conflict in *The Tower* is oedipal, between father and son. But the father is a king, the son a poet-prince. Like *Hamlet*, the play is political as well as psychological. The father justifies political repression, as the Austrian liberals had done, by the rationale of order based on law. His subjects, his imprisoned son among them, are excluded from participation in the ceremony of the whole; hence they turn to aggression. Where law ignores instinct, instinct rebels and subverts order. Politics is here psychologized, psychology politicized. The poet-prince, however, masters his aggressions and seeks to redeem the society with a new dynamic form of social order, a form inspired by the unifying, non-repressive paradigm of art. Where the father justifies his rule by law, the son aspires to a rule by grace. The attempt fails, and the drama ends in tragedy. The masters of political manipulation organize in their own interest the chaos unleashed by

the overthrow of the father and his old law. It is too late for a politics based on law alone, too soon for a politics of grace which sublimates instinct. The poet-prince dies, like Hofmannsthal, leaving his message for future generations.

Hofmannsthal and Schnitzler both faced the same problem: the dissolution of the classical liberal view of man in the crucible of Austria's modern politics. Both affirmed as fact the emergence of psychological man from the wreckage of the old culture. Schnitzler approached the problem from the moral and scientific side of the Viennese liberal tradition. His sociological insight was greater than Hofmannsthal's, but his commitment to the dying culture induced in him an autumnal pessimism that deprived his work of tragic power. Hofmannsthal escaped the paralysis of drift which Schnitzler thought to be integral to aesthetic culture, and from which Hofmannsthal himself had suffered. Accepting psychological man no less than Schnitzler, he applied the principles of art to politics. He sought a form in which to canalize rather than to repress the irrational force of feeling. His politics of participation in the ceremony of the whole was tinctured with anachronism and led him to tragedy. But his witness to the need for widening the range of political thought and practice to comprehend human feeling as well as rational right posed a central issue for the post-liberal era. Hofmannsthal once observed that the activity of modern poets "stands under the decree of necessity, as though they were all building on a pyramid, the monstrous residence of a dead king or an unborn god."[17] Hofmannsthal, with his Habsburg traditionalism and his daring quest for a new politics of sublimation, seemed to be at work on both.

❧ NOTES ❦

[1] Roland Manuel, *Maurice Ravel*, tr. Cynthia Jolly (London, 1947), p. 83.
[2] *Neue Freie Presse*, March 2, 1897.
[3] *Die Fackel*, I (April 1899), 15.
[4] Cited in Jakob Laubach, *Hugo von Hofmannsthals Turmdichtungen*, Doctoral Dissertation (Freiburg in der Schweiz, 1954), p. 88.
[5] Alexander Bein, *Theodor Herzl. Biographie* (Vienna, 1934), p. 36; cf. pp. 96–7.
[6] *George Brandes und Arthur Schnitzler: Ein Briefwechsel*, ed. Kurt Bergel Bern, 1956), p. 29.

7 Freud to Schnitzler, May 14, 1922, in Ernest Jones, *The Life and Work of Sigmund Freud* (New York, 1951), III, 443–4; cf. Herbert I. Kupper and Hilda S. Rollman-Branch, "Freud and Schnitzler (*Doppelgänger*)," *Journal of the American Psychoanalytical Association*, VII (Jan. 1959), pp. 109 ff.

8 Hugo von Hofmannsthal, "Prolog zu dem Buch Anatol," *Die Gedichte und kleinen Dramen* (Leipzig, 1912), p. 78.

9 *Die Fackel*, I (April 1899), 25, 27.

10 Hofmannsthal to Schnitzler, July 19, 1892, "Briefe an Freunde," *Neue Rundschau*, XLI (April 1930), 512.

11 "Der Dichter und diese Zeit," in Hugo von Hofmannsthal, *Selected Essays*, ed. Mary Gilbert (Oxford, 1953), pp. 125–6.

12 "Ein Brief," *ibid.*, p. 109.

13 Hugo von Hofmannsthal and Eberhard von Bodenhausen, *Briefe der Freundschaft* (Berlin, 1953), p. 97.

14 Hugo von Hofmannsthal, *Dramen*, ed. Herbert Steiner (Frankfurt am Main, 1953–8), II, p. 508.

15 *Ibid.*, p. 512.

16 *Ibid.*, p. 520.

17 "Der Dichter und diese Zeit," Hofmannsthal, *Selected Essays*, p. 138.

II

THE RINGSTRASSE, ITS CRITICS, AND THE BIRTH OF URBAN MODERNISM

IN 1860, the liberals of Austria took their first great stride toward political power in the western portion of the Habsburg Empire and transformed the institutions of the state in accordance with the principles of constitutionalism and the cultural values of the middle class. At the same time, they assumed power over the city of Vienna. It became their political bastion, their economic capital, and the radiating center of their intellectual life. From the moment of their accession to power, the liberals began to reshape the city in their own image, and by the time they were extruded from power at the century's close, they had largely succeeded: the face of Vienna was transformed. The center of this urban reconstruction was the Ringstrasse. A vast complex of public buildings and private dwellings, it occupied a broad belt of land separating the old inner city from its suburbs. Thanks to its stylistic homogeneity and scale, "Ringstrasse Vienna" has become a concept to Austrians, a way of summoning to mind the characteristics of an era, equivalent to the notion "Victorian" to Englishmen, "*Gründerzeit*" to Germans, or "Second Empire" to the French.

Toward the close of the nineteenth century, when the intellectuals of Austria began to develop doubts about the culture of liberalism in which they had been raised, the Ringstrasse became a symbolic focus of their critique. Like "Victorianism" in England, *"Ringstrassenstil"* became a quite general term of opprobrium by which a generation of doubting, critical, and aesthetically sensitive sons rejected their self-confident, parvenu fathers. More specifically, however, it was against the anvil of the Ringstrasse that two pioneers of modern thought about the city and its architecture, Camillo Sitte and Otto Wagner, hammered out ideas of urban life and form whose influence is still at work among us. Sitte's critique has won him a place in the pantheon of communitarian urban theorists, where he is revered by such recent creative reformers as Lewis Mumford and Jane Jacobs. Wagner's conceptions, radically utilitarian in their basic premises, have earned him the praises of modern functionalists and their critical allies, the Pevsners and the Giedions. In their contrasting views, Sitte and Wagner brought to thought about the city the archaistic and modernistic objections to nineteenth-century civilization that appeared in other areas of Austrian life. They manifested in their urban theory and spatial design two salient features of emergent twentieth-century Austrian higher culture—a sensitivity to psychic states, and a concern with the penalties as well as the possibilities of rationality as the guide of life.

I shall first consider the Ringstrasse itself as a visual expression of the values of a social class. It is important to remember, however, that there was more to municipal development than the projection of values into space and stone. The liberals who ruled Vienna put some of their most successful efforts into the undramatic technical work which made the city capable of accommodating in relative health and safety a rapidly increasing population. They developed with remarkable dispatch those public services common to the expanding modern metropolis throughout the world. The Danube was channeled to protect the city against the floods that had plagued it for centuries. The city's experts developed in the sixties a superb water supply. In 1873, with the opening of the first city hospital, the liberal municipality assumed, in the name of medical science, the traditional responsibilities which previously the church had discharged in the name of charity. A public health system banished major epidemics, though tuberculosis remained a problem in the working-class dis-

tricts.[1] Unlike Berlin and the industrial cities of the north, expanding Vienna generally retained its Baroque commitment to open space. To be sure, parks were conceived no longer exclusively in the language of geometry but also in the physiological, organic terms favored by the nineteenth century: "Parks," said Mayor Kajetan Felder, "are the lungs of a megalopolis."[2] In the provision of parks, utilities, and public services, the liberals of Vienna established a respectable record.[3] By contrast, those features of city planning for which Vienna later became famous—the provision of low-cost housing and the social planning of urban expansion—were altogether absent in the Ringstrasse era.* The planning of the Ringstrasse was controlled by the professional and the well-to-do for whose accommodation and glorification it was essentially designed. The imperial decree governing its development program exempted the rest of the city from the purview of the City Expansion Commission and thus left it to the tender mercies of the private construction industry. Public planning was based on an undifferentiated grid system, with control applied only to the height of buildings and the width of streets.[4]

Whatever the strengths and weaknesses of the liberal city fathers in defining and developing the public services which are the bone and muscle of the modern city, they took their greatest pride in transforming the city's face. The new development of Vienna, by virtue of its geographical concentration, surpassed in visual impact any urban reconstruction of the nineteenth century—even that of Paris. In the new Vienna, the fathers "projected their image" no less consciously than the managers of the Chase Manhattan Bank a few years ago proclaimed their character in what they called the "soaring angularity" of their New York modular skyscraper. The practical objectives which redesigning the city might accomplish were firmly subordinated to the symbolic function of representation. Not utility but cultural self-projection dominated the Ringstrasse. The term most commonly used to describe the great program of the sixties was not "renovation" or "redevelopment," but "beautification of

* There were two exceptions: the establishment of a single public housing project by a foundation created for Francis Joseph's Jubilee in 1898; and a commercial project of 1912. See Hans Bobek and Elisabeth Lichtenberger, *Wien* (Graz-Cologne, 1966), pp. 56–7.

the city's image [*Verschönerung des Stadtbildes*]."[5] More eco-
nomically than any other single source, the great forum built along
Vienna's Ringstrasse, with its monuments and its dwellings, gives us
an iconographic index to the mind of ascendant Austrian liberalism.

<div align="center">

≥ I ⋵

</div>

THAT VIENNA should have had at its center a huge tract of open
land available for modern development was, ironically, a consequence
of the city's historical backwardness. Well after other European
capitals had razed their fortifications, Vienna had maintained them.
The massive defense works and the broad glacis which had protected
the imperial capital against the marauding Turk had long since
ceased to define the city limits. Our map of 1844 shows how solid
was the ring of habitation that had closed around the broad glacis
(Figure 1). The inner city remained insulated from its suburbs by
the vast belt of open land. Joseph II, the benevolent "people's
emperor," developed much of the glacis as a recreational area, but
the Revolution of 1848 redefined, both politically and militarily, the
place of the glacis in the life of the city. The abolition of feudal
political jurisdiction led to the incorporation of the suburbs fully
into the city. At the same time, the liberals extracted from the
emperor the right to municipal self-government after three centuries
of direct imperial rule. The new municipal statute of March 6, 1850,
although not fully implemented until the introduction of constitu-
tional government for all Austria in 1860, provided a political frame-
work for advancing civilian claims to the glacis. Behind the political
pressure lay the rapid economic growth of the 1850's, which created
for the city of half-a-million both a population influx and a severe
housing shortage.*[6]

The Revolution of 1848, while issuing in increased political and
economic demands for the civilian utilization of the defense zone,
also revitalized its strategic importance. The enemy in question was
now not a foreign invader but a revolutionary people. Through

* Between 1840 and 1870, both the population of Vienna and the number of
economic enterprises doubled.

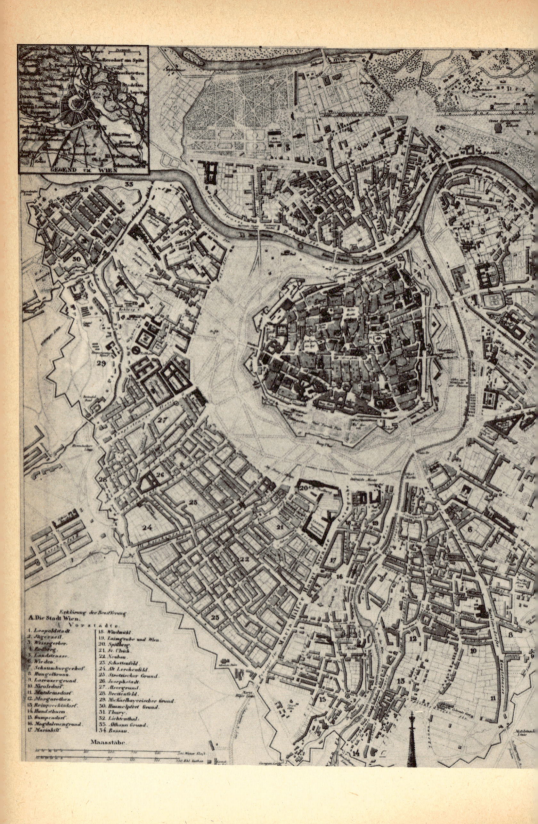

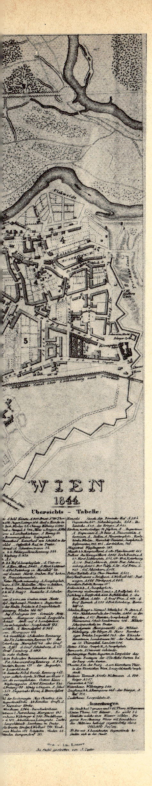

most of the 1850's, the Austrian army, smarting from having had to withdraw from Vienna in 1848, opposed plans for civilian development of the glacis. The Central Military Chancellery took as its major premise the persistence of a revolutionary threat. The imperial court must be secure against possible attacks "from the proletariat in the suburbs and outlying localities. Only the army could be relied upon to defend the imperial government," Generaladjutant Karl Grünne maintained, arguing as late as 1857 against the proposal to scrap the fortifications. In a period of "revolutionary swindle," he said, even the conservatives would remain passive in the face of "tumult."[7]

As the fifties progressed, economic needs proved stronger than counterrevolutionary fears in the highest councils of government. On December 20, 1857, Emperor Francis Joseph proclaimed his intention to open the military space to civilian uses, and established a City Expansion Commission to plan and execute its development. The liberal *Neue Freie Presse* later interpreted the symbolic import of the event in the language of fairy tale: "The imperial command broke the old cincture of stone which for many centuries kept Vienna's noble limbs imprisoned in an evil spell."[8] Yet the author of these lines, writing in 1873 when the liberals had taken over the Ringstrasse, distorted the beginnings of the development. In fact, during the first

Figure 1. Vienna before redevelopment, 1844.

three years (1857–60), the allocation of space and especially the priorities for monumental building still expressed the values of dynastic neo-absolutism. First came a great church, the Votivkirche (1856–79)—"a monument of patriotism and of devotion of the people of Austria to the Imperial House"—built to celebrate the emperor's escape from the bullet of a Hungarian nationalist assassin. Financed by public subscription under the leadership of the royal family and the higher clergy, the Votivkirche expressed the unbreakable unity of throne and altar against what Vienna's Archbishop, Joseph Cardinal von Rauscher, called at the cornerstone-laying ceremonies "the mortally wounded tiger of Revolution."[9] The fact that the Votivkirche was intended to serve simultaneously as church for the garrison of Vienna and as a Westminster Abbey for Austria's greatest men made it, in the words of the *Neue Freie Presse*, a symbol of the "*Säbel- und Kultenregiment* [the rule of the sabre and religion]."

The military for its part, although it lost the battle for the walls and fortifications, received favored treatment in the first Ringstrasse plans. To complete its chain of modernized counterinsurgency facilities, a program already well advanced by 1858, an imposing new arsenal complex and two barracks were strategically constructed near railway stations that could feed reinforcements into the capital from the provinces. Huge tracts of land adjacent to the Hofburg continued to be reserved as protective fields of fire against the suburbs.*[10] Finally, the military left its imprint on the Ringstrasse as a thoroughfare. With fortifications gone, Austrian army spokesmen, like their contemporary counterparts in the construction of the boulevards of Paris, favored the broadest possible street to maximize mobility for troops and to minimize barricading oppor-

* The Arsenal near the South Station was built to house three regiments and an artillery workshop in 1849–55. The architects Siccardsburg and van der Null participated in the work, although both had been officers in the Academic Legion, the main military force defying the Army in 1848. The Arsenal was supplemented by the sumptuous Military Museum, the first "cultural institution" built on the glacis. Its architect was Theophil Hansen, an enthusiast for the Greek Revolution who later designed the Austrian Parliament building. The largest of the barracks was the Franz-Josef Kaserne (1854–57), which was torn down at the century's end to make way for a new War Ministry, seat of the new-style bureaucratized army.

tunities for potential rebels.*[11] Hence the street was designed as a broad artery totally surrounding the inner city in order to facilitate the swift movement of men and matériel to any point of danger. Military considerations thus converged with civilian desires for an imposing boulevard to give the Ringstrasse both its circular form and its monumental scale.

Within a decade of the imperial decree of 1857, political developments had transformed the neo-absolutist régime into a constitutional monarchy. The army, defeated by France and Piedmont in 1859 and by Prussia in 1866, lost its decisive voice in the councils of state, and liberals took the helm. As a consequence, the substance and meaning of the Ringstrasse program changed, responding to the will of a new ruling class to erect a series of public buildings expressing the values of a *pax liberalis*. In 1860, the first leaflet presenting the development plan to the public recorded iconographically the ideology of the new sponsors (Figure 2). The meaning of the female figures flanking the map is clearly stated in the legends: on the right, "Strong Through Law and Peace" (i.e., not through military force); on the left (where the spirit of art is literally dressing her mistress, Vienna), "Embellished Through Art."

The contrast between the old inner city and the Ring area inevitably widened as a result of the political change. The inner city was dominated architecturally by the symbols of the first and second estates: the Baroque Hofburg, residence of the emperor; the elegant palais of the aristocracy; the Gothic Cathedral of St. Stephen and a host of smaller churches scattered through the narrow streets. In the new Ringstrasse development, the third estate celebrated in architecture the triumph of constitutional *Recht* over imperial *Macht*, of secular culture over religious faith. Not palaces, garrisons, and churches, but centers of constitutional government and higher culture dominated the Ring. The art of building, used in the old city to express aristocratic grandeur and ecclesiastical pomp, now became the communal property of the citizenry, expressing the various aspects of the bourgeois cultural ideal in a series of so-called *Prachtbauten* (buildings of splendor).

Although the scale and grandeur of the Ring suggest the persistent

* The army pressed in vain for the street itself to be still wider than the 82 feet stipulated for it.

power of the Baroque, the spatial conception which inspired its design was original and new. Baroque planners had organized space to carry the viewer to a central focus: space served as a magnifying setting to the buildings which encompassed or dominated it. The Ringstrasse designers virtually inverted Baroque procedure, using the buildings to magnify the horizontal space. They organized all the elements in relation to a central broad avenue or corso, without architectonic containment and without visible destination. The street, polyhedral in shape, is literally the only element in the vast complex that leads an independent life, unsubordinated to any other spatial entity. Where a

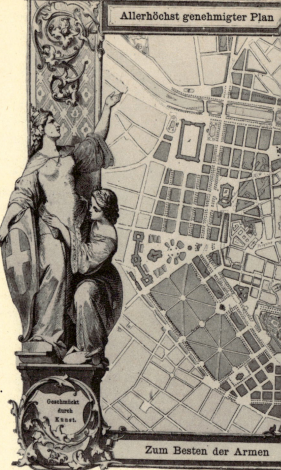

Figure 2. *Leaflet announcing the*

Baroque planner would have sought to join suburb and city—to organize vast vistas oriented toward the central, monumental features—the plan adopted in 1859, with few exceptions, suppressed the vistas in favor of stress on the circular flow. Thus the Ring cut the old center off from the new suburbs. ". . . [T]he inner city," wrote Ludwig von Förster, one of the chief planners, "acquired a closed and regular form by filling in its irregular edges as a seven-sided figure around which one of the most lordly promenades, the corso, could run [*ziehen*], and could separate the inner city from the

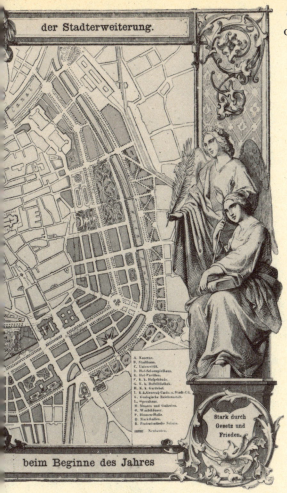

Ringstrasse development, 1860.

outer suburbs."[12] Instead of a strong radial system, which one would expect to link the outer parts and the city center, most of the streets that enter the Ring area from either inner city or suburb have little or no prominence. They debouche in the circular flow without crossing it. The old city was thus enclosed by the Ring—reduced, as one critic has observed, to something museum-like.[13] What had been a military insulation belt became a sociological isolation belt.

In the vast, continuous circular space of the Ring, the great representational buildings of the bourgeoisie were placed sometimes in clusters, sometimes in isolation. Only rarely were they oriented to each other under some principle of subordination or primacy. The broad avenue does not focus upon them; rather, the buildings are separately oriented toward the avenue, which serves as the sole principle of organizational coherence. The photograph in Figure 3, taken where the Ringstrasse rounds one of its corners at the Parliament building, reveals the linear power generated by the street. The University at center right does not face the Parliament at left, which is separated from it by the park. Like the Parliament itself and like the Rathaus rising at center left, the University fronts the Ringstrasse

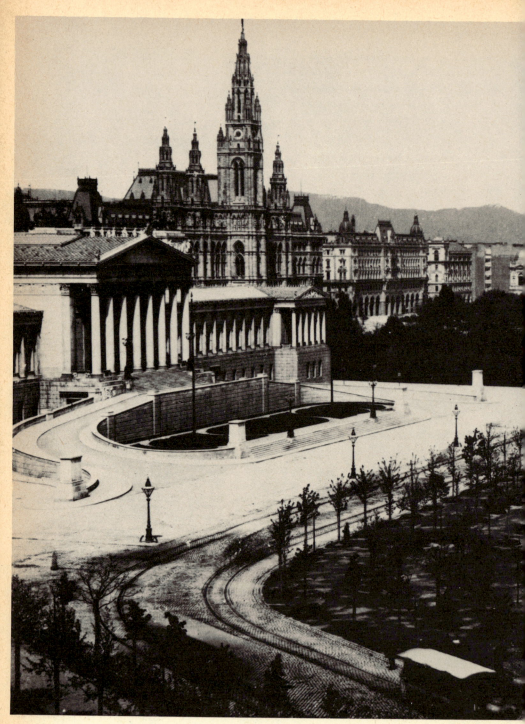

Figure 3. Ringstrasse, showing (left to right) Parliament,

Rathaus, University, and Burgtheater, c. 1888.

quite independent of its neighbors' weighty presence.* Trees running along the entire length of the Ringstrasse only serve to heighten the primacy of the street and the isolation of the buildings. Vertical mass is subordinated to the flat, horizontal movement of the street. No wonder that the "ring *street*" gave the whole development its name.

The several functions represented in the buildings—political, educational, and cultural—are expressed in spatial organization as equivalents. Alternate centers of visual interest, they are related to each other not in any direct way but only in their lonely confrontation of the great circular artery, which carries the citizen from one building to another, as from one aspect of life to another. The public buildings float unorganized in a spatial medium whose only stabilizing element is an artery of men in motion.

The sense of isolation and unrelatedness created by the spatial placement of the buildings is accentuated by the variety of historical styles in which they were executed. In Austria as elsewhere, the triumphant middle class was assertive in its independence of the past in law and science. But whenever it strove to express its values in architecture, it retreated into history. As Förster had observed early in his career (1836), when he set out to bring the treasures of the past to the attention of modern builders in his journal, *Die Bauzeitung*, ". . . [T]he genius of the nineteenth century is unable to proceed on its own road. . . . The century has no decisive color."[14] Hence it expressed itself in the visual idiom of the past, borrowing that style whose historical associations were most appropriate to the representational purpose of a given building.

The so-called Rathaus Quarter, which I used above to illustrate the equivalency principle in the placement of buildings, also exemplifies the pluralism of architectural styles and its ideational significance. The four public buildings of this sector together form a veritable quadrilateral of *Recht* and *Kultur*. They represent as in a wind rose liberalism's value system: parliamentary government in the Reichsrat building, municipal autonomy in the Rathaus, the higher learning in the University, and dramatic art in the Burgtheater. Each building was executed in the historical style felt to be appropriate to its

* Notable exceptions to street-centered placement are the two major museums, of Art History and Natural History, which face each other across a space conceived by its planners as a square (see page 101).

function. Thus to evoke its origins as a free medieval commune, now reborn after a long night of absolutist rule, liberal Vienna built its Rathaus in massive Gothic (Figure 4). The Burgtheater, housing the traditional queen of Austria's arts (Figure 5), was conceived in early Baroque style, commemorating the era in which theater first joined together cleric, courtier, and commoner in a shared aesthetic enthusiasm. On the grand staircase within, one of the youngest masters of Ringstrasse painting, Gustav Klimt, won his spurs in decorating the ceiling with canvases depicting the history of the theater.* Like the Opera and the Museum of Art History, the Burgtheater provided a meeting ground for the old aristocratic and new bourgeois élites, where differences of caste and politics could be, if not expunged, at

* See pages 209–11.

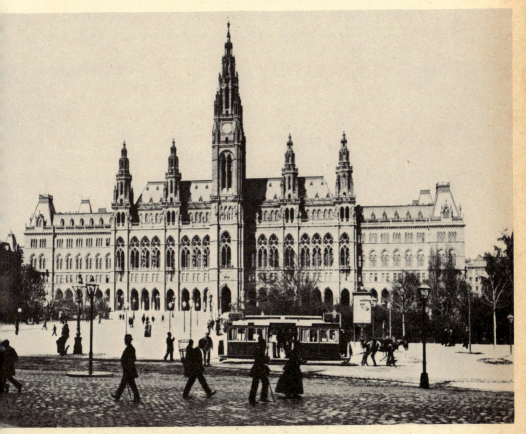

Figure 4. Rathaus (Friedrich Schmidt, architect), 1872–83.

least attenuated by a shared aesthetic culture. The imperial court (*Hof*) could comfortably extend itself to the newly widened public in the institutes of the performing arts—the *Hof*burgtheater, *Hof*oper, *Hof*museen—while the new bourgeoisie could eagerly absorb traditional culture in those arts without surrendering its proud sense of separateness in religion, politics, and science.

The Renaissance-style University, in contrast to the Burgtheater, was an unequivocal symbol of liberal culture. Accordingly, it had long to wait to realize its claims to a significant building site on the Ringstrasse. As the citadel of secular rationalism, the University was the last to win recognition from the diehard forces of the Old Right, and suffered first from the rise of a populist, anti-Semitic New Right. The siting of the University and even its architectural style occasioned years of conflict within the government and among its shifting constituent social interest groups. For years the University dwelt under the shadow of its role in the Revolution of 1848. The

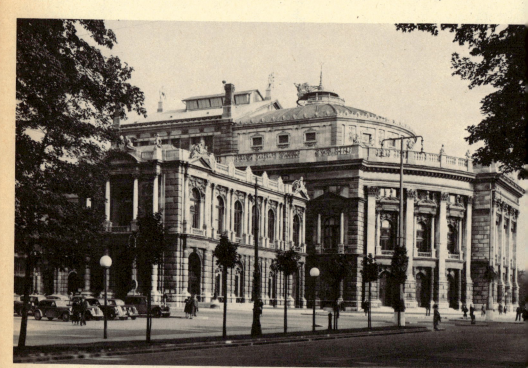

Figure 5. Hofburgtheater (Gottfried Semper and Carl Hasenauer, architects), 1874–88.

Academic Legion, composed of faculty and students of the University and other institutions of higher learning, had been the heart of revolutionary Vienna's organized fighting force. The imperial army could neither forget nor forgive its own ignominious withdrawal in the face of the intelligentsia-in-arms. After the suppression of the revolution, the military occupied the old University in the inner city, and forced the dispersion of its functions in buildings scattered through the outer districts. On assuming office in July 1849, the aristocratic, pious, but enlightened conservative Minister of Religion and Instruction, Count Leo Thun, had sought both to modernize and to domesticate the University, to restore its autonomy yet to link it more closely to throne and altar. He strove in vain against the army and other political objectors to bringing the University out of its punitive diaspora. From 1853 to 1868, Thun and his collaborators worked to create a new English- and Gothic-style University quarter which would be clustered around the Votivkirche —to no avail.[15]

The University problem was resolved only when the liberals came to power. At that time, the three public institutions most important to the liberals—University, Parliament, and Rathaus— were still housed in quarters either temporary or inadequate, while the army held on to the parade ground, the last open tract (over 500 acres) of the old glacis. Immediately after its formation in 1868, the new *Bürgerministerium* (Citizens' Ministry) petitioned the emperor for that plot, without success. Mayor Kajetan Felder finally broke the deadlock by setting up a commission consisting of the three architects for Parliament, Rathaus, and University to draw site plans to accommodate all three buildings on the parade ground. In April 1870, with the enthusiastic support of the liberal-dominated city council, Felder won the emperor's approval for the triple building plan. Against a large compensatory payment from the City Expansion Fund, the army finally surrendered its *champ de Mars* to the champions of liberal politics and learning.[16]

The political change that made possible the location of the University in a place of highest honor on the Ringstrasse was reflected also in the form and style of the building itself. Count Thun's plans for a medievalizing *cité universitaire*, with Gothic buildings huddled about the Votivkirche like chicks around a mother hen, faded with the neo-absolutist politics that had given them birth. The University

now took the form of an independent building, massive in feeling and monumental in scale. Not Gothic, but Renaissance was the style chosen for it, to proclaim the historical affiliation between modern, rational culture and the revival of secular learning after the long night of medieval superstition.

Its designer, Heinrich Ferstel (1828–1883), a Vicar of Bray even among the politically flexible architects of the day, commanded all the varieties of historical "style-architecture," as it was called, ready to meet the changes in preference that accompanied changes in political power. The son of a banker, Ferstel had had his youthful moment as a revolutionary in the Academic Legion in 1848, but soon retrieved this blighted start as architect for the Bohemian aristocracy in the conservative fifties. With the patronage of one of these aristocrats, Count Thun, Ferstel soared to fame as architect of the Votivkirche.[17] But when the liberal phase of University planning finally began, Ferstel was commissioned to design a building in Renaissance style. He went to the cradle of modern humanist learning, Italy, to study the universities of Padua, Genoa, Bologna, and Rome. To be sure, certain natural scientists objected to Ferstel's seeking to outdo in his imposing structure the models of the Renaissance past. Those venerable buildings, their petition ran, did not serve the purpose of furthering the natural sciences. These flowered elsewhere—in the universities of Berlin and Munich, the Collège de France, the University of London. In their simple buildings, "better suited to sober requirements . . . the exact sciences can feel comfortable." But even these critics advanced their functional views somewhat apologetically, accommodating themselves in the end to the prevailing emphasis on representational considerations: "When everyone is marvelling at the style of the Italian universities, then surely we shall gain great glory if we outdo them."[18] Renaissance thus won the day as the proper style for Vienna's monumental center of liberal learning (Figure 6).

Perhaps the most imposing building in the quadrilateral of *Recht* and *Kultur* was the Reichsrat or Parliament (Figure 7). Its Danish architect, Theophil Hansen (1813–1891), built five of the public buildings in the Ringstrasse complex,* but it was on the Parliament

* Hall of the Music Society, Academy of Fine Arts, Stock Exchange, Evangelical School, and Parliament.

that he lavished his greatest effort. He selected the style he most revered—the classical Greek—to dress the exterior of the building, even though its articulated, blocklike volumes had greater affinity with the Baroque. A true Philhellene, Hansen believed that his "noble, classical forms would produce with irresistible force an edifying and idealizing effect on the representatives of the people."[19] As in the case of the University, the plans for the form, style, and location of the Parliament changed as the power of the liberals grew. At first the two houses of the legislature were to be in separate buildings executed in different styles. In his original plans Hansen projected the House of Lords in classical Greek, the "nobler" style. For the House of Representatives, he contemplated Roman Renaissance. But all plans were suspended with the Austro-Prussian War and the ensuing internal crisis in 1866. When the smoke cleared and a more liberal constitution was established, it was decided in 1869 to unite the two houses in "a single monumental building of splendor

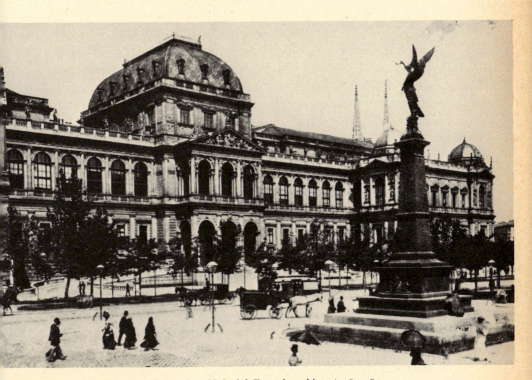

Figure 6. University (Heinrich Ferstel, architect), 1873–84.

[*Prachtbau*]," with a wing for each House. A shared central hall, shared reception rooms for the presidents of both chambers, and the adoption of the "nobler" Greek style for the whole symbolized the hoped-for parliamentary integration of peers and people.[20] No expense was spared to provide the richest materials for the execution of Hansen's sumptuous plans.

The liberation of the parade ground from the army also gave the Parliament a site befitting its new political importance. Instead of the modest location originally contemplated,* the building now assumed

* On the present Schillerplatz.

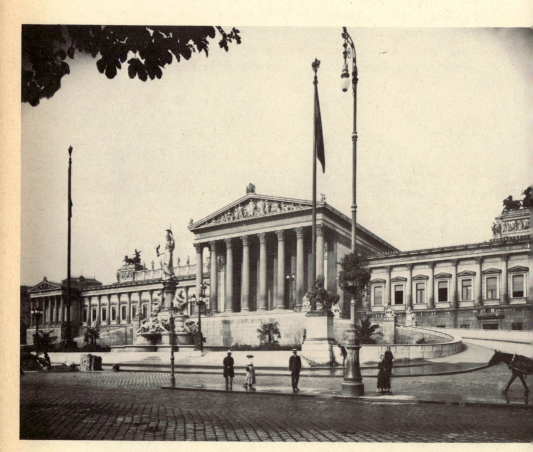

Figure 7. Reichsrat (Parliament) (Theophil Hansen, architect), 1874–83.

prime Ringstrasse frontage, where it could directly face the Hofburg across a small park. Hansen so designed the building as to create every possible illusion of height, as Figure 7 shows. He placed the main entrance to the Parliament building on the second story within an imposing columned porch, and constructed a wide ramp running up to it from the ground level for vehicles. The vigorous ascending diagonal line of the ramp imparts to the massive, rough-textured ground floor the character of a masoned acropolis on which the polished classic upper stories rest. Yet, however ingenious the illusion achieved, the temple of *Recht* did not secure the effect of dominating its environment that its creator seems to have wished for it.

The statuary gracing the ramp betrayed the degree to which Austrian parliamentary liberalism sensed its lack of anchorage in the past. Having no past, it had no political heroes of its own to memorialize in sculpture. It borrowed a pair of "tamers of horses" from Rome's Capitol Hill to guard the entrance to the ramp. Along the ramp itself were placed the figures of eight classical historians— Thucydides, Polybius, and other worthies. Where historical tradition was lacking, historical erudition had thus to fill the void. Finally, Athena was chosen as central symbol to stand at the front of the new building (Figure 8). Here myth stepped in where history failed to serve. The Austrian parliamentarians did not gravitate toward a figure as freighted with a revolutionary past as Liberty. Athena, protectrix of the polis, goddess of wisdom, was a safer symbol. She was an appropriate deity, too, to represent the liberal unity of politics and rational culture, a unity expressed in the oft-repeated Enlightenment slogan, "Wissen macht frei" (Knowledge makes [us] free). Despite her grand scale, Athena is no more able to dominate the scene than Hansen's Reichsrat. She stares stonily across the windswept center of life: the Ringstrasse itself.*

The primacy of the stylistically imposing over the functionally useful, which is present even in the well-designed Parliament building, did not always appeal to the practical men who sat on the building committees. In 1867, when the architects Ferstel and Hansen submitted plans for the museums of Art History and

* Kundmann's statue of Athena, though a part of Hansen's plan, was erected only in 1902, nearly twenty years after the completion of the building, and long after the spirit of rationality had abandoned the Reichsrat.

Natural History that provided inadequate interior space in the interest of the facades, one of the committee members countered by drawing an engineer's sketch of "a functional structure [*Nutz-bau*], with a usable floor plan and an unusable facade." A new architect, Gottfried Semper, who advocated in principle the unity of utility and splendor, had to be brought in from Germany to reconcile the conflicting demands.[21] Interestingly enough, it was only in urban building that the bourgeois fathers felt impelled to assert the primacy

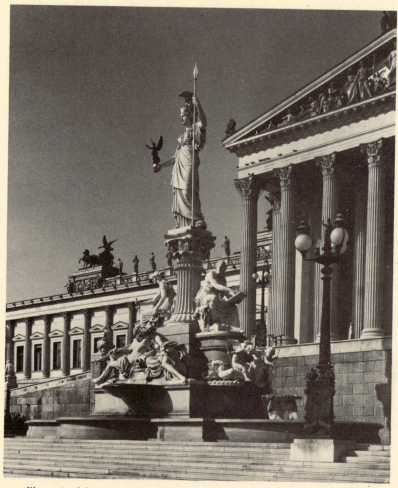

Figure 8. Athena fountain before the Parliament (Theophil Hansen and Karl Kundmann), 1896–1902.

of the aesthetic. In the countryside, they felt no need to screen their businesslike identity. Thus when the city councilmen had to select a style for the Baden aqueduct of the new Vienna water supply system, they rejected a suggestion for "something with decoration [*etwas mit Schmuck*]." Instead, they followed the advice of one of the architects, who averred that for such a practical structure in the countryside, there was only one appropriate style, "which is called the style of Adam; namely, naked and strong."[22] In the city, such a baring of muscle would have been considered gross. There the truth of industrial and commercial society had to be screened in the decent draperies of pre-industrial artistic styles. Science and law were modern truth, but beauty came from history.

Taken as a whole, the monumental buildings of the Ringstrasse expressed well the highest values of regnant liberal culture. On the remnants of a *champ de Mars* its votaries had reared the political institutions of a constitutional state, the schools to educate the élite of a free people, and the museums and theaters to bring to all the culture that would redeem the *novi homines* from their lowly origins. If entry into the old aristocracy of the genealogical table was difficult, the aristocracy of the spirit was theoretically open to everyone through the new cultural institutions. They helped forge the link with the older culture and the imperial tradition, to strengthen that "second society," sometimes called "the mezzanine," where the bourgeois on the way up met the aristocrats willing to accommodate to new forms of social and economic power, a mezzanine where victory and defeat were transmuted into social compromise and cultural synthesis.

The contemporary liberal historian Heinrich Friedjung interpreted the Ringstrasse development as a whole as a redeemed pledge of history, the realization of the labors and sufferings of generations of ordinary Viennese burghers, whose buried wealth and talent were finally exhumed in the late nineteenth century "like huge coal beds lying under the earth." "In the liberal epoch," Friedjung wrote, "power passed, at least in part, to the bourgeoisie; and in no area did this attain fuller and purer life than in the reconstruction of Vienna."[23]

One young provincial, Adolf Hitler, who came to Vienna because, as he said, he "wanted to be something," fell under the Ringstrasse's spell no less than Friedjung: "From morning until late

at night," he wrote of his first visit, "I ran from one object of interest to another, but it was always the buildings that held my primary interest. For hours I could stand in front of the Opera, for hours I could gaze at the Parliament; the whole Ring Boulevard seemed to me like an enchantment out of 'The Thousand-and-One Nights.' "*24 As an aspiring artist and architect, Hitler soon learned in frustration that the magical world of *Recht* and *Kultur* was not easy to penetrate.[25] Three decades later he would return to the Ring as the conqueror of all it stood for.

❧ II ❧

THE EXTRAORDINARY ARRAY of monumental buildings in the Ringstrasse complex can easily obscure the fact that large apartment houses occupied most of the building space. The ingenuity of the City Expansion Commission consisted precisely in harnessing the private sector to create the financial basis for public construction. The proceeds of the sale of land went into a City Expansion Fund *(Stadterweiterungsfond)*, which in turn defrayed the cost of streets, parks, and, in considerable part, of the public edifices.

The authorities manifested complete confidence in private enterprise to produce the desired financial results, and accordingly encouraged rather than constrained speculation in the released properties. The acute housing need of the inner city in the 1850's provided an appealing economic argument for such a course. Despite the protests of the property owners of the inner city, who feared the competition of vast new housing construction, the Expansion Commission operated on the principle that the most lucrative exploitation of the land would produce the best results for the community. The Commission defined its aims, of course, not in terms of the needs of the low-income groups for housing, or even in terms of urban economic development as a whole, but simply in terms of the representative public buildings and public spaces of the Ringstrasse. Building controls for the residential sector were limited as to height, building line, and to some extent land parcelization. For the rest, the

* Hitler's close, personal, and often perceptive criticism of the Ringstrasse makes clear its power and vitality as symbol of a way of life.

market determined the results. And "the market" meant the inter-section of the economic interests and cultural values of the well-to-do.

The urban geographer Elisabeth Lichtenberger has made an in-tensive study of the Ringstrasse's social and economic structure which, taken together with Renate Wagner-Rieger's researches on Ringstrasse architecture, makes it possible for us to understand the habitat that the new Viennese ascendancy class constructed for itself in the half-century after 1860. Both spatial organization and aesthetic style reveal the needs and aspirations of the builders and their clientele.

The fundamental residential building was the apartment house. Four to six stories high, the normal multiple-unit dwelling rarely contained more than sixteen units.[26] The formal model for this type of building was the *Adelspalais* (aristocratic palace) of the Baroque era, of which many fine examples existed in Vienna's inner city. Adapted to the needs of the new Ringstrasse élite, the *Adelspalais* became, in the language of the day, a *Mietpalast* (rent-palace) or *Wohnpalast* (roughly translated, an apartment palace).* It was also called, from the viewpoint of the investor rather than the tenant, a *Zinspalast* (an interest-bearing palace). Plebeian in relation to the *Adelspalais*, the *Mietpalast* was aristocratic in relation to the *Mietkaserne* (rent-barracks), the monotonous multi-story tenements that sprang up simultaneously in Vienna's outer districts to house the working class.[27] Both types of building proclaimed in their rec-tangular forms and ample dimensions their affiliation to Baroque and classical progenitors in the inner city: the bourgeois Mietpalast to the noble's palais; the working-class Mietkaserne to the imperial soldiers' barracks. Neither the upwardly mobile new men of wealth nor the downwardly mobile artisans who were entering the army of industrial workers retained their traditional forms of housing, which, whether single or multiple, had been at once residence and workplace for both master and men.[28] Nineteenth-century urban life gradually separated living and labor, residence from shop or office; the apart-ment building reflected the change. The Ringstrasse buildings marked

* The word *Palast* used alone signified not only the grand one-family house, but also imposing clubs, organizational buildings, and even warehouses of a certain grandeur. Cf. Renate Wagner-Rieger, *Wiens Architektur im 19. Jahrhundert* (Vienna, 1970), pp. 205–6.

a transitional stage in this development. While still integrating commercial space with housing in the pseudo-palace that was the Mietpalast, the commercial part was seldom the workplace of those who lived in the building.

When the question of housing patterns first opened up for the Ringstrasse planners, some of them saw an opportunity to rectify the damage they felt that history had done in forcing the population into concentrated housing. *How Should Vienna Build?* Under that title, a contemporary pamphlet addressed the question confronting the ruling élite. In the old city the predominance of multiple-unit dwellings for the middle class had been imposed by increasing population growth. The single-family dwelling now found two prominent champions, the authors of the pamphlet. They were Rudolf von Eitelberger, the University's leading art historian, and Heinrich Ferstel, whom we have already encountered as architect of the Votivkirche, the University, and other major Ringstrasse buildings. Both men were romantic historicists and both were, like so many Austrian liberals, Anglophiles. Ferstel, inspired by travels in England and the Low Countries in 1851, pressed the superior merits of the English semi-detached house, with its small private garden, for the Ringstrasse development. But the English town house, especially in its nineteenth-century incarnation, was a pure dwelling. A product as well as a symptom of the modern division of labor, which concentrated work in specialized buildings and even in separate districts, the English upper-middle-class residence no longer served as the place of work. When the two Austrian critics advocated the English house for the Ringstrasse, however, they adapted it to an earlier lifestyle: that of the prosperous artisan or merchant of early capitalism, whose home was also his workplace. Eitelberger's and Ferstel's model house would contain, in a quite un-modern and un-English way, store or office on the ground floor, living quarters for the family on the second floor, workshops and quarters for the servants and workers on the upper stories. For those more modern bourgeois families for whom residence was separated from workplace, Eitelberger and Ferstel proposed a house with separate apartment units, one to a floor. This so-called *Beamtenhaus* (in Austria the state official was indeed the forerunner of the business executive) still maintained the scale of their medievalizing burgher-house, in the interest of aesthetic homogeneity.[29] The conception of the middle

class that emerges from these housing designs reflects the slow pace of Austrian capitalist development and the social archaism which consequently marked some of the most vigorous artistic spokesmen of the middle class.

The English or patrician town-house did not prevail in the Ringstrasse developers' councils. It satisfied neither the demand for maximum land use nor the yen for the symbols of aristocratic station. The dwellers of Vienna's inner city had been accustomed by Baroque tradition to the Miethaus. The problem was not to supersede this but to exalt it. The new Viennese middle-class man aspired to be not so much a patrician as a nobleman, in his outward appearance even if not in his inner values. The Ringstrasse Mietpalast as a building type bore the stamp, with all its contradictions, of the Austrian bourgeois-aristocratic rapprochement.

The decision to sell the land in lots modeled not on the small parcel size prevalent in inner city and suburb, but on that of the traditional palais, effectively sealed the fate of the English house idea.[30] Although a few new imposing palais were built on these lots as individual residences by the nobility of blood or wealth, most of the buildings were conceived as multiple-family dwellings, whose "aristocratic" character was established first and foremost by their facades. While the lower floor, often heavily rusticated, was let for commercial use, the second floor contained the most spacious apartment(s), and bore the name of *Nobelétage* or *Nobelstock* (from Italian usage: *piano nobile*). Sometimes the third floor duplicated the floor plan of the *Nobelstock*, sometimes it was further subdivided into smaller apartments. Vertical differentiation of the facade by height of window, richness of ornamentation, pillars, and so on, reflected to some extent the size and lavishness of the apartments within: the higher the floor, the more numerous and the smaller the living units. Yet the so-called ennoblement (*Nobilitierung*) of the facade was frequently deceptive. The number and deployment of the apartments in the interior space, as Wagner-Rieger has pointed out, was a matter of consumer demand and speculator's will.[31]

In the first building period of the Ringstrasse, 1861–65, the overriding need for middle-income housing generated a tendency toward smaller, uniform units, to which corresponded a certain classical uniformity in the facade. The Kärntner Ring shows this tendency (Figure 9). In the second wave of building, 1868–73, differentiation

predominated in both facade and interior, proclaiming alike the fact
of stratification within Ringstrasse society and the aspirations of its
members. In the Reichsratsstrasse, an exclusive street behind the
Parliament, the laminated facade reached its zenith (Figure 10).
Architects developed floor plans placing as many apartments as pos-
sible at right angles to the street in order to distribute the prestigious
blessings of facade windows and thus maximize rental values.[32]
"Ennobling" features that increased the rental yield did not have to
be located in the individual apartment units. Imposing stairwells
(Figure 11) and large vestibules (Figure 12) became favored de-

Figure 9. Kärntner Ring.

vices adapted from palace architecture to the apartment house.[33] These features, of course, were also used for grandiosity in public buildings—one thinks of the "Imperial Stairway" (*Kaiserstiege*) in the Opera, or the two whole wings devoted solely to lavishly decorated stairways in the Burgtheater, one for the court, one for the public (see Essay V, Figure 33). In the apartment buildings with strong vertical differentiation, the master stairway (*Herrschafts-stiege*) might go only as high as the *Nobelstock*, or perhaps one higher, with simple stairs serving the upper stories. As in the broad streets of the Ring area, so in the interior of its buildings (both

Figure 10. Reichsratsstrasse.

public and private) communications space was squanderously magnified to produce a sense of grandeur.

As a residential area, for both buyers and tenants, the Ringstrasse

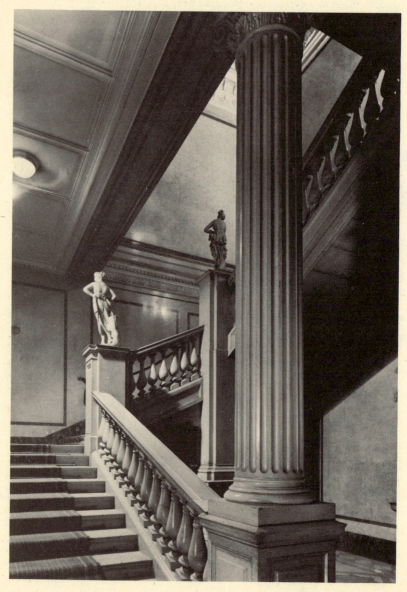

Figure 11. Stairwell in Kärntner Ring No. 14, 1863–5.

scored a stunning success. Until the fall of the monarchy—and notwithstanding the development of villa districts in the suburbs— the Ringstrasse retained its magnetic power for all elements of

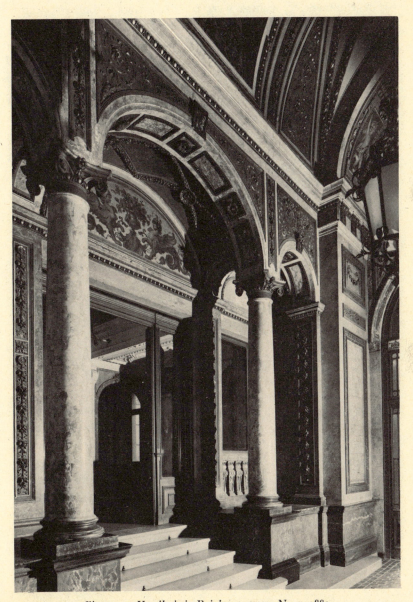

Figure 12. Vestibule in Reichsratsstrasse No. 7, 1883.

Vienna's élite: aristocratic, commercial, bureaucratic, and profes-sional.[34] The highest strata of society not only resided in the Ring area but, with surprising frequency, owned the buildings in which they lived. For the Ringstrasse apartments, although generally built by development companies, were prized as among the most secure and lucrative private investments. To maximize their attractiveness, the state and city waived property taxes for thirty years. The high aristocrat, the merchant, the widow of fixed income, or the doctor who could afford it, were all drawn to buying an apartment building, living in one of its units, and earning income from the rest. In the Ringstrasse house, social desirability and profitability thus reinforced each other.

Great ingenuity went into satisfying the demand for the maximum income-producing grandeur at reasonable cost. The development companies purchased parcels of a whole block. The best architects—August von Siccardsburg and Eduard van der Null of the Opera, Theophil Hansen of the Parliament—were engaged to devote their skills to maximum land use. Covering the whole block with a single building whose very scale and proportions proclaimed grandeur, they employed stairwells and courtyards to achieve rhetorical im-pact without consuming too much space in relation to the actual dwelling units. But to attract individual investors smaller units were necessary. Hansen solved this problem for one development com-pany, the Allgemeine Oesterreichische Baugesellschaft, with a kind of condominium, the Gruppenzinshaus (Figure 13). Hansen designed his block-size building in such a way that it could be divided into eight multiple-dwelling entities, each to be sold to a separate owner (Figure 14). By sharing the interior court and a vast, palatial facade, and by using uniform entry designs, each owner could benefit from a grandeur that would have been prohibitively expensive for in-dividually designed units of the size he purchased.[35] When designing neighboring buildings for different clients, the architects sometimes tuned their designs to each other to achieve not only economies but also the grandeur that stylistic homogeneity in sill-lines, floor-lines, and even ornament could produce.[36]

The felicitous combination of prestige and profit in individually owned rent-palaces reflected one of the major social tendencies of the liberal era: the rapprochement of aristocracy and bourgeoisie. The drive toward integration did not always come from below.

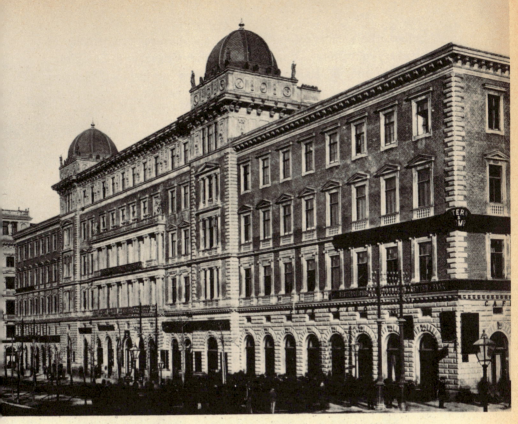

Figure 13. *Gruppenzinshaus (apartment building) (Theophil Hansen, architect), 1870.*

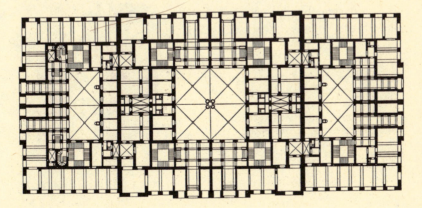

Figure 14. *Floor plan of the Gruppenzinshaus.*

Indeed, the nobility of both wealth and lineage were among the first heavy investors in Ringstrasse housing in the 1860's. This highest social stratum developed a virtual quarter of its own, centering on the spacious Schwarzenbergplatz (Figure 15). There its members, such as Archduke Ludwig Victor and the banker Freiherr von Wertheim,* own-ed almost half the houses. The aristo-crats were not merely absentee land-lords; half of them lived in the palace-like rental houses they had built. While the titled nobility of all kinds also owned much property every-where on the Ring as late as 1914 (about one-third of all the privately owned houses), only in the Schwar-zenberg Quarter did they tend to re-side in the buildings they owned.[37]

Within the middle class, the textile manufacturers composed the largest group of resident owners concentrated in a single neighborhood, occupation-ally defined. What the Schwarzen-berg Quarter was for the aristocracy, the Textile Quarter was for the bour-geoisie: an area of visible pre-eminence. The textile industry was well into

* Ferstel built the palaces of both these clients, with interesting variations in internal lay-out accommodating to the persistent difference in life-styles of old nobility and financial aristocracy. See Norbert Wibiral and Renata Mikula, *Heinrich von Ferstel*, in Renate Wagner-Rieger, ed., *Die Wiener Ringstrasse*, VIII, iii, 76–85.

Figure 15.
Schwarzenbergplatz.

the process of modernization in the sixties when the Ringstrasse development began. Yet it had strong ties with the past. Until the twentieth century, textile firms in Austria were not anonymous

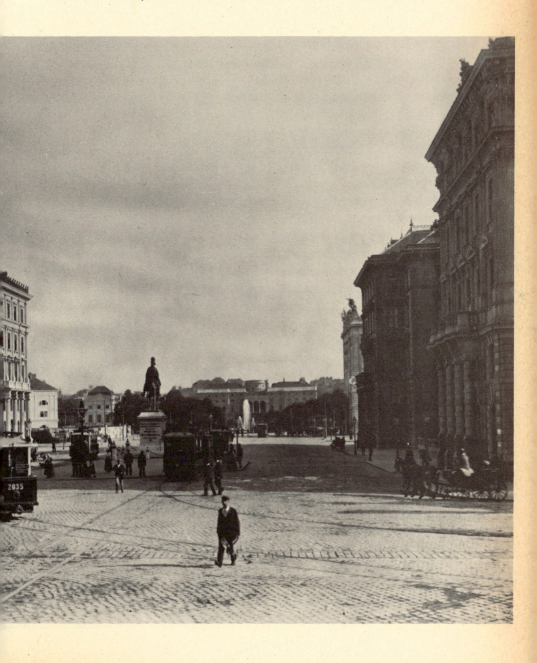

corporations, but family firms headed by individual entrepreneurs.
While manufacturing was carried on largely in the provinces,
especially in Bohemia and Moravia, management remained centered
in the capital. The ancient clothmakers' quarter of the inner city
simply spilled over into the northeast sector of the Ringstrasse to
become the new Textile Quarter. There the textile entrepreneurs
built houses which united
residence and workplace in
the customary way (Figure
16). On the ground floor
and sometimes on the mez-
zanine was the company
office. On the *Nobelétage*
the owner and his family
resided. The top floors,
when not used for further
office or warehouse space,
were rented out. After the
nobility, the textile manu-
facturers belonged to the
group with the highest ratio
of home owners to tenants
in the Ringstrasse area. In
general, of course, it was
only the most prosperous
firms whose owners could
afford headquarters in the
Ringstrasse development.
Two-thirds of the 125 en-
terprises represented in the
area employed over 500
persons; two-fifths, over
1,000.[38]

There were other busi-
ness enterprises scattered in
the Ring, but their offices

Figure 16.
Concordiaplatz.

tended to be accommodated in buildings designed as multiple-unit dwellings. By the time the large bureaucratized company began to assert its need for a specially designed building-type, the Ringstrasse was virtually complete and the dominance of the residential Miet-palast established. New offices could be accommodated only by renovation. As late as 1914, only 72 of the Ringstrasse's 478

privately owned buildings were in the hands of corporate owners, and of these only 27 had their business in the houses they owned.[39] Here too, the Ring development showed itself a creature of the era of individualism. The dwellings located over the businesses subordinated them, absorbing them visually into their facades. Commercial needs were not permitted to dominate the face of the residential blocks or the social function of representation which the buildings had been designed to satisfy.

While the Textile Quarter and the area around the Schwarzenbergplatz bore rather prominent class marks, most of the Ringstrasse neighborhoods blended the fluid strata of the aristocracy and upper bourgeoisie. As one passes clockwise along the Ring from the Schwarzenbergplatz to the Opera district, the "second society"—that fusion of cultivated aristocratic, *rentier*, bureaucratic, and business élite—took over, while the presence of the high nobility diminished. Proceeding still further to the area between the museums and the University, one entered the classic zone of the *Grossbürgertum*, the Rathaus Quarter. Here dwelt the strongest social pillars of ascendant liberalism, as the dignified personages strolling on the Reichsratsstrasse suggest (Figure 10) and the statistics demonstrate. Financial and business leaders, *rentiers*, university professors, and the largest number of high officials of government and business to be found in any quarter lived here.[40] The cluster of monumental buildings of the new order in politics and culture—Reichsrat and Rathaus, museums and Burgtheater, the University—served as a magnet to draw the ruling élite to reside in their precincts, just as the imperial Hofburg in the old city had earlier attracted the nobility to settle nearby.

The apartment houses of the Rathaus Quarter, though built to a scale reminiscent of St. Petersburg, achieve a strong collective dignity despite their individual pomposity. The Reichsratsstrasse, lying behind Hansen's Parliament and leading to the Rathaus (Figure 10), seems almost like a bourgeois answer to the old aristocratic Herrengasse leading to the square before the Hofburg (Figure 17). The facades of the individual Reichsratsstrasse apartment buildings, though highly individuated in their heavy neo-Renaissance facades, are adjusted to each other through sills, rustication, and scale of fenestration to produce a homogeneous street vista with sight lines to the great public buildings, the Rathaus and Votivkirche. Like the

Herrengasse, the Reichsratsstrasse establishes a firm sense of a street of habitations. This is in contrast to the Ringstrasse itself, which dwarfs the buildings both by its width in relation to their height and by the force of its horizontal thrust. Finally, the Rathaus Quarter architects muted the commercialism of their rental palaces by the most discreet accommodation of the shops and offices on the ground

Figure 17. Herrengasse.

floor. Whether by concealing business or store fronts beneath costly arcades in the manner of the rue de Rivoli in Paris, or by simply avoiding prominent signs, the designers assured an elegance rare even in the Ringstrasse area. While not as imposing as the Schwarzenbergplatz with its vast Baroque square and its fully exposed block buildings, the Rathaus Quarter achieved the sense of opulent dignity to which the élite of the liberal era aspired. Its residential buildings provided a fitting environmental setting for the confidently assertive monumental public edifices that were the jewels in liberal Vienna's Ring.

III

IF THE RINGSTRASSE embodied in stone and space a cluster of social values, those who criticized it inevitably addressed themselves to more than purely architectural questions. Aesthetic criticism had its anchorage in broader social issues and attitudes. Those who perceived dissonances in the relationship between style and function in the Ringstrasse were in fact raising a wider question, a question of the relationship between cultural aspiration and social content in a liberal bourgeois society. But the discrepancy between style and function could be approached from either side. Camillo Sitte took seriously the historical-aesthetic aspirations of the Ringstrasse builders, and criticized their betrayal of the tradition to the exigencies of modern life. Otto Wagner launched his attack from the opposite point of view, denouncing the masking of modernity and its functions behind the stylistic screens of history. Thus in the battle of the books around the Ringstrasse, both ancients and moderns attacked the synthesis of the mid-century city builders. Sitte's archaism and Wagner's functional futurism both fed a new aesthetic of city building in which social aims were influenced by psychological considerations.

In his major work, *Der Städtebau (City Building)* (1889), Sitte set forth the basic critique of the modern city from the point of view of the ancients, using the Ringstrasse as a negative model. Sitte called himself a "lawyer for the artistic side," aiming at "a modus vivendi" with the modern system of city building.[41] This self-

definition is important, revealing as it does Sitte's deeply held assumption that "artistic" and "modern" were somehow antithetical terms. The "modern" to him meant the technical and rational aspects of city building, the primacy of what he repeatedly referred to as "traffic, hygiene, etc." The emotionally effective *(wirkungsvoll)* and picturesque *(malerisch)* on the one hand, and the efficient and practical on the other, were by nature contradictory and opposed, and their opposition would increase as modern life became ever more governed by material considerations.[42] The lust for profit, dictating the achievement of maximum density, governed land use and street plan. Economic aims expressed themselves in the ruthless geometrical systems of city layout—rectilinear, radial, and triangular. "Modern systems!" Sitte complained, "Yes! To conceive everything systematically, and never to deviate a hair's breadth from the formula once it's established, until all genius is tortured to death, all joyful sense of life suffocated, that is the mark of our time."[43]

Against the uniform grid, Sitte exalted the free forms of ancient and medieval city-space organization: irregular streets and squares, which arose not on the drawing board but *"in natura."* Against the powerful claims of speculator and engineer, he set out to achieve by deliberate artistic planning what earlier eras had achieved by spontaneous slow growth: picturesque and psychologically satisfying spatial organization. He invoked Aristotle against the modern age: "A city must be so constructed that it makes its citizens at once secure and happy. To realize the latter aim, city building must be not just a technical question but an aesthetic one in the highest sense."[44]

In his critique of the Ringstrasse, Sitte had little quarrel with the individual monumental buildings. He fully approved of the borrowed historical styles in which they were executed. He never questioned the nineteenth-century principle of selecting the historical style associated with a building's purpose, nor felt the visual dissonance which the modern eye sees it as creating. Far from combatting historicism, Sitte wanted to extend it—from the individual building to its spatial environment. The modern architect imitates Greek, Roman, and Gothic in his buildings; but where are the appropriate settings: the agora, the forum and the marketplace? "No one thought of that," Sitte complained.[45]

It was the square that Sitte saw as the key to redeeming the city from "our mathematical century" and the reign of the street.[46] The square, a comfortable enclosed space, had in the past given visual expression to the ideal of community. The right kind of square could lift from the soul of modern man the curse of urban loneliness and the fear of the vast and bustling void. Anonymous space is transmuted by the containing sides of a square into a human scene, infinite urban riches in a little room. A square is not merely a piece of unbuilt land, in Sitte's view, but a space enclosed by walls, like a room outdoors, serving as a theater of the common life.[47]

Sitte's critiques were redolent with nostalgia for a vanished past. They also raised peculiarly modern social-psychological demands which he shared with contemporary critics of the culture, and especially with his hero, Richard Wagner. The Ringstrasse embodied for Sitte the worst features of a heartless utilitarian rationalism. On the Ringstrasse, "the rage for open space"—the broad street ungovernable by the eye, the wide squares—isolated both human beings and buildings. Sitte argued that a new neurosis was in the making: agoraphobia *(Platzscheu)*, a fear of crossing vast urban spaces. People feel dwarfed by space, and impotent in the face of the vehicles to which it has been consigned.[48] They also lose their sense of relationship to the buildings and monuments. The "craze for free placement"—isolating buildings in open rather than contained space —destroys the integration of architecture and environment. The effect *(Wirkung)* of buildings such as Vienna's Votivkirche and Opera House is destroyed, dissipated into empty, uniform space. "A free-standing building remains forever a cake on a platter."[49] Moreover, such buildings do not reach out to their users. Even the University, the work of Sitte's own architecture teacher, Heinrich Ferstel, suffered from this defect, he thought: its beautiful internal court had never drawn in the passers-by. Great facades must beckon the people, space must frame the fine facades, and fine facades enrich the space. Sitte criticized the entire Ring from the point of view of humanized construction, and pleaded for the integration of architecture and people in communitarian union.

What was to be done for the Ringstrasse? Sitte made specific proposals. He would create squares, islands of human community in the cold sea of traffic-dominated space. Before several of the great buildings—the Votivkirche, the Parliament, and others—he proposed

the construction of arms reaching out from the main structure to form a square, which would frame the principal facade. Sometimes these arms were to take the form of walls of lower buildings, like the City Hall square of Brussels; sometimes, that of colonnades in the manner of Bernini's at St. Peter's. In all cases the result was to be the interiorization of space, its transformation from a boundless medium into a defined volume. The aimless flow of the Ringstrasse would be arrested in pools of satisfying scale. Sitte thus developed a kind of psychological functionalism of the plaza, to offset the movement-oriented functionalism of the street. He employed historical models of squares not to symbolize a function, as in the architectural styles of the Ringstrasse buildings, but to re-create the experience of community within the framework of a rational society.

How did Sitte come by his ideas, so fruitful in the history of modern city planning? Certainly one ingredient in his thought was a typical nineteenth-century enthusiasm for the art of the past. He acquired this, as did several of the academic architects of the Ringstrasse, through the study of the new and exciting discipline of art history. But Sitte's commitment to the artistic heritage of a vanished past was not merely a scholarly romantic nostalgia. In Austria the culture and society of a pre-industrial era were still very much alive in the mid-nineteenth century, if on the defensive; and Sitte had his roots in them. For contemporary English reformers such as Ruskin and Morris, revival of a dead artisan and craft culture was the issue. In backward Austria, the issue was not revival but survival: the preservation of an artisan society still alive but mortally threatened. Sitte sprang from this artisan class. In his person he synthesized new learning and old craft.

Sitte's father, Franz, was a noted church builder and restorer. He called himself "private architect," and the title reflected the transitional status between a medieval master builder and a modern state-licensed architect with academic pedigree. In the Revolution of 1848, the elder Sitte played a role in the fight for neo-Gothic as a national folk style against the prevailing governmental classicism. Involved in the struggle also was the autonomy of architects as artists. But unlike some of his professional co-belligerents, the elder Sitte cherished the values of a moribund pre-industrial social class, and retained as much suspicion of the new academic professionalism as of the state authority.[50]

Through working at his versatile father's side from boyhood, Camillo Sitte learned of the fine arts of painting and sculpture as part of the *Gesamtkunst,* the total art, of building, as architectural embellishment. His theoretical education as modern architect and art historian rose on this artisan base. What he learned in modern books only reinforced Sitte's commitment to the ancient way and his love of the values of bygone city life. The intimate Piarist Square, where his father had renovated the church facade and where he himself attended gymnasium, remained Sitte's ideal, a model of Vienna's amiable traditional living space to be held up against the heartless Ringstrasse.[51]

The historistic pathos of Sitte's university culture reinforced the values imparted to him in childhood and youth. His principal professor at the University was Rudolf von Eitelberger, Vienna's first professor of art history (appointed in 1852) and a vigorous champion of the applied arts. We have already encountered him as unsuccessful advocate of the private dwelling unit for Ringstrasse housing. After his return from the London Exposition of 1862, where he had become inspired by the South Kensington (now Victoria and Albert) Museum, Eitelberger persuaded the government to establish a Museum of Art and Industry. At a time when factory production and liberal legislation against the guilds were weakening the crafts, Eitelberger enlisted state assistance to carry the craft tradition into the industrial age. In good nineteenth-century fashion, redemption was to come through the primacy of the idea. Eitelberger expected his museum to inspire the worker and manufacturer to create products "according to the prevailing styles of high art."[52] Thus what the elder Sitte had striven for from below, out of a practical artisan tradition, Eitelberger sought to achieve from above, through state-sponsored scholarship, public exhibition, and education. In 1863, Eitelberger succeeded in securing approval for the Museum; in 1868, an associated School of Applied Art was added to it. Camillo Sitte's principal teacher of architecture at the Polytechnikum, Heinrich von Ferstel, designed the building on the Ring for Eitelberger's school and museum, conceiving it in the grand pedagogic manner as a *Gesamtkunstwerk* (total work of art) of applied art.[53] Thus Eitelberger and Ferstel, who had failed to revive the medieval burgher ideal in their joint campaign for single-family town houses on the Ringstrasse, succeeded in introducing traditional crafts as

state-fostered artistic models for modern industry. Through education in museum and school, modern production could be enhanced by an infusion of the craft spirit. Here too, as in architecture, the *novi homines* looked to the past for forms to enrich the present.

The economic crash of 1873 gave a second impetus to state support for the traditional outlook in arts and crafts. Having just completed the legal annihilation of the traditional guild structure in the crafts— by the Trade Ordinances of 1859—in favor of complete laissez-faire, the Liberal government itself turned to find in education a substitute for the guilds as a means of strengthening the distressed artisan class. The wholly unexpected failure of free enterprise evoked both guilt and nostalgia in the new ruling class. At the same time it strengthened the resentments of the artisans, who began to organize politically for a widened franchise and for economic protection.[54] The government took control over education in the crafts out of the hands of the Ministry of Trade and charged the Ministry of Education with the task of developing a comprehensive craft school system. The high bureaucrat who designed the school system was himself a liberal whose nationalism was both intensified by the failures of "cosmopolitan" capitalism in Austria and driven into traditional romantic channels by it.*

The new program of craft education afforded Camillo Sitte an ideal institutional setting in which to pursue in combination his two major interests, the building arts and crafts, and the history of arts and monuments. In 1875, on Eitelberger's recommendation, Sitte became head of the new State Trade School *(Staatsgewerbeschule)* in

* This official was Armand Freiherr von Dumreicher, son of a Vienna University professor of surgery, and a personal friend of Eitelberger's. His German nationalism aroused and frustrated by the experience of the Austro-Prussian conflict of the 1860's, the young bureaucrat turned to cultural nationalism at first for its long-run political potential. While more conservative elements of the aristocracy and artisanate also supported the strengthening of the crafts, it is worth observing that the leadership for their specifically educational rehabilitation came from a disillusioned liberal. Dumreicher resigned his position in the state bureaucracy out of nationalist conviction in 1886 to carry his torch into Parliament. A decade later he resigned from the liberal Constitutional Party executive because of its refusal to fight to the end against Slovenian rights in the schools. Cf. Ferdinand Bilger, "Armand Freiherr von Dumreicher," *Neue Oesterreichische Biographie, 1815–1918* (Vienna, 1923 *et seq.*), V, 114–29.

Salzburg. In 1883, he was called to establish and direct a similar school in Vienna. Franz Sitte bitterly resented his son's selling out his birthright as a free artist for such a bureaucratic position.[55] In fact, the son's compromise preserved his quasi-medieval artisan culture by the only possible means: state-fostered education and scholarly propaganda. Combining the aesthetic-critical erudition of a John Ruskin with the practical craft knowledge of a William Morris, Sitte not only organized instruction in a multitude of crafts from ceramics to woodcarving, but conducted a massive public campaign on behalf of the arts and crafts in the press and on the lecture platform. He wrote of bookbinding, leather work, the history of majolica production, the restoration of fountains, peasant pottery, and countless other topics, combining reverence for the past with the liberation of the modern aesthetic imagination.[56]

Enough has been said to indicate that Sitte came to his work as a city theorist in 1889 not as an urban "planner" but as champion of the applied arts and as conservator-protagonist of an artisan-made environment. He called his book not *City Planning*, but *City Building (Der Städtebau);* the title, with its stress on actual "making" rather than on abstract design, conveys the author's artisan outlook. The subtitle, however, reflected Sitte's modern aesthetic self-consciousness: *City Building . . . According to its Artistic Principles.* The modern man, he implied, must accomplish through aesthetic ratiocination what was once achieved in living artisan practice.

The theory which enabled Sitte to synthesize historical erudition and artisan tradition into an aesthetic social mission was that of the musician Richard Wagner. In his school days in the Piarist Gymnasium, Sitte had formed lasting friendships with musical schoolmates in the associated Löwenburg Convent School, where, in a tradition of musical artisanship, the famous Court Choir Boys (now the Wiener Sängerknaben) were trained. While Sitte himself became an accomplished amateur cellist, one of his dearest classmates, Hans Richter, went on in the 1860's to become an intimate assistant to Richard Wagner and a great Wagnerian conductor.[57]

After 1870, in the wake of the Prussian victory over France and Germany's unification, Wagner's nationalism spread rapidly among young Austrian intellectuals, while the crash of 1873 made particularly attractive his glorification of the German medieval artisan

community against modern capitalist society. Sitte was among those swept into the powerful current, and remained a passionate Wagnerian for the rest of his life. Of course he became a Bayreuth devotee.[58] The Festival's scenery painter, Josef Hoffmann,* as well as Richter, the first conductor of the *Ring*, were his intimate friends. Through them he became familiar with Wagner's theater architect, Gottfried Semper, whose ideas of city planning and theater bore fruit in the Ringstrasse itself. In 1876, the year when Richter conducted the first complete *Nibelungenring* at Bayreuth, Sitte's first son was born; he named the child Siegfried. And when in 1883 Sitte decorated the fine apartment he came to occupy as director of Vienna's new State Trade School, he adorned the ceiling of its salon with paintings of scenes from the *Nibelungenring*.[59]

In an address to the Vienna Wagner Verein in 1875, Sitte revealed the importance of Wagner in providing an intellectual framework for his own advocacy of artisan values in a modern capitalist world.[60] The fundamental fact of modern existence, according to Sitte, was the lack of a coherent set of values by which to live. The makers of the modern world were either scientists, from Galileo to Darwin, or explorer-conquerors and merchant adventurers. Goethe's Faust and Wagner's Flying Dutchman (the latter modeled on a real merchant-adventurer, says Sitte) were the epic heroes of this uniquely modern type—subversives, "disturbers of the peace," who destroyed the religious myths by which men previously organized their lives. The essence of the modern condition being the fragmentation of life, we stand in need of an integrating myth. The frantic determination of historicism to restore Greek or other cultures could not work, Sitte insisted; it produced only bloodless ghosts, in art as in life. He called for a new ideal, concretely presented, to stand "beside and above the real world," to weld man's shattered values in the present into an image of a coherent future. Sitte exalted Wagner as the genius who recognized this redemptive, future-oriented work as the special task of the artist. The world that the rootless seekers of science and trade destroyed, leaving the suffering *Volk* without a vital myth to live by, the artist must create anew. Sitte cited the injunction of the Spirits to Faust:

* Not to be confused with the Secessionist architect of the same name.

You have destroyed it,
The beautiful world;

. . .

Build it again,
In your breast rebuild it.*

Richard Wagner had shown the way in two senses, Sitte maintained: as builder of the *Gesamtkunstwerk* and as creator of a mythic hero for national redemption. The *Gesamtkunstwerk* provided a model for the overcoming of fragmentation. As the music-drama united the divided arts, so a national myth must unite a divided modern society. The Wagnerian hero pointed the way to this task for both artist and people. Wagner's Siegfried, with his roots in the Teutonic age of physical strife, had strength, the special virtue needed for the revitalization of the German people in this hypercerebral, utilitarian age. Out of innocent power and the will-to-do, Siegfried forged from the fragments of his father's sword a new weapon to slay the dragons of hoarded wealth and to shatter the authority of moribund gods. So too must the modern artist generate, by the example of his art, the strength to overcome fragmentation and provide a "community life-outlook" for the people as a whole.

Sitte's conception of the people exactly followed Wagner's: the *Volk* is conservative, prone to philistinism, but also capable of responding to the call of genius and of recognizing the deepest values. The burgers of *Die Meistersinger* show the people "fully developed," Sitte says. Normally living by the rules of artisan tradition, they can nonetheless respond to the new art of the opera's hero, an art based on the call of the heart. Yet for Wagner and Sitte the people are not the active element in politics, as they are for Marx or the French revolutionary theorists. They are the passive, conservative ones, who need liberation from the modern, destructive subversives-from-above —the scientists and merchant-adventurers. The artists as redeemers would bring progress not, like Faust, by ruthlessly destroying the conservative (that is, pre-industrial) people, but in alliance with

* Du hast sie zerstört,
Die schöne Welt,

. . .

Baue sie wieder,
In deinem Busen baue sie auf.

them.* They would create a theater of "newly structured modern life," corresponding to "the innermost motive of its culture." Sitte explicitly states that to make Siegfried is to make the future, the new German man. That is the task of the plastic artist (*der Bildner*) no less than of the music-dramatist.

Thus armed, Sitte devoted his life to promoting the Wagnerian ideal in urban criticism and to reordering the man-made environment. Under the Wagnerian conception of the artist's function in modern society, all the ingredients in Sitte's work and outlook fall into place: his loyalty to the artisan class, which he served as educator, scholar, and propagandist, reviving and publicizing its past artistic achievements as a way of legitimizing its continued existence; and his commitment to bringing *all* the relevant arts to bear on any architectural or urban project.[61] Finally, Sitte translated Wagner's idea of the total work of art as social model for the future from the opera house to the city itself. As "advocate of the artistic side" of city building, Sitte freighted the word "artistic" with communitarian social criteria far beyond those of his teacher Eitelberger or the historicist architects of the Ringstrasse. His social traditionalism and his Wagnerian functionalism led him to define the role of the city planner as Wagner had defined the composer's: as the regenerator of culture. This was Sitte's contribution to the formation of the mind of the modern city planner as we have come to know him: a Siegfried-like figure who remakes our lives through redesigning our environment.

The city, conceived in Sitte's Wagnerian terms, must be not "a merely mechanical bureaucratic product," but "a significant spiritual work of art . . . a piece of great, genuine folk art . . . especially in our time, when a popular, *volkstümlich* synthesis of all visual arts in the service of a national *Gesamtkunstwerk* is lacking."[62] If the architect cannot build a whole city, at least give him the square. What music-drama is to Wagner, the square is to Sitte: an artwork of—or, more accurately, an artwork *for*—the future. The square must unify the several arts into a visual *Gesamtkunstwerk*. The artist

* In Goethe's *Faust*, the hero as a modern entrepreneur, in building a new society on land reclaimed from the sea, kills a virtuous peasant couple representing the old order. But Faust transcends this social crime in his final vision of a free society of producers. Goethe, *Faust*, Part II, Act V.

must create a model of community wholeness in a society sur-
rendered to the harsh, divisive rule of Reason, Mammon, and Utility.
In the cold traffic-swept modern city of the sliderule and the slum,
the picturesque, psychologically comforting square can reawaken
memories of the vanished burgher past. This spatially dramatized
memory will inspire us to create a better future, free of philistinism
and utilitarianism. While Sitte thus points toward the future, he
compromises no less than Richard Wagner with the ruling powers
of the present:

. . . [T]he artist needs for his purpose only a few main streets and
squares, all the rest he can cheerfully surrender to traffic and daily ma-
terial demands. Let the great mass of housing be dedicated to work, and
let the city there appear in work clothes; but the few principal squares
and streets should be able to appear in Sunday dress—for the pride and
joy of the inhabitants, the awakening of a sense of belonging [*Heimats-
gefühl*] and for the development of great, noble sentiments in . . . youth.
That's how it was in the old cities.[63]

For the Ringstrasse, Sitte's proposals, however modest, came too late.
His efforts to break the sovereignty of the street by enclosing into
squares the spaces in front of the Votivkirche and the monumental
buildings of the Rathaus complex shattered against both established
interests and the values sustaining them—the pride in the primacy of
mobility and fluidity that the Ringstrasse embodied. The impact of
Sitte's communitarian vision of re-humanized urban space had to
await a more general aversion to megalopolis than prewar Austrian
society would produce.

⇒ IV ⇐

In 1893, four years after Sitte published *Der Städtebau*, the
architect Otto Wagner won a competition for a new development
plan for Vienna on very different premises from Sitte's. The competi-
tion, sponsored by the municipality, was occasioned by the annexation
in 1890 of a vast new belt of suburbs, which confronted the city
with its first massive opportunity for planned development since
the opening of the Ringstrasse. In 1859, when the Ringstrasse de-

velopment was formally begun, the government's statement of objectives had specifically postponed to the future any development plan for the city as a whole. As a result, the Ringstrasse was treated as an independent zone without regard to its wider effects. This time the city council decided to tackle the regulation of future growth in a more comprehensive way than had the planners of the Ringstrasse.* It focused on the non-aesthetic factors of urban development: communications, social and sanitary controls, and land-use differentiation.[64]

In accordance with the new concerns of the council, Wagner submitted for the competition of 1893 a design dominated by ideas of transportation as the key to growth. He proposed a series of four circumferential road and rail belts, of which the Ringstrasse would constitute the first. These would be intersected by radial arteries. Infinite expansion was the premise, cheerfully adopted, for Wagner's Vienna of the future. The aims of "representation" and "beautification of the city image," which had governed Ringstrasse planning, played no part either in the specifications of the competition of 1893 or in Wagner's approach to it. On the contrary, Wagner adorned his project for Vienna as megalopolis with a motto that would have chilled the heart of Camillo Sitte: *Artis sola domina necessitas* (Necessity is art's only mistress).[65]

For Wagner, at this stage, "necessity" meant simply the demands of efficiency, economy, and the facilitation of the pursuit of business. That was what modern man—as opposed to the man of the past—was all about. His planning included no sketch of how the constituents of the city's life—industry, residence, office space— would be geographically deployed. Rather, he centered his design on transportation, which could unite a widespread metropolis into an efficient unit, wherever and whatever its components might be. Only in the new outer belt of the city did Wagner propose outposts *(Stellen)* as centers of communication and local services.[66]

Where Sitte had tried to expand historicism to redeem man from modern technology and utility, Wagner worked in the opposite direction. He wished to roll back historicism in the interests of the

* The city competition called for "designs for a general plan for regulating the whole municipal area of Vienna [zur Erlangung von Entwürfen für einen Generalregulierungsplan über das gesammte Gemeindegebiet von Wien]."

values of a consistently rational, urban civilization. "The function of art," Wagner proclaimed, "is to consecrate all that emerges, in the fulfillment of [practical] aims. . . . Art has the task of adapting the face of the city to contemporary humanity."[67] In 1895, he prefaced his textbook *Modern Architecture* with a repudiation—in capital letters—of the historicism that governed all nineteenth-century architectural education:

One idea inspires the whole book; namely, THAT THE WHOLE BASIS OF THE VIEWS OF ARCHITECTURE PREVAILING TODAY MUST BE DISPLACED BY THE RECOGNITION THAT THE ONLY POSSIBLE POINT OF DEPARTURE FOR OUR ARTISTIC CREATION IS MODERN LIFE.[68]

In thus launching the first major assault on "the outlived world of forms" of the Ringstrasse era, Wagner posed new demands of architects and city planners. They must, he later added, "make visible [*veranschaulichen*] our better, democratic, self-conscious and sharp-thinking essence, and do justice to the colossal technical and scientific achievements as well as to the fundamentally practical character of modern mankind."[69]

Thus at the close of the Ringstrasse era, while Sitte was evoking visual models from the communitarian past to counteract the anomie of modern urbanism, Wagner sought new aesthetic forms to express the truths of the hectic, purposive, capitalist urbanity he joyfully embraced. As architect and polemicist, as teacher and urban theorist, Wagner emerged from Ringstrasse culture as the modernist par excellence.

Born in 1841, Wagner had a rich and successful career as Ringstrasse architect behind him when he suddenly unfolded his assault on its historicism in the 1890's. As in the case of Sitte, the social background and intellectual relations of the thinker cast light upon his creative critique of the Ringstrasse's principles. Where Sitte had his roots in the insecure artisan class, Wagner was born into the "second society" that conceived and built the Ringstrasse in its own image. Wagner's father, though of humble origins, had made a successful career as court notary. His energetic mother came of a wealthy bureaucratic family. Early widowed, Madame Wagner had imbued her son with the new entrepreneurial values—a strong

sense of self and an even stronger ambition for economic success. Wagner reported that his "idolized and revered mama" told him many times "to strive for independence, money, and then again money as the means thereto; then people will recognize your worth." In retrospect he called it "a remarkable philosophy, but the only right one," which in fact had enabled him, as she had predicted, "to live by his own ideals."[70]

From boyhood, Wagner was involved with the builders of the Ringstrasse. Even before 1848, his enterprising mother had had a block of three apartment houses "modernized" by Theophil Hansen, the architect of the Parliament.[71] Madame Wagner purposefully educated her son to succeed in the new world of *Bildung* and *Besitz*. None of the craftsman's experience, none of the historical pathos that saturated Sitte's education, touched Wagner. After a solid preparatory schooling, young Otto entered the Vienna Polytechnic School to begin his architectural training. A brief exposure to Berlin's classical school of architecture prepared him to consolidate his professional education in the orthodox, élite Viennese Academy of Fine Arts, which he entered in 1861. There his masters were August Siccardsburg and Eduard van der Nüll, Ringstrasse architects then at the height of their powers and prestige, jointly engaged in building the Opera House. Siccardsburg, Wagner recalled, "took over my artist's soul and cultivated the principle of utility in me," while van der Nüll inspired him through his gift for drawing.[72] Utility behind a screen of historical style: that was the Academy's legacy to Wagner.

In the late sixties, while Sitte was developing his craft orientation and archaistic erudition on the intellectual fringes of Ringstrasse society, Wagner plunged into the speculative center of its building boom. For a quarter of a century he pursued the career of architect-entrepreneur, building many apartment houses in the Ringstrasse area. Often Wagner lived in his buildings himself until he could sell them off to finance the next venture. Hewing closely to the favored "free Renaissance" style, Wagner gave little grounds for suspecting in him a modernist in the making.[73] Similarly in his public projects, where his successes were fewer, Wagner reflected the gargantuan spirit of monumentality that marked so much Beaux Arts and Ringstrasse architecture. How far his fantasy could carry him in this

direction is shown in his Artibus project of 1880 (Figure 30), a utopian museum complex on a scale that left the Ringstrasse museums far behind.*

In one respect, Wagner early diverged from Ringstrasse practice. Attracted by the idea of the independent commercial structure, he pulled away from the custom of accommodating both business and residential functions in a single building. In the Länderbank (1882–

* See below, p. 105.

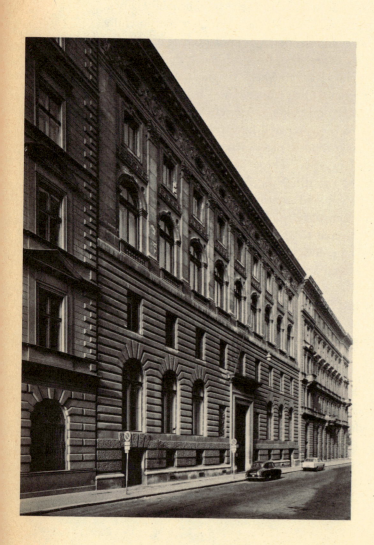

Figure 18.
Otto Wagner,
Oesterreichische
Länderbank, 1882–4,
street facade.

84), one of the early independent corporate buildings of Vienna, Wagner drastically simplified the customary two-tiered Renaissance facade (Figure 18). By virtually obliterating the vertical joints between the rusticated stone blocks on the lower portion, he transformed the masonry into horizontal bands that mediate the building to the trajectory of the street. On the inner courts of the building (Figure 19), the architect went further still. He stripped the exterior walls of every trace of ornament and, bringing the windows out to the plane of the stuccoed walls, adumbrated clearly the functional

Figure 19.
Oesterreichische
Länderbank,
rear court.

style—or meta-style—of the future. In the stairwell of the Länderbank too, Wagner broke with Ringstrasse practice. Where his contemporaries treated stairways with opulent magnificence to celebrate the status of the owner, Wagner used lean classical forms to suggest by the very simplicity of the statement the function of stairs for the user: to provide a straightforward means of vertical communication (Figure 20).

Despite a few such indicators of new directions, Wagner did not

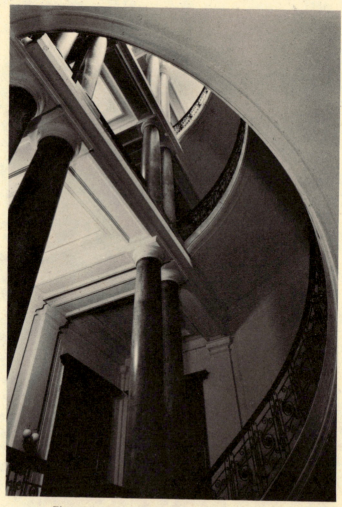

Figure 20. Oesterreichische Länderbank, stairwell.

emerge as a functional theorist and stylist of urban construction until he became engaged in the municipal development projects of the 1890's. The first step in his metamorphosis came through his involvement with urban engineering projects; the second, through his participation in the Secessionist movement, Vienna's *art nouveau*. A city railway project gave him new construction principles, while the Secession provided a new style in which to execute them. Engineering problems and *art nouveau* aesthetics together affected Otto Wagner in the nineties as craft education and Wagnerian ideology had influenced Sitte in the seventies. They provided the coordinates of an intellectual system to criticize and transform the urban forms associated with the Ringstrasse, both in theory and in building practice.

Having espoused the idea of the transportation net as the key to urban planning in the competition of 1893, Wagner soon found himself plunged into the great engineering project related to it: the construction of the Vienna city railway system in 1894–1901. Named chief architect of the undertaking, Wagner not only designed more than thirty stations but became involved in the placement and design of viaducts, tunnels, and bridges. He sought to design stations of simplicity and utility, which would at the same time, through the subdued elegance and variety of their exteriors, serve their neighborhoods as focal points of public movement. Wagner strove for what he later called "a harmonization of art and purpose . . . the first condition of a good solution . . . in the modern view."[74] At first "art" predominated in his designs, with stations constructed in traditional materials of faced or stuccoed brick. Even along the tracks, "style" asserted its continued pre-eminence in miles of railings whose Roman-inspired square-and-diagonal modules served as an appropriate unofficial signature of the Austrian imperial capital's metro system. As the work progressed, however, the functions and materials exerted increasing pressures on both design and form.[75] Wagner allowed iron elements to surface in the station architecture: unfaced I-beams served him as lintels, while iron appeared in the entrance and ticket halls.[76] Even in the most anachronistic of all Wagner's stations—the private city railway pavilion for the royal family at Hietzing (Schönbrunn)—a profusion of iron burst forth in a barrel-vaulted porte-cochère of his quasi-Baroque stone building. Here an idolatry of modern material expressed itself not in opposition to historical style, but as an ornamental supplement to it. In another Wagner

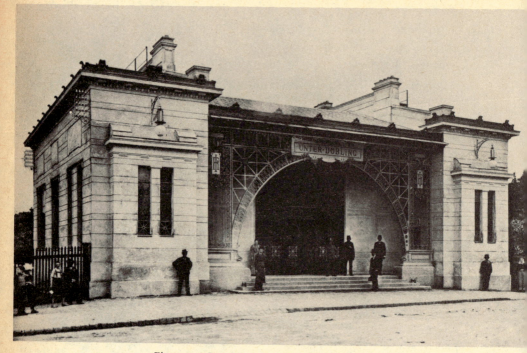

Figure 21. Otto Wagner, Unter-Döbling Station, 1895–6.

station, that of Unter-Döbling, the persistence of the Ringstrasse's demand for symbolization in architectural form can be seen turned against itself (Figure 21). There an ornamental iron arch supporting the projecting roof of the central building block is shaped in the form of an iron railway trestle. Thus Wagner used iron representationally, to symbolize through a form in which iron normally functions on an elevated railway—the form of the trestle—a function it does not here perform.[77] How curious are the paradoxes of nascent functionalism! The iron arch here proclaims, in the face of the Ringstrasse tradition, the validity of technological forms as symbols. Thus Wagner brought into the city the utilitarian "style of Adam . . . naked and strong," which the Ringstrasse builders had admitted only in the engineering works of the countryside.

Such anomalies were the inevitable accompaniment of Wagner's effort to assimilate new building materials as vocabulary into a traditional grammar of architectural expression. The same problem had attended the efforts of Wagner's predecessors, the Beaux Arts archi-

tects of railway stations in the mid-century.[78] What distinguished Wagner's work was the attempt to dignify the technological, to celebrate it as "culture." In most of his stations, his basic idiom remained historical. Though inventively infiltrated with the new materials—especially iron and glass—the traditional structural forms remained dominant in his station buildings. In viaducts, cuts, and bridges, however, Wagner proceeded more radically, assigning primacy to the engineered structure, and allowing its aesthetic attributes to show forth in sweeping girders, massive riveted elbows at abutments, and so forth (see, for example, Figure 22). Yet even here Wagner usually tuned his radical structural aesthetic to tradition by adding cosmetically the features that would make the structure beautiful: stone facings to screen raw iron pillars; swags, wreaths, and statuary to adorn and, as it were, to civilize the new structural material. With few exceptions, a dissonance between the functional ethic of construction and the traditional aesthetic of beautification indelibly marked Wagner's efforts at this time.

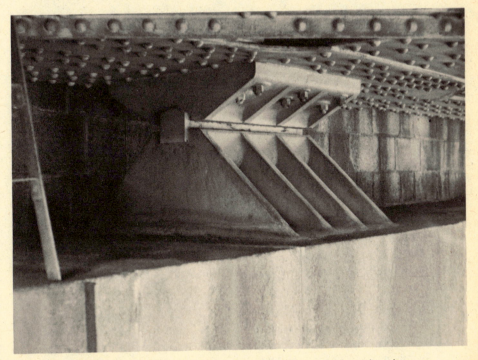

Figure 22. Otto Wagner, Nussdorf Dam, 1894–8: aesthetic engineering.

In 1894, while still engaged in the work that would revolutionize his architectural practice, Wagner was appointed professor of architecture at the Academy of Fine Arts. The very fact of his selection signified the acceptance of his work on the municipal railway. The idea of a utility-oriented concept of urban architecture was eroding the Ringstrasse's cultural ideal even in its citadel, the Academy. The professorial chair to which Wagner was named had previously been defined by historical style, with its occupant required to be "a convinced representative of classical Renaissance." Advanced architecture students had had to choose either this Renaissance "Special School" or its equivalent in Gothic architecture.

Among the architects who applied but were rejected for the position was Camillo Sitte. In the atmosphere of revulsion against capitalism in 1876, Sitte's traditionalistic, pro-craft ideas had had drawing power, winning him the directorship of the State Trade Schools. Now, two decades later, it was Wagner's turn to ride the tide of the times, and to profit from the enthusiasm for bringing modern transport and engineering into the city. For the municipal railway was replacing the grand avenue as the symbol of urban greatness and progress, just as in the Ringstrasse era the avenue had displaced the square. The Academy's faculty appointments committee followed the trend. It chose Wagner not for the distinction of his three decades of building in the Renaissance style but, on the contrary, for his capacity "to bring the needs of modern life and the employment of modern building materials and construction into consonance with artistic demands." Not without a twinge of regret, the committee recorded in its report that the decline in monumental building made masters of historical styles hard to identify.*[79]

Wagner's responsibilities as professor gave him the occasion for consolidating and formulating his ideas. In his inaugural address to the Academy, he sounded the keynote for a new era in architecture:

The realism of our time must penetrate the work of art. . . . No decline of art will result from that; rather it will breathe a new, pulsating life

* Carl Hasenauer (1833–1894), the previous incumbent in the chair, had been chosen for his mastery of monumental styles, and had designed or participated in designing some of the Ringstrasse's grandest buildings: the two museums, the Burgtheater, and the new Hofburg.

into the forms [of architecture] and conquer new areas, such as, for example, the field of engineering, which are still deprived of art.[80]

While Wagner stressed the primacy of utility, demanding that the architect should adapt form frankly to purpose *(Zweck)*, he had by no means abandoned the idea of the architect as artist. In contrast to Sitte, however, who saw the architect as the champion of beauty against utility, Wagner sought to revitalize the aesthetic function of the architect through his service to utility as a good. In his inaugural address he prophesied that modern life itself would compel architects to find "a unique style to represent us." As a first step, the architect would have to liberate himself from the enslavement to history, to the tradition of *"Stilarchitektur."*

In his challenging textbook, *Modern Architecture* (1895), Wagner developed a historical theory to explain the sorry dilemma of nine-teenth-century eclectic "style-architecture." Each new style, every new ideal of beauty throughout history, he said, had emerged gradually from the one preceding it. "New construction, new ma-terials, new human tasks and views called forth a change or recon-stitution of existing forms. . . . Great social changes have always given birth to new styles." But in the last half of the nineteenth century this process had broken down. The pace of social change had run too fast for the development of art to match it. Unable to devise a style to express modern man's needs and outlooks, architects dredged up *all* past historical styles to fill the void. Wagner observed that the Ringstrasse era called an architectural commission a "style assignment" *(Stilauftrag)*. Unthinkable in any previous era of history, the very concept betrayed the separation of art from purpose, the reduction of architectural works to products of archeological study. Such were the origins of the "artistic hangover" from which con-temporary man was now suffering. Wagner summoned the archi-tect as *artist* (not just as utilitarian technician) to a moral revolt on behalf of modern man against a half-century of lethargy in art.[81] In his educational theory, Wagner declared war on the training of the memory, the faculty favored by historicism. He condemned the Italian journey, classic capstone of a Beaux Arts architectural educa-tion, on the ground that Italy's models said too little to modern men. Let the architectural novitiate visit instead "the metropolis" and "those places where modern luxury resides."[82]

But what was a modern style? To tear off the screens of history was one thing; to define modern man and to celebrate his nature in building was another. In the quest for a visual language suited to his age, Wagner found allies in a younger generation of Viennese artists and intellectuals who were pioneers in forming twentieth-century higher culture. In 1897 a group of them banded together to form the Secession, an association that would break the manacles of tradition and open Austria to European innovations in the plastic arts—and especially to *art nouveau*. The motto of the Secession could only have struck the strongest response in Wagner: "To the Age Its Art, to Art Its Freedom." So, too, *Ver Sacrum (Holy Spring)*, the name chosen for the Secession's periodical, expressed the movement's solemn commitment to regenerate art in Austria and Austria through art. One of Wagner's most gifted younger associates, Josef Olbrich, designed the Secession's pioneering modern building, using the form of a modernized temple to suggest the function of art as a surrogate religion for Vienna's secular intellectual élite (Figure 39).*

Among the many symbols devised by the Secession, perhaps the most congenial to Wagner would have been that of *Nuda veritas:* a virginal waif, holding up the mirror of art to modern man (Figure 38). The painter Gustav Klimt, who designed the symbol, shared with Wagner the imperative to proclaim a new function for art before he had found the artistic means to express it. President of the Secession and its most powerful talent, Klimt (again like Wagner) abandoned classical historical painting, in which he had made his fame as Ringstrasse artist, to engage in an almost frenetic experimental search for a painterly language to present the condition of modern man. Wagner idolized Klimt, calling him "the greatest artist who ever walked the earth."†[83] Klimt became for him what Richard Wagner had been to Sitte: a culture hero who helped him redefine his mission both as professional and as artist. As Sitte had decorated his living room with scenes from Wagner's operas, so Otto Wagner hung Klimt paintings on the walls of his elegant villa in Hüttelsdorf.[84]

Klimt and the Secession affected Wagner's ideas in two ways: they strengthened his commitment to the modern, and they gave him a

* See below, Essay V, pp. 213–19.
† ". . . der grösste Künstler, der die Erde je getragen."

new visual language to substitute for the historical styles of the Ring-strasse. Yet the relationship was riddled with paradox. For Klimt and Otto Wagner saw quite different faces of modern man re-flected in the mirror of *Nuda veritas*. Moreover, the *art nouveau* style served as much to inhibit as to advance Wagner's principles of utility and structural function in urban architecture.[85]

Klimt's search for modern man was essentially Orphic and internal, a quest for that *homo psychologicus* who had already emerged in the literature of the early 1890's. Beginning with a cheerful revolt on behalf of the instinctual—especially the erotic—life, Klimt very soon became obsessed with the pain occasioned by the return of the repressed. Presenting a Schopenhauerian universe of boundaries liquefied and rational structures undermined, Klimt limned in allegorical and symbolic language the suffering psyche of modern man impotently caught in the flow of fate.*

How different was the face in Wagner's mirror of modernity: an active, efficient, rational, modish bourgeois—an urban man with little time, lots of money, and a taste for the monumental. Wagner's metropolitan man suffered from only one pathological lack: the need for direction. In his fast-moving world of time and motion, what Wagner called "painful uncertainty" was all too easily felt. The architect must help to overcome it by providing defined lines of movement. The style of Klimt and the Secession helped Wagner in this effort. First, Klimt's two-dimensional concept of space, while conceived to present symbolically the abstract essence of the illusory world of substance, lent itself in architecture to create a new sense for the wall. As opposed to the heavily articulated and indented wall of the Ringstrasse Mietpalast, Wagner's first Secession-style apartment house presented a facade proclaiming in its flatness its function as wall. Where the sculpturesque Ringstrasse house asserted its differentiation from the street, Wagner's Secessionist front reflected the street's simplicity as plane, thus submitting to and reinforcing its direction. In his interiors, Wagner similarly adapted the *art nouveau* line to his passion for guidance: stair rails, carpets, and parquet floors were designed with inlaid strips in the principal direction of movement to help the denizens to overcome their "painful uncertainty."

* See below, pp. 225–31.

Militantly anti-historical in its ideology, the Secession self-consciously liberated the fantasy to formulate a style untrammeled by the past. But the self-conscious search for style as such remained. In providing Wagner with a new ornamental vocabulary, it kept alive in him a continued separation of structure from style—the very aspect of Ringstrasse architectural culture he had so fundamentally attacked. The "beauty" in Wagner's buildings remained to some degree adventitious, a matter of the skin, an aesthetic sheath to ornament his forms, proclaiming in fashionable symbols the glory of modernity.

Two adjoining apartment houses which Wagner erected on the Wienzeile in 1898–99 show his exploitation of Secession style to make a radical break from the Renaissance palace model of the Ring (Figure 23). In these buildings Wagner united for the first time three constituent principles he had developed in the nineties. From the engineering projects came two of these principles: the primacy of function (*Zweck*) as determinant of form; and the candid use of modern materials in terms of their inherent properties; the third principle, a general commitment to the a-historical, quasi-symbolic language of modernity, he drew from the Secession.

In pursuit of the first principle, that of functional honesty, Wagner gave up the screenlike integration of commerce and domicile behind a unifying Renaissance front. Instead, he let the facade of his Wienzeile buildings proclaim in distinct, contrasting forms the two separate functions of the space within: business below and residence above (Figure 23). A forceful continuous band of glass and iron marks off the ground story as commercial space. Above the second story, the residential function takes over the facades and ornament begins.* Wagner's insistently dichotomous symbolization of the building's two functions is best grasped from the corner perspective. The right-hand face, fronting the residential side street, is treated in a unitary way, with small ground-floor shops unobtrusively absorbed in the traditional manner to suit the quiet atmosphere of the residential side street. In contrast, the left-hand facade of the building,

* On one of the two adjoining buildings, a great rose tree spreads upward from the second story to cover the whole face of the residential floors. On the other building, trees of life, gilded and clipped, are raised in relief on the protruding pillars at the ends of each wall.

which faces the busy Wienzeile and its market, is horizontally split between workplace and dwelling, with each composed in its own style and material. The treatment of the building's corner carries the resulting duality to a peak of intensity, with the angular iron and glass office space protruding assertively from beneath the gracefully bowed and stuccoed corner of the upper residential floors. At the top, a luxurious loggia trimmed with *art nouveau* swags, sprays, urns, and statues crowns the building like an opulent diadem, symbol of the urbane life of luxury that could have its economic basis in the prosaic, rational offices below. In the Wienzeile buildings, Wagner expressed the two sides of modern urban man as he saw him, each side in its own stylistic idiom: the man of business and the man of taste. Thus he laid bare in precarious but open juxtaposition what the Ringstrasse architects had tried to integrate by conceal-ment when, as in the Textile Quarter, they screened commercial functions in the residential style of the Renaissance palace.

Wagner's duality of idiom did not last long. Within a few years, the rational style he had developed for the commercial section of the Wienzeile buildings conquered and prevailed, first in office buildings, then in residences. It was as if modern man's "businesslike essence" (Wagner's phrase) and the style appropriate to his work life came to dominate all dimensions of his existence. Behind this architectural development lay the bureaucratization of both govern-ment and business. The expansion of a centralized administrative apparatus created appetites for space that could no longer be satis-fied by the traditional accommodation of offices in one or two lower floors of apartment buildings. Wagner, who had pioneered in Vienna's autonomous office building with his Länderbank in 1882–84, eagerly responded to the new opportunities for functional design.

The occasion for the architect's last creative outburst was pro-vided, appropriately enough, by the development of the final seg-ment of the Ringstrasse in the last prewar decade, the so-called Stuben Quarter. Wagner had been involved in planning the pro-gram for this section in the 1890's. After the turn of the century, the imperial government speeded its progress by opening competi-tions for two great administrative buildings in the area: a new War Ministry, and an office block for the central office of the Imperial Postal Savings Bank. The two projects, although modern in confront-ing the needs of a vast bureaucratic concentration, represented

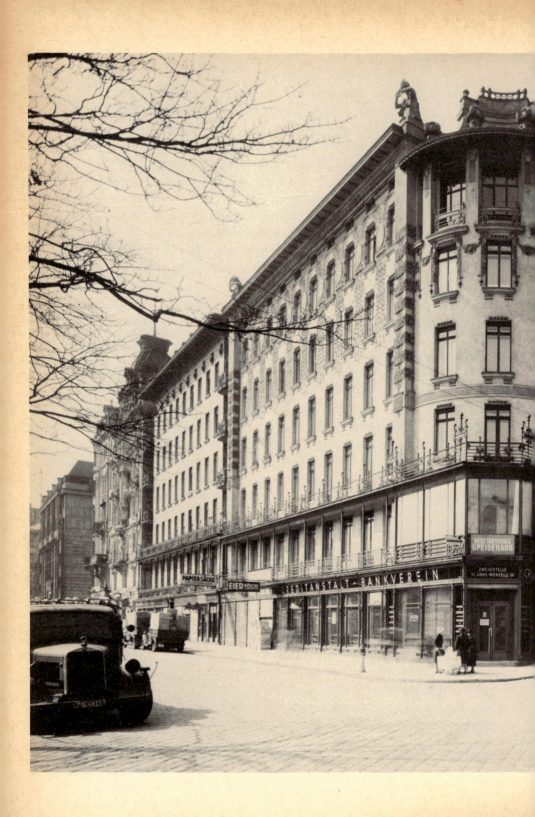

Figure 23.
Otto Wagner,
apartment houses,
Linke Wienzeile and
Köstlergasse,
1898–9.

politically a kind of archaism. They marked the return to the
Ringstrasse of the army and Catholicism—the two traditional forces
that, though presiding at the Ringstrasse's birth, had been early
banished from its development by the victory of liberalism. Both of
these old forces, however, now made their re-entry in modern,
bureaucratic form. The new War Ministry, an imperial Pentagon to
house the huge administration of a modern conscript army, was
assigned the site of one of the old professional army's counter-
revolutionary strongpoints of the 1850's, the Franz-Josef Barracks,
torn down as anachronistic in 1898. Otto Wagner lost the com-
petition for this commission to a more traditional, Baroque-revival
architect.

The Postal Savings Bank Office, whose headquarters Wagner built,
bore witness to the parallel revitalization of the old religious forces
in new social guises. The institution was created for the "little man"
as a state-supported effort to offset the power of the big banking
houses—the "Rothschild party." It was adopted by the Christian
Social party as an institutional answer for the lower middle class
to the power of the Jewish bankers and the liberals: many small
depositors would combine their resources to offset the power of
the mighty few. The bureaucrat who created the Postal Savings
Bank in the 1880's, Georg Coch, became a martyr-hero for the
Christian anti-Semites. His supporters failed in their effort to place
his bust in the new headquarters building, allegedly because of in-
fluential Jewish opposition. Mayor Karl Lueger took up the cause
as a political issue. His Christian Social municipal government re-
named the square in front of the Postal Savings Bank for Coch and,
with Otto Wagner's express consent, placed Coch's bust on a
pedestal in the square—the first monument to an anti-Semitic culture
hero on the Ringstrasse.[86] We have seen how the Votivkirche had
symbolized the power of traditionalist Catholic reaction at one end
of the Ringstrasse just as the liberal era began; the Postal Savings
Bank marked its revival as a populist force at the other end of the
street—opposite a new War Ministry—as the liberal era closed.

Whatever the anti-capitalist political import of the Postal Savings
Bank, its functional architectural requirements were thoroughly
modern. Otto Wagner, champion of the urban business life-style,
achieved in the execution of the building the rich yet lean and
elegant modern style to which he had aspired for at least a decade

(Figure 24). In it he carried further the tendencies previously noted in the Wienzeile apartments: the flat facade with windows almost flush with the walls, the experimentation with new materials (in this case, aluminum), the simplification of design. The imposing uniformity of bureaucratic rationalism was reflected in the very surface of the building, with its equalized, unobtrusive casements, its unadorned walls of marble slabs anchored by rich but simple aluminum bolts, its entrance efficiently capacious, yet unostentatious by comparison with the monumental portals favored in the Ringstrasse's earlier public buildings.*

Once having solved the problems of the office building as a special type, Wagner was soon applying to residential architecture the techniques he had developed there: the use of aluminum, curtain walls, poured reinforced concrete; the drastic geometrical simplification of design for stairs, exposed columns, light fixtures; and an elegant consistency between interior finish and external form. Such were the features of Neustiftgasse 40 (Figure 25), the first apartment house he built after the Postal Savings Office.

In Neustiftgasse 40, Wagner accomplished his great innovation— the transfer of a new style conceived for the office building to the habitation itself. It marked the end of a long development in Wagner's thought and practice. In his early days, his functional experiments in commercial construction had been contained within basic Renaissance forms (Figure 18). Then the Wienzeile buildings scored a first, partial breakthrough of utilitarian forms into the conventionally dominant realm of residential building (Figure 23). Finally, in Neustiftgasse 40 (Figure 25), the trajectory of development reached its fulfillment in the victory of the office over the home. The modular windows of Neustiftgasse 40, sill-less and equal in size, unmistakably suggest the uniform cellular space of a commercial building. They also imply, in contradistinction to the vertical differentiation of Ringstrasse apartments that express on the exterior the varied economic status of the inhabitants, an equality among the tenants. Gone too is all adventitious ornament—whether of Victorian stone or *art nouveau* painting and appliqué. Only restrained, rectilinear lines and patterns reinforce the geometricity of

* Much more could be said of the building's structural innovations, but these lie beyond our scope.

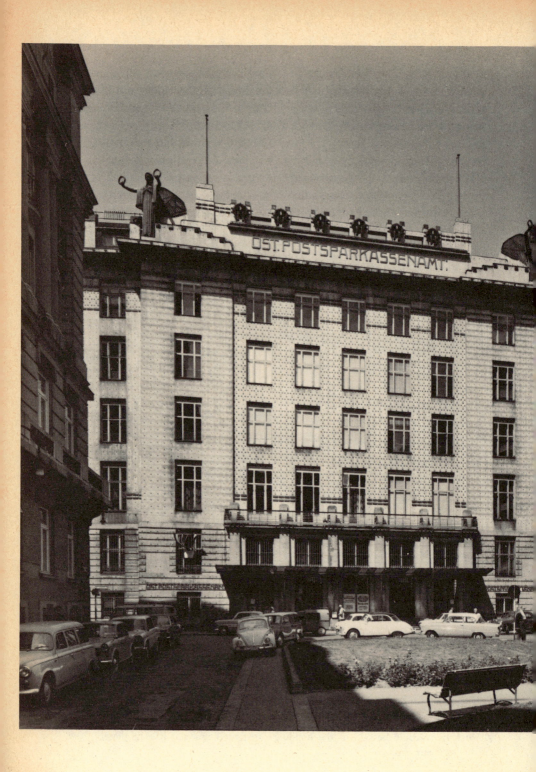

Figure 24.
Otto Wagner,
Postal Savings Office,
1904–6, with Georg
Coch monument in
foreground.

Figure 25. Otto Wagner, Neustiftgasse No. 40, 1909–10.

the structure. The commercial space at the base of the building, though still set off from the upper stories in the Renaissance fashion, is strongly defined by store windows and bands of glazed black tile. Whereas in the Wienzeile the upper residential quarters asserted through their gracious forms and decoration their independence of the commercial fronts below, here the upper stories modestly accept the stylistic idiom of the business portion. Moreover, Wagner's busy citizen in need of direction to this most rational edifice could find it easily—in the clear, blocklike form of the whole, and with the help of the great slablike exterior panel that blazons from on high the building's street address.

In Neustiftgasse 40, the architect achieved at last a uniform building style for modern urban man, and a final stage in his long experimental quest.

<p style="text-align:center">⋺ V ⋹</p>

IN 1910, the year in which Wagner perfected his modular modern building in Neustiftgasse 40, he took up once more the problem of the city as a whole. Fifty years had now elapsed since ground had been broken on the Ringstrasse, almost twenty since the adoption of Vienna's second city expansion plan. Wagner had participated in both phases. As architect-speculator in the first, he had shared in the class-bound historistic monumentalism that governed it. As successful contestant in the competition for the city's second development plan in 1893, Wagner had placed transportation factors at the center of his proposal, thus turning from the primacy of the aesthetic to the primacy of the functional and the technical. The subsequent decade he had spent in developing a style for the modern bourgeois' practical truth. Synthesizing new technology and new art, Wagner had created an architecture astonishingly free of historical pathos, and achieved an elegant, simple, and functionally expressive style for contemporary urban building, both office and residential. It remained for him to articulate an idea of the city on similar lines—to project a setting in which his buildings would realize their functional and aesthetic potential.

Appropriately enough, Wagner formulated his new notions of the modern city in response to an invitation from America, already the classic land of megalopolis. In a handsomely designed volume entitled *Die Groszstadt (Metropolis)*, Wagner set forth the ideas he had worked out for a Columbia University International Conference on Urban Art.*

Like Sitte in his *Städtebau*, Wagner used Vienna to expound his principles of urban design, stressing less the practices of the past than the opportunities of the future. By implication though not by name, he directed a strong attack against Sitte and his followers, against "the yammering of the historicists in the problem of city building."[87] Wagner spurned their "beloved slogans of folk art, fitting into the city's image, homeyness [*Gemüt*] in the cityscape, etc.," along with all the measures Sitte proposed to achieve these—picturesque layout, deliberately irregular streets and squares, the "alas so beloved 'dressing up' [*Aufputz*] of a city."[88] Precisely the factors that Sitte regarded as the necessary evils of modern city building—economic factors, "traffic, hygiene, etc."—Wagner accepted as the basis of positive planning. Above all he valued the massive uniformity that Sitte abhorred, and consciously developed its potential for artistic urban design.

For Wagner, a modern economy made the infinite expansion of the city inevitable. He associated himself with the "self-understood" will to growth of every city administration. The necessity of expansion appeared as a psychological value. Invincible bourgeois urbanite that he was, Wagner had no doubt that "the majority of men would rather live in a metropolis than in a small city or in the country. . . . Making a living, social position, comfort, luxury, the presence of intellectual and physical facilities, entertainment in the good and bad sense, and finally art motivate this phenomenon." As in architecture, so in urban planning, art "must . . . adapt the city's image to contemporary man."[89]

Urban expansion and capitalist economics dictated the huge housing block as the only solution to accommodate the urban millions. "Our democratic essence, which is imposed upon us by both the

* The conference met under the joint auspices of New York State and New York City. See Otto Wagner, *Die Groszstadt. Eine Studie über diese* (Vienna, 1911), p. 1.

call for cheap and healthy houses and the enforced economy of our lifestyle, has the uniformity of our dwelling houses as its consequence." We must meet the challenge not by retreat into the past but "by raising uniformity into monumentality."[90]

For the Ringstrasse builders, the key to monumentality lay in the great public buildings to which the street carried the citizen on his rounds. Wagner vested monumentality in the street. The natural placement of houses in a row created "long, even surfaces framing the street." Regulated as to height and stripped of disturbing surface ornament, the houses made the street a monument in itself. The smooth, linear facade of the housing block offered a psychological advantage too. It reinforced the trajectory of the street, so important, as we have seen, to providing direction and orientation to the pursuit of business. Finally, the artist-planner could serve both the monumentality and the orienting function of the street by interrupting it occasionally with architectonic foci in the Baroque manner: formal plazas, public buildings, or stone monuments. These "interruptions" to the street, as Wagner called them, were not so much to move *in*, as with Sitte, as to move *toward*. Sitte, fighting anomie, used the square to arrest the flow of men in motion; Wagner used it to give that flow direction and goal. The vehicular perspective dominated Wagner's urban concepts as the pedestrian's governed Sitte's. Wherever Wagner affirmed the pedestrian urban experience, it was in the spirit either of the man of business or of the shopper. Like a Baudelaire of consumerism, Wagner gloried in the bright "unbroken chain of beautiful stores glittering with the artistic products of town and country."[91]

Committed as he was to the infinitely expandable city, Wagner faced the problem of making that city viable. He recognized the need to free the center from undue population pressure, and to contain integrated work and living within reasonable geographic limits. His solution, like that for his modern apartment house, was the module. Using Vienna as his model, he proposed that each city district be planned as a semi-autonomous sub-city of 100,000 to 150,000 inhabitants. Each would have its workplaces (Wagner eschewed the mention of factories!), its uniform apartment blocks, each one abutting on a square of green, and its highly formal "air center" in which would be placed the public and cultural buildings. Certainly ruler and compass celebrated their triumph in the plan

shown in Figure 26. Wagner's drawing of the air center viewed from above (Figure 27) also shows how uncompromisingly he conceived his aim of raising uniformity into monumentality. The Ringstrasse's aspirations to grandiosity seem beggared by Wagner's megalopolitan utopia, a late rationalist's "dream of reason."

Sitte had, in a spirit of discouraged realism, relinquished most of the city to the utilitarians, stressing preservation of the urban treasures of the past and construction of squares as models for a better urban future. Wagner made the opposite choice: recognizing the hopelessness of rebuilding the old city, he left that task to the historicists and recommended only the necessary minimum of regulation and renovation of the existing city. His sights were set where the future lay: on the periphery and the surrounding countryside. There the city might yet be rationally planned. As in his plan of 1893, Wagner projected in *Die Groszstadt* radial arteries of rail and road from the center to set the direction of growth (Figure 28).

In the meshes of the net thus formed, new sub-cities could be added as their time arrived. Wagner rejected out of hand the idea of a green belt around the city—just when Vienna was in fact acquiring one under its reforming Christian Social government. "After all," he wrote, "the development of a [green] belt around the city is again only a pre-established constraint, which should surely be avoided. . . . It seems more correct to give every single district adequate air centers."[92] Wagner's rationalism left no place for romantic nature. His very renderings make clear that his infinite city would not only engulf the land but convert all vegetation into green architectural sculpture.

Nothing could have been more radically foreign to the sensibility of Sitte. He went the other way, ingesting *nature naturante* into his reposeful and picturesque urban community. The *Allee*, where trees are but an ornamental gesture of the street—so prominent in Wagner's urban design—was for Sitte "a burning indictment of our taste."

Can there be anything more degenerate than to take the free natural form of trees, which precisely in the city should conjure up the magic of open nature, and to arrange these identically in height, at mathematically calibrated intervals . . . and, on top of it all, in sheer endless extension.

Figure 26. *Otto Wagner, Modular City District, 1911.*

Figure 27. *Otto Wagner, Drawing of an*
Air Center, 1911.

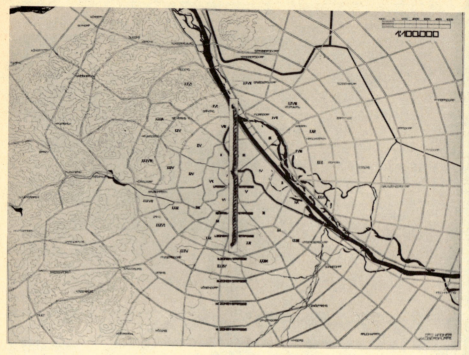

Figure 28. Otto Wagner, Modular Plan for the
Expansible City, 1911.

One literally gets a headache from such oppressive boredom. And this is the major art form of our city planners of the geometric persuasion![93]

Camillo Sitte and Otto Wagner, the romantic archaist and the rational functionalist, divided between them the unreconciled components of the Ringstrasse legacy. Sitte, out of the artisan tradition, embraced Ringstrasse historicism to further his project of restoring a communitarian city, with the enclosed square as his model for the future. Wagner, out of a bourgeois affirmation of modern technology, embraced as essence what Sitte most abhorred in the Ringstrasse: the primary dynamic of the street. The conservative Sitte, fearful of the workings of time, placed his hope for the city in contained space, in the human, socializing confines of the square. Wagner, even more than the Ringstrasse progressivists before him, subjected the city to the ordinance of time. Hence street was king, the artery of men in motion; for him the square could serve best as

goal of the street, giving direction and orientation to its users. Style, landscaping, all the elements through which Sitte sought variety and picturesqueness in the fight against modern anomie, Wagner employed essentially to reinforce the power of the street and its temporal trajectory.

Although both theorists rebelled in their divergent ways against the Ringstrasse's uneasy synthesis of historistic beauty and modern utility, both retained fidelity to one of the cardinal values of liberal bourgeois city builders: monumentality. Sitte developed his reform proposals for the Ringstrasse by designing squares as spatial settings to magnify the great public buildings.[94] Wagner judged the success of the urban planner as artist by his capacity to elevate uniformity to monumentality.

On the basis of their shared commitment to the monumental, the two critics were united in admiration for the most grandiose project of the whole Ringstrasse development: the Outer Burgplatz (Figure 29). Gottfried Semper designed this mammoth square—he called it the Kaiserforum—to join the Hofburg with the two great museums of Natural History and Art History across the Ringstrasse. A friend and fellow freedom-fighter of Richard Wagner in 1848, Semper had drawn the first plans for Wagner's theater for staging his redeeming music-dramas. How could Sitte fail to admire such a one? After the revolution Semper had fled to England where, as cofounder of the South Kensington Museum to unify art and industry, he also became an influential positivistic theorist of architecture. This side of him naturally appealed to Otto Wagner.

In his Ringstrasse Kaiserforum, Semper offered a practical solution to a "representational" problem of urban design. He conceived his huge square in such a way as to challenge the sovereignty of Förster's circulating space. The forum would be an axis bisecting the Ringstrasse. Great arches were to link the two museums in the foreground to two extensions of the imperial Hofburg in the background. The axis would thus break the cincture of pavement with which the Ringstrasse had replaced the cincture of stone fortifications around the inner city. It would bind old and new: the court and the popular centers of high culture, the residence of ancient royalty and the institutes of bourgeois science and art, the inner city and the outer city.

For Sitte, Semper had conceived the "majestic new Burgplatz . . .

colossally," in the spirit of the ancients—especially of Rome. Because of its enormous size, Rome had developed spatial models usable for modern cities, spaces "capable of handling monstrous masses of men." Sitte's normal concern for intimacy and the picturesque yielded to the heroic proportions of Semper's project. He saw it as a sign of Vienna's maturation that it had commissioned a project which, at the beginning of the Ringstrasse development, "would probably have been regarded as utopian." The time had ripened

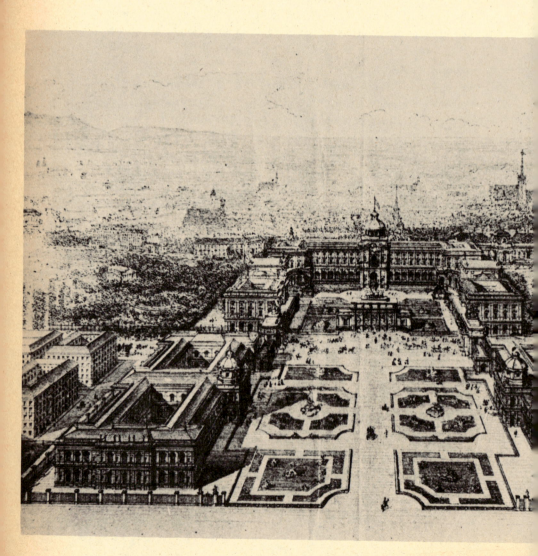

and the hour had struck for Semper, a master of dramatic space.[95]

Otto Wagner had since the nineties admired Semper as a theorist of the primacy of purpose and technology in the determination of style. Moreover, the Baroque grandeur and clear foci of Semper's Hofburg-and-museum forum suited Wagner's sense of rationality as well as scale. The rectilinear lawns with paths leading clearly to portals or other destinations, the simple symmetry in the placement of the buildings, could have been designed to meet Wagner's imperatives of clarity of direction within monumentality. Against Vienna's artistic failures, Semper's work stood out in glory for Wagner. "Despite the presence of favorable premises, Vienna has not for sixty years produced any metropolitan image [*grossstädtisches Bild*] except Semper's Outer Burgplatz . . . while the Ringstrasse itself owes its origin to lucky accident." Wagner used Semper's plaza as the exception to prove to the layman the rule that "without the vision called for in [*Die Groszstadt*], without art ever and again consecrating the emergent, a beautiful metropolis cannot arise."[96]

Ironically, this one piece of the Ringstrasse that united our two critics in admiration was never completed. Semper's arches to connect the imperial residence with the seats of bourgeois culture were not sprung across the Ringstrasse. Reinforced by speeding motorcars, the street has only strengthened its dividing power between the inner city and the outer districts.

To few architects or urban designers in any age is it given to realize their dreams.

Figure 29. Gottfried Semper, Outer Burgplatz (Kaiserforum), 1869.

Sitte's and Wagner's own visions of a city of the future fared even less well than Semper and his forum. In the rapidly expanding cities of the *fin de siècle*, the sense that history was moving fast lent urgency to communicating the ideas of the good city before speculation and public indifference should freeze the urban future into drabness and sprawl. Hence both Sitte and Wagner propagandized tirelessly—in their schools, on the public lecture platform, in the press, and on countless committees of state, municipal, and professional associations. Both showed themselves children of the nineteenth century when they turned to one of its favorite vehicles to convey their respective messages to posterity: the museum. For each the museum served at once as pedagogic project and as a somewhat wistful personal monument, to dramatize the ideas each had striven to impose upon a refractory social reality. A comparison of their museum projects, both unbuilt, affords us a final insight into their place as critics.

Sitte conceived his museum as a great tower, a national monument to German culture. It was to provide visual exhibits for a great scholarly project on which he worked all his life: a seven-volume *Gesamtkunstgeschichte* of art forms. In his city planning, Sitte had reluctantly compromised with modern utilitarian demands and economic power; his museum he envisaged as uncontaminated by reality, "cut free from every practical purpose, a purely artistic national monument." Form and location expressed both an assertive ideal and an actual withdrawal. Calling the museum "Dutchman's Tower (*Holländer Turm*)," Sitte wished it placed far from the city, on a barren beach. Wagner's *Flying Dutchman* is reported to have inspired his choice of the tower's name.[97] Perhaps Sitte was here conflating the Dutchman with Goethe's aging Faust, who built a tower in his final role as modern land reclaimer and utopian community builder in Holland.* Whatever the source of the image,

* Since Sitte had associated Wagner's Dutchman with Goethe's Faust as archetypal modern entrepreneurs (see pp. 69–71), the Faustian ingredient may have been present also in the choice of the tower form. Faust, to build a tower for surveying his modern works in Holland, killed off the traditional peasants who rescued and helped wanderer-types like the Flying Dutchman (*Faust*, Part II, Act V). Hence Sitte's tower, dedicated to immortalizing the folk culture of the past, would acquire in relation to Goethe's the character of an atonement for the crimes of modern developers.

Sitte's tower-museum expressed both in its phallic form and in its historistic content his wish to assert the potency of the past against the predations of the present. Sitte placed his tower with psychological appropriateness. Only far from an actual modern metropolis could such a necrophilic fantasy be cultivated in security.

Otto Wagner's dream museum was of another sort. It was devoted to the arts of the present and the future. Yet, like Sitte's monument to the arts of yesterday, Wagner's museum for tomorrow memorialized his own still unfulfilled commitment to transform urban civilization. Wagner too had addressed the problem of museums all his life. Early in his career (1880), he had drafted a kind of utopian Museum City called "Artibus" (Figure 30). With a pantheon of the arts at its center, this hypertrophied Beaux Arts corner of urban paradise shows how fully Wagner originally shared the aspirations of Ringstrasse culture.[98] But with his conversion to the Secession and the quest for a new style in 1897, his ideas of a museum changed direction. Wagner joined the Secession's campaign for a state-sponsored museum of modern art. His efforts through political agitation, committee work in the Arts Council of the Ministry of Culture and Instruction, and the submission of museum designs brought only limited success for the cause, and no commissions.[99] Wagner rejected the prevailing conception of a modern museum as a repository of discrete *objets d'art*, collected and curatorially supervised. Eschewing even the name "museum," he advocated instead a dynamic showcase, which would present "a clear picture of the state of artistic production over the coming century."[100] Wagner envisaged the interior of the gallery as unfinished. Its space would be subdivided into twenty units, to be filled one by one at intervals of five years over the course of a century. Each unit would accommodate an integrated exhibition of the best art and architecture produced in a given half-decade. Curators were neither needed nor desired. The organization of each quinquennial exhibit of the state of the arts, Wagner argued, should be assigned to a leading contemporary artist or group of artists, "whose creation corresponds to the sensibility and spirit of their time."[*101] Thus, where Sitte's

* Wagner must have been inspired in this program by the Secession's strategy of winning representative status for itself from the Austrian government and mounting unified exhibits in foreign expositions, etc. The open plan of the

museum was scholarly, past-oriented, curatorial, and static, as befitted his will to conservation, Wagner's house of art was to be self-defining, presentistic, creative, and dynamic.

House of Secession, developed by Wagner's student Josef Olbrich in 1897, may also have influenced his modern gallery program. See pp. 218–19.

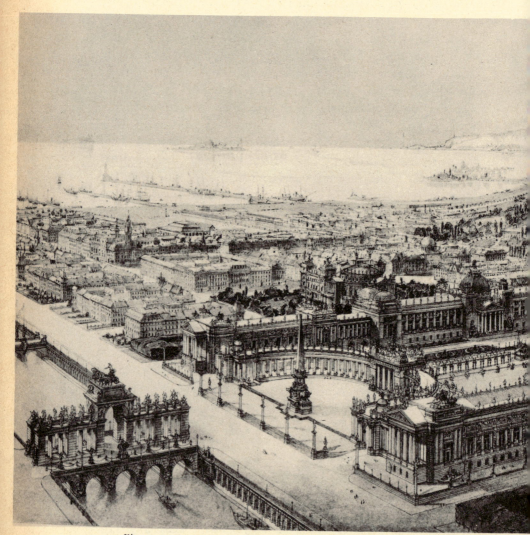

Figure 30. Otto Wagner, Museum City Project ("Artibus"), 1880.

The first architectural form which Wagner gave his "Gallery for Artworks of Our Age" in 1900 was as earthbound as Sitte's was soaring: a sturdy, low, two-story building (Figure 31). Across the whole broad, horizontal face of the second story, Wagner spread a majolica frieze with his familiar message concerning the truth-function of modern art: "The arts lift the veil which has previously

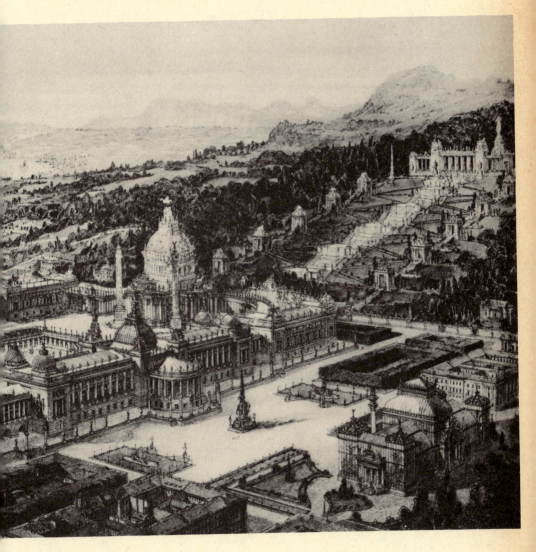

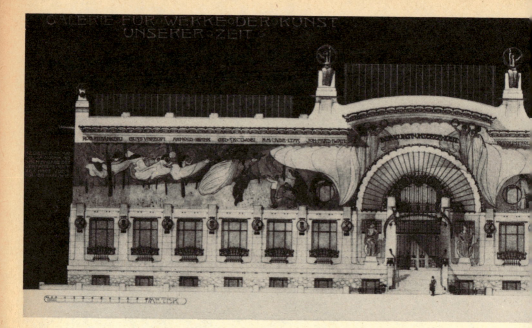

Figure 31. Otto Wagner, Gallery for Artworks of Our Age, 1900.

Figure 32. Otto Wagner, House of Art, MCM–MM, 1913.

weighed upon mankind."[102] Wagner's reformist impulse and his historical optimism were still at work in this design.

By 1913, when, at the age of seventy, he recast his modern gallery plans once again, Wagner's optimism had clearly diminished.[103] The new building, called simply "MCM–MM," far from making an ideological statement about the revelatory function of modern art, betrays a strange mixture of modernity in feeling and traditionalism in form (Figure 32). Wagner treated the walls in his modern manner as skins, suggesting volume rather than mass beneath. But in the building's form he returned to history and the masters of the Ringstrasse. The reference to the museums of Art History and Natural History by Semper and Hasenauer (Figure 29) is unmistakable: two stories divided into five bays, with a projecting central entrance bay. The strangest element in this quotation of Ringstrasse neo-Renaissance form is the dome that crowns the facade. Where Wagner's masters had used a solid, roofed dome, he placed only ribs of metal, like a skeletal *memento mori* for the Ringstrasse Renaissance.

Despite his will to avoid the cloistered mentality of Sitte, Wagner's growing awareness of

the artist's isolation and his relative impotence to shape the modern world, even according to its own utilitarian needs, had forced him back upon the past he wished to leave behind. The final irony for this rational optimist was to be compelled by the truth of his own proud slogan—*Artis sola domina necessitas*—to design his monument for the aesthetic models of the "modern" as a historical museum after all. For the center of his cherished native city, Wagner had unwittingly conceived an equivalent to Sitte's "Dutchman's Tower" on the beach—a museum of ideal visions of the future cast in a phantom form from the Ringstrasse whose historicist culture he had so boldly striven to transcend.

❧ NOTES ☙

[1] Hans Bobek and Elisabeth Lichtenberger, *Wien* (Graz-Cologne, 1966), pp. 60–1.

[2] Karl Glossy, "Kajetan Felder," *Neue Oesterreichische Biographie*, IV, 215–17. (Hereafter *N.O.B.*)

[3] For a detailed account of Vienna's administrative history, see Rudolf Till, *Geschichte der Wiener Stadtverwaltung* (Vienna, 1957), pp. 38–99.

[4] Bobek and Lichtenberger, *Wien*, pp. 45–7.

[5] Eduard Suess, *Erinnerungen* (Leipzig, 1916), p. 171.

[6] For the generative structure behind the transformation of the city in the nineteenth century, see Bobek and Lichtenberger, *Wien*, pp. 30–41.

[7] For the complex evolution of the military attitude toward the city's expansion plans, see Walter Wagner, "Die Stellungnahme der Militärbehörden zur Wiener Stadterweiterung in den Jahren 1848–1857," *Jahrbuch des Vereines für Geschichte der Stadt Wien*, XVII/XVIII (1961–2), 216–85. For Grünne's final position on the eve of the emperor's approval of the opening of the glacis, see *ibid.*, 282–4.

[8] *Neue Freie Presse*, Dec. 2, 1873 (Morgenblatt).

[9] Reinhold Lorenz, "Politische Geschichte der Wiener Ringstrasse," *Drei Jahrhunderte Volk, Staat und Reich* (Vienna, 1944), pp. 487–9. The allocation of glacis land for the church anticipates, of course, the general edict of 1857 releasing the area.

[10] Heinrich Friedjung, *Oesterreich von 1848 bis 1860* (3rd ed.; Stuttgart and Berlin, 1912), II, i, 424–6.

[11] Wagner, *Jahrbuch . . . Wiens*, XVII/XVIII, 284.

[12] Quoted in Bruno Grimschitz, *Die Wiener Ringstrasse* (Bremen and Berlin, 1938), p. 6. See also Renate Wagner-Rieger, ed., *Die Wiener Ringstrasse, Bild einer Epoche* (Vienna-Cologne-Graz, 1969 et seq.), I. *Das Kunstwerk im Bild* (1969), 87.

13 Grimschitz, *Ringstrasse*, p. 6. The best discussion of the radial communication pattern is that of the geographer Elisabeth Lichtenberger, *Wirtschaftsfunktion und Sozialstruktur der Wiener Ringstrasse*, in Wagner-Rieger, ed., *Die Wiener Ringstrasse*, VI, 24–6.

14 Quoted in Grimschitz, *Ringstrasse*, p. 8.

15 Norbert Wibiral and Renata Mikula, *Heinrich von Ferstel*, in Wagner-Rieger, ed., *Wiener Ringstrasse*, VIII, iii, 44–9.

16 Lorenz, *Drei Jahrhunderte*, pp. 497–9; Friedjung, *Oesterreich, 1848–1860*, II, i, 426–7; Wibiral and Mikula, *Ferstel*, pp. 55–7.

17 A true man of the "second society," in which bourgeois-aristocratic fusion was accomplished, Ferstel built not only great public buildings but palaces for members of the imperial family and bankers, and also apartment houses for speculative construction companies. For Ferstel's career, see Wibiral and Mikula, *Ferstel, passim;* on his involvement with the various University projects, pp. 44–75.

18 Quoted from a faculty petition of Aug. 4, 1871, in *ibid.*, p. 61.

19 Conversation with Hansen reported by Suess in *Erinnerungen*, pp. 171–2. Hansen had served as teacher and architect in the young Greek monarchy from 1838 to 1846 and had designed the Greek Academy of Sciences in 1861.

20 These and other details in the history of the planning were included by the joint parliamentary planning commission in its *Bericht zur Begutachtung der Pläne für das neue vereinigte Parlaments-gebäude zu Wien eingesetzten gemischten Kommission*, March 5, 1873, Baron Kübeck, *Berichterstatter* (Vienna, 1873). See also Renate Wagner-Rieger, *Wiens Architektur im 19. Jahrhundert* (Vienna, 1970), pp. 177–8.

21 Suess, *Erinnerungen*, pp. 171–2. For the great debate over the museum competition, see *Festschrift des historischen Museums zur Feier des fünfzig-jährigen Bestandes*. Part I. Alphons Lhotsky, *Die Baugeschichte der Museen und der neuen Burg* (Vienna, 1941), pp. 53–92.

22 Suess, *Erinnerungen*, p. 216.

23 Friedjung, *Oesterreich*, II, i, 427–8.

24 Adolf Hitler, *Mein Kampf*, tr. Ralph Mannheim (Boston, 1943), p. 19.

25 *Ibid.*, chs. II and III, *passim.*

26 Lichtenberger, *Wirtschaftsfunktion und Sozialstruktur*, p. 46.

27 For 19th-century Viennese working-class housing development, see Bobek and Lichtenberger, *Wien, passim.*

28 For a comprehensive and nuanced discussion of the evolution of 19th-century housing forms out of traditional ones, see Lichtenberger, *Wirtschaftsfunktion und Sozialstruktur*, pp. 46–8.

29 *Ibid.*, pp. 34–6; Wagner-Rieger, *Wiens Architektur*, p. 216.

30 Lichtenberger, *Wirtschaftsfunktion und Sozialstruktur*, p. 34.

31 Wagner-Rieger, *Wiens Architektur*, p. 206.

32 Cf. Lichtenberger, *Wirtschaftsfunktion und Sozialstruktur*, pp. 34, 39–43.

33 Wagner-Rieger, *Wiens Architektur*, p. 206.

34 For a full social analysis of owners and tenants of the Ring, see Franz

Baltzarek, Alfred Hoffmann, Hannes Stekl, *Wirtschaft und Gesellschaft der Stadterweiterung*, in Renate Wagner-Rieger, ed., *Die Wiener Ringstrasse*, V (Wiesbaden, 1975).

[35] Wagner-Rieger, *Wiens Architektur*, pp. 207-9, from which the floor plan is also taken. See also Theophil Hansen, "Die für die Allgemeine Oesterreichische Baugesellschaft ausgeführte Baugruppe am Schottenring," *Zeitschrift des Oesterreichischen Ingenieur- u. Architektenvereins*, p. 30, Figures 1-6.

[36] Wagner-Rieger, *Wiens Architektur*, p. 208. That the architects who built in both the public and the private sector became a powerful interest group in their own right goes without saying. For their influence over architectural education in the Academy of Plastic Arts, see Walter Wagner, *Die Geschichte der Akademie der Bildenden Künste Wiens* (Vienna, 1967), pp. 119-246, *passim*.

[37] Lichtenberger, *Wirtschaftsfunktion und Sozialstruktur*, pp. 55-8. For a detailed breakdown by social stratum of owners and tenants by neighborhood, on which this and the following discussion is based, see pp. 53-63, where the materials are conveniently presented in tabular form.

[38] *Ibid.*, pp. 58, 68-72.

[39] *Ibid.*, pp. 57-9.

[40] *Ibid.*, p. 63.

[41] Camillo Sitte, *Der Städtebau nach seinen künstlerischen Grundsätzen* (5th ed., Vienna, 1922), p. 102.

[42] *Ibid.*, pp. 121-2, 102.

[43] *Ibid.*, p. 101.

[44] *Ibid.*, p. 2.

[45] *Ibid.*, p. 92.

[46] *Ibid.*, p. 2.

[47] *Ibid.*, pp. 2-12.

[48] *Ibid.*, p. 56.

[49] *Ibid.*, pp. 67, 33.

[50] Cf. for the elder Sitte's major architectural works, "Sitte, Franz" in Thieme-Becker, *Allgemeines Lexikon der bildenden Künstler* (Leipzig, 1907-50), XXXI, 106. On the architectural dimension of the Revolution of 1848, see Wagner-Rieger, *Wiens Architektur*, pp. 106-8. For Franz's biography, see Heinrich Sitte, "Camillo Sitte," *N.O.B.*, VI, 132-49, *passim*.

[51] He invokes the Piarist Square in *Der Städtebau* but only indirectly in discussing vernacular Baroque church-and-square design. Sitte, *Städtebau*, pp. 151-2.

[52] Wagner-Rieger, *Ringstrasse*, I, ii, *Erläuterungen*, p. 139; idem, *Wiens Architektur*, p. 150.

[53] Idem, *Ringstrasse*, I, ii, 139-40. The building was completed in 1871. It is well analyzed in Wibiral and Mikula, *Ferstel*, pp. 126-33.

[54] For the stubborn social durability of Austrian craft industry and small tradesmen compared to those of Germany, and for the political pressures

the artisanate exercised on liberalism during the Great Depression after 1873, see Hans Rosenberg, *Grosse Depression und Bismarckzeit* (Berlin, 1967), pp. 227–52.

55 George R. Collins and Christiane Crasemann Collins, *Camillo Sitte and the Birth of Modern City Planning*, Columbia University Studies in Art History and Archeology No. 3 (New York, 1965), p. 8.

56 For a representative list of Sitte's articles, see Collins, *Sitte*, p. 112, note 12.

57 Wilhelm Kienzl, "Hans Richter," *N.O.B.*, VII, 218–24.

58 Sitte, "Sitte," *N.O.B.*, VI, 138, 140–1, 143. He also designed costumes for *Parsifal*. See Robert Judson Clark, *Joseph Maria Olbrich and Vienna*, unpublished dissertation, Princeton University (1973), p. 24, note 37.

59 *N.O.B.*, VI, 138, 141, 143.

60 *Richard Wagner und die deutsche Kunst*. Ein Vortrag. Separatabdruck aus dem Zweiten Jahresbericht des Wiener Akademischen Wagner-Vereins (Vienna, n.d. [1875]). The ensuing discussion is based on this address.

61 This is evident in his Mechitarite Church, where Sitte executed the paintings as well as the architecture. See Sitte, "Sitte," *N.O.B.*, VI, 141.

62 Camillo Sitte, "Grossstadtgrün" (1900), Appendix of 5th edition of *Städtebau*, p. 211.

63 Sitte, *Städtebau*, p. 102.

64 See Sokratis Dimitriou, "Grossstadt Wien—Städtebau der Jahrhundertwende," *Der Aufbau*, XIX (1964), 189, 192.

65 The motto is Gottfried Semper's, pioneer theorist of industrial art. Heinz Geretsegger and Max Peintner, *Otto Wagner, 1841–1918* (Salzburg, 1964), p. 12. [English translation by Gerald Onn, *Otto Wagner, 1841–1918* (London, 1970).]

66 Dimitriou, *Aufbau*, XIX, 193, 196.

67 Otto Wagner, *Die Baukunst unserer Zeit. Dem Baukunstjünger ein Führer auf diesem Kunstgebiet* (4th ed., Vienna, 1914), p. 76. This is an expanded edition of the textbook Wagner published first in 1895 under the title *Moderne Architektur*. Wagner changed the title from "Architecture" to "The Art of Building" (*Baukunst*), he said, under the impact of Hermann Muthesius' polemic, *Baukunst, nicht Stilarchitektur*, an important document in the revolt against the historical aesthetic.

68 *Ibid.*, pp. 10–11.

69 Otto Wagner, *Die Groszstadt. Eine Studie über diese* (Vienna, 1911), p. 39.

70 Hans Ostwald, *Otto Wagner. Ein Beitrag zum Verständnis seines baukünstlerischen Schaffens*. Diss. ETH Zurich (Baden, 1948), p. 24.

71 Geretsegger and Peintner, *Wagner*, p. 11.

72 Ostwald, *Wagner*, p. 17.

73 Geretsegger and Peintner, *Wagner*, p. 12.

74 Wagner, *Baukunst*, p. 75.

75 Dagobert Frey, "Otto Wagner," *N.O.B.*, I, 181.

76 Geretsegger and Peintner, *Wagner*, p. 56.

77 The original design had elaborate scrollwork in the part of the arch now

occupied by the rectilinear struts, with their functional symbolism. See *ibid.*, p. 55, fig. 25.

[78] Cf. e.g., Carroll Meeks, *The Railroad Station* (New Haven, 1956), *passim*.

[79] Walter Wagner, *Geschichte der Akademie*, pp. 251–2.

[80] Quoted in Ostwald, *Wagner*, p. 60.

[81] Wagner, *Baukunst*, pp. 17, 31–3.

[82] *Ibid.*, pp. 26–7.

[83] Cited from an unpublished letter, Ostwald, *Wagner*, p. 23.

[84] *Ibid.*, p. 56.

[85] We shall pursue here only those dimensions of Wagner's encounter with the Secession that relate to his general urban theory and practice. His interesting architectural development in the narrower sense demands separate treatment. The best start has been made by Adriana Giusti Baculo, *Otto Wagner dall' architettura di stile allo stile utile* (Naples, 1970), pp. 83–98 and *passim*.

[86] Gerhardt Kapner, *Ringstrassendenkmäler*, in Wagner-Rieger, ed., *Wiener Ringstrasse*, IX, i, pp. 59–61; *idem*, "Monument und Altstadtbereich, Zur historischen Typologie der Wiener Ringstrassendenkmäler," *Oesterreichische Zeitschrift für Kunst und Denkmalkunde*, XXII (1968), 96.

[87] Wagner, *Groszstadt*, p. 2.

[88] *Ibid.*, pp. 3, 4.

[89] *Ibid.*, pp. 7, 3.

[90] *Ibid.*, p. 3.

[91] *Ibid.*, p. 5.

[92] *Ibid.*, p. 10.

[93] Camillo Sitte, "Grossstadtgrün," Appendix to *Städtebau*, p. 210.

[94] Sitte, *Städtebau*, pp. 161, 126.

[95] *Ibid.*, p. 161.

[96] Wagner, *Groszstadt*, p. 22.

[97] Because Sitte kept his museum project secret from the public, we know of it only from his most intimate associates. He left a voluminous archive of drafts and notes for the history of art forms, which was to provide the content of the museum. On the whole project, see Julius Koch, "Kamillo Sitte," *Zeitschrift des oesterreichischen Ingenieur- und Architektenvereins*, LV (1904), 671; Karl Henrici, [obituary] *Der Städtebau*, I, Heft 3 (1904), pp. 33–4.

[98] Geretsegger and Peintner, *Wagner*, pp. 180–1. The inspiration of Semper's Kaiserforum (Figure 29) seems clear.

[99] For the role of Wagner in the Arts Council, see Allgemeine Verwaltungsarchiv, *Protokoll des Kunstrates*, 1900, pp. 7, 10; for Wagner's museum projects, Geretsegger and Peintner, *Wagner*, pp. 196–7. On the history of the Modern Museum, see Felix von Oppenheimer, *25 Jahre Vereinsarbeit für öffentliche Kunstsammlungen* (Vienna, 1936), *passim*. The Secession position is given in *Ver Sacrum*, III (1900), p. 178.

[100] Otto Wagner, *Einige Skizzen, Projekte and ausgeführte Bauwerke* (Vienna, 1890–1922), III (1906), No. 21, 3–4.

101 *Ibid.,* p. 4.

102 Geretsegger and Peintner, *Wagner,* Fig. 209 and caption text. See the program for the gallery in Wagner, *Einige Skizzen,* IV, No. 21, pp. 14–15.

103 See, for stages in the growth of Wagner's pessimism with respect to the future of art, the introduction to his *Einige Skizzen,* III; and his presidential address to the International Congress of Architects in 1908 in *Bericht über den VIII. Internationalen Architektenkongress* (Vienna, 1908), pp. 112–16. On the final museum project, see Otto Graf, "Ein 'Haus der Kunst MCM–MM'. von Otto Wagner," *Mitteilungen der Oesterreichischen Galerie,* VI (1962), No. 50, pp. 33–45.

III

POLITICS
IN A NEW KEY:
AN AUSTRIAN
TRIO

❧ I ❧

''PEOPLE WHO were not born then,'' wrote Robert Musil of the Austrian *fin de siècle*, ''will find it difficult to believe, but the fact is that even then time was moving faster than a cavalry camel. . . . But in those days, no one knew what it was moving towards. Nor,'' Musil continues, ''could anyone quite distinguish between what was above and what was below, between what was moving forward and what backward.''[1]

The social forces that rose to challenge the liberal ascendancy could not fail to baffle an observer who viewed them through a liberal's conceptual screen and with a liberal's expectations of history. In the 1860's the Austrian liberals, though neither utopians nor believers in perfectibility, had rather clear notions of ''what was above and what below . . . what was moving forward and what backward.'' Socially, they believed that the aristocratic class, having been ''above'' through most of history, was either being liberalized or sinking into a harmless, ornamental hedonism. The principles and

programs which made up the liberal creed were designed to supersede systematically those of "the feudals," as the aristocrats were pejoratively called. Constitutional monarchy would replace aristocratic absolutism; parliamentary centralism, aristocratic federalism. Science would replace religion. Those of German nationality would serve as tutor and teacher to bring up the subject peoples, rather than keep them ignorant bondsmen as the feudals had done. Thus nationality itself would ultimately serve as a principle of popular cohesion in a multinational state. "The Germans in Austria," wrote the liberal leader J. N. Berger in 1861, "should strive not for political hegemony, but for cultural hegemony among the peoples of Austria." They should "carry culture to the east, transmit the propaganda of German intellection, German science, German humanism."[2] Finally, laissez faire would break the arbitrary rule of privilege in the economic sphere and make merit, rather than privilege or charity, the basis of economic reward.

In all these aspects of their program, the Austro-liberals knew themselves to be combatting the socially superior and the historically anterior: they saw themselves as leading what was below and moving forward against what was above and backward. If the common people could not yet be trusted, since they did not always understand, the spread of rational culture would one day provide the prerequisite for a broadly democratic order. Popular power would increase only as a function of rational responsibility.

Austrian society failed to respect these liberal coordinates of order and progress. During the last quarter of the nineteenth century, the program which the liberals had devised against the upper classes occasioned the explosion of the lower. The liberals succeeded in releasing the political energies of the masses, but against themselves rather than against their ancient foes. Every shot aimed at the enemy above produced a hostile salvo from below. A German nationalism articulated against aristocratic cosmopolitans was answered by Slavic patriots clamoring for autonomy. When the liberals soft-pedaled their Germanism in the interest of the multi-national state, they were branded as traitors to nationalism by an anti-liberal German *petite bourgeoisie*. Laissez faire, devised to free the economy from the fetters of the past, called forth the Marxist revolutionaries of the future. Catholicism, routed from the school and the courthouse as the handmaiden of aristocratic oppression, returned as the ideology of

peasant and artisan, for whom liberalism meant capitalism and capitalism meant Jew. By the end of the century even the Jews, to whom Austro-liberalism had offered emancipation, opportunity, and assimilation to modernity, began to turn their backs on their bene-factors. The failure of liberalism left the Jew a victim, and the most persuasive answer to victimization was the flight to the national home that Zionism profferred. Where other nationalists threatened the Austrian state with disruption, the Zionists threatened secession.

Far from rallying the masses against the old ruling class above, then, the liberals unwittingly summoned from the social deeps the forces of a general disintegration. Strong enough to dissolve the old political order, liberalism could not master the social forces which that dissolution released and which generated new centrifugal thrust under liberalism's tolerant but inflexible aegis. The new anti-liberal mass movements—Czech nationalism, Pan-Germanism, Christian Socialism, Social Democracy, and Zionism—rose from below to challenge the trusteeship of the educated middle class, to paralyze its political system, and to undermine its confidence in the rational structure of history.

It is not our task here to trace the complex history of the extrusion of the Austro-liberals from political power, or of the paralysis of parliamentarism by national and social conflict. We shall focus rather on the nature of the leaders who, breaking from their own liberal origins, organized and expressed the aspirations of the groups which the liberals had failed to win. Our trio of leaders of the new mass movements reveals, despite their differences in political purpose, a common new style—harbinger of a new political culture in which power and responsibility were differently integrated than in the culture of rational liberalism.

Not all the new movements, national and ideological, which assaulted liberal ascendancy from the flanks and from below repre-sented departures from liberal political culture. The non-German nationalist parties and the Social Democrats were the least difficult for ordinary liberals to comprehend. Having been involved for a half century in a struggle for German national self-determination, the German liberals could understand, even when they deplored or rejected, the Czechs' increasingly radical demands for equality in legal and cultural institutions. The Social Democrats, formally founded as a party in 1889, likewise offered few conundrums to the

liberal mind. Indeed, of all the filial *révoltés* aspiring to replace the fathers, none bore the paternal features more pronouncedly than the Social Democrats. Their rhetoric was rationalist, their secularism militant, their faith in education virtually unlimited. True, the principal Social Democratic leader, Victor Adler, had rebelled against rationalism as a student, when he espoused German nationalism and Wagner's ideas of social integration on a folkish basis.[3] Yet, in subsequently embracing the Marxist creed, Adler affirmed a fundamental allegiance to the rationalistic heritage of science and law.

The liberals themselves felt the socialists' affiliation to their culture across the issues that divided them. Liberals could condemn Social Democrats for their utopianism, for their absurd demands for a welfare state before "the most primitive prerequisites" of political enlightenment had yet been created.[4] But neither the impatient rationalism nor the class-oriented cosmopolitanism of the socialists destroyed the liberals' sense of kinship with them. Though one might reject a socialist's position, one could argue with him in the same language. To the liberal mind, the Social Democrat was unreasonable, but not irrational.

Other movements resulting from the liberal failure to bring the masses into the state represented a far more revolutionary break from the tradition of Austrian liberalism and evoked a more traumatic response in the liberal community. These movements were Pan-Germanism, Christian Socialism, and—in answer to both of these—Zionism. Against the dry, rational politics of liberalism, the powerful leaders of these movements developed what became known as "the sharper key," a mode of political behavior at once more abrasive, more creative, and more satisfying to the life of feeling than the deliberative style of the liberals. Two leading virtuosi of the new key—Georg von Schönerer of the Pan-Germans and Karl Lueger of the Christian Socials—became the inspirers and political models of Adolf Hitler. A third, Theodor Herzl, pioneered in providing Hitler's victims with the most appealing and powerful political response yet devised to the gentile reign of terror. Thus, even before Vienna's intellectuals blazed trails to the twentieth century's higher culture, three of her sons pioneered in its post-rational politics.

Schönerer, Lueger, and Herzl all began their careers as political liberals and then apostasized to organize masses neglected or rejected by liberalism in ascendancy. All possessed the peculiar gift of

answering the social and spiritual needs of their followers by composing ideological collages—collages made of fragments of modernity, glimpses of futurity, and resurrected remnants of a half-forgotten past. In liberal eyes, these ideological mosaics were mystifying and repulsive, confounding the "above" with the "below," the "forward" with the "backward." Yet each of these political artists—Schönerer, Lueger, and Herzl—grasped a social-psychological reality which the liberal could not see. Each expressed in politics a rebellion against reason and law which soon became more widespread. In their manner of secession from the liberal political tradition and in the form of the challenge they posed to its values, this triad of politicians adumbrated a concept of life and a mode of action which, transcending the purely political, constituted part of the wider cultural revolution that ushered in the twentieth century.

❧ II ❧

GEORG VON SCHÖNERER (1842–1921) organized the radical German nationalists in 1882 and led them into extreme anti-Semitic politics. Although he never succeeded in forming a powerful party, he elevated anti-Semitism into a major disruptive force in Austrian political life. Perhaps more than any other single figure, he was responsible for the new stridency in Austrian politics, the "sharper key" of raucous debate and street-brawling that marked the last decade of the nineteenth century.

A curious compound of gangster, philistine, and aristocrat, Schönerer conceived of himself as the militant knight-redeemer of the German *Volk*. He rejoiced in epithets redolent of chivalry: "Knight George" or—after his estate in Lower Austria—"the Knight of Rosenau." The official song of his party, *Ritter Georg hoch!*, was sung to the tune with which the Austrians traditionally honored their military hero, Prince Eugene of Savoy, "the noble knight" who had saved Austria from the Turks.[5] It is striking that for his program of revolutionary national subversion Schönerer appealed to democratic students and to a frustrated lower middle and artisan class in the archaistic garb of knight. His aristocratic pretension offers a clue both to the psychological sources of his own

rancorous rebellion against liberal culture and to the social sensibilities of the strata which he organized.

Georg von Schönerer acquired his title by honest inheritance, but he was far from being an aristocrat of the blood. Alone among our three leaders, he came from the new industrial class. His father had received his patent of nobility from the hands of a grateful emperor for services as an engineer and railway administrator. Georg was thus the son of a self-made man, "a man with qualities." He spent his life in oscillation between living up to his inheritance and living it down.

Matthias Schönerer: what a father, what an archetypical man of the early industrial era! In 1828, when only twenty-one, he built Austria's first railway—a horse-drawn affair—and thereafter several steam-powered lines.* From a study tour of railway engineering in the United States, he returned to Vienna in 1838 with the first steam locomotive, the "Philadelphia." He thereupon organized the first locomotive and car-building works to eliminate Austria's dependence on foreign equipment and brought in American locomotive engineers to train native drivers.[6] Matthias's perquisites of office included a residence in Vienna's new South Station; it was in this very modern stable that the future savior of German nationalism was born in 1842. The elder Schönerer displayed the talents of an administrator no less than those of a builder.† In an industry in which the closest collaboration between engineer and banker was called for, Schönerer developed excellent working relations with the great financial tycoons of the day. Whether through his diplomatic talent

* Schönerer's drive, business acumen, and ruthlessness emerged in this first venture, where he replaced the chief designer, his own teacher, by siding with economy-minded directors against him. See Oesterreichischer Eisenbahnbeamtenverein, *Geschichte der Eisenbahnen der Oesterreichisch-Ungarischen Monarchie* (Vienna, Teschen, and Leipzig, 1897–1908), I, Part i, 99–101.

† An urn presented to Schönerer by his loyal personnel in 1846, when he was director of the Vienna-Gloggnitz Railway, celebrated his many talents with the iconographic variety characteristic of the age: Minerva stood for "Civil Engineering"; Mercury was elevated from his traditional role as trickster and divine messenger to represent "Administration"; a locomotive joined the pantheon to present "Railway Management," while an anvil, labeled "Machine Construction," completed the quartet of symbols. Cf. Constantin von Wurzbach, *Oesterreichische Nationalbiographie* (Vienna, 1856–91), XXXI, 149.

or his indispensability as a railway builder, he managed to work with two of the bitterest rivals in Austrian high finance: on the one hand, with the House of Rothschild; on the other, with Baron Simon Sina, who was often associated in his railway ventures with the Jewish house of Arnstein and Eskeles. When the competition between these great private bankers took the more formidable form of a struggle between the colossal new joint stock banks—Sina's Crédit mobilier and the Rothschilds' Oesterreichische Creditanstalt,[7] Matthias Schönerer could be found high in the councils of the railway enterprises of both groups. In 1834, the Rothschilds called upon him as an expert to determine whether they should power their great projected Nordbahn by horse or by steam.[8] It was this railroad that Schönerer's son was to make the focus of his anti-Semitic nationalization crusade in 1884. Schönerer senior achieved the height of his business career as member of the board of directors of the Empress Elizabeth Railway (built in 1856–60). A Rothschild-dominated enterprise, its board was thoroughly interlocked with that of the Creditanstalt.[9] The vigorous engineer became a wealthy man, the collaborator of bankers, liberals, Jews, stock-jobbers, and imperial bureaucrats: all those social types to whose destruction his son Georg would devote his political life—after his father's death.

In 1860, on the occasion of the dedication of the Empress Elizabeth Railway, the grateful emperor honored Matthias Schönerer for his services as railway builder with a patent of nobility. Like others proud of their achievements in the world of industry and trade, Schönerer chose an escutcheon appropriate to his vocation: a winged wheel in the colors of technology, silver and blue. His motto too, *Recta sequi* ("To follow the right"), conformed well to the ethic, if not always to the practice, of his class and generation.[10] Less typical was Matthias's decision to celebrate his social achievement by the purchase of a feudal holding. He bought the manor of Rosenau near Zwettl, a fourteenth-century estate with a charming castle from the era of Maria Theresa. In England, time had hallowed the passage of the merchant into the squirarchy via the country house. In Austria, nobility for service had become common, but its normal badge and accompaniment was higher culture, not a country seat. The acquisition of a noble's estate was not in good taste; it would carry some stigma of social presumptuousness.

The elder Schönerer felt untouched by such qualms. And, unlike

other self-made men of his era, he did not seem concerned to foster in his offspring the humanistic culture integral to the social style of Austria's *haute bourgeoisie* and especially of the service nobility which Schönerer had now entered. The two of his five children about whom something is known were both intellectual middle-brows by the standards of their class. Alexandrine von Schönerer, Georg's sister, shared the organizing talents of her father and brother. But she also shared the ruling Viennese passion for the theater. After some experience as an actress, Alexandrine turned her talents and her substantial legacy to account as a theatrical entrepreneur. In 1889, she bought the Theater an der Wien, one of the oldest centers of popular theater. (Its original manager was Immanuel Schickaneder, librettist of Mozart's *The Magic Flute* and first producer of Beethoven's *Fidelio*.) Under Mme. Schönerer's management, it became the outstanding theater for operetta, with the hedonistic works of Johann Strauss and Karl Millöcker replacing the more astringent social-morality plays of Johann Nestroy and Ludwig Anzengruber. As a member of the cosmopolitan Austrian theatrical community, which numbered many Jews, Alexandrine explicitly rejected her brother's anti-Semitic politics. Both as enthusiast for the theater-as-entertainment and as entrepreneurial spirit, she remained loyal to the culture of middlebrow Viennese liberalism.[11]

Georg seems to have suffered more deeply than his sister from the ambiguities bedeviling the child of an energetic parvenu. In Matthias Schönerer's education of his son, one again suspects a certain eccentricity in this otherwise regular royal entrepreneur. He sent the boy not to the Gymnasium, usual for his class, but to the technically oriented Oberrealschule. The fact that Georg changed schools several times suggests some kind of adjustment problem.[12] In 1859, Georg entered the school of commerce in Dresden. In the following years, when his father acquired knighthood and a landed estate, Georg changed course. He left the business school in 1861 and completed his education in two agricultural academies. In the spirit if not under the pressure of his father, Georg thus prepared himself for inheriting the newly acquired estate and title—and for making the life of a country squire pay. Aristocratic pretension and economic realism were to be harmonized in the second Ritter von Rosenau if not in the first.

It was appropriate, therefore, that Georg should have put the

capstone on his education by serving as a steward or farm manager on the estates of one of Austria's greatest aristocratic entrepreneurs, Johann Adolf Prince Schwarzenberg. Prince Schwarzenberg was to the economic modernization of the landed aristocracy what his gifted brother, Felix, Franz Joseph's mentor, had been to its political *aggiornamento* in 1848–52.[13] Educating himself in England in the latest techniques of capitalist agriculture, food-processing, and mineral extraction, Johann Adolph transformed his ancient estates into a vastly profitable landed empire. He was called "the prince among farmers and the farmer among princes." As political leader in the Bohemian Diet, he was a pillar of extreme aristocratic conservatism, but as entrepreneur he operated in the same bourgeois circle of finance and industry in which Matthias Schönerer also moved. Prince Schwarzenberg served on the founding committee and as the first president of the board of directors *(Verwaltungsrat)* of the Oesterreichische Creditanstalt, which was so deeply intertwined with the board of the Empress Elizabeth Railway.[14] Matthias Schönerer would have had ready access to the prince through their many common financial associates. Although specific evidence is lacking, one may suppose that the father used his connections to secure so valuable an entrée for his son into the technocratic aristocracy. In any event, the future Knight of Rosenau could scarcely have found a more promising apprenticeship than on the estates of Prince Schwarzenberg.

Whereas most sons of the successful middle class in Austria entered an urban vocation, Georg Schönerer was thus committed to becoming a modest replica of Prince Schwarzenberg, taking science and the entrepreneurial spirit to the land as a modern lord of the manor. Whether this career emerged from the wishes of the father or the ambitions of the son we do not know.[15]

Certain it is that Georg strove with dogged if graceless conviction to fill the role of *grand seigneur*. Yet, within the framework of the honest, "noble" way of Rosenau, he gradually prepared to rebel against virtually everything upon which his father had built his life: Habsburg loyalty, capitalism, interracial tolerance, and financial speculation. As a frustrated pseudo-aristocrat, Georg prepared himself almost unconsciously to lead those social strata who chafed under the rule of the industrial bourgeoisie from which he himself

sprang. Revolting masses and rebellious son would in due course find each other.

The process of transformation of the Knight of Rosenau into a nationalist demagogue proceeded slowly and was completed only after his father's death in 1881. Thanks to his fortune, his energy, and his practical knowledge of rural needs, Schönerer first established in his home district a firm base for a political career. He formed and financed agricultural-improvement associations, equivalents of the American grange, and volunteer fire departments. For his work in his own constituency, he chose the ideological symbol of the *Volkskaiser*, Joseph II, who had made it his policy to bring the fruits of science to the land and to build a strong peasantry. Schönerer erected plaques in various villages of his district showing the Emperor Joseph with his hand on the plow.[16] Here the liberal cult of science and public welfare mingled with Habsburg loyalty: Schönerer was clearly still within the framework of the liberal Josephan tradition.

On this secure rural base, Schönerer began his parliamentary career. Elected to the Reichsrat in 1873, he joined the Fortschrittsklub,* the left-democratic wing of the liberal camp. He established an early reputation as a defender of the farmer's interest. Soon he came into conflict with the dominant liberal forces. There were two issues that first aroused Schönerer's dissatisfaction with his colleagues: their indifference to social problems, and their inadequate vigor in combatting Slavic nationalism. On the latter front, Schönerer scored his first great success in weakening Austro-liberalism. The German liberals as a whole were then dividing on the nationality question. Concessions to the militant Czechs meant breaking the German middle-class hold upon Bohemia and Moravia and thus weakening liberalism. On the other hand, by driving the Slavic peoples into sharper reaction, failure to make concessions might threaten the Empire itself. Either way, the liberals had no principle to bind together their national, their cosmopolitan, and their social loyalties. Their best defense seemed the maintenance of the restricted-suffrage system, which kept the radical nationalist masses away from the polls.[17] If their national values suffered some loss, the integrity of

* The *Klub* was the basic unit of party organization within the Parliament. A party was a loose structure generally composed of several such groups.

the multi-national Empire could still be maintained with the liberals' legal and social ascendancy only slightly weakened.

After the divided liberals fell from power in 1879, Schönerer and an important group of young university intellectuals who had adopted him as their parliamentary representative openly rebelled against their party's line. They placed the principles of democracy and German nationalism ahead of imperial stability and middle-class oligarchy.* In the so-called Linz program (1882), this group formulated a platform which combined radical democracy, social reform, and nationalism in a manner resembling the contemporaneous phenomenon of populism in the United States. In its support for home industries and "honest labor," a compulsory training certificate for artisans, and prohibition of house-to-house peddling, the program took account of the grievances of the anti-Semitic Viennese artisan associations. These were survivors of an earlier economic era now hard-pressed by the advent of the factory, the retail store, and the Jewish peddler who sold factory products to the former customers of the stationary artisan. The program was not, however, directly anti-Semitic in intent.

The Linz program carried overtones of a "greater German" orientation in its demands for a customs union and stronger treaty arrangements with the German Empire.[18] It did not, however, incorporate one aim which Schönerer had expressed in the Reichsrat in a moment of choler: "If only we already belonged to the German Empire!"[19] Schönerer's fellow nationalists in 1882 had not reached the point where they would wish to dissolve the Habsburg Empire entirely, and most of them never would. But they agreed with him in yoking together two of the great claims on the Austrian state which the liberals had unleashed but could neither curb nor satisfy: the demands for national ascendancy and for social justice.

Schönerer expressed his synthesis of solvents in a manifesto for his nationalist association, the Verein der deutschen Volkspartei, in 1881: "We want to give lively expression to the feeling of solidarity

* These included, among others, Victor Adler and Engelbert Pernerstorfer, later leaders of Social Democracy; Robert Pattai, later Christian Social leader; and Heinrich Friedjung, the liberal historian. The group had its origins primarily in a university students' organization, the Leseverein der deutschen Studenten Wiens (1871–78). See William J. McGrath, "Student Radicalism in Vienna," *Journal of Contemporary History*, II, No. 2 (1967), 183–95.

of the German nation in Austria not only in contending with Slavdom, but also in a struggle against the exploitation of the noblest forces of the people [presumably the peasants and artisans] to the advantage of a few."[20] Such a synthesis could encompass a rather broad front of Austro-German liberal nationalists concerned for social reform. But the front could not be stabilized. Schönerer himself pressed on to extend both terms of his synthesis to the point where they became wholly incompatible with Austro-liberalism. On the national side, he interpreted "the feeling of solidarity" to encompass not only "the Germans in Austria" but Germans everywhere. Schönerer here drew upon the *grossdeutsch* ideal of 1848, when German democratic revolutionaries sought to supplant the non-national monarchical states system with a unitary Pan-German republic. During the Franco-Prussian War and with the founding of the German Empire in 1871, university students in Vienna and elsewhere had agitated for an extension of unification into the Habsburg lands. In 1878, Schönerer was elected honorary member of the student Leseverein at the same time as the aged chaplain of the Academic Legion of the 1848 revolution. This coincidence reveals how difficult it was to distinguish "forward" from "backward" and how easily the older democratic nationalism could become reincarnated in new right-wing radical forms. Schönerer, for his part, aimed not at a unitary German republic, like the democrats of 1848, but at the break-up of the "pro-Slav" Habsburg monarchy in order that its western portion might be united with the Bismarckian monarchy. Not many left-wing progressives could follow Schönerer into this conservative-revolutionary direction. But his development of anti-Austrian national loyalty found a resounding echo in student circles. The universities, once centers of triumphant Austro-liberalism, became in the late seventies and eighties the scene of brawling nationalist agitation as the influence of the *Schönerianer* spread.[21]

Schönerer's second extension of his national-social program was into anti-Semitism. He made his first programmatic statement against the Jews in an electoral platform in 1879. Here Schönerer characteristically linked aristocracy and people—"the interests of landed property and of productive hands" against "the heretofore privileged interests of mobile capital—and the . . . Semitic rule of money and the word [i.e., the press]." As if condemning his aged father and hence the sources of his own considerable fortune, he called for laws

"against the moral and economic dangers arising out of the inadequate responsibility of founders of companies and corporation boards of directors."[22] Wider political opportunities for Schönerer as anti-Semitic radical soon opened up, and these coincided with his father's approaching death in 1881, which released his inhibited aggressions against all that Matthias Schönerer stood for. The social base for Georg's anti-liberal leadership and the psychological conditions for asserting it converged.

As in his Pan-Germanism Schönerer had been anticipated by the nationalistic student associations, so in his social anti-Semitism he was anticipated by the artisan movement. In 1880, the first anti-Semitic Society for the Defense of the Handworker was founded in Vienna. In 1882, it was absorbed into the Austrian Reform Union, at whose founding meeting Schönerer was the major speaker, declaring war on "the sucking vampire . . . that knocks . . . at the narrow-windowed house of the German farmer and craftsman"—the Jew.[23] The vicious "new key" of his rhetoric appealed to frustrated artisans no less than to Wagnerite students.

Schönerer achieved his greatest notoriety as parliamentarian in the years 1884–85, when he led the fight for the nationalization of the Nordbahn, the railway which his father had counseled the Rothschilds to construct years before. The franchise for this profitable line was due for renewal at the very time when the revolt against laissez faire was making itself felt in various strata of society. Turning the popular struggle against the bankers and brokers into anti-Semitic channels, Schönerer invested the issue with the explosive energy of his belated oedipal rebellion. He accused not only the Liberals and ministers but indirectly the court itself of "bowing before the power of the Rothschilds and their comrades," and he threatened all with "colossal forcible overturns" at the hands of the people if that power were not now broken.[24] The return of the repressed in capitalist society had its analogue in the return of the repressed in Schönerer's psyche. The Liberals, in the face of this outbreak of raw rancor, found themselves with their backs to the wall.

Schönerer's other target in his anti-Semitic campaign he took more directly from the radicalized artisans of Vienna with whom he became identified. The Jewish peddler was the lower-class analogue to the Jewish department-store owner: both threatened the traditional shopkeeper; both attracted the hostility as well as the custom of the

small consumer. Finally, Schönerer centered his campaign against the Jews in an attempt to restrict their immigration from Russia at the time of the pogroms. Where his father had looked to American engineers for technical models for railway design, Georg turned to the United States for a legislative model for racial discrimination: the Chinese Exclusion Act of 1882.

In some respects, Schönerer's anti-Semitism is much more central to consideration of his disintegrative influence on liberal society than his nationalism as such. The Jews, as Hannah Arendt has rightly observed, were the "state-people" par excellence in Austria.[25] They did not constitute a nationality—not even a so-called unhistoric nationality like the Slovaks or Ukrainians. Their civic and economic existence depended not on their participation in a national community, such as the German or the Czech, but, on the contrary, on not acquiring such a status. Even if they became assimilated completely to the culture of a given nationality, they could not outgrow the status of "converts" to that nationality. Neither allegiance to the emperor nor allegiance to liberalism as a political system posed such difficulties. The emperor and the liberal system offered status to the Jews without demanding nationality; they became the supra-national people of the multi-national state, the one folk which, in effect, stepped into the shoes of the earlier aristocracy. Their fortunes rose and fell with those of the liberal, cosmopolitan state. More important for our concerns, the fortunes of the liberal creed itself became entangled with the fate of the Jews. Thus, to the degree that the nationalists tried to weaken the central power of the monarchy in their interest, the Jews were attacked in the name of every nation.

Schönerer was the strongest and most thoroughly consistent anti-Semite that Austria produced. He was equally and correspondingly the bitterest enemy of every principle of integration by which the multi-national empire could be held together: the enemy of liberalism, of socialism, of Catholicism, and of imperial authority. As a total nationalist, he could not rest content with the imperial state. The emperor appeared to him, correctly, as compromising among the peoples into which his realm was nationally divided and the ideologies into which his realm was socially divided. If the emperor was supra-national, the Jews were subnational, the omnipresent folk substance of the Empire, whose representatives could be found in every national and every creedal grouping. In whatever group they

functioned, the Jews never strove to dismember the Empire. That is why they became the victims of every centrifugal force as soon as, and only as long as, that force aimed to subvert the Empire.

Schönerer was the first leader of centrifugality *à outrance* to arise in the era of liberal ascendancy. No one ever espoused in such full measure *every* disruptive potentiality in the society: class, ideology, nationality, and religion. Nationalism provided the positive center of Schönerer's faith; but, since nationalism might have been satisfied without total disintegration, he needed a negative element to give coherence to his system. Anti-Semitism was that element, enabling him to be simultaneously anti-socialist, anti-capitalist, anti-Catholic, anti-liberal, and anti-Habsburg.

Schönerer never succeeded in building a great mass movement as his successors Lueger and Hitler did. His principal lasting impact was in the area of political deportment, in words and in action, where his style was as aggressive as his ideology, but more contagious. Into the Reichsrat, center of liberal legality and dignity, Schönerer and his colleagues introjected the sharper key, with its raucous diapason of disorder and invective. That august body had to accustom itself to his diatribes against finance Jews, Northern Railway Jews, Jew peddlers, press Jews, Jew swindlers, and the like. These attacks on behalf of the "noble" German people were delivered in the presence of both Jews and Gentiles. It took some getting used to.

In June of 1886, Dr. Ernst von Plener, leader of the Liberal party, a dignified lawyer and anglophile gentleman, tried to put a term to the anti-Semitic agitation in the Reichsrat. He expressed his regret that the president (speaker), "who otherwise . . . had cared so well for the dignity of the house," had permitted such vituperative tones to rend it. He hinted at a sterner use of the powers of the chair. Plener also proposed that the anti-Semites at last present their much-vaunted exhortations to curb the Jews in the form of legislative proposals. "Then," Plener concluded, "we shall see what these gentlemen really intend, and then the . . . house will be given an opportunity to express its opinion concerning an agitation which is one of the most regrettable symptoms of our time."

Schönerer responded to the challenge with a vigorous combination of parliamentary action and the threat of force. He promised to bring in a variety of bills to curb the Jews. Between the promise and

the fulfillment fell the threat. If the president of the House should follow the suggestion of Plener to curb freedom of discussion on the Jewish question, "then this question could not be brought nearer to solution through proposals made and words spoken in the parliament; and in that case, the fists will have to go into action outside parliament."[26] While Liberal parliamentarians condemned " 'the so-called anti-Semitic movement as unworthy of a civilized people,' " the Knight of Rosenau called for the "moral rebirth of the fatherland" by elaboration of "legal restrictions on the Jewish exploiters of the people." Here again Schönerer used threatening rhetoric. He promised the Reichsrat in 1887 that if his movement did not succeed now, "the avengers will arise from our bones" and, "to the terror of the Semitic oppressors and their hangers-on," make good the principle, " 'An eye for an eye, a tooth for a tooth.' "[27]

Political style and personal temperament in Schönerer both bore the marks of paranoia. Whether as accuser or accused, he became frequently involved in libel trials. Aggression, which brought him many followers, in the end proved his undoing. Less than a year after he had threatened the Reichsrat with "an eye for an eye," the noble knight broke into the offices of the *Neues Wiener Tagblatt* and, with the help of some colleagues, beat up the staff of this "Jewish rag." The paper's editor, Moritz Szeps, was an intimate of Crown Prince Rudolf. As one of the more aggressive liberals, Szeps had been engaged in both verbal and legal duels with Schönerer before, and not always as the winner.* Schönerer's raid on the editorial office, however, was the first time the new style in politics took the form of trial by battle. The sharper tone in verbal combat was one thing, the *musique concrète* of physical assault another. The court sentenced Schönerer not only to a brief prison term but—most fatefully for his political career—to a suspension of political rights for five years.[28] Finally, the court conviction automatically cost Georg von Schönerer his title. With this, the Knight of Rosenau had lost the one inheritance from his father that he truly prized. In attempting to destroy his father's world, he destroyed the symbol of higher status

* In 1885, Szeps spent a month in jail as the result of a successful libel action brought against him by Schönerer. See Bertha Szeps-Zuckerkandl, *My Life and History*, tr. John Sommerfield (London, 1938), pp. 86, 91, 95.

that was the reward for success in that world. Schönerer's career of political destruction ended in self-destruction. He soon returned to that oblivion whence his father had emerged.

The perplexing combination of elements in Schönerer's makeup reminds us again of the serious historical content in Musil's ironical remark that in that age no one quite knew how to distinguish between what was above and what below, between what was moving forward and what backward. Both in his person and in his ideology, Schönerer combined the most diverse and contradictory elements. Desperately aspiring to aristocracy, he might have succeeded as a Prussian junker, but never as an Austrian cavalier. For the Austrian nobiliar tradition demanded a grace, a plasticity, and, one might add, a tolerance for the wrongs and ills of this world which were wholly foreign to Schönerer's makeup. Most socially aspiring sons of successful Viennese middle-class families, especially those of the service nobility, acquired aesthetic culture as an acceptable substitute for entry into the historical aristocracy of pedigree. Schönerer—or his father—tried a more drastic course, forcing the issue by acquiring a feudal estate and becoming a baronial technocrat, not a cavalier, but a knight by *force majeure*. Correspondingly, Schönerer vented his political passion, not against the aristocracy whose circles he failed to penetrate, but against his father's world of liberals, the higher bourgeoisie whom he had hoped to leave behind. His career of political destruction seems to have had its personal sources in the thwarted ambition of the under-educated and over-extended son of a parvenu father.

In the pursuit of his revolution of rancor, Schönerer constructed his ideology out of attitudes and values from many eras and many social strata: aristocratic élitism and enlightened despotism, anti-Semitism and democracy, 1848 *grossdeutsch* democracy and Bismarckian nationalism, medieval chivalry and anti-Catholicism, guild restrictions and state ownership of public utilities. Every one of these pairs of values the nineteenth-century liberal would have seen as contradictory. But there was a common denominator in this set of ideational fractions: total negation of the liberal élite and its values.

As Schönerer was an angry man, so his ideological montage appealed to angry people: artisans cheated out of their past with no comfort in the pieties of the present and no hope in the prospect of

the future; students with the spirit of romantic rebellion unsatisfied by the flat homilies of the liberal-ethical tradition: these were the first of the rootless, the spiritual predecessors of decaying Europe's social jetsam whom rightist leaders would later organize. It was fitting that the deeply middle-class Knight of Rosenau, a belated and violent Don Quixote, should find in artisans and adolescents a pseudo-feudal retinue with whom to rehearse his brutal farce. One day that farce would take the stage as tragedy, with Schönerer's admirer, Hitler, in the leading role.

⇒ III ⇐

K A R L L U E G E R (1844–1910) had much in common with the Knight of Rosenau. Both men began as liberals, both criticized liberalism initially from a social and democratic viewpoint, and both ended as apostates, espousing explicitly anti-liberal creeds. Both used anti-Semitism to mobilize the same unstable elements in the population: artisans and students. And—crucial for our purposes—both developed the techniques of extra-parliamentary politics, the politics of the rowdy and the mob. Here the similarities end.

Schönerer's central positive accomplishment was to metamorphose a tradition of the Old Left into an ideology of the New Right: he transformed democratic, *grossdeutsch* nationalism into racist Pan-Germanism. Lueger did the opposite: he transformed an ideology of the Old Right—Austrian political Catholicism—into an ideology of a New Left, Christian Socialism. Schönerer began as a master organizer in his country constituency and ended as an agitator with a small, fanatical following in the city. Lueger began as an agitator in the city, conquered the city, and then organized a great party with its stable base in the countryside. Our concern will be with Lueger militant, not with Lueger triumphant. After 1900, the mature national politician shepherded his once unruly flock into the homely stall of the Hofburg. We shall focus rather on Lueger the tribune, Lueger the partner and competitor of Schönerer as composer in the new key; for this is the Lueger who yoked "backward" and "forward," "above" and "below," who brought together the ancient and modern enemies of liberalism for a successful political assault on its

central bastion, the city of Vienna. In the year 1897, when the reluctant emperor finally ratified Lueger's election as mayor, the era of classical liberal ascendancy in Austria reached its formal close.

"Wir können warten. Wissen macht frei." (We can wait. Knowledge liberates.) In these confident words the stalwart Ritter von Schmerling expressed the rationalistic expectations of the political process at the beginning of the liberal era in 1861.[29] At the end of that era, the poet Hugo von Hofmannsthal, scion of a cultivated middle-class family, offered a different formula for political success: "Politics is magic. He who knows how to summon the forces from the deep, him will they follow."*[30] Lueger began his career in the traditional liberal way as "Dr. Lueger," but when he found his stride he became *der schöne Karl*, beautiful Charles, the spellbinder. Even more successfully than his rival Schönerer, he traversed the road from Schmerling to Hofmannsthal, from the politics of reason to the politics of fantasy.

Where Schönerer was reared in the executive's apartment of Vienna's South Station, little Karl Lueger grew up in the quarters of a far lowlier civil servant: the superintendent's flat in the Vienna Polytechnic Institute. Lueger publicly expressed pride in his father, Leopold, who, coming into Vienna from the countryside, "could reach such a goal [the superintendency] without having enjoyed a previous educational background."[31] But one suspects that Karl's mother was the real force in the household. Neither her two daughters nor her son married—a sign of extreme maternal authority. According to one historian, Frau Lueger exacted on her deathbed a pledge from her forty-four-year-old son that he would remain unmarried to care for his sisters.[32] She had also kept these sisters close to her side in managing the tobacco shop through which, after her husband's death, she earned her modest living. There is no evidence that the rising fortunes of her son altered the family's simple style of life—or the primary loyalty of the son to his strong-willed mother.[33] Where a powerful parvenu father shaped the Knight of Rosenau, a tough little *petite bourgeoise* formed the future "Lord God of Vienna *(Herrgott von Wien)*."

Frau Lueger encouraged her son from an early age to follow the

* "Politik ist Magie. Welcher die Mächte aufzurufen weiss, dem gehorchen sie."

educational road to higher social status. "A simple woman of the people," her grateful son reported, "she [nevertheless] read Cicero's orations [with me]. She understood not a word of them; she merely followed the words of the text with scrupulous attentiveness—and woe to me if I recited a passage incorrectly! She held me strictly to learning."[34] Fortified by maternal discipline, young Karl gained admission to the most exclusive preparatory school in Vienna, the Theresianum.*

It must not be thought that Karl mingled on equal terms with the sons of the great during his six years at the Theresianum. He was not a cadet *(Zögling)* but a day scholar *(Externist)*. Only since 1850 had day scholars been admitted to the school at all. They came almost exclusively from the Viennese district of Wieden, where the school was located. While the sons of the upper bourgeoisie predominated among the day scholars,† "there always appeared beside them," the school's historian tells us, "the child of completely simple folk . . . such as Dr. Karl Lueger . . . son of a servant at the Technical High School."[35] The day student sat in the same classes with the cadets, but presumably wore no uniform.

The day scholar must have felt his distinction from the "regulars"— especially if he came, as did Lueger, from the lowest social stratum

* The importance of this academy to the high nobility of blood and service may be gauged by the fact that the establishment of a secure quota of places for the scions of prominent Hungarian families became a matter of high-level negotiations between the Austrian and Hungarian administrations after the establishment of the dual monarchy in 1867 (Eugen Guglia, *Das Theresianum in Wien. Vergangenheit und Gegenwart* [Vienna, 1912], pp. 156–7). The post of Curator of the Theresianum, the equivalent of the chairman of the board of trustees in an American school, generally fell only to a figure of national prominence. When Lueger entered the school in 1854, the curator was Count Taafe, father of the minister president during whose tenure of office Lueger was to rise to prominence. Another chief of government, Anton Ritter von Schmerling, occupied the school's curatorship from 1865 to 1893, while his successor, Baron Paul Gautsch von Frankenthurn, became minister president of Austria in 1897, the year when Lueger finally realized his dream of becoming mayor of Vienna.

† Some bourgeois families were too proud of their station to expose their sons to the snobbish aristocratic milieu of the Theresianum. The favorite Gymnasium of the secular liberal—and the Jew—was the Akademisches Gymnasium. Cf. Karl Kautsky, *Erinnerungen und Erörterungen* ('s-Gravenhage, 1960), p. 211.

represented. Yet Karl seems to have drawn only profit from his experience at the Theresianum. There is no evidence that he ever became, like Schönerer, envious of the aristocracy. He acquired and always retained a deferential attitude toward Austria's traditional ruling class. Rabble-rouser though he became, his style always bore the marks of a certain grace, an almost aesthetic distinction, which earned him the epithet *der schöne Karl*.[36] He belonged to that strange silent community of understanding that subsisted in Vienna between the decaying nobility and the depressed "little man"—what Hermann Broch called the "gelatin democracy" of Vienna's gay apocalypse. The Theresianum undoubtedly refined Lueger's natural feeling for social distinction and gave him, in relation to the more unbending bourgeois breed who were to be his foes, a subtle sense of social superiority despite his lowly origins. His was the sensibility of the well-trained servant, who knows breeding better than the classes do that lie between his master's and his own. It proved to be an asset in his later political task of welding together a coalition of aristocracy and masses against the liberal middle class.

As a university student, Lueger pursued the study of law. In his final oral examination in legal and political science, the young man defended theses which reveal him as an Austro-democrat, an advocate of universal suffrage with a concern for the social problem. Unlike most democrats, however, Lueger seems to have rejected national orientations. "The nationality idea is destructive and an obstacle to the progress of mankind": to defend a thesis so radically cosmopolitan was not typical of student opinion when Lueger took his exams on the eve of the Franco-Prussian War (January 14, 1870).[37] After the war broke out, when waves of German nationalist passion swept through the Vienna University student community, young Dr. Lueger returned to his alma mater to combat prussophil nationalism. At a student demonstration of solidarity with those who were fighting and dying under the black, white, and red, Lueger precipitated a near-riot by denouncing the North German colors as "the product of despotic arbitrariness." Though cheered by his supporters, Lueger was so manhandled by the irate nationalists that he had to flee the hall.[38] He had his first experience with the sharper key in politics as victim—and that on the only issue whereon he remained steadfast throughout his career: opposition to the *klein-*

deutsch idea of German unity without Austria. Herein he showed himself not a typical democrat of the time but a true son of the Theresianum.

Hostility to North Germany did not, however, suffice to build a political career in the city of Vienna in the early seventies. With a law degree in hand as his union card, Lueger entered politics through the surest vestibule, the Liberal Bürgerklub of his own third district of the city. Its leader, Ritter von Khunn, an aging veteran of 1848, cultivated the young man as one with access to the "little people"—those who, though still without a vote, threatened to become the shock troops of the democratic radicals. In 1876, after but a year in the Vienna city council, Lueger won the plaudits of the *Neue Freie Presse* as "the breastplate of the center parties against the Left."[39] Not for long. In the same year, Lueger swerved to the Left, aligning himself with a Jewish Democrat, Ignaz Mandl, a tribune who inveighed against monopoly and corruption in the Liberal oligarchy that controlled the city. Mayor Kajetan Felder, self-made man, lawyer, and lepidopterologist, became the chief target of the Mandl-Lueger forces. The two partners represented the small shop-keepers, the "tailor and greengrocer assemblies," in their demands for a greater voice in political affairs. These supporters were not proletarians but small taxpayers, the "10-gulden men" of the third voting class who were especially sensitive to waste in city government and to the benefits of patronage in which they had no share. They also resented the stranglehold which a class franchise accorded the privileged in municipal government.[40] Lueger and Mandl introduced a new style into municipal politics. The *Salonton* of the once homogeneous "city council of the intellectuals" gave place to what Felder called "the shirt-sleeve manners" of the demagogic Democrats.[41] The righteous mayor, refusing to allow the increasingly democratic city council to investigate the conduct of his administration, resigned in 1878. It was the major triumph of the Viennese lower middle class in its democratic incarnation.[42] Lueger and Mandl meanwhile led the group within the city council which demanded extension of the suffrage—a reform on which the Liberals divided, and which was not achieved until 1884, when 5-gulden taxpayers were accorded the franchise.[43] The resistance of some of the Liberals—Mayor Felder at their head—to the extension of the

franchise only increased the anti-liberal mood of the lower classes. In such a context democracy and liberalism became contradictory terms.

Almost imperceptibly, Lueger's success as a democratic agitator drew him deeper into the growing opposition to the liberal order as a whole. He seized upon tangible issues where social resentment could be dramatized to reinforce democratic grievance with economic envy. The identification of his Liberal political foes with the men of high finance offered an easy target for the focusing of rancor. Thus Lueger launched a campaign against an English engineering firm destined to receive the contract for constructing a city transport system. Lueger charged the supporters of this firm with attempts to bribe him and other city council members; the ensuing libel trial brought him great public notice. Like Schönerer, he now appeared in the role of David against the mighty Goliath of "international capital." "These financial cliques and money powers . . . poison and corrupt public life," said Lueger, after a second trial had acquitted him of libel in March 1882; and he pledged himself to fight on against them.[44]

For five more years, from 1882 to 1887, Lueger continued to designate himself a Democrat and to sit with the Left in the Reichsrat. As a city politician whose greatest talent lay in reflecting and expressing the attitudes of his constituents, it was inevitable that he should follow the "little folk" as they moved toward more radical positions: from anti-corruption into anti-capitalism, and from anti-capitalism into anti-Semitism.

In 1883, Lueger joined Schönerer in his crusade to block the renewal of the Rothschilds' lucrative franchise for the Northern Railway. While Schönerer led the fight for nationalization in the Reichsrat, Lueger organized support for him in the city council and in Viennese public opinion.[45] Fighting the "interests" as a democratic urban reformer carried Lueger into the lower artisan strata, where anti-Semitic feeling was on the rise. He established connections with the same Austrian Reform Union at whose founding meeting in 1882 we have seen Schönerer perform.

More the opportunist than Schönerer, less the slave of his own intense feelings, Lueger was slower to commit himself to an anti-Semitic stance. Lueger reflected in his public positions in the fluid eighties the murky transition from democratic to protofascist

politics. As late as 1884, he still participated actively in drafting a Democratic party program which insisted upon "the principle of the equality of all denominations."[46] In the Reichsrat elections of 1885, the first in which the 5-gulden taxpayers participated, Lueger still ran as a Democrat. It was characteristic of both his Vienna district (Margarethen) and his voting class that his rival for a Reichsrat seat in 1885 was also listed as a Democrat. The difference between the candidates lay in their external endorsements: the anti-Semitic Reform Union supported Lueger; the Liberals, his rival. Democratic ideology still served as common ground for a liberalism in decline and an anti-Semitism on the rise. By stressing his democratic crusade against "the interests," pursuing anti-Semitism only in a low key, Lueger annoyed the Reform Union but kept enough Democratic voters to win the election by eighty-five votes. Lueger thus took his seat in the Reichsrat in 1885 with the Austrian Democrats led by Dr. Ferdinand Kronawetter, but his commitment to the party lacked the old firmness. "We shall see which movement will become the stronger, the Democratic or the anti-Semitic," he told Kronawetter. "One will have to accommodate oneself accordingly."[47]

When Schönerer brought to the floor his legislation to restrict Jewish immigration in May 1887, Lueger seemed to make up his mind: he supported Schönerer's bill. A final break with Kronawetter followed; Lueger gave up the attempt to hold together the two increasingly disparate tendencies, democracy and anti-Semitism. Despite his rejection of Pan-Germanism, Lueger found alliance with Schönerer more promising than the outmoded commitment to Kronawetter.

Lueger thus completed in 1887 the same evolution that Schönerer had undergone five years before: from political liberalism through democracy and social reform to anti-Semitism. But there was a difference: Lueger was a *Viennese* politician, hence a representative of the city's interests as an imperial capital. He retained a fundamental allegiance to the Habsburg monarchy and hence was unattracted to German nationalism, the positive fluxing substance of Schönerer's myriad hates. Lueger would have to find his integrating ideology elsewhere.

Even while Lueger was being impelled toward Schönerer by his lower-middle-class and artisan followers, possibilities for a less na-

tionalistic mass politics were quietly opening up in a most unexpected quarter—namely, in the Catholic community. Catholicism offered Lueger an ideology that could integrate the disparate anti-liberal elements which had been moving in contradictory directions as his career developed: democracy, social reform, anti-Semitism, and Habsburg loyalty. Conversely, Lueger could give Catholicism the political leadership to weld together its shattered social components into an organization strong enough to make its way in the modern secular world.

Until the emergence of Lueger's Christian Social party in about 1889,* Austrian Catholicism, both political and ecclesiastical, had been languishing in anachronism. Both intellectually and sociologically, the Catholic leadership remained committed to an order which the liberal ascendancy had forever destroyed. The chief political leaders of Catholicism were federalist Bohemian noblemen and provincial conservatives from the Alpine lands. Their parliamentary clubs were *Honoratiorenparteien,* small groups of notables. Modernity and all its works and pomps alarmed them; they could only look back wistfully to the vanished days when religion provided the basis of a deferential society in which the landed aristocracy predominated. For protection in the living present, they leaned, in Josephan fashion, on the emperor, even though he had since 1860 evidently become a prisoner of the liberals.

The hierarchy, whose highest prelates tended to be drawn from the nobiliar families, likewise offered little resistance to the dismantling of the Church's traditional authority. Both bishops and priests, like the Vatican itself, were overwhelmed by the collapse of neo-absolutism. The Austrian emperor, first son and last protector of the Church Universal, had been defeated in the field by the Piedmontese apostates in 1860 and the Prussian Protestants in 1866. "Casca il mondo!" exclaimed Pius IX's secretary of state when he heard of Austria's defeat at Königgrätz. The words were as prophetic for the fate of baroque Catholicism in a liberal era as they were expressive of the limited, frightened outlook of its ecclesiastics. For now liberalism celebrated its triumph in Austria not only by

* The date is unclear because of the years of slow regrouping of the entities that composed the new movement.

instituting constitutional government but by denouncing the Concordat between Empire and Papacy, introducing school reform, and cheering while the pope lost Rome and immured himself in the Vatican.

"Casca il mondo!" As the old world collapsed, the Austrian Church, unable to adapt to the new, returned to its Josephan habits of behavior. It clung to the imperial system as to the rock on which its ship was wrecked, worked through the *Honoratioren* and the court, and tried to keep out of trouble. The Church thus behaved in much the same fashion as the bulk of the nobility of which its leaders were a part. It bowed to the inevitable and bore its sufferings as a patient victim, without self-examination and without self-doubt.

No regeneration could emerge from such a resigned stance. In Austria, as elsewhere in Europe, new vitality in the Catholic community came only when the faithful re-examined modern society for its possibilities and simultaneously scrutinized their ancient Church for its faults. Laity as well as clergy slowly became engaged in this process of review and reorientation. That complex development, extending well beyond the social sphere, lies outside our scope. Its aggressive spirit, however, does concern us, for this affected the world of secular liberalism. That spirit appeared clearly in the first all-Austrian Catholic Congress of 1887. Its preparatory commission expressed the new mood in a message to Pope Leo:

There is no dearth of peoples loyal to the faith in our lands, but many of the most upright Catholics lack a clear understanding of the situation, knowledge of the methods of combat necessary under the new conditions, and above all the requisite organization. Always accustomed to being ruled in a Christian spirit by our Catholic monarch and the trustworthy men freely chosen by him, the great majority of Catholic laymen no longer know how to orient themselves.[48]

This statement contains the elements of the program which the Catholic political renewal would have to follow: to free the Catholic community from dependence on the monarch and his advisers, to find new methods of combat appropriate to new conditions, and to organize.

Between 1875 and 1888, while Lueger was drawing away from his

liberal origins and vacillating uneasily between secular democracy and nationalist anti-Semitism, the elements of a political Catholicism capable of fulfilling these tasks slowly emerged. The contributors to the new movement came from sectors of society smarting in varying degrees under liberal capitalist rule: aristocrats and Catholic intellectuals, businessmen, clergymen, and artisans. Paradigmatic for the whole new complex was the act of Count Leo Thun, one of the more moderate leaders of the Catholic Conservatives, in appointing Freiherr Karl von Vogelsang as editor of his political and theoretical organ, *Das Vaterland*. Vogelsang identified capitalist social indifference as the Achilles' heel of liberalism. Against it this neo-feudal theorist aimed his deadly shafts. Linking capitalism with the spirit of 1789, Vogelsang could reach across the middle class to both the artisan and the worker who were in increasing rebellion against the pressures of laissez faire. What was above—parts of the aristocracy —joined with what was below—the lower-class victims of laissez faire. It was a pattern for which, *mutatis mutandis*, strong precedent existed in England, France, and Vogelsang's native Germany. But in none of these did this ideology become the program of a successful democratic party.

In the sphere of social legislation some aristocrats developed a practical analogue to Vogelsang's ideology. Prince Alois von Liechtenstein, known to his enemies as "the Red Prince," took the lead in pressing social legislation from the right side of the House in the 1880's. Karl Lueger supported his endeavors from the left. Aristocratic deviant and democratic demagogue found each other.[49] Two other elements joined the loose coalition to round out the ingredients of the Christian Social party: a zealous group of young priests and theologians looking toward a more vital tie between church and people, and the anti-Semitic artisan movement, which had already lent its support to Schönerer and Lueger.

The first meeting of unofficial representatives of all these elements took place in a symbolic setting: the villa of Princess Melanie Metternich-Zichy. Under auspices thus redolent of the vanished past, aristocrats, social theorists, and practitioners of mass politics joined forces: Prince Liechtenstein; a moral theologian, Professor Franz Schindler; Vogelsang; Lueger of the Democrats; Ernst Schneider of the anti-Semitic artisans. Under the intellectual guidance of Schindler, they worked out a program in a long series of discussion

meetings and launched it in the religious world through the Austrian Catholic Congresses of 1889 and 1893. Through the formation of the United Christians (1888) and their expansion into the Christian Social party, a political organization was developed to carry out the task of Catholic renewal.

In both the ecclesiastical and the political sphere, the program of Christian social-democratic action encountered the opposition of the older and more cautious generation. The new program involved throwing the gauntlet down to the establishment, hence to incur risk, never popular with the chastened leaders of the Catholic world. The sharper key, with all its ruthlessness, appeared within the Catholic fold in the late eighties and nineties just as clearly as it did in the Liberal Vienna city council when Mandl and Lueger unleashed their democratic opposition, or in the Reichsrat when Schönerer embarked upon his crusade against the Jew. The radical Catholics manifested many of the signs of cultural alienation that characterized the Pan-Germans, the Social Democrats, and the Zionists. They established their own press, they organized sport clubs, they developed, like the Pan-German nationalists, a school association to free their community of dependence on state education. And they took to the streets in rowdy mass demonstrations, as shocking to the old guard Catholic hierarchy as they were alarming to the liberals. The younger Catholics of the new style, like the younger nationalists, seemed to feel the need to manifest their alienation from the established order as the necessary prelude to redemption. Whether their salvation should lie in a withdrawal from the state or in its conquest, the psychological premise of success would seem to have been the clear profession of minority status, frank self-definition as an oppressed social subgroup. This was as true for the new Catholics as for the new nationalists and the Zionists.

The political chemist who fused the elements of Catholic social disaffection into an organization of the first magnitude was Karl Lueger. Although not particularly religious, Lueger knew how to use the new Catholic social theory as a catalyst in his political experiment. Having secured the support of the Schönerer forces by professions of anti-Semitism, he was able, thanks to Schönerer's imprisonment, to lead most of his Vienna artisan following into the Christian Social fold.

In the city of Vienna, Lueger's following increased from election

to election until, in 1895, he acquired the majority in the city council needed to elect him mayor. His public persona contained all the colors of his multi-hued constituency. *Der schöne Karl* commanded that fine, almost dandyish presence which, as Baudelaire observed, arises as an effective attribute of political leadership in "periods of transition when democracy is not yet all-powerful and aristocracy is only partially tottering. . . ."[50] His elegant, almost cool manner demanded deference from the masses, while his capacity to speak to them in Vienna's warm folk dialect won their hearts. A *Volksmann* with an aristocratic veneer, Lueger also had some attributes to draw the Viennese middle class to his banner. He loved the city with a true passion and worked to enhance it. Yet he criticized his predecessors ruthlessly for their needless expenditures and kept his critical tongue at the ready for all signs of waste. Thus Lueger made steady inroads into the following of the Liberals until, in March of 1895, he captured the prosperous second curia of voters. Only the richest property holders remained true to liberalism.

Lueger's victory at the polls in Vienna in 1895 opened a two-year period of deadlock which may be regarded as the last stand of Viennese liberalism. Although Lueger had been duly elected mayor by the necessary majority of the city council, the emperor refused to ratify his taking office. A trinity of pressures was brought to bear on the emperor against him: the Liberals and Conservatives in the coalition government, and the higher clergy. The government, through the personal mediation of Franz Cardinal Schönborn, tried in vain to secure papal intervention against the movement. The Viennese went to the polls to reaffirm their choice. The emperor persisted in his refusal until 1897.

The Liberals, erstwhile champions of representative government, were now in a most paradoxical posture. They might be convinced, as their leader Ernst von Plener said, that a coalition government which had made the fight against the radicalization of political life an explicit part of its program could not allow the emperor to sanction "the spokesman of a movement bordering on the revolutionary," "a communal demagogue" who was responsible for "the barbarization of the parliamentary tone in our House of Representatives."[51] However comprehensible Plener's reasoning, his anti-clerical party was now in the position of relying first on episcopal—even

papal—discipline to avoid the consequences of liberal institutional arrangements and, second, on imperial dictate to prevent the will of the electorate from being fulfilled. Even the progressive Sigmund Freud, who in his youth had, like Beethoven, stubbornly refused to show respect for the emperor by doffing his hat, now celebrated Francis Joseph's autocratic veto of Lueger and the majority's will.[52]

The imperial veto could not be sustained in an age of mass politics. On Good Friday 1897, the emperor capitulated, and *der schöne Karl* entered the Rathaus in triumph. At the same time, the Austrian government entered a profound crisis over the language ordinances in the Czech lands. Thus, just as the old liberal bastion fell to the Christian anti-Semites, the Reichsrat fell into such hopeless discord that the emperor had to dissolve it and establish government by decree. The liberals could, however ruefully, only welcome the change. Their salvation lay henceforward in a retreat to Josephanism, an avoidance not only of democracy but even of representative parliamentary government, which seemed to lead to only two results: to general chaos or to the triumph of one or another of the anti-liberal forces.

Schönerer and Lueger, each after his fashion, had succeeded in championing democracy while fighting liberalism. Both composed ideological systems which unified liberalism's enemies. Each in his way utilized aristocratic style, gesture, or pretension to mobilize a mass of followers still hungry for a leadership that based its authority on something older and deeper than the power of rational argument and empirical evidence. Of the two leaders, Schönerer was the more ruthless and the stronger pioneer in unleashing destructive instincts. He breached the walls with his powerful anti-Semitic appeal, but Lueger organized the troops to win the victory and the spoils.

Lueger was both less alienated and more traditional than the frustrated bourgeois-knight of Rosenau. Even in his anti-Semitism Lueger lacked the rancor, conviction, or consistency of Schönerer. While Schönerer exploited the supra-national character of the Jewish community to attack every integrating principle of Austrian social and political life, Lueger relativized anti-Semitism to the attack on liberalism and capitalism. His famous phrase, "Wer Jude ist bestimme ich (Who is a Jew is something I determine)," allowed Lueger to

blunt the explosive and subversive potential of anti-Semitism in the
interests of the monarchy, the Catholic church, and even of the
capitalism he professed to fight. A coalition-builder cannot work
well with principle. Lueger therefore tolerated the most vicious
anti-Semitism among his lieutenants, but, more manipulator and
machine-builder than ideologue, he himself employed it rather than
enjoyed it. Even in the politics of the new key, Lueger adapted for
the age of mass politics—and at the expense of his truculent rival
Schönerer—the ancient Habsburg principle:

> Bella gerant alii,
> Tu, felix Austria, nube. . . .*

He succeeded better in producing an alliance of aristocrats and
democrats, artisans and ecclesiastics, by confining the uses of racist
poison to attacking the liberal foe.

⋟ IV ⋞

AS THE POLITICAL FOUNDATIONS of liberalism became
eroded and its social anticipations belied by events, those committed
to liberal culture began to seek new foundations to save its most
cherished values. Among them was Theodor Herzl (1860–1904). He
sought to realize a liberal utopia for his people, not on the rational-
istic premise of a Schmerling—"Wissen macht frei (Knowledge
liberates)"—but out of creative fancy, on the premise of desire, art,
and the dream: "Wollen macht frei (Desiring liberates)." In Zionism,
Herzl constructed a fitting if ironical monument to the era of liberal
ascendancy and a fitting sequel to the awesome work of creative
destruction which Schönerer and Lueger had begun.

Herzl could offer such powerful leadership to the victims of anti-
Semitism because he embodied in his person the assimilationist ideal.
The very model of the cultivated liberal, he generated his highly
creative approach to the Jewish question not out of immersion in

* "Let others wage war.
You, happy Austria, marry [to prosper]. . . ."

the Jewish tradition but out of his vain efforts to leave it behind. He came to his meta-liberal politics of fantasy not, like Schönerer and Lueger, out of social hostility and political opportunism but out of personal frustration and aesthetic despair. Even Herzl's conception of Zion can be best understood by viewing it as an attempt to solve the liberal problem through a new Jewish state as well as to solve the Jewish problem through a new liberal state. His life experience endowed him with all the values of the *fin-de-siècle* intellectual. It was these which he drew upon to redeem the besieged Jew from the collapsing liberal order. If his response to the task was his own, the materials out of which he framed it were those of the non-Jewish liberal culture, which, like so many upper-middle-class Jews, he had adopted as his own.

That Herzl was born and bred in Budapest did not prevent him from being Viennese to his fingertips. His family belonged to that increasingly prosperous stratum of Jews who, entering the modern entrepreneurial class, adopted German culture and the German language even in a dominantly non-German ethnic region. The faith of the fathers declined as the status of the sons rose. Theodor's paternal grandfather, alone among three brothers, clung to his religion, while his son, Herzl's father, gave up all but its forms. Theodor's mother, Jeanette Diamant, had been given a secular education by her father, a well-to-do cloth merchant. Her brother pursued the swifter course to assimilation by bearing arms in Hungary's revolutionary army in 1848, though his commission could not be sanctioned until the Jews were fully emancipated in 1867.[53] When Theodor was born in 1860, his family was well out of the ghetto: economically established, religiously "enlightened," politically liberal, and culturally German. Their Judaism amounted to little more than what Theodor Gomperz, the assimilated Jewish classicist, liked to call "un pieux souvenir de famille."

Herzl thus grew up in the setting of enlightened Jewry as an educated citizen of the Austro-liberal *Staatsvolk*. His mother, a strong, imaginative woman superior in social status and cultural attainment to her less-educated husband, conveyed to her son a deep enthusiasm for German literature. In his fourteenth year, not long after his bar-mitzvah (his parents preferred to call it his *Konfirmation*), Herzl organized with his schoolfellows a German literary

society called "We," pledged to widening the members' knowledge by writings in which the ideas "must always be clothed in an agreeable form."[54] With the beginnings of Magyar anti-Semitism in his school, young Herzl transferred to the Budapest Evangelical Gymnasium, in which the majority of students were Jewish. Herzl explicitly rejected as a youth the mounting tendency of Hungarian Jews to assimilate into Magyar culture. Reinforced by his mother's strong germanophil influence, by domestic theatricals, and private lessons in French, English, and music, Herzl turned more and more to cosmopolitan German culture, especially to its aesthetic, humanist tradition, as the center of his value system.

How different was this process of acculturation from that of Herzl's father! Herzl senior had realized social mobility through economic activity and religious secularization. By the time he was fifteen, he had completed the four years of German secondary modern school (Normalschule), was apprenticed to a relative in Debreczen, and was well on the way to a business career. His son Theodor at the same age was absorbing in the Gymnasium a general culture with no direct bearing upon any vocational commitment.

Each of our three protagonists developed a commitment to "nobility" and to the aristocratic heritage: Schönerer acquired his aristocratic role by paternal assignment and worked it out in antiliberal rancor. Lueger's flexible relationship to the aristocracy came by deferential association in school and politics; he quested neither to enter nor to destroy the highest class. Herzl's relationship to aristocracy, though likewise sociological in origin, was more intellectual in nature. As ambitious to be "noble" as Schönerer, Herzl's social position and his mother's values both led him to espouse a romantic aristocracy of the spirit as surrogate for an aristocracy of pedigree or patent. In common with many young bourgeois intellectuals, Herzl acquired aesthetic culture as a substitute for rank.* The ladder of the spirit was a social ladder too.

In Austria, where higher culture was so greatly prized as a mark of status by the liberal, urban middle class, the Jews of that class merely shared the prevalent values, holding them perhaps more intensely, because the taint of trade had stained their lives more

* See above, pp. 7, 8, 15, 296–8.

deeply. Herzl observed later in life that the Jews actually seek to escape the commercial existence which has been supposed natural to them: "Most Jewish businessmen allow their sons to study [at the University]. Hence the so-called Judaicization of all educated professions."[55] Assimilation through culture as a second stage in Jewish assimilation was but a special case of the middle-class phaseology of upward mobility, from economic to intellectual vocations. Herzl's parents ran true to the values of their class when they gave their full support to the boy's intention to become a writer, insisting only that he study law at the University to provide an anchor to windward.

Even Herzl's earliest writings, dating from his student years, reveal the strange mixture of values resulting from his ambiguous social position as *haut bourgeois* aristocrat of the spirit. The heroes of his playlets and stories were generally noblemen both by blood and by ethical conviction. Surrounded by the crass dishonesties of a materialistic world, they manifested sangfroid, grace, and generosity in defense of the victims of malevolence or misfortune.[56] Neither self-realization nor mastery of reality, but self-sacrifice and renunciation seem to be central aims of the Herzl hero. Not the bourgeois commitment to law and labor, but the nobiliar spirit of chivalry and honor informs his action. Yet these noble heroes have no social base; they are exceptions in their environment, socially anachronistic and spiritually isolated in an alien world.

Herzl cultivated as a student a public persona thoroughly compatible with his aristocratic heroes. Even in Gymnasium, he had begun to develop the characteristics of a dandy. A schoolmate recalled him as "a dark, slim, always elegantly clothed youth, always good-humored and ever ready for fun and wit, yet mostly superior, ironical, even sarcastic."[57] Both dreamer and cynic, he had strong defenses against the world, and the dandy's lonely way of asserting his superiority over it by using it as mirror. During his university years, his proud personal style became even more pronounced. Arthur Schnitzler, who attended the University of Vienna at the same time, eyed Herzl from a distance, longing to be accepted as a friend, envying his sangfroid, his lofty disdain for an inferior world. Both students belonged to the Akademische Lesehalle, originally a non-political student union which, after a sharp conflict, was taken over by the German nationalists in the same semester when Herzl joined

it. Schnitzler was impressed by Herzl's capacity as speaker in the new key: "I still remember 'the first time I saw you.' You were making a speech, and were being 'sharp'—so sharp! . . . You were smiling ironically. If only I could speak and smile in that way, I thought to myself."[58]

Or again, when young Schnitzler, aspiring to sartorial elegance, appeared in the most modish attire, Herzl "examined my cravat, and —destroyed me. Do you know what you said? 'And I had considered you a—Brummell!' " In the face of Herzl's ironical smile and commanding poise, Schnitzler fell into "that mood of depression one has vis-à-vis people who are outstripping one by twenty paces along the same road." Above all, Schnitzler was overwhelmed by Herzl's confidence in his future as a master of Vienna's most prestigious art, drama: "The new Burgtheater was still being built; we were strolling back and forth in front of the board fence on a late autumn evening. You said, with a modestly conquering look at the walls rising up, 'I'll be in there one day!' "[59]

Schnitzler greatly exaggerated the stability and confidence which lay behind young Herzl's mask of self-possession and savoir-faire. In fact, Herzl feigned a success he longed for but despaired of reaching. His sensitive biographer, Alex Bein, has exposed the painful frustration that Herzl's vaulting ambition—both literary and social—caused him.*

At times Herzl thought that he would find the greatest fulfillment as a member of the high bureaucracy or in the army officer corps. Were it not for the attitude of his parents, he might himself have accepted the baptism necessary for these careers. Even after he had committed himself to the Jewish cause, his longing for quasi-aristocratic status did not leave him. "If there is one thing I should like to be," he confided to his diary in July 1895, "it is a member of the Prussian nobility."[60] Or, again, in negotiating with Count Badeni over assuming the editorship of an official government paper in 1895, he posed as his principal condition that he be permitted to

* "Success does not come," Herzl wrote in his diary in 1883, after his manuscripts had failed to win acceptance in the first-class theaters and journals to which alone he would submit them. "And I truly need success. I thrive only on success." Alex Bein, *Theodor Herzl. Biographie* (Vienna, 1934), p. 70; cf. also pp. 54, 73.

speak to Badeni at any time, "comme un ambassadeur."[61] When in 1891 Herzl received the important post of Paris correspondent of the *Neue Freie Presse*, he not only expressed to his parents satisfaction that he had acquired "a springboard from which he could rise high," but reminded them that the greatest journalists, such as Heinrich Heine and Henri Blowitz of the London *Times*, had occupied the same post "like ambassadors."[62]

In the light of these personal fantasies, Herzl's literary heroes are meaningful enough. As aristocrats thwarted in their noble life of service by a corrupt bourgeois world, they were inverted images of Herzl's personal predicament as a bourgeois whose aspirations to nobiliar status were thwarted by an impermeable aristocratic world.

Herzl's romantic aestheticism, however characteristic of his generation of young bourgeois, achieved great psychological power. It was strengthened by his experience of developing anti-Semitism in the University. In 1880, Herzl had become associated with the *Burschenschaft* Albia, then a strongly nationalistic dueling fraternity. Herzl would seem at this time to have been strongly drawn to German nationalism. The rise of anti-Semitism, however, made this position impossible for him. One of his fraternity brothers in Albia, Hermann Bahr, took the lead in an anti-Semitic student ceremony on the occasion of Wagner's death in 1883, in which police intervened. When Albia supported Bahr, Herzl offered to resign, on personal grounds as a Jew and on political ones as a "freedom-lover [*freiheitsliebender*]." He was mortified to find his resignation brusquely accepted.[63]

The irony of Herzl's rejection by his fellow students was that he himself regarded the Jews as a whole with distaste, as physically and mentally malformed by the ghetto. External intolerance and Jewish inbreeding had, he believed, "restricted [the Jews] physically and mentally. . . . They have been prevented from the improvement of their race. . . . Crossbreeding of the occidental races with the so-called oriental one on the basis of a common state religion, this is the great desirable solution," wrote Herzl in 1882.[64] That he espoused such total racial and religious assimilation made his extrusion as Jew poignant as well as pointless.

Herzl's experience undermined his dandyish assurance. Those who admired his poise and strength, he confided to his diary, "do not know how much misery and pain and despair this 'up and coming

young man' carries concealed behind his [confident] front. Doubt, despair! An elegant doubt, a perfumed despair!"[65]

With this sense of social impotence and individual isolation, Herzl embarked upon his career as a writer. The life of art could serve him in part as a vehicle of success, in part as a means of self-projection. It was fitting that, rather than devoting himself purely to belles lettres, he sought anchorage in journalism. Here he would have outlet for his creative ambitions, acquire an audience, and become an arbiter in the area of culture without the risks of solitude and failure which genius must endure. To Herzl, as aristocrat of the spirit, journalism would give the same secure base for his later Zionist career as the estate of Rosenau gave to Schönerer as knight-redeemer of the German *Volk*.

The strong aestheticizing tendency of the Viennese press suited Herzl's talents. He devoted himself to producing *feuilletons*. This most popular and characteristic genre of Viennese journalism presented the naturalistic description demanded by a positivistic culture, but in a highly personal perspective.* It offered the reader a journalistic equivalent of Walter Pater's idea of the function of art in general: "a corner of life screened through a temperament."

Even as a Gymnasium student, Herzl had identified the dangers that beset the *feuilleton* writer. Yet these dangers—excessive subjectivism, narcissism—were part of his own nature and made him a master of the genre. After nearly a decade of free-lance experience, however, his achievement in it won him an escape. In 1891 Herzl was appointed to one of the most coveted positions in Austrian journalism, that of Paris correspondent of the *Neue Freie Presse*. If the duties of this office left much freedom for the cultivation of the spirit, they also demanded hard, cold reporting of the political and social scene. Paris forced Herzl back into the world of social reality from which he had, since his university days, escaped into aesthetic journalism. "In Paris," said Herzl, "I became involved—at least as an observer—in politics."[66] Four years of close observation of French political and social life transformed Herzl: first from aesthete to concerned liberal, then from liberal to Jew, and finally from Jewish liberal to Zionist crusader.

In Austria in his student days Herzl had learned the pains of anti-

* See above, p. 9.

Semitic contempt and liberalism's weakness. France, he assumed, would be different. Like most Austrian liberals, he went to France as to the font of liberty and civilization, the motherland of the rights of man. His superiors on the *Neue Freie Presse*, sharing Herzl's francophil prejudices, colored their instructions to the new Paris correspondent accordingly: "Our sympathies are mostly on the opportunist-republican side. . . . We gladly allow our correspondent, who must establish and maintain connections, to be a few degrees more francophil [than we]."[67]

Disposed and instructed to report on France as a land of enlightenment, Herzl found instead a nation wracked by a severe general crisis of the liberal order. In the early nineties, France seemed to be dissolving into a chaos worse, if anything, than Austria's. The republic suffered all the social diseases of the time: aristocratic decadence, parliamentary corruption, socialist class warfare, anarchist terror, and anti-Semitic barbarism.

The lofty indifference with which Herzl had viewed political life in Austria was less easy to maintain in a society of which he expected more. His duties as reporter, moreover, obliged him to analyze at close range the components of the social and political scene. Yet even as his interest in politics increased, Herzl continued to maintain a deliberate aesthetic distance from the scene he chronicled. The analytic categories of politics, he felt, were too closely tied to the social entities they described and, like them, lost their connection with each other. "Artisan," "worker," "taxpayer," "citizen": such concepts in the modern world made of the political analyst a "huckster of details,"[68] unable to make the parts cohere in a unified whole. Herzl self-consciously approached French politics with the eye of the artist, convinced that art could penetrate better into the general human condition which underlay the disparate social fragments. "Poetry," he wrote at the close of his first year in Paris, "deals with a higher abstraction than politics: the world. And can he who is able to grasp the world be incapable of comprehending politics?"[69] Deliberately clinging to the aesthetic attitude of the feuilletonist as he moved into the concrete political realm, Herzl established a posture of impartiality toward the groups that composed it—a posture that sharpened his vision while it imposed limits on his commitments.

The phenomena that particularly engaged Herzl's attention in

France during the early nineties were those connected with the erosion of the liberal legal order. Herzl did not, like Schönerer or Lueger, deny legitimacy to that order or welcome its collapse; on the contrary, he watched and reported the process with a kind of horrified fascination. In 1892, Herzl reported on the anarchists, whose assassinations and bombings were sending a shudder of fright through all Europe. He covered the trial of the French terrorist François Ravachol. While Herzl did not justify the terrorist, he both sympathized with and admired him. Herzl arrived at a psychological resolution of the moral problem of political crime: Ravachol "believes in himself and his mission. He has become honest in his crimes." Ravachol "has discovered a new voluptuousness: the voluptuousness of the great idea and of martyrdom."[70] Thus, while Herzl repudiated the anarchist's cause, he showed his affinity for the psychological sources of its power. Yet he roundly condemned the jury for failing to recommend the death penalty. The failure of the jurors showed that popular sovereignty in France had lost its courage and its honor, Herzl believed. Democracy had become hollowed out, and a yearning for monarchy had become its essence. Society "is ripe for a savior once more," one who would take upon his own person all the responsibility which the law-abiding citizens refuse to assume out of fear. This new and stern lord, Herzl prophesied, would arise saying: " 'Hear ye, I shall take all the discomfort [Ungemach] from you. On my head shall fall all the hatred of the oppressed.' "[71] Thus the voluptuousness of terror in the lower-class champion would find its answer for the upper class in a savior-ruler. Republican legality, in this perspective, would yield to a charismatic monarchical order.

Herzl's fears were premature. Ravachol was condemned by a higher court and publicly executed, and Herzl genuinely rejoiced that the republic had found its strength again. Yet the restoration of Herzl's confidence in liberal order was incomplete. He had himself sensed the deep reality of "the voluptuousness of the great idea" in a mass leader and, as a response to it, the temptation to a savior-monarch on the part of supporters of legal order who were touched by the terror of anarchy. Not as Jew but as Austrian liberal, Herzl felt the tremors of French anti-republican politics deep in his own being.

Failure above, explosion below: this was the combination that bore

in ever more forcefully upon Herzl as he went his subsequent rounds as reporter of French developments. Above all, the problem of the masses engaged him. "I stared at the phenomenon of the mass—for a long time without understanding it," Herzl later recalled.[72] It was not the mass claims for social justice that defied his comprehension. Like most young liberals of his background, he championed those claims —at least in principle—against traditional laissez-faire liberalism. He believed that technology was producing a wider distribution of private property. From this bourgeois utopian perspective on the future, Herzl viewed Marxism as regressive, as aiming at the restoration of the primitive system of communal property, while all history moved toward individuation and the enlargement of private rights.[73]

What engaged Herzl in Marxian socialism was not its economic claims but the psychological dynamic that thrust it forward. The Socialist movement in France, the real proletariat on the move, was a form of group primitivism that filled Herzl with awe and fright. He watched the masses defeat the courts: when the Socialist leader Paul Lafargue was sent to prison in 1892, the voters of Lille liberated him by electing him to the chamber of deputies.[74] In the summer of 1893, during an election campaign, Herzl recorded the gripping experience of the masses in a Socialist rally at Lille. On the one hand, Herzl expressed sympathy for the human slaves of the machine who composed the audience. On the other, he described their mass demeanor in a way little calculated to bring cheer to the reader of the *Neue Freie Presse:*

Their murmuring swells, it becomes a dark and ominous [*dumpfe*] flood in this still darkened hall. It runs through me like a physical premonition of their power. Indistinguishable from one another as individuals, together they are like a great beast beginning to stretch its limbs, still only half conscious of its power. Many hundreds of hard heads and twice as many fists. . . . That is only one district in one city in France.[75]

Dangerous in its strength, the mass is also amorphous, fickle, and suggestible. In the election campaign of 1893, Herzl recorded the triumph of magical demagogy over solidity and political sense. Like other Austrian intellectual liberals whose faith in the unenlightened electorate was never strong, Herzl began to see "the people" as "the

mass." He despaired of their wisdom with the question: "And these should be consulted?"[76] In this disillusionment with the democratic process in France we can find the sources of Herzl's later political evaluations as Zionist. In his first great Zionist tract, he wrote in 1896: "The folk is everywhere a great child, which one admittedly can educate. But this education would, even under the most favorable conditions, demand such enormous spans of time that we . . . can help ourselves long before in other fashion."[77]

Herzl's loss of faith in the people can best be understood in relation to its counterpart, his loss of confidence in their rulers. Here the Panama scandal was crucial, a testimony of the bankruptcy of French parliamentarism. Political bribery and peculation was laid bare in the investigation of gross mismanagement of the great Canal project, which had cost thousands of lives as well as millions of francs. Responsibility had broken down; the parliamentarians did not "represent" the people in any moral sense. Corruption undermined the rule of law and unleashed the irrational power of the mass. Finally, the newest enemies of the republic broke through the surface: the anti-Semites. Herzl watched the drama as the whole political system erupted, as the seething inner tensions of French society broke through the august restraints of law and morality.

The reporter Herzl, child of the threatened culture of law, raised central questions for the liberals of Austria. What is the sense of parliamentary government, vulnerable as it is to both corruption and assault? Was it justified for the courts to deliver such a shattering blow to the republic by prosecution of public officials in the Panama scandal? Herzl was here treading dangerous ground, questioning the primacy of law itself and the political wisdom of applying it when the republic and society were endangered thereby. Herzl concluded his survey of the year 1892 with an apocalyptic assessment of France's direction: "Whoever saw with his own eyes the last sessions of the Chamber had a vision of the Convention [of 1792]. Follies and crimes repeat themselves, like mankind itself. Persistently, memories rise again. Thus it was a hundred years ago, and the bloody year ensued. Deathknells sound, 'Ninety-three!' "[78] At her parliamentary heart, the motherland of liberalism was sick. For an Austrian intellectual, it meant more than just a new political experience; it was a shattering of confidence in the viability of

political liberalism, for it was now breaking down even on its native ground, France.

In this broad setting of a crisis of liberalism in the early nineties, the problem of anti-Semitism arose to obtrude itself insistently upon Herzl's consciousness. Somehow, there was no attack upon the republic in which anti-Semitism did not play its part. Édouard Drumont's *La France juive* (1885) held international Jewry responsible for the decline of France and called for the retraction of emancipation and the expropriation of Jewish capital. In 1894 Drumont floated his influential periodical, *Libre Parole*, to serve as a base for unremitting attack against the Jews and their defenders. Again the irrational political style attracted Herzl: "I owe Drumont much for my present freedom of conception," he wrote in his diary just after he moved to Zionism in 1895, "because he is an artist."[79] And an artist in politics, it will be recalled, meant to Herzl one who could free himself from the limitations of fragmentation inherent in the categories of positivistic social analysis.

Alex Bein has traced Herzl's deepening concern with the Jewish question in France to its climax in the condemnation of Captain Dreyfus. Through one episode after another—an anti-Semitic play, an officer's death in a duel in defense of his honor as a Jew, anti-Semitic demonstrations, libel trials, the Panama scandal—Herzl reported, reflected, and became ever more deeply engaged. At first, as a good assimilationist, he saw the Jewish problem as peripheral to the social question. The Jewish problem, being an aspect of the problems of modern society, could only be solved with the larger ones. In 1893, he concluded that the Jews, "pressed against the wall, will have no other alternative than Socialism."[80] Herzl wrote not in affirmation of such a solution but in despair of any other.

Even as experience consumed his hopes, his central concern still remained to save gentile society, in which case the Jewish problem would take care of itself. Thus he was moved to advise influential Austrians on how to forestall the revolt of the masses that was exploding in France. He urged the *Neue Freie Presse* editors to espouse universal suffrage before the democratic populace should turn against liberalism out of indignation at its restriction of the franchise. He recommended positive social action, too. In a draft memorial to Baron Chlumecky, an influential liberal leader, Herzl proposed the

establishment of a state labor service to remove unemployed workers, potential urban revolutionaries, from the cities and put them to constructive work in the countryside. "Internal colonization" might provide a *via media* between socialism and laissez faire. This approach to social reform was to appear in Herzl's later plans for a Jewish state. In 1893, however, he was still concerned, not with the Jews, but with helping Austrian liberalism to overcome its social limitations.[81]

It was too late, and Herzl soon realized it. From France, Herzl watched Lueger and the anti-Semites gain in strength in every Austrian election. His concerns for the fate of liberal order in France and Austria converged. As they did so, the "Jewish question" was transformed in his thinking from a symptom of European social malaise—a lightning rod for the discharge of gentile frustrations—to a life-and-death question for the victims.

How could the Jews be saved? The question grew logically from his years of observation, and yet it was wholly new, radically dissociated from his previous roles as artist, reporter, or liberal. Herzl's final commitment to it had all the character of a conversion experience.

A strong personal ingredient, more accessible to the psychologist than to the historian, unquestionably played a crucial part in his espousal of the redeemer's role. Since 1890, Herzl had suffered a series of personal traumas. His marriage to a woman of higher social standing than himself had proved unsatisfactory from the start, and he spent much time away from his wife and children. Although he had not, like Karl Lueger, remained single, Herzl clearly adored his handsome, strong-willed mother as much as Lueger did his. In the two men's relations to their sisters, too, there were similarities. Lueger, remaining a bachelor, devoted himself to the care of his spinster sisters in obedience to his mother's will. Although Herzl's sister, Pauline, died when he was eighteen, he remained almost pathologically loyal to her memory. Every year he made a pilgrimage to her grave in Budapest on the anniversary of her death.[82] His persistent fixation upon the women of his family of origin seems to have made the cultivation of new love of women difficult for Herzl. His wife, Julia, was the principal victim. If Herzl's few remaining letters to her sometimes show affection, they are solicitous rather than loving. More secure in a paternal than a lover's role, he

often addressed his wife as "My dear child," and signed his letters, "Your faithful Papa, Theodor."[83]

A second personal ingredient in Herzl's conversion was a crisis in his friendships. Here too the early nineties took harsh toll, for he lost his two best friends. They represented two extreme types of the Jewish intelligentsia. The first, Heinrich Kana, a sensitive person incapable of meeting his own standards of creative achievement, committed suicide. The second, a vigorous journalist, lost his life while engaged in founding a colony for Russian Jews in the tropics.[84] The two men seemed to flank Herzl's position at the time; he saw both fates as Jewish, both as wasted, senseless.

Disappointed in marriage, bereft of his dearest friends, Herzl's emotional life in the Paris years was thus more than usually impoverished. It may help to explain his readiness to abandon his aloofness from the social world, to identify himself heart and soul with a wider cause. The Jewish body social became a collective love object to him as he returned to a fostering mother he had never adequately recognized.* But why did he not embrace instead the proletarian or the liberal causes, both of which engaged his attention in his early years in France? The fact is that they had no such deep referent to his own origins as did Judaism. In the 1890's, as in his student years, when anti-Semitism had first struck him a hard blow, his culturally induced resistance to a Jewish self-identification broke down. "In fact," he wrote in 1895 of his relationship to the Jewish problem, "I have always returned to it when it was possible for me to consider the general aspects of my personal experiences, joys and sorrows."[85]

In the traumatic years in France, the hollowing out of his personal life slowly converged with the experience of liberalism's crisis and the powerful thrust of anti-Semitism to precipitate what can only be called Herzl's conversion to the Jewish cause. The urbane assimilationist, by a free act of filial re-identification, became the savior of the suffering chosen people. He solved his own problems by tackling theirs and thus completed his transition from artist to politician.

* Norman O. Brown, in *Love's Body* (New York, 1966), opens a radically new understanding of community identification as mother substitution which clarifies Herzl's development. See esp. pp. 32–36.

Several features of Herzl's attitude as he approached his moment of conversion betray his deep kinship with Schönerer and Lueger: his rejection of rational politics, and his commitment to a noble, aristocratic leadership style with a strong taste for the grand gesture. Another tie linking him to his enemies, even though he drew different conclusions from it, was his distaste for the Jews.

By 1893, Herzl had come to reject the whole approach to solving the Jewish problem through reliance on rational persuasion. He would have nothing to do with the Society for Defense against Anti-Semitism founded by eminent German and Austrian intellectuals. In refusing his collaboration to the society's newspaper, Herzl made clear his conviction that reasoned argument was hopeless: "The time has long since passed when it was possible to accomplish anything by polite and moderate means." It seemed impossible for the Jews "to rid themselves of the characteristics for which they are justly rebuked . . . a long, difficult, hopeless road." He saw only two effective possibilities: one palliative, one therapeutic. The best palliative against the symptoms of anti-Semitism would be a resort to "brutal force," in the form of personal duels with the maligners of the Jews.[86] Herzl, then as ever, placed the *honor* of the Jews at the center of the problem. It was only fitting he should seek to vindicate his romantic feudal values by the romantic feudal method of personal combat. "A half-dozen duels," he wrote to the society, "would very much raise the social position of the Jews." In one of the more vaulting heroic fantasies which he confided to his diary (the passage was excised from the published version), Herzl contemplated taking the field himself as knightly champion of Jewish honor. He would challenge the leaders of Austrian anti-Semitism—Schönerer, Lueger, or Prince Alois Liechtenstein—to a duel. If he should lose his life in the encounter, he would leave a letter signalizing his death as martyr-victim of "the world's most unjust movement." If he should win, Herzl envisaged —perhaps on the basis of the trials he had covered in France—a stirring role in the courtroom in which he would be prosecuted for the death of his adversary. After extolling the personal honor of his victim, Herzl would give a great oration against anti-Semitism. The court, compelled to respect his nobility, would proclaim his innocence, the Jews would wish to send him into the Reichsrat as their

representative, but Herzl would nobly refuse "because I could not go to the House of Representatives over the body of a human being."[87] The palliative for anti-Semitism thus took the form of an affair of honor.

The other, therapeutic approach to anti-Semitism remained assimilationist, but as he lost confidence in the power of liberalism Herzl regressed in his assimilationism to a more archaic, Christian vision: mass conversion. Even here, fantasies of personal grandeur rose in Herzl's mind. In 1893, he dreamed of striking an epoch-making agreement with the Pope. With the help of the Austrian princes of the Church, Herzl would gain access to the Holy Father, saying:

If you help us against the anti-Semites, I shall lead a great movement for the free and decent conversion of the Jews to Christianity. . . . In the clear light of day, at high noon, in solemn procession [and] to the tolling of bells, the conversion would take place in St. Stephen's Church. With a proud countenance, [the Jews would enter the church]—not ashamed like the individual convert heretofore . . . whose conversion has appeared either as cowardice or climbing.[88]

The vision was still assimilationist, but hardly liberal. Theatrical, irrational, it bore the stamp of the Herzl who had the secret wish to be a Prussian aristocrat, of the Herzl who learned from the anarchist Ravachol "the voluptuousness of the great idea," or from the anti-Semite Drumont the power of political "artistry."

Assimilation of the Jews through the Church of Rome—a strange proposal for a secular liberal! The *beau geste* of the duel likewise betrayed an anachronistic quality: to strike a blow not for modern freedom but for feudal honor. Assimilationist objectives took on archaistic, pre-bourgeois forms as Herzl groped for post-rationalist solutions to the future of the Jews. Still isolated from the Jews themselves, rejecting some as *Geldjuden* and others as *Ghettojuden*, some as too-optimistic rationalists and others as too-primitive believers, Herzl thus began to bring together for the Jews the elements of politics in the new key: an aristocratic stance, the prophetic rejection of liberalism, the dramatic gesture, and the commitment to the will as the key to the transformation of social reality.

Herzl's personal fantasies had not yet taken the shape of a comprehensive program. His own withdrawal from the gentile world was still incomplete. A succession of political events of varying magnitude completed in 1895 the psychological revolution that transformed Herzl from a Viennese assimilationist into a leader of the new exodus. The condemnation of Alfred Dreyfus on December 22, 1894, was the first of these. Herzl's dispatches on Dreyfus's trial and degradation reflect the reporter's profound state of tension. At a time when Dreyfus's guilt was accepted by almost all, Herzl doubted it, despite the lack of evidence. Herzl argued out of his own psychology, the psychology of the assimilated Jew with aristocratic values who had succeeded in the gentile world. He told the Italian military attaché, Colonel Alessandro Panizzardi, "A Jew who has opened a career avenue of honor as a general staff officer cannot commit such a crime. . . . As a consequence of their long civic dishonor, Jews have an often pathological desire for honor; and a Jewish officer is in this respect a Jew raised to the nth power."[89] Even if Dreyfus were guilty, the cry of the mob which called for his blood transcended the question of treason: "À mort! À mort les Juifs!" Four years later, Herzl reflected that this miscarriage of republican justice "contained the wish of the enormous majority in France to damn a Jew, and, in this one Jew, all Jews." This happened not in Russia, nor even in Austria, but in France, "in republican, modern, civilized France, one hundred years after the Declaration of the Rights of Man." Herzl drew his conclusion: "The edict of the Great Revolution has been revoked."[90]

If the Dreyfus affair were not enough, a few crowded days in May 1895 sealed Herzl's abandonment of any assimilationist approach, whether rational or romantic, forever. On May 25 and 27, he witnessed interpellations in the French chamber directed toward preventing Jewish "infiltration" into France—the equivalent of Schönerer's proposed Jewish-exclusion legislation in Austria in 1887–88. Two days later, Karl Lueger won a majority in the Vienna city council for the first time. Though he would not yet accept the mayoralty, it was the first of the series of elections, each producing an increased majority for the Christian Socials, which finally made the emperor and his cabinet give way to the anti-Semitic tide in 1897 and ratify Lueger as mayor. For Herzl, the last mooring snapped.

⇝ V ⇜

ONE BY ONE the ties that had bound Herzl to "normal" gentile culture had perilously frayed: marriage, friendship, the French Republic of tolerance, the dream of Jewish dignity through assimilation, now Austrian liberalism in its Viennese stronghold. After receiving the news of the Vienna election, Herzl went to a performance of *Tannhäuser*. No fanatical Wagnerite, or even an opera-goer beyond the Viennese norm, Herzl was this time electrified by *Tannhäuser*. He came home exalted and sat down to sketch out in a fever of enthusiasm akin to possession his dream of the Jewish secession from Europe. That it was Wagner who should have triggered the release of Herzl's intellectual energies into a torrent of creation: how ironic, yet how psychologically appropriate! The student demonstration in Wagner's honor shortly after his death in 1883 had occasioned Herzl's first traumatic encounter with the limits of gentile tolerance and had forced him to choose between the honor of fraternity membership and his honor as a Jew. Since then, Herzl had led an un-Jewish life as an educated, enlightened, and refined European, relying on the "progress of gentile society." Only recently had he turned in fantasy to ancient Christian authority for a solution to the Jewish problem. Could Tannhäuser speak to Herzl?—Tannhäuser, the romantic pilgrim who, having sought in vain the help of the Pope in his crisis of Christian conscience, reaffirmed his own integrity by affirming the profane love which he had tried in vain to shake off. Could Herzl have felt in Tannhäuser's morally liberating return to the grotto a parallel to his own return to the ghetto? We cannot know. In any event, Wagner must have been to Herzl, as to so many of his generation, the vindicator of the heart against the head, the *Volk* against the mass, the revolt of the young and vital against the old and ossified. In that spirit—but armed with the weapons of modern rationality as well as with the intuitions of art— Herzl now plunged toward his break with the liberal world and the secession of the Jews from Europe. The Zionist movement would be a kind of *Gesamtkunstwerk* of the new politics. Herzl sensed this when he said, "Moses' exodus would compare [to mine] like a Shrove Tuesday *Singspiel* of Hans Sachs to a Wagnerian opera."[91]

Herzl devoted himself now to the glory of dreaming for the Jews

as he had earlier dreamed of glory for himself. Consciously and explicitly he affirmed dream, waking fantasy, the unconscious, and art as the sources of the power to overcome and shape a refractory social reality. "Dream is not so different from deed as many believe," he wrote. "All activity of men begins as dream and later becomes dream once more."[92] The task of politics was to present a dream in such a form as to touch the sub-rational wellsprings of human desire and will. Heretofore the Jews had sought solutions in the outer world, where none could be found. Now they must be directed toward an inner, psychological reality. "No one thought of looking for the promised land where it is, and yet it lies so nearby. There it is: inside ourselves! . . . The promised land is wherever we carry it!"[93]

The driving force to create a Jewish state, Herzl said, was the need to have one. Desire and will alone stood between dream and reality. "The Jews who wish it will have their state and they will earn it," he wrote in 1895. At the head of his utopian novel, *Altneuland* (*Old-New Land*) (1900), Herzl affixed the legend, "If you wish it, it is no fairy tale." In the epilogue he warned, "If you don't wish it, it is a fairy tale and will remain one."[94]

Herzl's radical subjectivism separated him clearly from the cautious liberal realists, Jewish or non-Jewish, around him, and linked him to his mortal enemies. His commitment as aesthete to the power of illusion affected his style as political leader. Like Goethe's Prometheus, Herzl would shape a new race of men in defiance of reality and out of his power as an artistic creator. In his eruptive conversion experience, Herzl rejected a positivistic conception of historical progress in favor of sheer psychic energy as the motive force in history. In a passage defining both the weight of social reality and the analogous gravity of political style that made the liberals powerless to alter it, Herzl set forth the dynamic of his politics of fantasy: "Great things need no firm foundation. An apple must be placed on the table to keep it from falling. The earth hovers in the air. Thus I can perhaps found and secure the Jewish state without any firm anchorage. The secret lies in movement. Hence I believe that somewhere a guidable aircraft will be discovered. Gravity overcome through movement."[95] Zionism would accordingly be not a party, said Herzl, not a part of a defined whole, but a *movement* —"the Jewish people on the move [*unterwegs*]."[96]

The practical corollary of this dynamic conception of politics was Herzl's determination to appeal not to the minds but to the hearts of the Jews. Symbols must be devised to awaken the energies that would break the force of social gravity which held the Jews in thrall. To the sober and calculating philanthropist Baron Hirsch, Herzl held up the model of German unification as proof of the primacy of the irrational in politics. "Believe me, the politics of a whole people—particularly if it is scattered over all the world—can only be made with imponderables that hover high in the air. Do you know out of what the German Empire arose? Out of dreams, songs, fantasies and black-red-gold ribbons. . . . Bismarck merely shook the tree that fantasies had planted."[97] The very survival of the Jews was a tribute to the power of fantasy, namely, their religion, a fantasy which had sustained them for two thousand years. Now they must have a new, modern symbol system—a state, a social order of their own, above all a flag. "With a flag one can lead men wherever one wants, even into the promised land." A flag is "about the only thing for which men are prepared to die in masses if one trains them to it."[98]

The will to die: one of the "imponderables" which Herzl saw as essential to his dynamic politics. Here again he invoked Bismarck as master and model. For Bismarck knew what to do with those "stirrings, mysterious and undeniable like life itself, which rose out of the unfathomable depths of the folk-soul in response to the dream" of unity in 1848. Herzl separated the psychological dynamic of politics clearly from its rational goals. So, in his view, did Bismarck. Bismarck understood that people and princes could not be moved to small sacrifices for the objects of all the songs and speeches. Therefore he imposed *great* sacrifice upon them, forced them into wars. The German people, who had fallen to sleep and become sluggish in peace, joyfully rushed toward unification in war.[99]

Not the content of the goal, then, but the form of the action was decisive in Herzl's concept of a political movement. His idea of the nation reflected a similar psychological abstractionism. There was nothing Jewish about it. *Every* nation, he concluded, was equally "beautiful." What made it so was not its distinctive virtues but the psychological virtues which *all* nations evoked in their people. For every nation "is composed of all the best [qualities] of the individuals:

loyalty, enthusiasm, the joy of sacrifice and the readiness to die for an idea."[100] The nation was but the vehicle for the organization of group energy to overcome social inertia. The chivalric and sacrificial virtues which nationhood called forth in a society were the same as those which Herzl, in his earlier dreams of glory, had valued in himself as an individual.

His concept of nationhood helped Herzl to transform his long-standing fear of the masses into hope. Heretofore, as a liberal and a Jew, he had faced them—anarchists, socialists, nationalists, anti-Semites—as threats to the liberal order. Then he was concerned with pacifying or deflecting the gentile masses, now he aimed at activating the Jewish ones. Perhaps because he had so long observed the masses, as he had said, "without grasping them," his self-conscious sense of manipulating them when he turned to the Jews became the more acute. The sophisticated intellectual élitist became a kind of populist as he shifted to Jewish politics. Yet he kept his reserve and his distance from the mass he led. What Lueger did by instinct, Herzl achieved by design.

The masses had two functions in Herzl's initial strategy of Zionism. On the one hand, they would provide the shock troops of exodus and the settlers in the promised land. On the other, they could be used as a club to compel the rich European Jews to support the Zionist solution. The ghetto Jew as carrier of the new nation, the ghetto Jew as weapon: of the first of these mobilizations, Herzl spoke publicly; the second, no less integral to the new key in politics, he confided to his diary.

In his first and greatest political pamphlet, *Der Judenstaat (The Jewish State)* (1896), Herzl candidly explored the best methods for directing the masses. Criticizing the attempts of Jewish philanthropic colonizers to attract pioneers by appealing to personal self-interest and by financial inducements, the irreligious Herzl urged instead that the Jews follow the models of Mecca and Lourdes. A mass can best be led if one sets a goal or center of aspiration for its "deepest need to believe." In the Jewish case, the desire to harness and guide was the age-old wish for "the free homeland."[101] While Herzl tapped the archaic religious aspiration, however, he did not, as a modern secular leader, fully rely upon it. At first he did not even wish to locate the Jewish homeland in Palestine—though, as he told the Rothschilds,

"the name alone would be a program . . . strongly attractive to the lower masses." Most Jews, however, were "no longer orientals, and had accustomed themselves to other climes [*andere Himmels-striche*]."[102]

Therefore Herzl added essentially modern attractions to the allurements of ancient hopes in his political *Gesamtkunstwerk*. He envisaged the seven-hour day as the principal magnet for the modern European Jew. Zion would outbid the Socialist International by one hour of leisure! Even the flag of the Jewish state was to reflect the value which Herzl attached to the drawing power of modern social justice. On a white field signifying the new life of purity, seven gold stars would represent the seven golden hours of our working day. "For under the sign of work the Jews go into the promised land." Of the star of David or any other Jewish symbol, Herzl made no mention.*[103]

In his appeal to the masses, Herzl combined archaic and futuristic elements in the same way as Schönerer and Lueger before him. All three leaders espoused the cause of social justice and made it the center of their critique of liberalism's failures. All three linked this modern aspiration to an archaic communitarian tradition: Schönerer to the Germanic tribes, Lueger to the medieval Catholic social order, Herzl to the pre-diaspora Kingdom of Israel. All three connected "forward" and "backward," memory and hope, in their ideologies, and thus outflanked the unsatisfying present for followers who were victims of industrial capitalism before being integrated into it: artisans and greengrocers, hucksters and ghetto-dwellers.

Even though Herzl was to turn to the lower-class Jews as the major resource as well as the object of his redemptive mission, he first sought support from the wealthy and influential. For his own cause among the Jews, he drew the same conclusion as for the cause of the Jews among the Gentiles, namely, that "in the present state of the world . . . might goes before right."[104] To enlist Jewry's leading philanthropists—Baron Hirsch and the Rothschilds—seemed to Herzl the logical first step to solve his problem of power in 1895—

* The actual flag adopted by the Zionist movement was a white flag with two blue stripes and a single star of David between them—an improvisation out of the ancient prayer shawl, the tallith.

96. Again the vision of a Prussian success danced before his eyes. "I went to Hirsch, I am going to Rothschild, like Moltke from Denmark to Prussia."[105] He hoped to bring Hirsch "and all the big Jews under one hat," and to put them on the administrative council of the Jewish Society, the institution which was to organize his exodus politically. On the one hand, Herzl honestly felt that he was "bringing the Rothschilds and the great Jews their historical mission"; on the other, if they refused cooperation, he was determined to smash them. In 1895 and 1896, fantasies of violent reprisal oscillated wildly with hope in his fevered soul. If in practice Herzl never resorted to the violence implicit in the politics in a new key, he clearly revealed its temptation for him in his accounts of his relations with the Rothschilds, a strange mixture of blandishment and blackmail. He would tell the family council, "*J'accueillerai toutes les bonnes volontés—we must be united—et écraserai les mauvaises!*" Should they prove among the *mauvaises*, Herzl threatened to unleash "storms of rage" and street disturbances. He either would save the Rothschild fortune if they collaborated—"or the opposite."[106] If Hirsch should betray him by publishing one of his confidential letters, Herzl said, "I would shatter him for it, unleash fanaticism against him, and demolish him in a pamphlet (I shall tell him that in due course)."[107] Even in *Der Judenstaat*, where Herzl expressed his political passions circumspectly, he sternly warned the rich Jews who might "attempt a fight against the Jewish movement" that "We shall conduct such a fight, like every other that is imposed upon us, with ruthless hardness."*

Beyond the threats of unleashing mass resentment against his élite antagonists, Herzl in the period of his conversion shared one more political characteristic with the anti-Semitic leaders: his belief in the power-potential of induced crisis. In 1893, he had rejected the rational, "instructional" approach of the journal of the Society for

* In this case, the ruthless measure Herzl specified was the organization of the Jewish middle class in a joint bank. The threat was reminiscent of the Pereires in organizing the Crédit mobilier against the Rothschilds, though there is no evidence of Herzl's awareness of that episode. Alternately, he would take up a public subscription from Jews and anti-Semites to fight Jewish plutocracy. Cf. Theodor Herzl, *Der Judenstaat* (9th ed., Vienna, 1933), p. 64.

Defense against Anti-Semitism with the argument that a journal could be effective only if it contained "the threat of deeds."[108] By 1895 he had convinced himself that "a man who invents a terrible explosive does more for peace than a thousand mild apostles."[109] When a friend objected that the attempt to organize the Jews for an exodus might provoke new persecutions, Herzl felt that they would be his explosive: "Precisely this concern shows how right I am on the basic points. For if I can succeed in making the question acute, then that is the only effective means of power which I dispose of—albeit a terrible one."[110] Thus in loosening the shackles that bound the Jews to Europe, the very mass irrationalities that he had only recently feared from others appeared not only possible but sometimes even promising to Herzl for his own cause. Properly inspired, the most backward Jews would serve as an instrument to break the resistance of their "enlightened" upper-class brethren, even if by the indirect route of provoking pogroms. Seldom did Herzl think such thoughts, but, in the passion of his new-found mission of saving the Jews from crumbling liberal Europe, they ceased to frighten him when they occurred.

The leaders of assimilated Jewry who would have made his task comparatively easy had they collaborated, resented and resisted more than any Gentile the challenge which Herzl offered to the liberal-Jewish dream. Naturally they became the targets of his aggressive fantasies. As all our pioneers of politics in the new key were rebels against the liberal matrix whence they sprang, so each had as his particular foe those liberals closest to the cause he wished to purge of compromise. For Schönerer, the German national liberals were the most treasonous of Germans and the most dangerous of liberals; for Lueger, the pusillanimous but well-entrenched liberal Catholics offered the strongest obstacle to Catholic-social renewal. So too for Herzl: the "enlightened" liberal Jews were on the one hand part of his own intellectual and social class and on the other blindly refused to recognize the nature of their own problem as Jews. Liberalism: *voilà l'ennemi!* Its continued vitality among the leadership group was the greatest problem for the new politics in each of the three communities whose masses the new leaders wished to organize. As Schönerer's first task was to break the German liberals, and Lueger's to break the Catholic

liberals, so Herzl fought the Jewish ones. But in each case, the new radicals sought to outflank liberal leaders with an authority figure that was *not* Austrian but recognized within their respective communities. Schönerer sought the support of Bismarck. Lueger solicited the aid of the pope. Herzl went to Hirsch and the Paris Rothschilds. All three failed. All three organized their communities not only in despite of the liberals within them but also without the support of the highest external authorities to whom they appealed.

What distinguished Herzl from his antagonists was his respect for and reliance on the highest authorities outside his own community. Partly this reliance was strategic. To make the Jewish question a national one implied solving it on an international plane.[111] The Herzl who even as journalist, it will be remembered, had wished to be treated by Minister Badeni "comme un ambassadeur" now behaved like one. He tactfully but persistently exploited every connection to win over the rulers of Europe, if possible through personal conversations. He made approaches to the czar, the pope, the German emperor, and the sultan—in the last two instances, not without success.[112]

His relations with princes, like Lueger's with the Austrian aristocracy and the Vatican, gave Herzl one arm of the pincers around his upper-middle-class assimilationist enemies; the ghetto and eastern European Jewry provided the other. In a diary entry on April 21, 1896, the day of the death of Baron Hirsch, whom Herzl admired despite their differences, Herzl articulated a significant shift in his own strategy: "Curious day. Hirsch dies and I establish contact with princes. A new book in Jewish affairs begins."[113] Next day, Herzl recorded the other side of the coin, his superior prospects of success with the poor masses. Hirsch failed with the poor because he was rich. "I tackle the same problem differently, and I believe better, more powerfully, because I go at it not with money but ideas."[114] Philanthropy must yield now to politics, minuscule colonizing efforts to independent statehood for the Jews. "The Jews have lost Hirsch," wrote Herzl, "but they have me."[115] The king was dead. Long live the king.

If Herzl did not become a king, he developed to regal dimensions the cool, aristocratic manner which had characterized him even as a youth. His disdainful sense of superiority, coupled as it was with

the most meticulous regard for all the theatrical dimensions of public effectiveness in a leader, mesmerized his sympathizers and outraged his opponents. He who felt himself a Bismarck of the Jews appeared to his followers as a King David. As his modern vision of a nation-state fulfilled an ancient religious dream, so his masterful western European manner evoked and reinforced the archetype of King David or Moses in the minds of eastern ghetto Jews.

At the first Zionist Congress in Basel (August 1897), Herzl's fanatical attentiveness to upper-class forms produced the maximum lower-class response. He changed the site of the congress at the last moment to Basel's elegant Municipal Casino because the beer hall which had been reserved for it did not afford a sufficiently imposing setting. He insisted that all delegates appear at the opening session in full dress. "The people," he told Max Nordau, whom he forced to change clothes, "should become accustomed to seeing in this congress the highest and most solemn occasion."[116]

His careful attention to the modern *mise en scène* reached its climax when, after an invocation and rambling reminiscence by the aged patriarchal president from the Jassy ghetto, Herzl slowly rose and walked to the tribune. The Zionist writer Ben Ami recalled the effect of his poised presence:

That is no longer the elegant Dr. Herzl of Vienna, it is a royal descendant of David arisen from the grave who appears before us in the grandeur and beauty with which legend has surrounded him. Everyone is gripped as if a historical miracle had occurred. And indeed, was it not a miracle that took place here? For fifteen minutes [the hall] shook with the enthusiastic cries of stormy rejoicing, applause and the waving of pennants. The two-thousand-year dream of our people seemed to be approaching fulfillment; it was as if the Messiah, son of David, stood before us. A powerful desire seized me to shout through this tempestuous sea of joy: "Yechi Hamelech! Long live the King."[117]

Was this truly "no longer the elegant Dr. Herzl of Vienna"? On the contrary: he was still the dandy Schnitzler had envyingly admired, appearing now as charismatic politician, in the line of Alcibiades and Caesar, Disraeli and Lassalle. The very mixture of contempt and genuine sympathy which Herzl felt for the backward Jew contributed to his appeal. The mass was his lover and his mirror.

In the synagogue of Sofia, where he committed the gaffe of turning his back to the altar, a member of the congregation called out, "You can stand with your back to the altar; you are holier than the Torah!" At the Sofia station, he was greeted with cries of "Führer," "Heil," and "Lord Israel."[118] Even the most cultivated Europeanized Jews, whether friend or foe, such as Freud, Stefan Zweig, and Karl Kraus, felt the impact of his lofty—almost hieratic—regal persona.[119] "King of the Jews": the epithet, used by scoffers[120] as well as enthusiasts, revealed a basic truth about Herzl's political efficacy and the archaizing nature of modern mass politics. Again Hofmannsthal's formula for politics comes to mind: "Politics is magic. He who knows how to summon the forces from the deep, him will they follow."[121]

Herzl's charismatic power as king-messiah *redivivus* should not lead us to neglect the modern middle-class elements which permeated his aims and methods. The Jewish state as he conceived it in his pamphlet of the same name had no trace of Jewish character. There would be no common language—certainly not Hebrew. "After all, we can't speak Hebrew with each other. Who among us knows enough Hebrew to ask for a railway ticket in that language? That word doesn't exist."[122] The new state would have a "linguistic federalism," in which each would speak the language he still loves, that of "our fatherlands, from which we were forced out." Only Yiddish, "the crippled and repressed ghetto language," "the purloined tongue of prisoners," would be abandoned. The hallmark of indignity must not survive in a cultivated cosmopolitan's paradise.[123] Religion, too, would be kept in its place. "Theocratic archaisms [*Velleitäten*]" of the clergy would not arise. "Faith holds us together, science makes us free." The clergy, while honored, would be confined to their temples like the army to the barracks, lest they cause trouble to a state committed to free thought.[124]

In all its features, Herzl's promised land was in fact not a Jewish utopia but a liberal one. The dreams of assimilation which could not be realized in Europe would be realized in Zion, where Jews would have the nobility and honor of which Herzl had dreamed since his youth. "Dass aus Judenjungen junge Juden werden (That Jew-boys might become young Jews)": thus succinctly Herzl stated the aim and function of a Jewish national home. It would make possible the overcoming of the so-called Jewish traits which cen-

turies of repression had called forth in the Jews. The new society would be stratified, not egalitarian. But through labor brigades for the young (*Arbeitertruppen*) organized on "altogether military" lines, then through advancement, pensions, and attractive living and working conditions, the common workers could be reared to dignity by means of discipline and justice. There would be "friendly, light, healthy schools" for the children, continuing education for the workers, labor service for the young.[125] Law, labor, and education— all fundamental to the European liberal outlook—would, with decaying Europe left behind, reappear without the limitations which had excluded or extruded the Jews from their blessings. Herzl's Zion reincarnated the culture of modern liberal Europe.

Herzl's persistent loyalty to contemporary Austro-liberalism was reflected too in the elements of anglophilism which permeated his program. The new Jews would be sportsmen and gentlemen. "The youth (even the poor ones) will get English games: cricket, tennis, etc." At least fleetingly, Herzl, like Hofmannsthal and his friends, considered emulating the English boarding school—"*lycées* in the mountains."[126] To the two institutions which would accomplish the exodus and set up the Jewish state Herzl gave English names. The Society of Jews, the corporation to lead the Jews politically, would organize the movement, represent the Jews as a proto-government, and ultimately serve as the state-founding authority. "The Society of Jews is the new Moses of the Jews." It was to be centered in England and composed of leading English Jews, a collective Anglo-Moses![127] An analogous institution in the economic sphere, the Jewish Company, was to serve as business agent and financial administrator for the emigrants. Herzl conceived it "partly on the model of the great territorial [expansion] companies—a Jewish Chartered Company." Its central office was to be in London, "because the Company would have to stand under the protection of a power that is not at this time anti-Semitic."[128] For the future Jewish social order, something like the British ideal of a politically effective and responsible aristocracy remained with him. "Politics must be made from above" remained his principle, but the class that made it must be permeable, not closed, like the Austrian aristocracy. "A powerful draught from above" must be cultivated in the new state. "Every great human being will be able to become an aristocrat among us," Herzl wrote.[129]

Hence he thought of his state as "an aristocratic republic," with many elements drawn from the same model which, perhaps unknown to Herzl, inspired the early English Whigs: Venice.[130]

In England no less than in Austria, rejection by most Jewish leaders forced Herzl to turn to the masses. As he left one of his unsuccessful meetings with the leaders, he turned to a friend and said, "Organize the East End for me."[131] There Herzl was enthusiastically received in 1896. Although he preferred to organize an "aristocratic republic," the inadequate support from even English Jewish leaders compelled him to the course of a "democratic monarchy." Herzl knew that the abdication of the élite made his own power greater, enhanced his messianic role. He saw the love of the ghetto Jews as based on ignorance of his nature, yet endowing him with an aura, a nimbus decisive for his mission. From a workers' podium in London,

I saw and listened as my legend grew. The people are sentimental; the masses do not see clearly. A light haze is beginning to well up around me which will perhaps be the cloud on which I shall go forward. It is perhaps the most interesting thing that I record in these diaries: how my legend grows. . . . I stoutly resolved to be even more worthy of their [the masses'] trust and love.[132]

As if to prove that he wished to admit even the lowliest Jew into the aristocracy to which throughout his life he had aspired, first for his person, then for his race, Herzl suggested that the East End Jews call their Zionist organization "The Knights of Palestine."[133] The Jewish ghetto-dwellers were to organize themselves for their assimilationist paradise by assuming collectively the romantic-feudal role of lay-Christian knighthood. A more vivid instance of the role of aristocratic fantasy in the birth of post-liberal mass politics would be difficult to find.

Like the Knight of Rosenau and *der schöne Karl*, Herzl led his followers out of the collapsing liberal world by tapping the well-springs of a deferential past to satisfy the yearnings for a communitarian future. That he should have espoused the politics of the new key in order to save the Jews from its consequences in the gentile world does not destroy Herzl's affinity with his antagonists. All in their respective fashions were rebellious children of Austro-

liberal culture, a culture which could satisfy the minds but starved the souls of a population still cherishing the memory of a pre-rationalist social order.

❧ NOTES ❧

1 Robert Musil, *The Man Without Qualities*, tr. Eithone Wilkins and Ernst Kaiser (London, 1953), p. 8.

2 J. N. Berger, *Zur Lösung der oesterreichischen Verfassungsfrage* (Vienna, 1861), p. 19, cited in Richard Charmatz, *Adolf Fischhof* (Stuttgart and Berlin, 1910), p. 219.

3 William J. McGrath, *Dionysian Art and Populist Politics in Austria* (New Haven and London, 1974), 17–39, 208 ff.; *idem*, "Student Radicalism in Vienna," *Journal of Contemporary History*, II, No. 2 (1967), 183–95; Hans Mommsen, *Die Sozialdemokratie und die Nationalitätenfrage im Habsburgischen Vielvölkerstaat* (Vienna, 1963), 101–27.

4 *Neue Freie Presse*, March 10, 1897.

5 Eduard Pichl, *Georg Schönerer* (Oldenburg and Berlin, 1938), II, 516.

6 See Oesterreichischer Eisenbahnbeamtenverein, *Geschichte der Eisenbahnen der Oesterreichisch-Ungarischen Monarchie* (Vienna, Teschen, and Leipzig, 1897–1908), I, Part i, 167–8, 174–5.

7 Creditanstalt-Bankverein, *Ein Jahrhundert Creditanstalt-Bankverein* (Vienna, 1957), pp. 2, 6–7. For the rivalry of the two giants in winning control of the railroads—from the government as well as each other—see Oesterreichischer Eisenbahnbeamtenverein, *Geschichte*, I, Part i, 321–5.

8 Schönerer counseled steam. Cf. *ibid.*, I, Part i, 133.

9 *Ibid.*, I, Part i, 447–9; Creditanstalt-Bankverein, *Ein Jahrhundert*, p. 31. See also the interesting account of the construction of the new company as seen through the experience of the Hamburg entrepreneur Ernst Merck, in Percy Ernst Schramm, *Hamburg, Deutschland und die Welt* (Munich, 1943), pp. 528–37.

10 Constantin von Wurzbach, *Oesterreichische Nationalbiographie* (Vienna, 1856–91), XXXI, 148–9.

11 J. W. Nagl, J. Zeidler, and E. Castle, *Deutsch-Oesterreichische Literaturgeschichte* (Vienna, 1899–1937), III, 798–800.

12 Pichl, *Schönerer* (I, 21–2), states that Georg transferred from the Oberrealschule to a private school in Dresden as the result of a conflict with the instructor in religion.

13 Cf. "Die Grafen und Fürsten zu Schwarzenberg," *Oesterreichische Revue*, IV, No. 2 (1866), 85–167.

[14] Heinrich Benedikt, *Die wirtschaftliche Entwicklung in der Franz-Joseph-Zeit* ("Wiener historische Studien," IV [Vienna and Munich, 1958]), 38, 42–3.

[15] Unless otherwise indicated, all biographical information on the son utilized here derives from the comprehensive but uncritical Pichl, who explores no problems that might alter his hero's epic stature. Cf. Pichl, *Schönerer*, I, 21–6. Pichl's complete silence on Matthias' interests, character, and relations with Georg suggests in itself the possibility of tension between father and son.

[16] *Ibid.*, I, 23, n. 2.

[17] Cf. Ernst von Plener, *Erinnerungen* (Stuttgart and Leipzig, 1911–21), III, 90–1.

[18] For the origins of the Linz program and Schönerer's role in it, see R. G. J. Pulzer, *The Rise of Political Anti-Semitism in Germany and Austria, 1867–1938* (New York, 1964), pp. 148–53; McGrath, *Dionysian Art*, pp. 165–81.

[19] December 18, 1878, cited in Pulzer, *Anti-Semitism*, p. 151.

[20] *Ibid.*, p. 152.

[21] For the Austrian student movement in general, see the nationalistic treatment by Paul Molisch, *Die deutschen Hochschulen in Oesterreich und die politisch-nationale Entwicklung nach 1848* (Munich, 1922).

[22] The full text of this program is given in Pichl, *Schönerer*, I, 84–7.

[23] *Ibid.*, II, 25–6; See also Hans Tietze, *Die Juden Wiens* (Vienna, 1933), pp. 238–9.

[24] Cited from a speech in the Reichsrat, May 2, 1884, in Pichl, *Schönerer*, I, 232. For the wider issue, see *ibid.*, 224–50; Oesterreichischer Eisenbahnbeamtenverein, *Geschichte*, I, Part ii, 360–5.

[25] Hannah Arendt, *The Origins of Totalitarianism* (2d ed., New York, 1958), esp. chap. ii.

[26] Pichl, *Schönerer*, I, 300–1.

[27] *Ibid.*, pp. 316–18.

[28] Oscar Karbach, "The Founder of Political Anti-Semitism," *Jewish Social Studies*, VII (1945), 20–2.

[29] Richard Charmatz, *Lebensbilder aus der Geschichte Oesterreichs* (Vienna, 1947), p. 78.

[30] Hugo von Hofmannsthal, "Buch der Freunde," *Aufzeichnungen* (Frankfurt am Main, 1959), p. 60.

[31] Franz Stauracz, *Dr. Karl Lueger. 10 Jahre Bürgermeister* (Vienna, 1907), p. 3.

[32] Heinrich Schnee, *Bürgermeister Karl Lueger. Leben und Wirken eines grossen Deutschen* (Paderborn, 1936), p. 12.

[33] Cf. Marianne Beskiba, *Aus meinen Erinnerungen an Dr. Karl Lueger* (Vienna, 1910), p. 16.

[34] Stauracz, *Lueger*, pp. 4–5.

35 Eugen Guglia, *Das Theresianum in Wien. Vergangenheit und Gegenwart* (Vienna, 1912), p. 177.

36 His style has been characterized as inspired by the muses, *musenhaft.* See Friedrich Funder, *Vom Gestern ins Heute* (2d ed.; Vienna, 1953), p. 102.

37 These theses are summarized in Kurt Skalnik, *Dr. Karl Lueger. Der Mann zwischen den Zeiten* (Vienna and Munich, 1954), pp. 14–15.

38 Paul Molisch, *Politische Geschichte der deutschen Hochschulen in Oesterreich von 1848 bis 1918* (Vienna and Leipzig, 1939), pp. 78–80; Skalnik, *Lueger*, p. 146.

39 Quoted in Skalnik, *Lueger*, p. 20.

40 Sigmund Mayer, *Die Wiener Juden* (Vienna and Berlin, 1918), pp. 379 ff.

41 Rudolf Till, *Geschichte der Wiener Stadtverwaltung in den letzten zweihundert Jahren* (Vienna, 1957), p. 77.

42 Skalnik, *Lueger*, pp. 16–28.

43 Till, *Stadtverwaltung*, pp. 69–71, provides an excellent outline of the suffrage extension problem, 1867–84, and its relationship to the authorities above the city fathers (*Statthalter*, Lower Austrian diet, emperor).

44 Skalnik, *Lueger*, pp. 31–2.

45 *Ibid.*, p. 43.

46 Pulzer, *Anti-Semitism*, p. 172.

47 *Ibid.*, p. 167.

48 Friedrich Funder, *Aufbruch zur christlichen Sozialreform* (Vienna and Munich, 1953), p. 41.

49 Heinrich Benedikt, ed., *Geschichte der Republik Oesterreich* (Vienna, 1954), p. 308.

50 Charles Baudelaire, *The Essence of Laughter and Other Essays . . .*, ed. Peter Quennell (New York, 1956), pp. 48–9.

51 Plener, *Erinnerungen*, III, 257; II, 301–2.

52 Ernest Jones, *The Life and Work of Sigmund Freud* (New York, 1953–7), I, 311.

53 Alex Bein, *Theodor Herzl. Biographie* (Vienna, 1934), pp. 11–16.

54 *Ibid*, p. 29.

55 Theodor Herzl, *Der Judenstaat* (9th ed., Vienna, 1933), p. 79.

56 Bein offers excellent summaries of Herzl's early writings illuminating his intellectual and psychological development. See Bein, *Herzl*, pp. 35–71 and *passim.*

57 *Ibid.*, p. 34.

58 Schnitzler to Herzl, August 5, 1892, "Excerpts from the Correspondence between Schnitzler and Herzl," *Midstream*, VI, No. 1 (1960), 48.

59 *Ibid.*, 49. The year was 1883.

60 Theodor Herzl, *Tagebücher* (Berlin, 1922), I, 223.

61 Bein, *Herzl*, p. 241.

62 *Ibid.*, p. 118.

63 *Ibid.*, pp. 44–7, 54–6, 66–7.

[64] Alex Bein, "Herzl's Early Diary," in Raphael Patai, ed., *Herzl Year Book*, I (1958), 331.

[65] Bein, *Herzl*, p. 68.

[66] Herzl, *Tagebücher*, I, 6.

[67] Bein, *Herzl*, pp. 117–18.

[68] *Ibid.*, p. 121.

[69] *Ibid.*, p. 123.

[70] *Ibid.*, p. 127.

[71] *Ibid.*, p. 128.

[72] Herzl, *Tagebücher*, I, 6.

[73] Bein, *Herzl*, pp. 124–5.

[74] *Ibid.*

[75] Quoted from "Wahlbilder aus Frankreich," *Neue Freie Presse* August [n.d.] 1893, in Bein, *Herzl*, p. 161.

[76] Bein, *Herzl*, p. 164.

[77] Herzl, *Judenstaat*, p. 14.

[78] Quoted in Bein, *Herzl*, p. 154. For Bein's account of Herzl's response to the Panama scandal, which is the basis of the above analysis, see *ibid.*, pp. 151–5.

[79] Herzl, *Tagebücher*, I, 110.

[80] Letter to Baron Leitenberger, Jan. 26, 1893, in Chaim Bloch, "Herzl's First Years of Struggle," in Patai, ed., *Herzl Year Book*, III (1960), 79.

[81] Bein, *Herzl*, pp. 157–9.

[82] *Ibid.*, p. 40; Leon Kellner, *Theodor Herzls Lehrjahre* (Vienna and Berlin, 1920), pp. 22–4. Herzl stipulated in his will that the remains of his sister should be exhumed and removed to Palestine along with his family's when the Jewish people should transfer his own coffin there. His wife, by contrast, was shabbily—indeed, vituperatively—treated in the will. See "The Testaments of Herzl," in Patai, ed., *Herzl Year Book*, III, 266. For the vicissitudes of Herzl's marriage, see Bein, *Herzl*, pp. 113, 121–2.

[83] Herzl's letters to Julia were in the possession of their daughter, Margarethe, and are believed to have perished with her at the hands of the Nazis in Theresienstadt. Cf. Alexander Bein, "Some Early Herzl Letters," in Patai, ed., *Herzl Year Book*, I, 310 and footnote, 321–4.

[84] Bein, *Herzl*, pp. 112, 138.

[85] Herzl, *Tagebücher*, I, 4.

[86] Letter to Baron Friedrich Leitenberger, Jan. 26, 1893, in Patai, ed., *Herzl Year Book*, III, 78, 79.

[87] Bein, *Herzl*, pp. 144–5; notes to chap. iv, p. 709.

[88] Herzl, *Tagebücher*, I, 8.

[89] Bein, *Herzl*, pp. 188–9, quoted from Herzl, *Zionistische Schriften* (2d ed., Berlin, 1920), pp. 257 ff.

[90] Bein, *Herzl*, p. 189.

[91] Herzl, *Tagebücher*, I, 44; see also McGrath, *Journal of Contemporary History*, II, No. 2 (1967), 195–201.

[92] From the epilogue to Herzl's novel, *Altneuland*, quoted in Bein, *Herzl*, p. 562.

93 Herzl, *Tagebücher*, I, 116.

94 Bein, *Herzl*, p. 562.

95 Herzl, *Tagebücher*, I, 398–9.

96 Bein, *Herzl*, p. 330.

97 Herzl, *Tagebücher*, I, 33.

98 *Ibid.*, I, 32, 33. Herzl, *Judenstaat*, p. 95.

99 Herzl, *Tagebücher*, I, 269–70.

100 Bein, *Herzl*, p. 303.

101 Herzl, *Judenstaat*, pp. 75–9.

102 Herzl, *Tagebücher*, I, 149.

103 Herzl, *Judenstaat*, p. 95.

104 Herzl, *Judenstaat*, p. 14.

105 Herzl, *Tagebücher*, I, 42.

106 Herzl, *Tagebücher*, I, 43. The French is Herzl's.

107 *Ibid.*, pp. 43, 42.

108 "Tatdrohung." Cf. Bein, *Herzl*, pp. 150–1.

109 Herzl, *Tagebücher*, I, 7.

110 *Ibid.*, I, 275.

111 Bein, *Herzl*, pp. 294 ff.

112 Cf. Adolf Boehm, *Die zionistische Bewegung* (Berlin, 1920), pp. 120–1; Bein, *Herzl*, Part II, *passim*.

113 Herzl, *Tagebücher*, I, 369. The prince was the Grand Duke of Baden.

114 *Ibid.*, p. 374.

115 *Ibid.*, p. 373.

116 Bein, *Herzl*, p. 339.

117 Quoted in *ibid.*, p. 341.

118 *Ibid.*, pp. 307, 304–5.

119 Cf. Felix Salten, *Gestalten und Erscheinungen* (Berlin, 1913), pp. 144 ff; Leo Goldhammer, "Herzl and Freud," in Patai, ed., *Herzl Year Book*, I, 195; Max Brod, *Streitbares Leben* (Munich, 1960), p. 69; Stefan Zweig, *The World of Yesterday* (London, 1943), pp. 88–9; Karl Kraus, *Eine Krone für Zion* (Vienna, 1898). The identification of Herzl with the leader figures of Jewry is made explicit in the biblical drawings of Ephraim Moses Lilien, in which both Moses and David are given Herzl's face. See Patai, ed., *Herzl Year Book*, II (1959), 95–103.

120 Cf. Boehm, *Die zionistische Bewegung*, p. 110.

121 Hofmannsthal, "Buch der Freunde," *Aufzeichnungen*, p. 60.

122 Herzl, *Judenstaat*, pp. 92–3.

123 *Ibid.*, p. 93.

124 *Ibid.*, pp. 93–4.

125 *Ibid.*, pp. 43–9.

126 Herzl, *Tagebücher*, I, 45. For other manifestations of Austrian Anglophilism, see pp. 48, 306.

127 Herzl, *Judenstaat*, pp. 82–92; Boehm, *Die zionistische Bewegung*, pp. 105–6.

128 Herzl, *Judenstaat*, p. 56. The nature and functions of the Jewish Company are fully described in *ibid.*, pp. 39–66.

[129] Herzl, *Tagebücher*, I, 242.

[130] Herzl, *Judenstaat*, p. 92.

[131] Herzl, *Tagebücher*, I, 482–5.

[132] *Ibid.*, p. 486.

[133] *Ibid.*

IV

POLITICS
AND PATRICIDE
IN FREUD'S
INTERPRETATION
OF DREAMS

THE UNRIDDLER of riddles who found the key to the human condition in the story of Oedipus was also a lover of jokes. When at the age of forty-five he was finally given an associate professorship, the still unknown Dr. Freud reported the event to a friend in mock journalese. He described his promotion as a political triumph:

The public enthusiasm is immense. Congratulations and bouquets keep pouring in, as if the role of sexuality had been suddenly recognized by His Majesty, the interpretation of dreams confirmed by the Council of Ministers, and the necessity of the psychoanalytic therapy of hysteria carried by a two-thirds majority in Parliament.[1]

It is a cheerful fantasy, very Viennese: political authority bends the knee to Eros and to dreams.

"Where he makes a jest, a problem lies concealed." In *The Interpretation of Dreams*, published two years before his jocular announcement, Freud had laid down his first principle of understanding

the problems of dreams: "A dream is the fulfillment of a wish." At the time of writing, in 1902, he was collecting material to demonstrate that the same rule held true for jokes. "Sometimes," he added, "the jest brings the *solution* of the problem to light as well."[2]

In his moment of elation at his promotion Freud did not simply lean back in satisfaction with the reward of his achievement. Instead, he freed his fantasy to conjure up a wider paradise. Playfully he projected an ordered parliamentary polity united in support of his unorthodox science of Eros. His imagined Parliament, which rallied a two-thirds majority to proclaim the necessity of the psychotherapy of hysteria was, of course, an exact inversion of the political reality of the time. The Austrian Reichsrat of 1902 had itself fallen so deep into political hysteria that it was unable to find a simple majority (let alone two-thirds) to legislate on anything.

We need not believe that political paralysis as such was a major concern to Freud by 1902. What gnawed at him was something both more and less specific: his relationship to the whole political system, including its academic components and consequences. Here it was that his joke fulfilled his wish—the wish to bring political authority to heel. "The jest brings the solution to the problem as well." In the play of Freud's wit the political powers were neither subverted nor dissolved but, on the contrary, miraculously harmonized, united in common recognition of the validity of his theories. Freud thus celebrated in fantasy a victory over politics, the side of human affairs from which he had expected most in youth and had suffered most in manhood.

In the same letter in which the new professor gaily trumpeted his triumph, he also sounded notes of doubt and guilt. Freud felt he could have had the professorship sooner if only he had pressed his own cause. "For four whole years, I had not put in a word about it," he wrote to his friend, Wilhelm Fliess. Only after he had completed *The Interpretation of Dreams* had he decided "to take appropriate steps" with his superiors. To do so, however, involved him in a moral dilemma, "to break with my strict scruples" against cultivating the powerful. Having taken the common-sense road of speaking up for the academic recognition that he felt to be his due, Freud found his success tainted by guilt. His professorship appeared to him ambiguous: on the one hand, it was a victory of his common sense; on the other, it seemed a surrender to hated authority. "I have learned that

the old world is governed by authority, just as the new is governed by the dollar. I have made my first bow to authority."[3]

Where Freud's playful fancy had escalated his promotion into a political triumph, his conscience thus shrank it into a moral delict. Behind these contradictory responses of fantasy and conscience to his long-awaited moment of professional success lay Freud's life-long struggle with Austrian socio-political reality: as scientist and Jew, as citizen and son. In *The Interpretation of Dreams* Freud gave this struggle, both outer and inner, its fullest, most personal statement— and at the same time overcame it by devising an epoch-making interpretation of human experience in which politics could be reduced to an epiphenomenal manifestation of psychic forces. I shall try to extract from the book a few of the materials which illuminate the counterpolitical ingredient in the origins of psychoanalysis.

The Interpretation of Dreams* occupied a special place in the mind and heart of its author. He regarded it both as his most significant scientific work, the foundation stone of his whole achievement, and as the work that brought him into the clear personally, the source of the strength to face a troubled life anew. The very structure of the work reflects this dual nature. Its surface organization is governed by its function as scientific treatise, with each chapter and section systematically expounding an aspect of dreams and their interpretation. To this scientific structure Freud explicitly subordinated the personal content of the book, designating the dreams and memories that constitute it only as "material by which I illustrated the rules of dream-interpretation."[4] Yet a closer look reveals a second, deep-structure of the work which, running from one isolated dream of the author to the next, constitutes an incomplete but autonomous subplot of personal history. Imagine St. Augustine weaving his *Confessions* into *The City of God*, or Rousseau integrating his *Confessions* as a subliminal plot into *The Origins of Inequality:* such is the procedure of Freud in *The Interpretation of Dreams*. In the visible structure of the scientific treatise he leads his readers upward, chapter by systematic chapter, to the more sophisticated reaches of psychological analysis. In the invisible personal narrative he takes us

downward, dream by major dream, into the underground recesses of his own buried self.

It is the second quest, a *recherche du temps perdu,* that must particularly interest the historian. By following the dreams simply in their order of presentation one becomes aware of three layers in a psychoarcheological dig: professional, political, and personal. These layers also correspond loosely to phases in Freud's life, which he presents in inverse temporal order in *The Interpretation of Dreams.* The professional one lies roughly in his present; the political, in the period of youth and childhood. Deepest of all, both in time and in psychic space, the personal layer leads back to infancy and into the unconscious where infantile experience lives still.* Thus Freud's dreams serve as a thread of Ariadne which we can follow stepwise downward into the realm of instinct.

The elements that appear in the dream arrangement as three clear layers were also constituents of a wracking crisis Freud experienced in the 1890's. Professionally, the frustrations that had dogged him from the beginning of his career had by 1895 produced a bitterness verging on despair. Wishing to be a research scientist, Freud had early been forced by impecuniousness into the career of a physician. True, he had easily won a prized fellowship to Paris in 1885 and briefly thereafter an appointment to a University hospital where he could have clinical material for teaching and research. But the Vienna children's hospital with which he was associated for a decade after 1886 gave him little research opportunity and less prestige. Efforts to win for it the status of a University teaching clinic failed. The most galling indignity Freud had to suffer, however, was the failure to be given a professorship. His long wait—seventeen years in all, where eight was the norm in the medical faculty—crowned his intellectual isolation, professional frustration, and social malaise with what appeared to be academic defeat.[5]

The wider context of Freud's professional frustrations was a

* The ordering of the dreams does not, of course, follow their actual chronology, nor that of Freud's self-analysis. For these chronologies the fundamental work has been done by Didier Anzieu, *L'Auto-analyse* (Paris, 1959). Nor does Freud analyze any of his dreams comprehensively in *The Interpretation.* Rather he uses them as components in the reconstruction of his own experience into a meaningful personal history that justifies both his life and his new science.

seething atmosphere of almost continuous political crisis. During the last five years of the nineteenth century Austria-Hungary seemed to be serving, as one of its poets observed, as "a little world in which the big one holds its tryouts"—tryouts for Europe's social and political disintegration.[6] The Habsburg Empire was pulling apart at the seams internally as Europe was internationally: vertically, on nationality lines; horizontally, on class and ideological lines. Until the nineties the contending political forces had been the classic ones: liberal versus conservative. But now lower social strata generated the strength to contest the power of the older élites. Out of the working class sprang socialism; out of the lower middle class and peasantry arose both virulent nationalism and Christian Socialism. The fall of Vienna to Karl Lueger's anti-Semites in the elections of 1895 was a stunning blow to the bearers of liberal culture, Jew and Gentile. The forces of racial prejudice and national hatred, which they had thought dispelled by the light of reason and the rule of law, re-emerged in terrifying force as the "century of progress" breathed its last.*[7]

Sigmund Freud, by family background, conviction, and ethnic affiliation, belonged to the group most threatened by the new forces: Viennese liberal Jewry. Though not—or, more accurately, no longer —a political man, Freud watched with anxious interest the rise to power of the New Right both in Austria and abroad, especially in the France of the Dreyfus affair. Karl Lueger was his *bête noir;* Émile Zola, the novelist who championed Dreyfus, his political hero.[8]

Freud needed no specifically political commitment to make him feel the lash of resurgent anti-Semitism; it affected him where he was already hurting—in his professional life. Academic promotions of Jews in the medical faculty became more difficult in the crisis years after 1897. Freud reported in ironically elliptical bureauc-ratese the answer another Jewish colleague awaiting promotion had elicited from a high-placed official, that "in view of the present state of feeling, it was no doubt true that, for the moment, His Excellency [the minister of culture] was not in a position etc. etc. . . . [to ignore] denominational considerations."[9]

In response to his professional and political frustrations Freud retreated into social and intellectual withdrawal. He actually stepped

* See above, pp. 5–7, 116–18, 144–5, and Essay III, *passim.*

down the social ladder, from the upper medical and academic in-
telligentsia to which he had gained access in the eighties to a simpler
stratum of ordinary Jewish doctors and businessmen who, if they
could not assist or further his scientific pursuits, did not threaten or
discourage him. In 1897 Freud joined B'nai B'rith, the Jewish frater-
nal organization, as a comfortable refuge where he was accepted
without question as a person and respected without challenge as a
scientist.[10]

The more Freud's outer life was mired, however, the more winged
his ideas became. He began to detach psychic phenomena from the
anatomical moorings in which the science of his day had imbedded
them. The speculative daring of his ideas, such as his theories of the
sexual etiology of the neuroses, increased his estrangement from the
very men who would have to support his professional advancement.
Freud's intellectual originality and professional isolation fed upon
each other.

The third dimension of Freud's crisis in the nineties was personal,
centering on the death of his father. "The most important event, the
most poignant loss, of a man's life," was Freud's evaluation. What-
ever the general validity of this statement, it certainly held true for
Freud. His father's death in 1896 came at a time when it could only
reinforce Freud's other difficulties. His dreams and their analysis
make plain that his psychological crisis over his father's death un-
folded as a crisis of professional failure and political guilt. To lay
his father's ghost Freud had either, like Hamlet, to affirm the
primacy of politics by removing what was rotten in the state of
Denmark (a civic task) or to neutralize politics by reducing it to
psychological categories (an intellectual task).

❧ II ❧

LET US NOW turn to *The Interpretation of Dreams* to see how
Freud's threefold crisis and his scientific work were related. In
chapter 2, the first substantive chapter of the book, Freud developed
his basic analytic principle, that a dream is the fulfillment of a wish.
He did so by personal means, constructing an extensive model analysis
with a single dream of his own, the Dream of Irma's Injection.
Though well aware of its many dimensions, Freud here interpreted

the Irma Dream rather narrowly, in terms of the first circle of his hell: professional frustration and self-doubt.[11] This was the circle least likely to encounter resistances in his readers. In chapter 4 Freud proceeded to refine and hence redefine his first principle to read: "A dream is a *disguised* fulfillment of a *suppressed* wish." Again he selected a dream of his own for demonstrative purposes, the Dream of the Uncle with the Yellow Beard. On its innocent, non-sensical surface the dream said nothing, but its analysis showed Freud the unseemly moral consequences ensuing from the thwarting of his professional ambition by politics. His dream-wish was for the power that might remove his professional frustration. As he described it, the dream contained the political wish to "step into the minister's shoes," where he could eliminate his competitors and promote himself to a professorship.[12] The dream also revealed a disguised wish either not to be Jewish or to have the power to eliminate Jewish rivals. A political ambition functioned here as a means to professional self-realization; or, seen analytically in terms of Freud's psycho-archeological dig, a political wish was found to lie as a deeper reality beneath the professional one.

To explain the principle of distortion which he had found to govern the Uncle Dream, with its latent political wish, Freud appropriately introduced political analogies. The dream-thought, he suggested, confronts the same problem in the psyche of the dreamer as "the political writer who has disagreeable truths to tell those in authority." If the censor is strong, the writer must "conceal his objectionable pronouncement beneath some apparently innocent disguise." Just as there are two social powers, ruler and people, Freud argued, so there are two psychic forces. "One of these forces constructs the wish which is expressed by the dream, while the other exercises a censorship upon this dream-wish and by the use of censorship, forcibly brings about a distortion in the expression of the wish." The social model provided an analogy for Freud to show us "a quite definite view of the 'essential nature' of consciousness."[13]

In his selection of the analogy, as in the elucidation of the Uncle Dream, we can see how the political reality of the nineties, through the issue of the professorship, had penetrated Freud's psychic life. In the Irma Dream analysis Freud gave his readers only his sense of personal professional impotence, easily deducible from the manifest content of the dream. In the Uncle Dream he pushed through the

opaque surface of the manifest content to find politics in the latent content. Recounting the background of the Uncle Dream, Freud stated that the information concerning the "denominational considerations" which blocked his promotion, although "not news to me, was bound to strengthen my feeling of resignation."[14] He did not make explicit what his analysis of the Uncle Dream shows us: that much as he might cultivate political resignation in his waking life, the wish to free himself from anti-Semitism reasserted itself in his dreams. And even there, the power of the "secondary force"—the censor representing the social reality—distorted the dreamer's wish for liberation from the fate of the Jews into denigration of, that is, aggression against, his Jewish friends and colleagues.

In his third extensively analyzed dream (the Dream of the Botanical Monograph) Freud's father entered the picture through two recollected episodes. They did little credit to his character. In one episode the father gave his little boy a book to destroy, "not easy to justify from an educational point of view!" In another, the father upbraided his adolescent son for extravagant book buying.[15] Father Jakob Freud thus first trod the boards in the dream book in the unpromising role of an anti-intellectual, frustrating little Sigmund the future scientist—as, more recently, the political world had done.

With this finding from childhood Freud adumbrated the next problem in his scientific exposition, the importance of infantile experience in dream life. In chapter 5, under the heading "Infantile Material as the Source of Dreams," we find, ironically enough, that Freud has concentrated most of the important political materials—memories and dreams—contained in *The Interpretation of Dreams*. On the hunt for the source of his own "pathological ambition,"[16] Freud opened the gates of memory on childhood and early youth. As he did so, a political flood surged in.

Childhood experience, whatever universals may govern it, must be lived in a specific cultural milieu. The one that Freud recovered in self-analysis was that of newly triumphant liberalism in the Austria of the 1860's. He recalled his father's enthusiasm for the new Liberal ministers of 1867: "We illuminated the house in their honor." As his mind reached back "from the dreary present to the cheerful hopes of the days of the *Bürgerministerium*," Freud remembered how "every industrious Jewish schoolboy carried a minister's portfolio in

his knapsack." A wandering poet in the Prater prophesied of young Sigmund—to the delight of his parents, one would presume—that he would be a cabinet minister.[17] Indeed, until the very end of his Gymnasium years, Freud planned—undoubtedly, given his father's values, with paternal encouragement—to study law, the royal road to a political career. His ambitions were further strengthened by the school friend he most idolized, Heinrich Braun. Then a militant German democrat, Braun later became one of Central Europe's most prominent socialist intellectuals.[18]

In such a context of clear and confident mid-century liberalism Freud acquired the political values he retained all his life: partisanship for Napoleon as conqueror of backward Central Europe; contempt for royalty and the aristocracy (in 1873 as a senior in the Gymnasium Freud had proudly refused to doff his hat to the emperor); undying admiration for England, particularly for the great Puritan, Oliver Cromwell, for whom Freud, the sexual liberator, named his second son; and above all, hostility to religion, especially to Rome.

Having recovered the liberal enthusiasms of his boyhood in his dream analysis and reminiscing on its bright political hopes, Freud suddenly introduces the reader of *The Interpretation of Dreams* to what can only be called his Rome neurosis.

Like most cultivated Austrians of his generation, Freud was steeped in classical culture. Once he hit upon the analogy between his work as depth psychologist and the work of an archeologist, his mild interest flowered into a burning passion for antiquity. He consumed with avidity Jakob Burckhardt's newly published *History of Greek Culture*, so rich in materials on primitive myth and religion. He read with envy the biography of Heinrich Schliemann, who fulfilled a childhood wish by his discovery of Troy. Freud began the famous collection of ancient artifacts which were soon to grace his office in the Berggasse. And he cultivated a new friendship in the Viennese professional élite—especially rare in those days of withdrawal—with Emanuel Löwy, a professor of archeology. "He keeps me up till three o'clock in the morning," Freud wrote appreciatively to Fliess. "He tells me about Rome."[19]

At first a hobby pursued for relief of tension, Freud soon found that Rome had acquired the character of a neurotic symptom. He was seized by an irrepressible longing to visit Rome. When he was

stalled in his work on the dream book in 1898, he could do nothing but study the topography of Rome, "for which the longing grows ever more torturesome."[20]

Five times Freud traveled to Italy between 1895 and 1898, without ever reaching Rome. Some inhibition held him back. At the same time Rome became, literally, the city of his dreams. In *The Interpretation* Freud reports four Rome Dreams, all of which suggest, in one form or another, redemption or fulfillment that is never quite achieved.[21] Even the manifest content of these dreams speaks worlds. Freud conflates dream images of Catholic Rome with Jewish ideas and situations. In one dream Rome appears as "the promised land seen from afar," implying Freud to be in the same relation to Rome as Moses to Israel. The vision, though Freud does not say so, seems to express a forbidden wish: a longing for an assimilation to the gentile world that his strong waking conscience—and even his dream-censor— would deny him. He also identifies Rome with Carlsbad, Bohemia's renowned spa, a city of pleasure, rest, and cure; in short, an earthly city of recreation (re-creation), of resurrection. Freud compares himself in the analysis of this dream to a poor, gentle Jewish character in one of the Yiddish stories he loved so well. Because the little Jew did not have the train fare to Carlsbad, the conductor beat him up at every station; but, undaunted, he continued on his *via dolorosa* (the expression is Freud's). Thus the lofty vision of Moses-Freud seeing Israel-Rome "from afar" had its lowly analogue in the picture of the little-Jew–Christ–Freud reaching Carlsbad-Rome on a *via dolorosa*. A third dream reinforces the Christian theme but telescopes it into that of ancient, pagan Rome. From a train window Freud sees across the Tiber the Castel Sant' Angelo, at once papal castle and Roman imperial tomb. Tantalizingly, the train moves off before he can cross the Bridge of the Holy Angel to reach the castle—a house of both buried paganism and Christian salvation.

Freud does not analyze these dreams fully in *The Interpretation*. While recognizing that the wish to go to Rome "had become in my dream a cloak and symbol for a number of passionate wishes," he discloses fully only one of them. The clue to it he finds in Hannibal: "Like him, I had been fated not to see Rome."[22] This idea leads Freud to the recovery of a childhood scene in which he finds part of the source of his Rome neurosis. In that scene, political obligation and oedipal aggression converged.

When Sigmund was ten or twelve years old (1866–68), his father sought to illustrate to him how much the triumph of liberalism had improved the lot of the Jew. He told his son how, in an earlier time, he had been publicly humiliated by an anti-Semitic ruffian, "a Christian," as Freud pointedly calls him. Freud discovered upon questioning that his father had offered neither protest nor resistance to the indignity. Little Sigmund was disgusted with his father's "unheroic behavior." He contrasted his situation with another "which fitted my feelings better: the scene in which Hannibal's father . . . made his boy swear before the household altar to take vengeance on the Romans."[23]

"To take vengeance on the Romans": it was both pledge and project. And as project it was at once political and filial. In most of the other great creative Viennese who were Freud's contemporaries, the generational revolt against the fathers took the specific historical form of rejection of their fathers' liberal creed. Thus Gustav Mahler and Hugo von Hofmannsthal both turned back to the baroque Catholic tradition. Not so Freud, at least not consciously. He defined his oedipal stance in such a way as to overcome his father by realizing the liberal creed his father professed but had failed to defend. Freud-Hannibal as "Semitic general" would avenge his feeble father against Rome, a Rome that symbolized "the organization of the Catholic Church" and the Habsburg régime that supported it.*[24]

We notice at once, of course, that the Rome of Freud the boy in the sixties—forbidding, hostile, bureaucratic—is quite different from the Rome in the dreams and longings of Freud the man in the nineties. The first is an object of hate, an enemy to be conquered, the

* That the Habsburg Empire in a wider sense was involved in Freud's boyhood militancy against Christianity is suggested in his identification of Hannibal with Napoleon—"both crossed the Alps"—and in his hero worship of Napoleon's Marshal Masséna. Little Sigmund learned of the latter from Louis Adolphe Thiers's *History of the Consulate and the Empire*, "one of the first books I got hold of when I had learnt to read." Masséna, whom Freud erroneously believed to be Jewish and who was born one hundred years to the day before Freud, was his "declared favorite" before he encountered Hannibal. Masséna not only fought the Catholic forces in Italy but occupied Vienna, making his headquarters in the Leopoldstadt (later the Jewish quarter in which Freud grew up).

second an object of desire, to be entered in love. Freud says nothing
directly about the difference or the relationship between the two.
But he offers a clue when he recalls a German classical author's
question: "Which of the two [men] . . . paced his study in greater
excitement after forming his plan to go to Rome: Winckelmann or
Hannibal?" Freud unhesitatingly identifies himself with Hannibal,
following in his footsteps of failure. "Like him, I had been fated
not to see Rome."[25] Here Freud conceals an important truth from us,
if not from himself, concerning his problem of political guilt as
scientist and son. The Rome of his mature dreams and longings is
clearly a love-object.[26] It is not Hannibal's Rome but that of Johann
Joachim Winckelmann, the great eighteenth-century archeologist
and art historian. He ardently loved Rome as the mother of European
culture. A Protestant, Winckelmann overcame his scruples and em-
braced Catholicism in order to enter Rome and pursue his passion for
classical antiquity as a papal librarian. He conquered his conscience
for the sake of his science, his *amor intellectualis* for Rome.*

Winckelmann or Hannibal? Scientist or politician? Freud had faced

* "It is the love of science and it alone," wrote Winckelmann, "that can move
me to give ear to the proposal suggested to me." Quoted in Carl Justi, *Winckel-
mann und seine Zeitgenossen* (5th ed., Cologne, 1956), I, 371. The first edition
of this classic biography appeared during Freud's Gymnasium years. The second
edition was published in 1898, when Freud's interest in archeology was at its
height and when he had resumed work on the interpretation of dreams, inclu-
sive of the Rome dreams. The Justi biography reveals remarkable similarities
between Winckelmann's life and intellectual stance and Freud's: poverty, an
acute sense of low social status, failure to find a congenial intellectual position
or adequate professional recognition, a string of intense friendships with homo-
sexual overtones, hatred of political tyranny, hostility to organized religion, and
a generativity crisis at the age of forty that resulted in a "first work" of a
new and revolutionary kind. Most of these features emerge clearly in Goethe's
perspicacious essay of 1805, "Winckelmann," in *Goethes Werke*, ed. Eduard von
der Hellen (Stuttgart, 1922), XV, 65–93. Herder, in a somewhat more romantic
essay, "Denkmal Johann Winckelmann," in *Herders Sämtliche Werke*, ed.
Bernhard Suphan (Berlin, 1892), VIII, 437–83, appreciates Winckelmann as a
serene and stoical hero of science in an age of prejudice and rulers' stupidity.
Freud would have seen himself in this version even more clearly than in
Goethe's. Though Freud had a magnificent command of the German classics, I
have been unable to determine whether he actually read any of these books;
but the fact that the Hannibal-Winckelmann contrast played a key role in his
analysis does suggest familiarity with Winckelmann's character and aims.

such a choice before, in 1873, when he changed his career plans in high school. Intoxicated with Goethe's erotic description of Mother Nature, young Freud had decided to enter the University in science instead of law, thus following in the footsteps of Winckelmann the scientist—a "soft" scientist like Freud. In so doing, he had abandoned Hannibal's political mission.

In the nineties, as Freud said, "the increasing importance of the effects of the anti-Semitic movement upon our emotional life helped to fix the thoughts and feelings of those early days."[27] The ghosts of Hannibal and his father rose to call again for "vengeance on the Romans." They barred Freud's road to Winckelmann's Rome—the Rome of pleasure, maternity, assimilation, fulfillment. Science would have to defeat politics and lay the father's ghost.

⇒ III ⇐

THESE OBJECTIVES Freud accomplished with the help of what he called "A Revolutionary Dream." The description and analysis of this dream occupies the central position in Freud's demonstration of the principle that a childhood wish is the fundamental determinant of the meaning of dreams.[28]

It was in August of 1898 that Freud dreamed the Revolutionary Dream—a time when politics hung especially heavy in the air. After a winter of violence between Czechs and Germans, especially in the universities, the thorny problem of language rights remained unresolved. Parliament was still paralyzed, for the German parties refused to abandon obstructionist tactics until the government should revoke the language ordinances favoring the Czechs. In June there had been violent anti-Semitic outbreaks in Galicia. In addition to these difficulties there was the nagging, acute problem of renewing the 1867 accords to regulate the economic and fiscal relations between the Austrian and Hungarian halves of the Dual Monarchy.

Count Franz Thun, Austrian minister president since March 7, 1898, was devoting most of his summer to negotiations of a preliminary accord between the Austrian and Hungarian cabinets—negotiations that had to reckon with the prospect of resistance from both German and Hungarian nationalists in their respective parliaments. Thun himself was an arch-aristocrat, a great landholder and head of

the party of the Bohemian high nobility; in short, a feudal political bureaucrat of the old school.* Though he aimed at compromise with the Germans, Count Thun was goaded by their aggressiveness into tough measures against them and quickly became the object of their cordial hatred.[29] This was the figure who became Freud's central antagonist in the Revolutionary Dream.

Ironically enough, 1898, year of paralysis and chaos, was also being celebrated as the fiftieth anniversary of Emperor Francis Joseph's accession. Since the emperor had been brought to power in the Revolution of 1848, that upheaval, too, was recalled to public mind, and to Freud's consciousness.[30]

On the day of his Revolutionary Dream, Freud was setting out for a holiday with his family at Aussee.[31] While he was waiting for his train at Vienna's Westbahnhof, he recognized Count Thun stalking onto the platform. The count was, as Freud correctly surmised, bound for the emperor's summer retreat in Ischl, where the pre- liminary Austro-Hungarian economic accords—the so-called Ischl clauses—were being worked out. In his bearing, as in his politics, Count Thun was a "*Feudalherr* from top to toe." "Tall, thin, dressed with exquisite elegance, [he looked] more like an Englishman than a Bohemian," one of his subordinates recalled. "His monocle never left his eye."[32] Now, as he passed through the train gate, the count displayed his aristocratic aplomb. Although he had no ticket, he waved the ticket-taker aside and entered a luxurious compartment. All Freud's resentment of aristocracy welled up at the minister's imperious behavior. He found himself whistling a subversive air from Mozart's *Marriage of Figaro:* "If the Count wants to dance, I'll call the tune."

The dream on the train bore the stamp of this chance encounter and the emotions it aroused. It telescoped Freud's present political feelings with his past political experiences and scenes and images from history. In the opening scene of the dream Freud found him- self at a university student gathering, where Count Thun (or a conservative predecessor, Count Taaffe) was belittling German na- tionalism. In his disdainful way the aristocrat deprecated the symbolic

* Franz Thun (b. 1847) was the nephew of Count Leo Thun (b. 1811), the Minister of Culture who introduced the educational and university reforms mentioned on pp. 38–9 and 282–3.

flower of the German nationalists as a limp plant, colt's foot [German, *Huflattich*], that Freud connected by verbal association with flatulence; in short, the speaker implied that German student militancy was so much wind. Freud, to his own surprise, rose in angry response to the minister's contemptuous remarks. In analyzing the scene he identified himself with Adolf Fischhof, a medical-student leader who helped to trigger the Revolution of 1848 at the University and to carry it onto the larger political stage.* Freud discovered another Jewish medical politico in the dream: his former fellow student, Victor Adler. By 1898 Adler had become the leader of Austrian Social Democracy. In analyzing the Revolutionary Dream Freud recalled having defied Adler, toward whom he had had strong feelings of envy and rivalry, in a German nationalist student organization to which they both belonged in the 1870's.[33] Fischhof and Adler had shown that one could be both a Jewish doctor and a political leader—a fact that Freud virtually denied to be possible in explaining his choice of careers.†[34] Even as Freud dreamed out his own long-repressed political wish and exhumed by analysis the figures who proved that his youthful dream of a political role might have been true, he refrained from putting the pieces together either for his reader or in all likelihood for himself.

In the scenario of the dream, after his outburst of anger at the minister, Freud suddenly fled the political scene. He retreated through the halls of the University, that is, through academia. Escaping into the street, he then tried to get out of town, to some destination where "the Court would not be in residence." The final scene, accordingly, was at the railroad station where, in his waking life, it had all begun. There Freud found himself on the platform in the company of a blind man, whom he recognized in his analysis as his dying father. Freud held a urinal for the helpless old man, conscious that the ticket-taker would look the other way. So ends the dream.

* Like Freud, Fischhof was a poor, Moravian-born Jew. He became a doctor because before 1848 no other academic course was open to his race. When the revolution broke, Fischhof occupied a medical position later held by Freud: that of *Sekundararzt* (intern) at the Royal Imperial General Hospital in Vienna. Cf. Richard Charmatz, *Adolf Fischhof* (Stuttgart, 1910), 14, 17–31.
† "A ministerial career is definitely barred to a medical man," wrote Freud of his decision to abandon the law in 1873.

With this scene, the dream had done its work in dissolving political impulses and political guilt. Before the dream, Freud had confronted the powerful Count Thun on the platform as a pre-revolutionary Figaro with the subversive wish to call the tune for the count. His present situation of political impotence and resentment dominated this waking fantasy. In the dream he had discharged, by his defiance of the count, the commitment of his youth to anti-authoritarian political activism, which was also his unpaid debt to his father.

It is easy for the modern reader to forget the boldness—half nerviness, half courage—involved in Freud's presentation of the Revolutionary Dream and its daytime prelude to his contemporaries. Count Thun, after all, still headed the government when Freud sent the last pages of his manuscript to the printer in early September 1899. In the Revolutionary Dream, his last explosive hail-and-farewell to politics, Freud took the field as liberal-scientific David against a very real political Goliath, the incumbent minister president. He laid bare his political and social feelings in no uncertain terms. Yet both on the station platform and in the dream, the encounter between the little Jewish doctor and the gaunt aristocrat suggests a quixotic duel, at once heroic and ridiculous. In it Freud found by analysis not so much his civic courage as an "absurd megalomania, which had long been suppressed in my waking life."[35] The strange encounter, Freud versus Thun, had brought it to the surface.

Neither the dream nor Freud's reading of it came to rest in affirmation or rejection of a particular political position, not even that of Count Thun. Freud implied his own ideological truth when he saw himself in his dream as rejecting both aristocratic authority (Thun-Taaffe) and the authority of socialism (Adler, the older and bolder brother). The "political" problem was dissolved in the final scene on the platform, where the dream-thought substituted the dying father for the living count. Here the flight from politics, through the University, and on to scientific medical service, found vindication. Freud had become a "minister" after all, as the prophet in the Prater had foretold—a minister not in the political sense, but in a medical sense, ministering to his dying father. Not Hannibal the general, but Winckelmann the scientist.

What was Freud's interpretation of the Revolutionary Dream? Strikingly, he ignored the flight from politics which is so prominent

in its scenario and manifest content. Instead, he brought his analysis to focus in the final scene on the station platform from which, in his view, the whole Revolutionary Dream received its basic meaning. Freud recalled two episodes of his childhood in which his father had reprimanded him for urinating. In one of them he finally found the personal, childhood source of his "pathological ambition," before it had been translated in his youth into the political sphere and in his maturity to the professional sphere. In that episode little Sigmund had "disregarded the rules which modesty lays down" and urinated in his parents' presence. His insensitive father had reprimanded him with a prophecy that rang like a curse: "This boy will come to nothing." In the final scene of the Revolutionary Dream, the grown-up Dr. Freud reversed this situation. Instead of the strong father reprimanding the weak son for urinating, the strong son helped the weak father in urinating. "As though I wanted to say," Freud comments, " 'You see I *have* come to something.' " Vengeance, of an intellectual kind, is being taken here not on Rome and not on Count Thun, but on the father. As the father replaces the prime minister on the station platform, patricide replaces politics.

Is not this something more as well: revenge on politics itself? Freud suggested this explicitly in a footnote where he connected his victory over his father with his victory over politics:

the whole rebellious content of the dream, with its *lèse majesté* and its derision of the higher authorities, went back to rebellion against my father. A Prince is known as father of his country; the father is the oldest, first, and for children the only authority, and from his autocratic power the other social authorities have developed in the history of human civilization.[36]

In this passage Freud adumbrated his mature political theory, the central principle of which is that all politics is reducible to the primal conflict between father and son.[37] The Revolutionary Dream, miraculously, contained this conclusion in its very scenario: from political encounter, through flight into academia, to the conquest of the father who has replaced Count Thun. Patricide replaces regicide; psychoanalysis overcomes history. Politics is neutralized by a counterpolitical psychology.

"*Wissen macht frei*"—so ran the great slogan of Austrian liberalism.

Freud had not paid his debt to his father as a revolutionary doctor like Adolf Fischhof in 1848 or Victor Adler in 1898. Instead, Freud would pay it as a scientific liberator. He dissolved the oath of Hannibal by his counterpolitical discovery: the primacy of infantile experience in the determination of human behavior. With that discovery, a new road to Rome lay open.

<div align="center">

⋟ IV ⋞

</div>

BEFORE FREUD could go to Rome he had to fulfill two more tasks left over from the victory over politics and father in the Revolutionary Dream. He had to send his father's ghost to an appropriate kind of Valhalla, and he had to universalize his personal experience as a scientific finding. He solved the first task with a dream of Hungary, the second with a myth of Thebes.

The Dream of Hungary must have been dreamed some time after October 1898, when Count Thun was still wrestling with the problem of pulling the two halves of the Empire, the Austrian and the Hungarian, together. After both governments had agreed on the Ischl formula, the fruit of Count Thun's negotiations, the Hungarian nationalists rebelled. Resorting to obstructionism in their parliament, in emulation of the Germans in the Reichsrat, in February the Hungarian nationalists brought down the government that had initialed the agreement.[38] It was in this situation that Freud in his dreams assigned his father the important role of peacemaker. Freud reported his dream as follows:

After his death my father played a political part among the Magyars and brought them together politically. Here I saw a small and indistinct picture: a crowd of men as though they were in the Reichstag; someone standing on one or two chairs, with other people around him. I remembered how like Garibaldi he looked on his deathbed, and felt glad that that promise had come true.[39]

A promise come true indeed! Here was Freud's father synthesizing in his person the two traditional allies of Austro-German liberals against the Habsburgs: Italian and Hungarian nationalists. As Garibaldi, father Freud was a modern Hannibal, a populist political-

military hero who also failed to take Rome (from the pope in 1867). As Hungarian leader, Jakob Freud was in his turn stepping into the minister's shoes and solving the Hungarian problem, which would soon bring down Count Thun.

As parliamentary ruler, reconciler of the irreconcilable Hungarians, father Jakob Freud thus made good his failures of Sigmund's youth. Freud found in the dream, along with elements denigrating his father, the wish that the father might stand "great and unsullied" before his children after his death. Freud makes no comment on the fact that the paternal apotheosis should be political. Yet the substance of the dream speaks clearly enough: a successful Father Garibaldi-Freud in Hungary made his son's pursuit of politics unnecessary and canceled the debt of 1868.

Freud's second task in opening his road to Rome was professional: to draw theoretical consequences from the experience of the patricidal impulse he had found in the Revolutionary Dream. This he did by identifying a mythic archetype, the myth of Oedipus, to give form to his finding that "the death-wish against parents dates back to earliest childhood."[40] He appropriated the Oedipus myth in such a fashion as to bring out the *sexual* dimensions it contains. In so doing he pushed the interpretation of dreams as a whole one step farther down from personal infantile experience, to which he had traced, in order to expose, his political encounters, to the childhood of the human race. The mythic layer is the deepest in *The Interpretation of Dreams*, where the individual experience of the unconscious is found embedded in the universal archetypal experience of primitive man. Here personal history joins the a-historical collective.

We cannot here treat the significance of the Oedipus legend for Freud's thought or for the structure of *The Interpretation of Dreams*. Let us only suggest a peculiarity of Freud's treatment of Oedipus related to the problem of neutralizing politics. Freud pays no attention to the fact that Oedipus was a king. As for Nietzsche and other modern philosophers, so for Freud, the Oedipus quest was a moral and intellectual one: to escape a fate and acquire self-knowledge. Not so for the Greeks. Sophocles' drama *Oedipus Rex* is unthinkable except as *res publica*, with its regal hero motivated by political obligation: to remove the plague from Thebes. Although Oedipus' guilt is personal, his quest to discover it and his self-punishment are a public matter and are required to restore public

order. Freud's Oedipus is not *Rex*, but a thinker searching for his identity and its meaning. By resolving politics into personal psychological categories, he restores personal order, but not public order. Dr. Freud left Thebes languishing still under the plague of politics, while he elevated his slain father's ghost to kingship in the Dream of Hungary.

Was there then nothing left of Hannibal-Freud, nothing of Figaro-Freud, nothing of Freud the challenger of the count in the Revolutionary Dream? The Latin legend on the title page suggests an answer: *Flectere si nequeo superos, Acheronta movebo* (If I cannot bend the higher powers, I shall stir up hell [the river Acheron]). These words from Virgil's *Aeneid* are spoken by Juno, divine defender of Semitic Dido against Aeneas, founder of Rome. Having failed to persuade Jupiter to let Aeneas marry Dido ("to bend the higher powers"), Juno summons from hell a Fury, Allecto, who unleashes seething passions of sex and military aggression in the camp of Aeneas' allies. Virgil paints a fearsome portrait of Allecto— a Gorgon-like phallic female "alive with black and writhing snakes," a bisexual monster.[41] Freud cites Juno's words again in his text in an important place, where he wishes to point up the overall significance of his research into dreams. After repeating the quotation, he says, "The interpretation of dreams is the royal road to a knowledge of the unconscious activities of the mind." And in a footnote he adds: "This line [the legend] is intended to picture the efforts of the repressed instinctual impulses."[42]

Freud was not the first to use Juno's threat to stir up hell as a motto for a work with subversive implications. Again the trail leads us back to politics, this time to the socialist Ferdinand Lassalle.[43] One of Lassalle's most brilliant pamphlets, *The Italian War and the Task of Prussia* (1859), also carried the words *Flectere si nequeo superos, Acheronta movebo* on its title page. On July 17, 1899, Freud wrote to Fliess that he had chosen this as the motto for *The Interpretation of Dreams;* in the same letter, but making no connection, he mentioned that he was taking "the Lassalle" on vacation for summer reading.[44] Conversant as he was with the *Aeneid*, Freud needed no Lassalle to discover the lines that graced his title page.[45] Yet the strong correspondence between Lassalle's pamphlet and Freud's cathexis of youthful political predilections and current political anxieties in the nineties makes it highly likely that Freud read it. *The Italian War*

contained many themes and attitudes that we have found in *The Interpretation of Dreams:* the hatred of Catholic Rome and the Habsburgs as the bastions of reaction; the linkage of Garibaldi and the Hungarians as liberal protagonists; and, like Freud in his dream-confrontation with Count Thun, the espousal of German national feeling against the aristocratic Austrian.[46] In intellectual strategy lay a further affinity. Lassalle, too, played with repressed forces, in his case the revolutionary forces of the people. That is why he chose the Virgil motto for his pamphlet. In it, Lassalle tried, *à la* Juno, to persuade the "higher powers" of Prussia to lead the German people, in alliance with the Italians, in a war of national unification against the Habsburg state. But behind his persuasion lay a threat: Should Prussia fail to act, her rulers would learn to their sorrow "in what strata of opinion power [actually] resides." Lassalle thus threatened "those above" with the latent forces of national revolution, with stirring up a political Acheron.[47] Freud would have found it easy to appropriate Lassalle's legend, transferring the hint of subversion through the return of the repressed from the realm of politics to that of the psyche.

The contents of Freud's dreams often confirm relationships that other evidence only suggests. In a dream of Lassalle,[48] Freud virtually celebrated the primacy of psychoanalysis over politics that his use of Lassalle's motto implies. Along with another Jewish German political leader, Eduard Lasker, Lassalle serves the dreaming Freud as a symbol of the fatal power of sex. Characteristically, Freud ignores in his interpretation of this dream the fact that the material carriers of the message were both politicians. He assigns them significance only as "men of talent." Both "came to grief over a woman," and thus illustrated the damage—in Lasker's case organic, in Lassalle's neurotic—"caused by sexuality." Freud found in the dream a monitory confirmation of his own fears, as another "man of talent," of coming to grief over a woman. In the dream Freud also conquers the power of his own sexual temptation by his clinical understanding of neurosis, while the two Jewish politicians are undone. Sex is stronger than politics, the dream seems to us to say, but science can control sex.*

* The dream is called "Autodidasker," after the single word that was its manifest content.

Freud's Acheron of "repressed instinctual impulses," like Lassalle's Acheron of the angry *Volk*, certainly had subversive implications for those in political authority. In the final pages of *The Interpretation of Dreams*, Freud took pains to assuage the fears such findings might arouse. Again he chose Roman lore for his example:

I think that the Roman Emperor was in the wrong when he had one of his subjects executed because he had dreamt of murdering the emperor ... would it not be right to bear in mind Plato's dictum that the virtuous man is content to *dream* what a wicked man really does? I think it best, therefore, to acquit dreams.[49]

Freud had earned the right to these lines, with their comforting message to "those above," whom Juno's threat might alarm. Having exhumed his own political past through dream analysis, he had overcome it by identifying his political obligations and impulses with his father, explaining them away as attributes of his father's ghost.

And so the spell of Hannibal's oath was broken. His theoretical work and his self-analysis accomplished in *The Interpretation of Dreams*, Freud actually entered the Eternal City in 1901, nearly five years after his father's death, not "to take vengeance on the Romans," but as intellectual pilgrim and psycho-archeologist, in the footsteps of Winckelmann. He wrote, "It was an overwhelming experience for me, and, as you know, the fulfillment of a long-cherished wish. It was [also] slightly disappointing." Freud described his varied reactions to three Romes: the third, modern, was "hopeful and likeable"; the second, Catholic Rome, with its "lie of salvation," was "disturbing," making him "incapable of putting out of my mind my own misery and all the other misery which I know to exist." Only the Rome of antiquity moved him to deep enthusiasm: "I could have worshipped the humble and mutilated remnant of the Temple of Minerva."[50]

Did Freud think of the significance of his spontaneous urge to worship Minerva in her ruins? Like Juno's hellish Fury, Allecto, whom Freud had invoked on his title page, Minerva, too, was a bisexual goddess. But where Juno's phallic female unleashed terror against the founders of the city, the virgin goddess was protectrix of the civic order, using her spear, her snaky aegis, and her Gorgon-

studded shield to repel the enemies of the polis. In 1902, not long after Freud had visited her temple in Rome, Minerva's long-awaited statue was erected before the Parliament building in Vienna, the symbol of liberalism's faith in a rational polity. Minerva's wisdom was of a special kind that reconciled one to Jupiter, to the structure of necessity and the reality of power.

In the letter with which this essay began, Freud had wryly celebrated his promotion to a professorship in the caricature of a political triumph. We can now see his humor as somewhat more bitter than its surface would suggest. Promotion came as a personal and professional triumph, but at a high moral cost. For, against his conscience, Freud had recourse to what was known in Austria as "protection"—the help of socially influential individuals to secure personal preferment.*

It was my own doing in fact. When I got back from Rome, my zest for life had somewhat grown, my zest for martyrdom diminished. . . . So I made up my mind to break with my strict scruples and take appropriate steps. . . . One must look somewhere for one's salvation, and the salvation I chose was the title of professor.[51]

The brilliant, lonely, painful discovery of psychoanalysis, which made it possible for Freud to overcome his Rome neurosis, to kneel at Minerva's ruined temple, and to regularize his academic status was a counterpolitical triumph of the first magnitude. By reducing his own political past and present to an epiphenomenal status in relation to the primal conflict between father and son, Freud gave his fellow liberals an a-historical theory of man and society that could make bearable a political world spun out of orbit and beyond control.

* For the way in which this effort involved Freud's destiny with the politics of modern Austrian art, see pp. 244-5.

❧ NOTES ❧

[1] Freud to Wilhelm Fliess, March 11, 1902, in Sigmund Freud, *The Origins of Psycho-analysis: Letters to Wilhelm Fliess, Drafts and Notes, 1887–1902*, ed. Marie Bonaparte, Anna Freud, Ernst Kris; tr. Eric Mosbacher and James Strachey (New York, 1954), p. 344.

[2] The opening observation was made by Goethe of J. G. Lichtenberg, Freud's favorite satirist. Freud quoted it approvingly in *Introductory Lectures on Psycho-analysis* (1915–16), in *The Standard Edition of the Complete Psychological Works of Sigmund Freud* (hereafter *SE*), tr. and ed. James Strachey *et al.* (London, 1953–64), XV, 38; *The Interpretation of Dreams* (1900), *SE*, IV, 121. For the whole problem, see *Jokes and Their Relation to the Unconscious* (1905), *SE*, VIII, *passim*.

[3] Freud, *Origins*, pp. 342, 344.

[4] Freud, *The Interpretation*, *SE*, IV, xxvi.

[5] Both the facts and the interpretation of Freud's slow-paced medical and academic career have been the subject of heated controversy. The most comprehensive, and often productively documented, attempt to defend the Austrian academic and bureaucratic authorities against the charge of hostility, injustice, or prejudice against Freud is that of Joseph and René Gicklhorn, *Sigmund Freuds akademische Laufbahn* (Vienna, 1960). Kurt R. Eissler redresses the balance in Freud's favor with further substantial research in his counter-polemic, *Sigmund Freud und die Wiener Universität* (Bern, 1966). On the length of Freud's wait for a professorship, see especially the latter work, pp. 24–5, 181–3.

[6] "Dies Oesterreich ist eine kleine Welt,/ In der die grosse ihre Probe hält." Friedrich Hebbel, quoted in Heinrich Benedikt, ed., *Geschichte der Republik Oesterreich* (Munich, 1954), p. 14.

[7] For the vertical (nationality) disintegration, Robert A. Kann, *The Multinational Empire* (New York, 1950), is the sturdiest general survey. Berthold Sutter focuses sharply on the nationality crisis of the late nineties in *Die Badenischen Sprachverordnungen von 1897* (Graz-Cologne, 1965). For the rise of the New Right in its anti-Semitic aspect, see P. G. J. Pulzer, *The Rise of Anti-Semitism in Germany and Austria* (New York, 1964).

[8] Freud to Fliess, Sept. 23, 1895; Nov. 8, 1895; Feb. 9, 1898, in Freud, *Origins*, pp. 124, 133, 245; Ernest Jones, *The Life and Work of Sigmund Freud* (New York, 1953–57), I, 392–3.

[9] Freud, *The Interpretation*, *SE*, IV, 137.

[10] Freud to Fliess, Dec. 12, 1902, in Freud, *Origins*, p. 237. Freud, "Address to the Society of B'nai B'rith" (1926), *SE*, XX, 273–4. The date of Freud's entry into B'nai B'rith is implied by him, and stated by the editors of the Standard Edition, to have been 1895. But Dennis Klein of the University of Rochester has established 1897 as the correct date on the basis of B'nai B'rith records. The sociology of Freud's friendships and associations has yet to be worked out in detail.

11 Erik Erikson has enlarged and deepened Freud's analysis of this aspect of the dream with the concept of the generativity crisis of middle age, in "The Dream Specimen of Psychoanalysis," *Journal of the American Psychoanalytical Association*, II (1954), 5–56. The most comprehensive and structured analysis is by Didier Anzieu, *L'Auto-analyse de Freud et la découverte de la psychanalyse* (Paris, 1959), pp. 24–45. For a broad and rich but less rigorous treatment and for further bibliography on this and other dreams, see Alexander Grinstein's useful work, *On Sigmund Freud's Dreams* (Detroit, 1968), pp. 21–46 *passim*.

12 Freud, *The Interpretation*, SE, IV, 134–41, 191–3.

13 *Ibid.*, pp. 142–4.

14 *Ibid.*, p. 137.

15 *Ibid.*, pp. 169–73, especially 172–3. Freud does not analyze at this point the meaning of these episodes, although his language clearly reflects resentment at his father's behavior.

16 *Ibid.*, p. 192.

17 *Ibid.*, pp. 192–3.

18 Freud to Julie Braun-Vogelstein, Oct. 30, 1927, in Sigmund Freud, *Letters of Sigmund Freud*, ed., Ernst L. Freud (New York, 1964), pp. 378–80; Julie Braun-Vogelstein, *Heinrich Braun* (Stuttgart, 1967), pp. 20–4.

19 Freud to Fliess, Jan. 30, 1899; Feb. 6, 1899; May 28, 1899; Nov. 5, 1897, in Freud, *Origins*, pp. 275–6, 282, 229. Suzanne Bernfeld has explored, with great sensitivity to cultural factors, the function of archeology both in Freud's scientific thought and, psychoanalytically, in his personal attempt to overcome guilt over death wishes. See her "Freud and Archeology," *American Imago*, VIII (1951), 107–28.

20 Freud to Fliess, Dec. 3, 1897; Oct. 23, 1899, in Freud, *Origins*, pp. 236, 269. The latter date, on which he reported his "ever more tortured longing [*die Sehnsucht immer quälender*]" (translation mine), was the anniversary of his father's death.

21 Freud, *The Interpretation*, SE, IV, 193–8. One later Rome Dream, in which the city is the setting of grief, is not included here. This dream's bearing on Freud's problem of ambivalence as a Jew has been interestingly demonstrated by Peter Loewenberg in "A Hidden Zionist Theme in Freud's 'My Son, the Myops . . .' Dream," *Journal of the History of Ideas*, XXXI (1970), 129–32.

22 Freud, *The Interpretation*, SE, IV, 196–7.

23 *Ibid.*, 197.

24 *Ibid.*, 196–8.

25 *Ibid.*, 196.

26 This Rome Freud connected (though not in *The Interpretation*) with his oedipal tie to his Czech Catholic nanny, who had introduced him to Catholicism and had given him "a sense of my own powers," in contrast with the discouragements of his Jewish father. Cf. Freud to Fliess, Oct. 3–4, 1897; Oct. 15, 1897, in Freud, *Origins*, pp. 219–22. Psychoanalytic literature, following Freud, has tended to accept his primary identification of the Rome longing

with the nanny as mother-substitute and oedipal love-object, reducing the Catholic and Czech attributes of Rome in Freud's dream-pictures to symbols of this primal tie, and interpreting the inhibition preventing travel to Rome as an expression of the incest taboo. See, for example, Grinstein, *Freud's Dreams*, pp. 75–6, 90–1; Jones, *Life*, I, 5–6; Bernfeld, "Freud and Archeology," *American Imago*, VIII, 114–20; and Kenneth A. Grigg, "All Roads Lead to Rome: The Role of the Nursemaid in Freud's Dreams," *Journal of the American Psychoanalytic Association*, XXI (1973), 108–26. By emphasizing here the historical significance of the Jewish-Catholic tension in the dreams' manifest contents, I am trying to restore Freud's political-cultural experience to its dynamic, formative role in the development of his psychoanalytic system of thought in which, in effect, he resolves the pain of general history by translating it into personal history.

[27] Freud, *The Interpretation, SE*, IV, 196.

[28] *Ibid.*, IV, 208–19; V, 431–5. My analysis of the Revolutionary Dream is far from complete. For other dimensions, see Grinstein, *Freud's Dreams*, 92–160; and William J. McGrath, "Freud as Hannibal: The Politics of the Brother Band," *Central European History*, VII (1974), 47–57.

[29] Richard Charmatz, *Oesterreichs innere Geschichte von 1848 bis 1907* (2d ed., Leipzig, 1912), II, 128–32.

[30] Freud, *The Interpretation, SE*, IV, 211.

[31] McGrath has established the date as Aug 11, 1898. See *Cen. Eur. Hist.*, VII, 47, note 29.

[32] Rudolf Sieghart, *Die Letzten Jahrzehnte einer Grossmacht* (Berlin, 1932), p. 35.

[33] Martin Grotjahn, "A Letter by Sigmund Freud with Recollections of His Adolescence," *Journal of the American Psychoanalytic Association*, IV (1956), 649–52.

[34] Freud, *The Interpretation, SE*, IV, 193.

[35] *Ibid.*, IV, 215.

[36] *Ibid.*, IV, 217 n. 1.

[37] This theory was set forth in Freud, *Totem and Taboo* (1913), *SE*, XIII.

[38] Ervin Pamlenyi, ed., *Die Geschichte Ungarns* (Budapest, 1971), pp. 450–4. The Ischl clauses were agreed upon on August 30, 1898. The Hungarian opposition inaugurated in October 1898 the obstruction crisis which provided the context of Freud's dream. Grinstein, *Freud's Dreams*, p. 376, suggests a later date than the crisis itself would in my view require.

[39] Freud, *The Interpretation, SE*, V, 427–8.

[40] *Ibid.*, IV, 257.

[41] Virgil, *The Aeneid*, bk. 7, lines 286–571, especially 312, 323–9, 445–55.

[42] Freud, *The Interpretation, SE*, V, 608.

[43] This discovery was made by Ernst Simon, "Sigmund Freud the Jew," Leo Baeck Institute, *Year Book*, II (1957), 301.

[44] Freud to Fliess, July 17, 1899, in Freud, *Origins*, p. 286. Freud does not mention any specific title in his letter, only "den 'Lasalle'" [*sic*]. While Lassalle's separate works were not readily available at the time, several collected editions which would include "The Italian War . . ." were issued in the

nineties. One of these, Erich Blum's *Ferdinand Lassalles politische Reden und Schriften*, appeared in Leipzig in 1899, when Freud was polishing the manuscript of *The Interpretation of Dreams*.

45 He first cited them in a letter to Fliess on Dec. 4, 1896. Freud, *Origins*, p. 172.

46 Ferdinand Lassalle, *Gesammelte Reden und Schriften*, ed. Eduard Bernstein (Berlin, 1919), I, especially 16–17.

47 *Ibid.*, I, 112. See his frank discussion of his political strategy in a letter to Marx, n.d. [mid-May], 1859, in Franz Mehring, ed. *Aus dem literarischen Nachlass von Karl Marx, Friedrich Engels und Ferdinand Lassalle* (Stuttgart, 1902), IV, 150.

48 Freud, *The Interpretation, SE,* IV, 298–302.

49 *Ibid.*, V, 620.

50 Freud to Fliess, Sept. 19, 1901, in Freud, *Origins*, pp. 335–6.

51 Freud to Fliess, March 11, 1902, in Freud, *Origins*, p. 342.

V

GUSTAV KLIMT: PAINTING AND THE CRISIS OF THE LIBERAL EGO

IN THE YEARS 1895 to 1900, when Sigmund Freud, socially withdrawn and professionally frustrated, was at work on his epoch-making *Interpretation of Dreams*, Gustav Klimt was engaged in a not dissimilar enterprise as artistic explorer. While Freud in his critical years worked in obscurity and virtually alone, Klimt headed a band of like-minded artistic heretics who quickly acquired strong social and financial backing. Nonetheless, despite their differences in fame and fortune, Freud and Klimt had much in common. Both pressed a personal crisis of middle age into the service of a radical reorientation of their professional work. Both decisively rejected the physicalist realism in which they had been reared. Both loosed their chosen fields—psychology and art, respectively—from their bio-logical / anatomical moorings. Seeking a road to the open out of the ruins of a substantialist conception of reality, both plunged into the self and embarked on a *voyage intérieur*. When they exhibited to the public the results of their explorations of the world of instinct, they encountered in varying degrees resistance from two quarters: from liberal-rationalist academic orthodoxy, and from anti-Semites. In

the face of this hostility, Freud and Klimt withdrew from the public scene to the shelter of a small but faithful coterie to preserve the new terrain they had conquered.

What leads me to pursue the problem of Klimt is not simply these symmetries of the artist's life and concerns with those of Freud. It is rather that Klimt illuminates so well the socio-cultural situation in which psychoanalysis also arose. He too confronted a period of historical transition imperious in its demand for what Heinz Kohut has called "a reshuffling of the self." With other intellectuals of his class and generation, Klimt shared in a crisis of culture characterized by an ambiguous combination of collective oedipal revolt and narcissistic search for a new self. The Secession movement in modern art, of which Klimt was the recognized leader—it was Austria's equivalent of *art nouveau*—manifested the confused quest for a new life-orientation in visual form.

⋟ I ⋞

GUSTAV KLIMT rose to fame in the service of the bourgeois culture of the Ringstrasse. His social origins, however, were more lowly than the educated liberal middle class with which he soon became identified. His father, an engraver, raised Gustav and his two brothers to follow in his footsteps as artist-craftsman. Like Camillo Sitte, Klimt began his education traditionally, in home apprenticeship, but then embarked on a more modern course of formal vocational schooling. At fourteen, he entered the School of Arts and Crafts *(Kunstgewerbeschule)*, which had been recently established (1868) in the historistic spirit of the new ruling group, as an educational arm of the Museum of Art and Industry. There young Klimt acquired both the technical virtuosity and the wide erudition in the history of art and design that an eclectic age demanded.

Klimt emerged from school as an architectural decorator just as the great Ringstrasse program of monumental building was entering its final phase. He found the opportunity to employ his versatile talent on historical paintings for two of the last great buildings, the Burgtheater and the Museum of Art History. In the first of these, in 1886–88, Klimt, his brother, and his partner Franz Matsch, decorated the grand stairway (Figure 33) with a series of ceiling paintings of

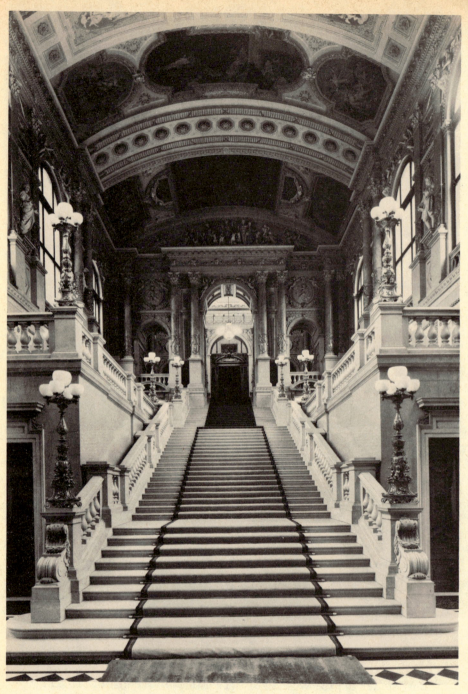

Figure 33. Grand Stairway of the Burgtheater with ceiling paintings by
Klimt and Matsch, 1886–8.

drama, from the festival of Dionysus to modern times. The panels show how closely the liberal fathers had integrated the theatrical and historical outlooks. Each mural celebrated the unity of theater and society, while the series as a whole represented the triumphant absorption of the theaters of the past into the rich eclecticism of Viennese culture. Thus a picture of Shakespeare's theater (Figure 34) represented not merely the players on stage, but also the audience of the age which found its mirror in theater. Klimt recorded in this painting his own sense of identification with the culture he served as painter. He pictured himself, in the company of his partner and his brother, as a member of the Elizabethan audience. (In Figure 34, Klimt stands in front of the column at right, wearing a large ruff.) Where earlier painters had presented themselves as witnesses in the Christian dramas of religion, Klimt historicizes himself as communicant in the Viennese religion of drama.

He painted other votaries of the theater, too—to his own profit. In 1887, the city council commissioned Klimt and Matsch to paint the old Burgtheater before it gave way to the new house (Figure 35). Not just the stage, but the patrons were to be immortalized on

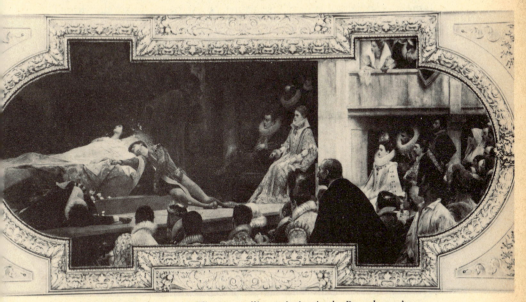

Figure 34. Shakespeare's Theater, *ceiling painting in the Burgtheater's Great Stairway, 1886–8.*

canvas. Klimt, painting the seating space from the stage, included in this vast group portrait of the Viennese élite more than a hundred individual portraits, with such figures as the emperor's mistress Katherina Schratt (herself a Burgtheater actress), the distinguished surgeon Theodor Billroth, and the future mayor Karl Lueger.* The canvas won Klimt the coveted Emperor's Prize in 1890, which catapulted him to prominence.[1]

In 1891, there followed a second important Ringstrasse commisson. For the new Museum of Art History, Klimt decorated the main lobby with a series of female figures representing each era of art. Figure 36 shows Athena, chosen to represent Hellenic culture. She is molded in a smoothly realistic, three-dimensional way. Holding her winged Niké and her spear, she poses like a young Viennese lady trying out a costume for a ball. The background of Athena and of the other figures is executed in the architectural or design idiom of the period portrayed. Here the positivistic historical spirit of the museum celebrates an almost photographic triumph. Not yet thirty, Klimt was well on his way to becoming one of Vienna's leading artists and architectural decorators.

During the very years when his Ringstrasse painting won Klimt his fame, the social stratum whose values he expressed was being undermined. We have seen how, beginning with the economic crash of 1873, challenges to the liberal hegemony grew ever more powerful. At the same time, within liberal society itself cries for reform mingled with groans of despair or disgust at the impotence of liberal Austria. A widespread, collective oedipal revolt began in the seventies to spread through the Austrian middle class. *Die Jungen* became the common name chosen by the rebels in one field after another. *Die Jungen* appeared first in politics, as a New Left in the Constitutional party in the late 1870's. *Jung-Wien* was the literary movement which about 1890 challenged the moralistic stance of nineteenth-century literature in favor of sociological truth and psychological—especially sexual—openness. Schnitzler's playboys and Hofmannsthal's aesthetes are equally products of the dissolution of the faith of the sons in the perspectives of their fathers.

* Klimt's partner recalled how the persons selected for the painting clamored for special sittings; it meant much to one's social status to be immortalized as a Burgtheater patron.

In the mid-nineties, the revolt against tradition finally spread to art and architecture. Within the principal artists' association (the *Künstlergenossenschaft*), *die Jungen*—the name was used again—organized themselves to break the prevailing academic constraints in favor of an open, experimental attitude toward painting. Needless

Figure 35. Auditorium of the Old Burgtheater, Vienna, 1888.

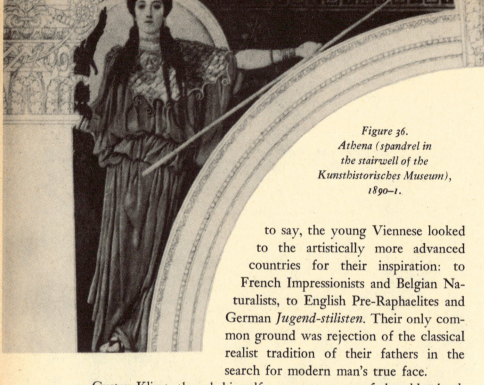

Figure 36.
Athena (spandrel in
the stairwell of the
Kunsthistorisches Museum),
1890–1.

to say, the young Viennese looked to the artistically more advanced countries for their inspiration: to French Impressionists and Belgian Naturalists, to English Pre-Raphaelites and German *Jugend-stilisten.* Their only common ground was rejection of the classical realist tradition of their fathers in the search for modern man's true face.

Gustav Klimt, though himself a young master of the old school, early assumed leadership in the revolt of *die Jungen* in the visual arts. In 1897, he led them out of the established artists' association to found the Secession. It is characteristic of Vienna's cultural situation that the ideology of this association of artists was developed as much by literary men and by people whose origins were in left-liberal politics as it was by artists. Yet that ideology contributed to transforming the painter's way of seeing his world and his way of presenting it.

The first salient feature of the Secession creed was to assert its break with the fathers. Marx once observed that when men are about to make revolution, they fortify themselves by acting as though they are restoring a vanished past. The Secession defined itself not as a mere *salon des réfusés,* but as a new Roman *secessio plebis,* in which the plebs, defiantly rejecting the misrule of the patricians, was withdrawing from the republic.* At the same time,

* The formulation of the Secession's Roman ideology was prepared by Max Burckhard (1854–1912), a Nietzschean, a political progressive, and a high-placed reformer of administrative law, who in 1890 had given up his legal-

the Secession proclaimed its regenerative function, calling its magazine *Ver Sacrum (Sacred Spring)*. The title was based on a Roman ritual of consecration of youth in times of national danger. Where in Rome the elders pledged their children to a divine mission to save society, in Vienna the young pledged themselves to save culture from their elders.[2]

For the first Secession show, Klimt provided a poster proclaiming the generational revolt. He chose as his vehicle the myth of Theseus, who slew the brutal Minotaur in order to liberate the youth of Athens (Figure 37).* We should observe that Klimt presents the theme not directly, but as a dramatic scene on the stage—as though it were Act I in the Secessionist drama. Athena, wise virgin protectrix of the polis chosen by the Austrian Parliament as its symbol, has been appropriated by Klimt to sponsor the liberation of the arts. From politics to culture as the scene of action: that is how the journey runs. In Klimt's Athena in the museum spandrel (Figure 36), the goddess had body, substantiality. Now she is two-dimensional—Klimt's new-found way of stating an abstraction. She sponsors a dramatic idea. Since it is not yet realized, it is treated as disembodied, allegorical, on the stage.

A second major aim of the Secession ideology was to speak the truth about modern man, or, as the architect Otto Wagner put it, "to show modern man his true face."† On the one hand, this involved a critical assault on the screen of historicism and inherited culture with which bourgeois man concealed his modern, practical identity. Ringstrasse Vienna, on which Klimt himself had worked, was ac-

political career to become Director of the Burgtheater, a post which he had just lost when he became co-editor of the Secession's journal, *Ver Sacrum*. He became associated with *die Jungen* in all aspects: in politics, literature, and the visual arts. On *die Jungen* in general, see Carl E. Schorske, "Generational Tension and Cultural Change: Reflections on the Case of Vienna," *Daedalus* (Fall, 1978), 111–22.

* Freud suggested that the bull might have significance as archetypal father: "Zeus seems originally to have been a bull. The god of our own fathers, before the sublimation instigated by the Persians took place, was worshipped as a bull." Freud to Wilhelm Fliess, July 4, 1901, in Sigmund Freud, *The Origins of Psycho-analysis: Letters to Wilhelm Fliess, Drafts and Notes: 1887–1902*, ed. Marie Bonaparte, Anna Freud, Ernst Kriss, tr. Eric Mosbacher and James Strachey (New York, 1954), p. 333.

† See above, pp. 73–4, 83–5.

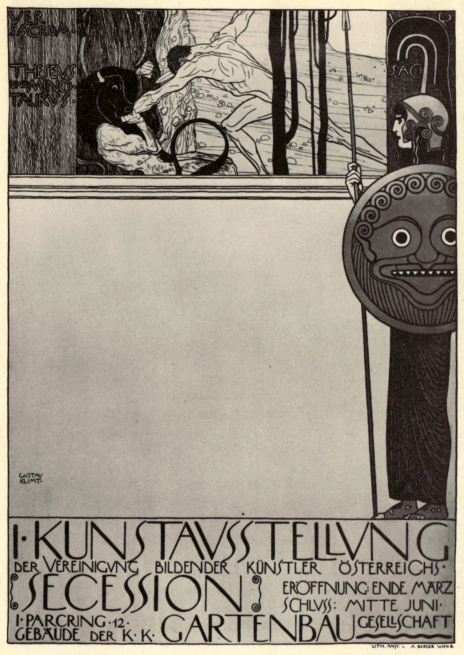

Figure 37. Theseus, poster for the First Secession Exhibition, 1897.

cordingly branded "a Potemkin city" in
the pages of *Ver Sacrum*. But if one were
to strike through the masks of historicity
that concealed modern man, what would
one find? That is the problem which
Klimt posed in an ideological drawing for
the first issue of *Ver Sacrum* (Figure 38).
A nubile waif, "*Nuda veritas*," is, like the
second Athena, two-dimensional—a con-
cept, not a concrete realization. With
vernal symbols at her feet to express the
hope of regeneration, she holds the empty
mirror up to modern man. What will the
artist see in it? Is it a *speculum mundi?* A
reflector of the burning light of truth? Or
perhaps a mirror of Narcissus? That is
the question which we shall now try to
follow with Klimt.

To complete the original Secessionist
roster of aims we must add still one more
idea to those of oedipal revolt and identity
quest: namely, that art should provide for
modern man asylum from the pressure of
modern life. The House of the Secession
was conceived accordingly.[3] The central
idea of its architect, Josef Olbrich, was "to
erect a temple of art which would offer
the art-lover a quiet, elegant place of
refuge." Whereas nineteenth-century mu-
seums were usually modeled on palaces, in
bourgeois emulation of Renaissance and
aristocratic Maecenases, the Secession's
architect found inspiration in a pagan
temple: "There would have to be walls
white and gleaming, holy and chaste.
[They would express] pure dignity, such
as I felt . . . shudder through me as I
stood alone before the unfinished sanctu-
ary of Segesta."[4] An almost sepulchral

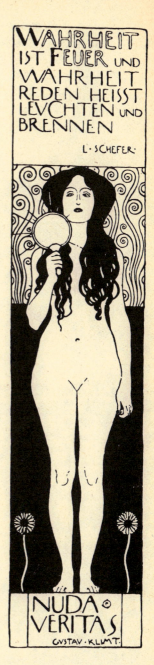

Figure 38.
Nuda Veritas, 1898.

solemnity characterizes the stairway and the portals of the Secession building (Figure 39). The entrance draws the votary inward to the shrine of art. Yet the interior space itself was left completely open by the artist—like the empty mirror of Klimt's *Nuda veritas*. Who could know in advance what spatial organization would meet the requirements of displaying modern art and design? The Secession museum space pioneered the use of movable partitions. As one critic

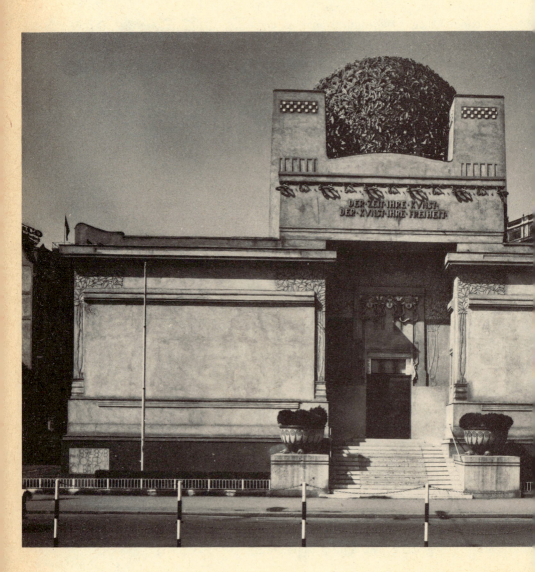

observed, the exhibition space had to be mutable, for that was the nature of modern life, "of the hurrying, scurrying, flickering life, whose manifold mirror image we seek in art, in order to pause for a moment of inward contemplation and dialogue with our own soul."[5]

Over the portals of its building the Secession proclaimed its aims:*

> TO THE AGE ITS ART,
> TO ART ITS FREEDOM.

But none knew what concrete meaning they would hold. Cultural renewal and personal introspection, modern identity and asylum from modernity, truth and pleasure—the components in the Secession manifestoes suggested many contradictory possibilities compatible only in one sense: their common rejection of the nineteenth century's certainties.

II

WITH THE SECESSION established as a secure social support for his work in 1897, Klimt unfolded a truly exuberant creative energy. What our aesthetic sensibility can only perceive as a welter of iconographic and stylistic confusion was in fact a vigorous experimental search for a new message and a new language, all at the same time. Yet despite the confusion

* The motto was chosen by the artists themselves from a list drawn up at their request by a friendly art critic, Ludwig Hevesi. See Ludwig Hevesi, *Acht Jahre Secession* (Vienna, 1906), p. 70, footnote.

Figure 39. Josef Olbrich, House of the Secession, 1898.

of tongues, it soon became clear that Klimt, as he sought the modern face in the mirror of *Nuda veritas*, was heading in the direction of an exploration of instinctual life.

"Sur des pensers nouveaux faisons des vers antiques," a friend of Hofmannsthal's said of his generation's work.* And in truth, myths and symbols drawn from primitive Greece proved a powerful means for laying bare the instinctual life that had been sublimated or repressed in the classic tradition. We have earlier seen how Hofmannsthal used the classical avenue to Dionysian vitality in his reversal of Keats's "Ode on a Grecian Urn." Where Keats had arrested and fixed erotic life in beauty, Hofmannsthal, in his "Idyll on an Ancient Vase Painting," showed his heroine as ripened for surrender to sexuality by the images she had seen on painted vases. Hofmannsthal proceeded from the truth of beauty to reawaken the active instinctual life which had been frozen in art. That the snaky heads of three furies should adorn the entrance of the Secession building bears witness to the same tendency.

Klimt too began his process of desublimating art by employing pre-classical Greek symbols. For the music-salon of Nikolaus Dumba, a Ringstrasse Maecenas, he painted a pair of panels representing the function of music in two sharply contrasting ways. One was historical and social, the other mythic and psychological. The first picture showed Schubert at the piano; the second, a Greek priestess with a kithera (Figures 40 and 41). In these panels, Biedermeier cheerfulness and Dionysian inquietude confront each other across the room. The "Schubert" panel represents *Hausmusik*, music as the aesthetic crown of a social existence both ordered and secure. The whole is bathed in warm candlelight, which softens the outlines of the figures to blend them into social harmony. In time and formal composition, it is a historical genre painting, quite in the line of Klimt's Burgtheater ceiling paintings. But now the clear substantiality of those earlier works, with their positivistic commitment to re-create realistically "wie es eigentlich gewesen (as it actually was)," has been sedulously expunged. Adapting Impressionistic techniques to his service, Klimt substitutes nostalgic evocation for his-

* "On modern thoughts let us make ancient verses." Helmut A. Fiechtner, *Hugo von Hofmannsthal. Die Gestalt des Dichters im Spiegel der Freunde* (Vienna, 1949), p. 52.

torical reconstruction. He paints us a lovely dream, glowing but insubstantial, of an innocent, comforting art that served a comfortable society. One is reminded of Schubert's own song, "An die Musik," in which the poet offered thanks to "the sublime art" for "transporting [him] into a better world." For Klimt and his bourgeois contemporaries, the once-hated age of Metternich was recalled now as the gracious-simple age of Schubert—a Biedermeier Paradise Lost.

How different in both idea and execution is the other "Music" panel (Figure 41). In contrast to the dissolved space of Impressionism in "Schubert," Klimt fills this canvas with symbols realistically represented, symbols as they would survive in archeological remains. The conception of art and the symbols to convey it bespeak Klimt's debt to two figures who play an important part in the *fin-de-siècle* crisis of rationalism: Schopenhauer and Nietzsche.[6] Music appears as a tragic muse, with the power of transforming buried instincts and mysterious cosmic power into harmony. The symbols are those which Nietzsche used in *The Birth of Tragedy*. The songstress's instrument is Apollo's—a kithera; but the materials of her song are Dionysian. On the hard stone tomb behind her are two figures: one is Silenus, the companion of Dionysus, whom Nietzsche called "a symbol of the sexual omnipotence of nature" and "companion of the sufferings of the god."[7] The other is the Sphinx, child-eating mother, embodiment of the metamorphic continuum of animal and man, of terror and female beauty. Silenus and Sphinx seem to represent the buried instinctual forces which the Apollonian necromancer will summon in song from the tomb of time. Thus, over against the gently glowing lost historical paradise of Schubert stand the archetypal symbols of instinctual energies, to which art has mysterious access through the heavy stony lid of civilization's coffer.

In the same year, 1898, Klimt produced another painting which made clear that his search for modern man would lead him to break open that coffer. It was another Athena, Klimt's third and fullest representation of the virgin goddess. He had painted her first in the Museum of Art History as a full-bodied protectrix of art-in-history (Figure 36). Then she became more abstract (hence two-dimensional) as symbolic champion of the Secession's hero, Theseus, in his civilizing oedipal revolt (Figure 37). In the new version (Plate I) Athena looms before us vaguely molded, impassive but with

enigmatic force. But more is changed than the character of Athena. In the lower left-hand corner of the picture, Niké, winged victory, is no longer in Athena's hand. In her place stands *Nuda veritas*, holding up her mirror to modern man. But *Nuda veritas* too has changed. Once a two-dimensional waif, she is now shapely and sexy, with hair, even pubic hair, of flaming red.[8] Not *Nuda veritas*, but *Vera nuditas!* Here we have a crucial turning point in the emergence of a new culture from an old. Klimt is distorting the ancient iconography in a truly subversive way: Athena, virgin goddess, is no longer the symbol of a national polis and of ordering wisdom, as she holds on her orb the sensual bearer of the mirror of modern man. Truly *les pensers nouveaux* are breaking out of the chrysalis of their *vers antiques!*

Like Freud with his passion for archaic culture and archeological excavation, Klimt uses classical symbols to serve as a metaphorical

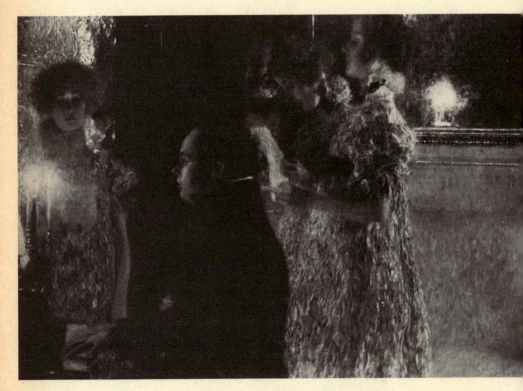

Figure 40. Schubert at the Piano, 1899.

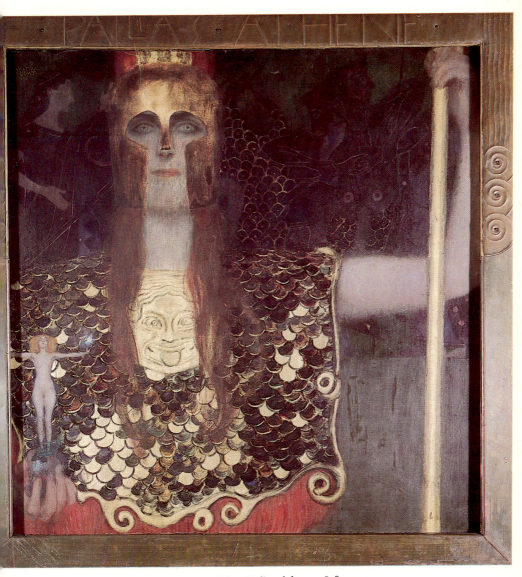

Plate I. *Gustav Klimt, Pallas Athena, 1898.*

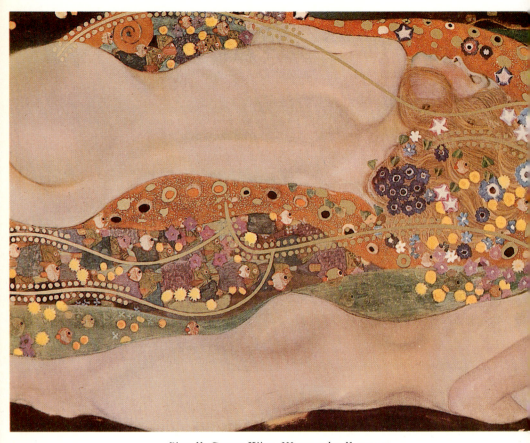

Plate II. Gustav Klimt, Watersnakes II, 1904–7.

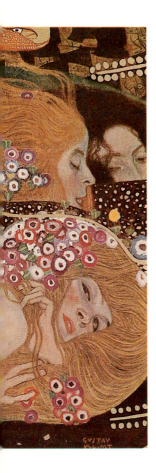

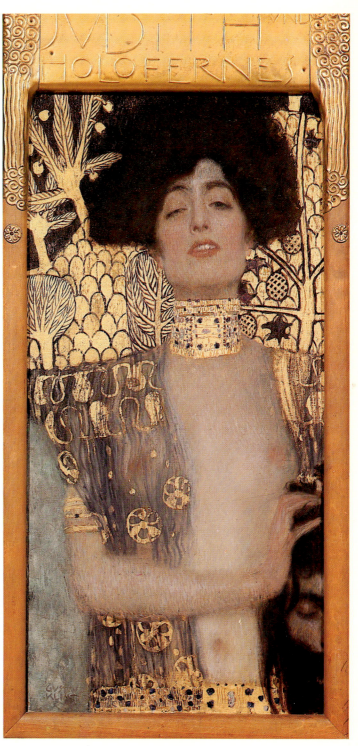

Plate III. *Gustav Klimt, Judith and Holofernes, 1901.*

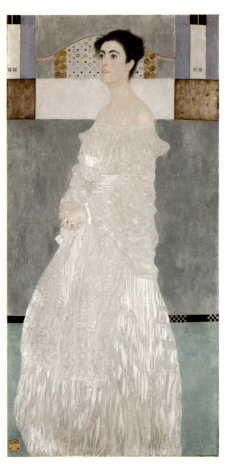

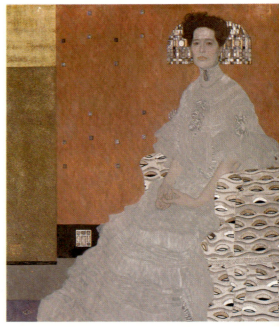

Plate V. Gustav Klimt, Portrait of
Fritza Riedler, 1906.

Plate IV. Gustav Klimt, Portrait of
Margaret Stonborough-
Wittgenstein, 1905.

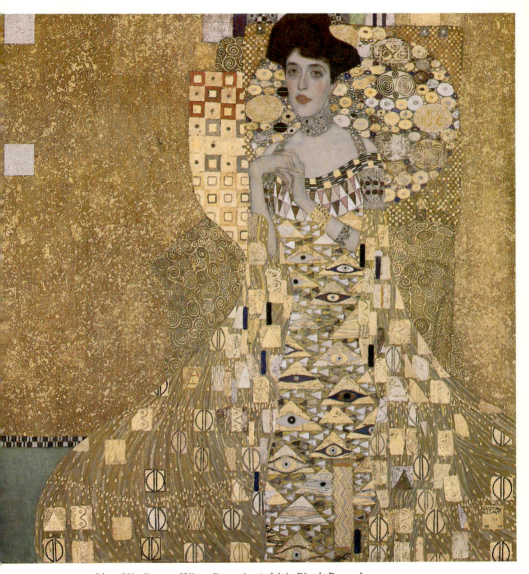

Plate VI. Gustav Klimt, Portrait of Adele Bloch-Bauer I, 1907.

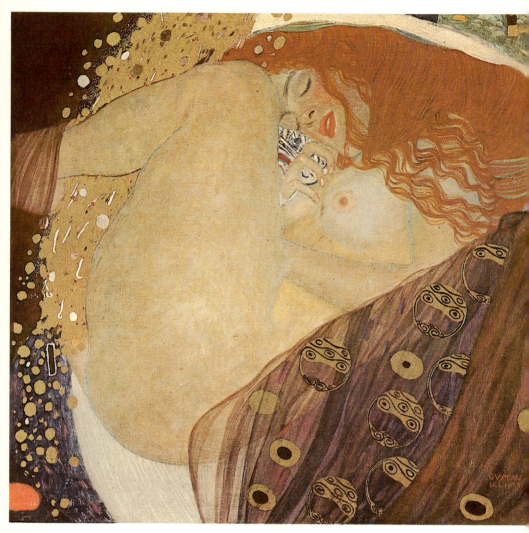

Plate VII. Gustav Klimt, Danae, 1907–8.

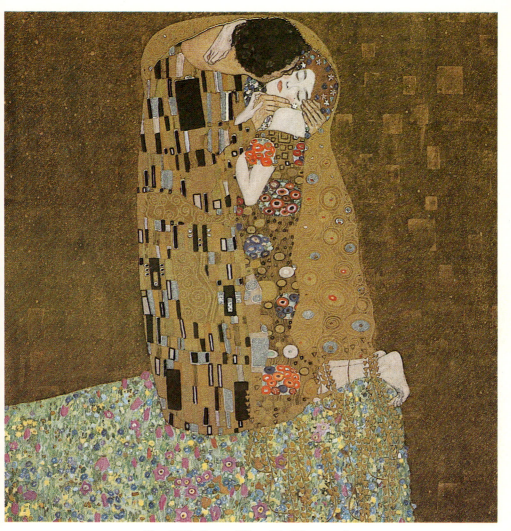

Plate VIII. Gustav Klimt, The Kiss, 1907–8.

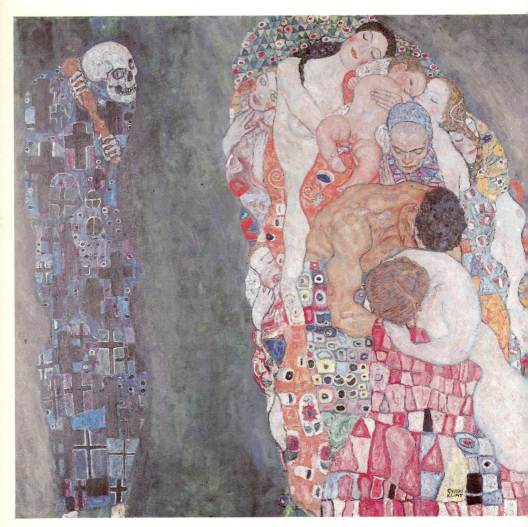

Plate IX. Gustav Klimt, Death and Life, 1916.

bridge to the excavation of the instinctual, especially of the erotic life. The erstwhile social painter of theater became the psychological painter of woman. After 1898, the angelic, sweetly feminine type of the "Schubert" picture disappeared for nearly a decade. Klimt turned to woman as a sensual creature, developing her full potential for pleasure and pain, life and death. In an endless stream of drawings, Klimt tried to capture the feeling of femaleness. Figure 42 shows but one of his many efforts to grasp and record the lineaments of ecstasy. In "Fish Blood," a drawing for the first issue of *Ver Sacrum*, Klimt celebrates womanly sensuality in a more active aspect (Figure 43). His joyful creatures surrender themselves freely to the watery element as it bears them swiftly downward on its unchanneled course. We see here what will soon become a major preoccupation of Klimt—one he shared with other *art nouveau* artists: woman's hair. The flowing tresses in this case mediate the sinuous bodies to

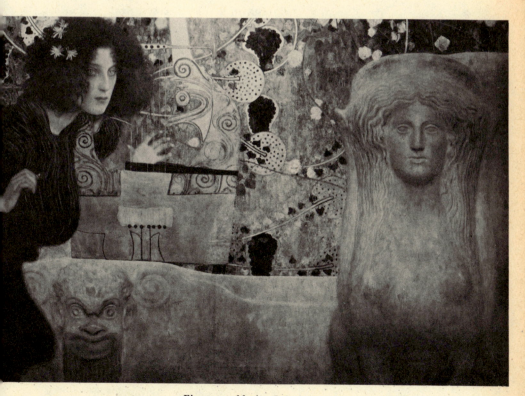

Figure 41. Music, 1898.

the powerful linear thrust of the water. Klimt's women are at home in a liquefied world, where the male would quickly drown, like sailors seduced by mermaids.

In "Watersnakes" (Plate II), the woman's sensuality both gains a new concreteness and becomes more threatening. Klimt's lubricious playgirls of the deep, in the half-somnolence of sexual satisfaction, are completely at one with their viscous medium. They are indeed watersnakes, their strongly corded hair in threatening contrast to the softness of the flesh and the sensitivity of the hands. Klimt's women-as-snakes overwhelm the male not so much with the temptation of the Garden as with a sense of his inadequacy in the face of their seemingly inexhaustible capacity for carnal bliss. In his exploration of the erotic, Klimt banished the moral sense of sin that had plagued the righteous fathers. But in its place arose a fear of sex that haunted many of the sensitive sons. Woman, like the Sphinx, threatens the male. Some of Klimt's finest paintings deal with the theme of castration, in its traditional inverted disguise as decapitation. His "Judith" (Plate III), fresh from her love-slaying of Holofernes, glows in quasi-maternal voluptuousness. In his treatment of Salome, the *fin de siècle*'s favorite phallic female, Klimt frighteningly contrasts the clawed hands and bony face with the warm contours of the body (Figure 44).

"To the Age its Art, to Art its Freedom," the Secession motto had proudly proclaimed. Seeking the image of pleasure-giving Eros as he held up the mirror to modern man, Klimt disclosed instead the psychological problems which attended the attempt to liberate sexuality from the constraints of a moralistic culture. The joyous

Figure 42. Untitled ("Sensuous Girl")
(no date).

explorer of Eros found himself falling into the coils of *la femme tentaculaire*. The new freedom was turning into a nightmare of anxiety.

❧ III ☙

''Gustav Klimt,'' wrote the poet Peter Altenberg, "you are at once a painter of vision and a modern *philosopher*, an altogether modern *poet*. As you paint, you suddenly transform yourself, fairy-

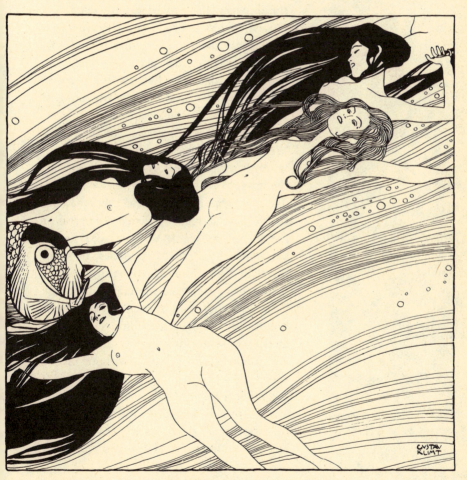

Figure 43. Fish Blood, 1898.

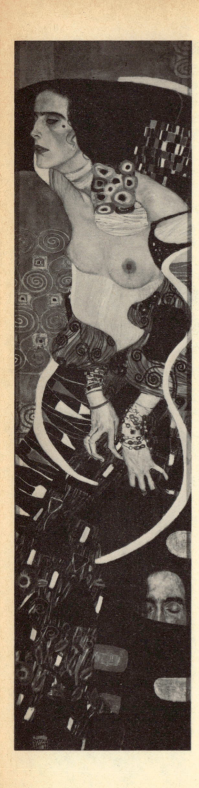

tale-like, into the most modern man, which perhaps you are not in daily life."[9] Klimt must have been pleased by Altenberg's accolade. His wide-ranging experimentation as a painter was connected with a larger mission. Klimt was a questioner and a prober of the questionable, the problematical, in personal experience and in culture. Like Freud, he sought answers to his riddles by exploring his own depths, and often made the answers plain to others by exhibiting himself. What he began as a cheerful quest for sensual liberation very nearly ended in professional—perhaps even personal psychological—disaster. But in the process Klimt became a kind of meta-psychologist in the world of vision.

In the nineties, the very nature of reality became problematical for Klimt. He did not know whether to seek it in the physical or the metaphysical, in the flesh or in the spirit. These traditional categories were losing their clarity and independence. The crisis of the liberal ego came to focus on the indeterminacy of the boundaries between them. In Klimt's constantly shifting representations of space and substance—from the naturalistically solid through the impressionistically fluid to the abstract and geometrically static—we can see the groping for orientation in a world without secure coordinates.

Appropriately enough, the University of Vienna provided Klimt with the occasion for presenting on canvas his vision of the human condition in its broadest sense. In

Figure 44. Salome (Judith II), 1909.

1894, the Ministry of Culture,* after consultation with a faculty committee, invited Klimt to design three ceiling paintings for the ceremonial hall of the new University. At that time, Klimt had just risen to prominence as the young master decorator of the Ringstrasse, of which the new University was one of the final monumental projects. But by the time he executed the commission (1898–1904), Klimt had become deeply engaged in the Secession and in his own quest for new truth. Painting his new vision for the University project, he brought upon himself the wrath of both old rationalists and new anti-Semites.[10] In the course of the ensuing struggle, the function of modern art in Vienna was vigorously debated by painters, public, and politicians alike. Out of that struggle, the limits of Secessionist radicalism were set with unmistakable clarity. Klimt's personal defeat in the battle brought an end to his role as subverter of the ancient way. It led him both to a more restricted definition of his mission as artist of modernity and ultimately to a new, abstract phase in his painting.

The theme of the University paintings was conceived by Klimt's academic clients in the best Enlightenment tradition: "The triumph of light over darkness." Around a central panel on this subject, to be designed by Klimt's partner, Franz Matsch, four paintings were to represent the four faculties. Klimt was to execute three—"Philosophy," "Medicine," and "Jurisprudence." After some preliminary disagreements in 1898 over his initial designs, the faculty commission and the Ministry of Culture granted Klimt a free hand. In 1900 he presented his first painting, "Philosophy," and in 1901, "Medicine."

Neither picture reflected an easy conquest of Light over Darkness. In "Philosophy" (Figure 45), Klimt showed himself to be still a child of a theatrical culture. He presents the world to us as if we were viewing it from the pit, a *theatrum mundi* in the Baroque tradition. But where the Baroque *theatrum mundi* was clearly stratified into Heaven, Earth, and Hell, now Earth itself seems gone, dissolved into a fusion of the other two spheres. The tangled bodies of suffering mankind drift slowly by, suspended aimless in a viscous void. Out of the cosmic murk—the stars are far behind—a heavy,

* I have abbreviated the full name of the office, "Ministerium für Kultus und Unterricht." The Ministry was in charge of religious, educational, and cultural policy.

sleepy Sphinx looms all unseeing, herself but a condensation of atomized space. Only the face at the base of the picture suggests in its luminosity the existence of a conscious mind. *Das Wissen*, as the catalogue calls this figure,[11] is placed in the rays of the foot-lights, like a prompter turned around, as though to cue us, the audience, into the cosmic drama.

Klimt's vision of the universe is Schopenhauer's—the World as Will, as blind energy in an endless round of meaningless parturience, love and death. Peter Vergo has suggested that Klimt drew his understanding of Schopenhauer from Wagner, especially from the latter's concise summary of the philosopher's thought in his widely read essay *Beethoven*, and that the iconography as well as the message of "Philosophy" was influenced by *Das Rheingold*.[12] Since Klimt moved in social and intellectual circles in which the interlocked figures of Wagner, Schopenhauer, and Nietzsche were all admired, he could have drawn inspiration for his cosmic vision from any one of them. Vergo has revealed the possible derivation of the central figure of "Philosophy" from Wagner's Erda; both her placement and her mantic posture support such an interpretation.* Yet Wagner's Erda is a warm, grief-laden earth-mother; Klimt's *Wissen* is cool and hard. Nor does she worry any more than Klimt and his prosperous patrons about the curse of gold that was so decisive for the politically charged Wagner and his cosmic heroes. Klimt's philosophic priestess betrays in her eerily luminous eyes a different attitude: a wisdom, at once wild and icy, affirming the World of Will. This rendering points, in my view, rather to Nietzsche's than to Wagner's reading of Schopenhauer's existential metaphysic. We have seen how Klimt had drawn on Nietzsche's *Birth of Tragedy* for his "Music" in 1898. Now his figure of Philosophy suggests the dark rhapsodic language of Zarathustra's "Drunken Song of Midnight":

> Oh man! Take heed:
> What does the deep midnight declare?
> "I was asleep—
> From a deep dream I woke and know:
> The world is deep,
> Deeper than the day has known.

* Vergo shows how closely both the stage directions for Erda's first appearance in *Das Rheingold* and the substance of her utterance resemble Klimt's color and composition. See note 12 of this chapter.

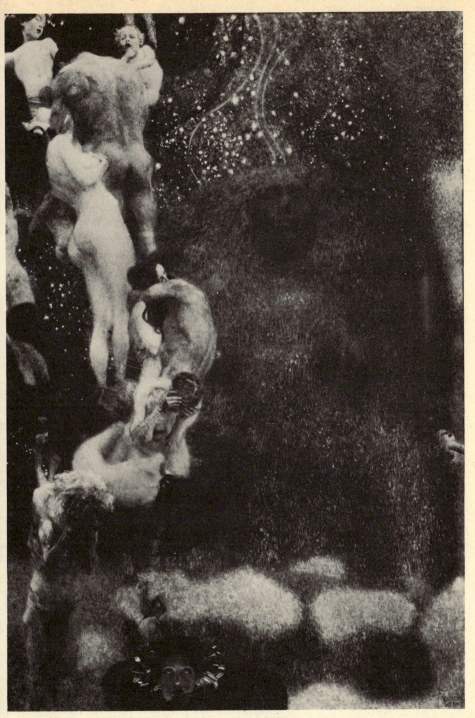

Figure 45. Philosophy, University ceiling painting, 1900.

Deep is its woe—
Desire—deeper still than agony:
Woe speaks: Go, die!
But desire wants eternity—
Wants deep, deep eternity!"*

This is the same song that Klimt's later hero, Gustav Mahler, had used as the center of his philosophic Third Symphony, completed in 1896. Indeed, Mahler's magnificent setting of the song can afford the viewer of Klimt's "Philosophy" another kind of access to that intellectual generation's painful, psychologized world-view—a view that at once affirms desire and suffers the deathly dissolution of the boundaries of ego and world which desire decrees.†[13]

Even Nietzsche's explication of his Midnight Song in the glowing finale of *Thus Spoke Zarathustra* reads as though written to elucidate

* O Mensch! Gib acht:
Was spricht die tiefe Mitternacht?
"Ich schlief, ich schlief—
Aus tiefen Traum bin ich erwacht;—
Die Welt ist Tief,
Und tiefer als der Tag gedacht.
Tief ist ihr Weh—
Lust—tiefer noch als Herzeleid;
Weh spricht: Vergeh!
Doch alle Lust will Ewigkeit—
—will tiefe, tiefe Ewigkeit!"
From the chapter "Das andere Tanzlied," end of Part III, *Also sprach Zarathustra*.

† There is no evidence for any direct philosophic influence of Mahler on Klimt. The painter probably did not know Mahler well until 1902, when the latter married Alma Schindler, whom Klimt had known since her childhood. But from the time of Mahler's appointment as Director of the Opera in 1897, they traveled in overlapping social and intellectual circles, which were permeated with Wagnerian and Nietzschean thought. Both frequented the house of Professor Zuckerkandl, and both knew well his friend, the Nietzschean lawyer Max Burckhard, director of the Burgtheater and editor of *Ver Sacrum*. When Mahler finally left Vienna for America after his enforced retirement from the Court Opera, Klimt was at the railway station with other Mahler enthusiasts to bid the conductor farewell. Cf., e.g., Alma Mahler-Werfel, *Mein Leben* (Frankfurt am Main, 1965), pp. 18, 22–6; Berta Szeps Zuckerkandl, *My Life and History*, tr. John Sommerfield (London, 1938), pp. 143–4, 151; Kurt Blaukopf, *Gustav Mahler*, tr. Inge Goodwin (New York and Washington, 1973), p. 218.

Klimt's painting.[14] Conversely, Klimt's entranced priestess with vine leaves in her hair could serve as an illustration of Nietzsche's midnight singer—"this drunken poetess" who has become, as her luminous upturned eyes suggest, "overwakeful [*überwach*]."* Like Nietzsche's poetess, Klimt's *Wissen* ingests into dream the pain—and, more, desire itself [*Lust*]—to affirm life in its mysterious totality: "Do you say 'yes' to a single desire? Oh, my friends, [then] you say 'yes' to all pain." As in Klimt's floating chain of being, "all things . . . are interlinked, entwined, enamored . . . thus you shall love the world."†

It was not thus that the professors of the University saw or loved the world. They had a different conception of "The triumph of light over darkness," and of how it should be represented in their halls. Klimt's painting touched a nerve end in the academic body. His metaphysical *Nuda veritas* had led him, with a few other intellectuals of his generation, into a terrain beyond the established limits of reason and right. Eighty-seven faculty members signed a petition protesting against the panel, and asking the Ministry of Culture to reject it. The fat was in the fire. Klimt's art was becoming an ideological issue and soon would be a political one.

IV

THE CRISIS over the University paintings has its importance for art history in its impact on the development of Klimt's work. For the general historian, however, the artistic *cause célèbre* opens a window on a wider problem, the intricate relationship between culture and politics as the new century dawned. The strength of the reaction to "Philosophy" and the positions taken by Klimt's opponents and defenders reveals how deep was the crisis of rationalism

* Klimt had originally conceived the allegorical figure of *Wissen* in the traditional manner of a seated female in profile, bowed in thought like Rodin's thinker. Only in 1899 did he substitute the Nietzschean midnight singer rising in challenging frontality. Cf. Christian M. Nebehay, *Klimt: Dokumentation* (Vienna, 1968), pp. 214–16, Figs. 311–315.
† Friedrich Nietzsche, *Also Sprach Zarathustra*, Part IV, "Das trunkene Lied," Section 10.

within the Austrian élite. The champions of the two components of
Austrian liberal culture identified in my first essay as complementary
—the culture of law and the culture of grace—now confronted each
other in hostile array. The imperial government, which had, for
political reasons yet to be examined, given support to the new
Secessionist art, soon found itself caught in the crossfire between the
contending forces of old ethical and new aesthetic culture. When
political issues became cultural, cultural issues became political. To
understand the significance of Klimt's art and the turn it took, I shall
first examine the cultural-political convergence in the University
painting crisis, looking at it closely through the positions of three
leading actors in the drama, all of them men of learning and erstwhile
colleagues at the University of Vienna: Friedrich Jodl, an orthodox
liberal philosopher who led the faculty opposition to Klimt; Franz
Wickhoff, a pioneer in the development of a new art history, whose
cultural relativism made him a ready ally of Klimt and modern art;
and Wilhelm von Hartel, formerly a classics professor, now Minister
of Culture. Hartel served in the cabinet of Ernest von Koerber, the
first ministry to attempt, in the face of a paralyzed Parliament, to
impose an enlightened policy by bureaucratic decree. As Klimt
acquired political significance for Hartel, so politics acquired exis-
tential and, in the end, aesthetic significance for Klimt.

The protesting professors showed in their initial petition that
they understood the meaning of Klimt's painting of Philosophy
even though they failed to identify explicitly its Schopenhauerian
world view. They accused Klimt of presenting "unclear ideas
through unclear forms *(Verschwommene Gedanken durch ver-
schwommene Formen)*." The critics' striking adjective, *ver-
schwommen*, suggested well the liquefaction of boundaries which
we have seen in the picture. While respecting the virtuosity with
which Klimt had employed color to create an atmosphere to suit his
"gloomy fantasm," this virtue could not compensate for the chaos of
symbols and the confusion of form they saw as revealing the in-
coherence of the idea behind the painting. Lacking intellectual grasp,
Klimt had produced an aesthetic failure, they maintained.[15]

The rector, a theologian named Wilhelm von Neumann, supporting
the professorial resisters, went to the heart of the controversy. In
an age when philosophy sought truth in the exact sciences, he said,
it did not deserve to be represented as a nebulous, fantastic con-

struct.[16] The ideal of mastery of nature through scientific work was simply violated by Klimt's image of a problematic, mysterious struggle in nature. What the traditionalists wished was evidently something akin to Raphael's "School of Athens," where the learned men of antiquity—Plato, Aristotle, Euclid, and others—are shown in calm discourse on the nature of things. One professor suggested a scene in which the philosophers of the ages would be shown assembled in a grove, talking, relaxing, tutoring students.[17] It should be noted that these suggestions center on a *social* imagery: learned men functioning in society, spreading mastery of nature and human life. Klimt's "Philosophy" had indeed outflanked the social element. In his universe, the socially supported structure of mastery had disappeared in the face of an enigmatic, omnipotent nature and the interior feelings of impotent man caught up in it.

Although the rector was charged by Klimt's supporters with having himself organized the professorial protest, its principal spokesman was the philosopher Friedrich Jodl (1849–1914).[18] Both the man and his line of argument illuminate the significance of Klimt for classical liberal culture in transformation. As an academic philosopher, Jodl championed Anglo-Saxon empiricism and utilitarianism, carrying this outlook, so readily assimilated by Austrian liberalism, into the area of ethics.[19] His well-known *History of Ethics* celebrated the emergence of a humanistic ethics out of the chrysalis of religious illusion. Rather like John Dewey in America, Jodl won public prominence as a philosophic spokesman for a variety of progressive social and political causes. In 1894, he was co-founder of the Vienna Ethical Society, inspired by the American Ethical Culture movement for a scientific morality freed from religious dogma. He championed woman's emancipation and civil liberties, and headed the Association for Adult Education (Volksbildungsverein) as part of the effort to bridge the regrettable cultural gap between upper and lower classes.[20] In short, Jodl represented in all its dimensions the progressivist phase of liberal rationalism at the turn of the century. The very nature of his rationalism, however, prevented him from allowing a painting of "dark, obscure symbolism which could be comprehended by few," to grace the University's precincts. Philosophy, which the painting was supposed to portray, was after all a rational affair. In explicit support of Jodl, the critic Karl Kraus took a similar position: Klimt had no understanding of philosophy, he said, and should have

left the choice of allegorical means to represent it to his patrons, the professors.[21]

It was not easy for a champion of freedom like Jodl to find himself identified in the Klimt affair with more traditional, religious-minded objectors to nudity and with opponents of artistic freedom. Yet Klimt's eroticized, organic representation of reality simply pushed Jodl and other stalwart defenders of the rationalist persuasion into the camp of their older enemies, the censorious clericals. To avoid the embarrassing alliance, therefore, Jodl tried to shift the issue from philosophic substance to aesthetic quality: It is "not against nude art, nor against free art that we struggle," he told the *Neue Freie Presse*, "but against ugly art."[22]

It was this supposedly purely aesthetic judgment that provided Klimt's defenders in the academic establishment with their cue for counterattack. A group of ten professors, led by the art historian Franz Wickhoff, submitted a counterpetition to the Ministry, denying that faculty members had the expertise to make judgments in aesthetic questions.[23] "What is ugly?" That was the issue on which Wickhoff chose to pick up the gauntlet that Jodl had thrown down.

Franz Wickhoff (1853–1909) brought to Klimt's cause more than his professional authority, important though that was. Along with Alois Riegl (1858–1905), Wickhoff was developing a new view of art history peculiarly suitable to creating understanding for innovation in art. The motto which the Secession had inscribed on its building in 1898—"To the Age its Art, to Art its Freedom"—could equally have served Wickhoff's emergent Vienna school of art history. As Klimt and the Secession rejected the Beaux Arts tradition and the classical realism of Ringstrasse culture, so Wickhoff and Riegl in the nineties assaulted the primacy of the classical aesthetic. Where their mid-century predecessors dismissed late Roman and early Christian art as decadent in relation to the Greek model, the new scholars saw an original art justified by the new cultural values which gave rise to it. "Decadence" for them was not in the object but in the eye of the beholder. Riegl rehabilitated Baroque in relation to the previous taste for Renaissance; Biedermeier in relation to the neo-classical. The old criteria of formal perfection were swept away, and with them the related ideas of aesthetic progress and decline. In art history, no less than in general history, what counted for the new Vienna school was, as Ranke had put it, the equality of all eras in

the eyes of God. In order to appreciate the unique forms that every age produced, one had to get at what Riegl called the society's *Kunstwollen:* the intention and purpose of art in every culture. This produced not progress and regression, but eternal transformation— an appreciation of plurality in art beyond any single *a priori* aesthetic standard.

Wickhoff and Riegl thus brought to art history the late liberal, non-teleological sense of flux so common in *fin-de-siècle* culture, and so clear in Klimt's "Philosophy" itself. Their work, as one of their most distinguished disciples said, represented "the victory of the psychological-historical conception of art over absolute aesthetics."[24] It revealed in the arts of past and present "a wealth of new sensations," and opened up plural modes of vision which Enlightenment aesthetics had blocked off. One wonders how many knew, when Wickhoff appeared to defend Klimt, that he would now employ on the modern artist's behalf the analytic method he had earlier tried on the very work of Raphael's which Klimt's opponents upheld against him: the painting of the School of Athens.[25]

"What Is Ugly?" In a polemical lecture on Klimt under that title given at the Philosophical Society, Wickhoff suggested that the idea of the ugly had deep bio-social origins, still operative in Klimt's antagonists.[26] Primitive man saw as ugly those forms which seemed harmful to the continuation of the species. Historical man, to be sure, had attenuated this connection. As long as the dominant classes and the people had continued to share a single set of ethical and religious ideals, artists and patrons had moved forward together, with new conceptions of the natural and new standards of beauty evolving together. In recent times, however, humanistic and anti-quarian studies had imbued the public with a sense of the primacy, if not the superiority, of classical art. Thus there arose an anti-thesis between the past-oriented public and the ever-progressing artist. Throughout modern times, Wickhoff said, the educated classes, led by the men of learning—prestigious but "second-class minds"—had identified beauty with the work of the past. They came to perceive as ugly the new and immediate visions of nature generated by artists. Such hypertrophied historical piety, Wickhoff argued, was now reaching its end. The present era has its own life of feeling, which the artistic genius expresses in poetic-physical form. Those who see modern art as ugly, he implied to his philosophic audience,

are those who cannot face modern truth. Wickhoff ended his lecture with an eloquent interpretation of Klimt's "Philosophy." He singled out the figure of *Wissen* as one who shone forth a consoling light, "like a star in the evening sky" of Klimt's oppressive, spaced-out world.

Although the debate between the two cultures that Jodl and Wickhoff represented—old ethics and new aesthetics—raged on the podium and in the press in the spring and summer of 1900, it was in the political sphere that the issue would be finally decided. Indeed, Klimt's painting achieved full significance only in its wider political context. Always an important constituent in Austrian public life, in the year 1900 art came to occupy a particularly crucial place in state policy. Modern art, ironically enough, came into official favor just when modern parliamentary government was falling apart. Why?

From 1897 to 1900, the nationality problem, with its conflicts over language rights in administration and schooling, had virtually paralyzed the government. Parliamentary obstructionism, led by the Czechs and Germans in turn, had finally rendered the construction of ministries out of party representatives impossible. The monarchy, which had begun its constitutional era in 1867 with a *Bürgerministerium* (Citizens' Ministry), suspended it in 1900 with a *Beamtenministerium* (Bureaucrats' Ministry). Austrian liberalism thus reverted to its eighteenth-century tradition of enlightened absolutism and bureaucratic rule. The formation of the Beamtenministerium in 1900 was entrusted to an able and imaginative official, Dr. Ernest von Koerber (1850–1919), who was determined to transcend the hopelessly dissonant political substance of Austria and to rule the country by decree as long as necessary. Koerber's long-range strategy was to outflank political tensions by a two-pronged campaign of modernization, one in the area of economics, the other in culture. In those fields, he believed, all the nationalities could find a common, overriding interest. "Material and cultural issues are knocking at the gates of the Empire," Koerber told the Reichsrat in his opening appeal. "The administration cannot put them by [merely] because the political and nationality problems are not yet solved." Pledging "the full power of the state in the service of culture and the economy," Koerber went to work to rejuvenate the bureaucracy, imbuing it with a fresh spirit of social service, "to transform [it]

into a modern instrument.''[27] To command the two prongs of his offensive, Koerber chose two outstanding former professors of the University of Vienna. The great economist Eugen Boehm-Bawerk became Minister of Finance, entrusted with the development of progressive taxation and economic policy reforms. Wilhelm Ritter von Hartel, respected both as a leading classical scholar and as a judicious administrator in the nationalistically charged area of education, took over the Ministry of Culture. For four years, 1900–1904, Koerber's ministry pursued its effort to save Austria through economic and cultural development.[28]

Within this framework of supra-national policy, state encouragement of the Secessionist movement made complete sense. Its artists were as truly cosmopolitan in spirit as the bureaucracy and the Viennese upper middle class. At a time when nationalist groups were developing separate ethnic arts, the Secession had taken the opposite road. Deliberately opening Austria to European currents, it had reaffirmed in a modern spirit the traditional universalism of the Empire. A Secession spokesperson had explained her commitment to the movement as "a question of defending a purely Austrian culture, a form of art that would weld together all the characteristics of our multitude of constituent peoples into a new and proud unity," what, in another place, she called a "Kunstvolk" (an art people).[29] The Minister of Culture, even before the formation of the Koerber ministry, revealed in strikingly similar terms the assumptions of the state in creating an Arts Council in 1899 as a body to represent its interest. He singled out the potential of the arts for transcending nationality conflict: "Although every development is rooted in national soil, yet works of art speak a common language, and, entering into noble competition, lead to mutual understanding and reciprocal respect."[30] Even while proclaiming that the state would favor no particular tendency and that art must develop free of regimentation, according to its own laws, the minister showed special solicitude for modern art. He urged the new Council "to sustain . . . the fresh breeze that is blowing in domestic art, and to bring new resources to it." Thus it came about that, while other European governments still shied away from modern art, the ancient Habsburg monarchy actively fostered it.

Wilhelm von Hartel (1839–1907) was well suited by scholarly

conviction, personal connections, and temperament to develop the new art policy.* As an impecunious student he had been tutor to Karl Lanckoronski, scion of a powerful Polish aristocratic family. Lanckoronski later became a great art collector, and used his influence to further the professional and administrative career of his former teacher. As a professor of classics, Hartel worked with Professor Wickhoff in the fight for a new history beyond the ideas of progress and decadence. In 1895, Hartel and Wickhoff collaborated on a work that still ranks as a pioneering classic of interdisciplinary scholarship: an edition of an early Christian codex, the "Vienna Genesis." While Hartel edited the Greek biblical text, Wickhoff provided an analysis of its Roman illustrations, showing that what had been regarded as a decadent echo of Greek painting was in fact a glorious transformation and adaptation of classical styles and modes of representation to the emergent Roman-Christian value system.[31]

As Hartel had committed himself in his scholarship to overcoming "sacrosanct ideals of art and conceptions of style,"[32] so as cultural policymaker he gladly threw the weight of the state behind the modern movement. Through the advisory Arts Council, he could draw on leading Secessionists in formulating state policy. Architect Otto Wagner, who idolized Klimt as "the greatest artist who ever walked the earth,"[33] and Karl Moll, a painter with a strong head for business, played a vigorous part in the Council's deliberations.[34] Modern artists won painting and architectural commissions and teaching posts. Not only some of Austria's major public buildings,

* Hartel's career is exemplary for the cultivated liberal bureaucracy. Son of a linen weaver, he rose through a combination of academic ability, tact, and aristocratic patronage into the educational bureaucracy and the service nobility. From 1896 to 1899, he was section chief in charge of university and secondary schools. He played a key role in opening university study to women, and in dealing patiently with nationalist student unrest. Like many other progressive liberals, Hartel was a fanatical Wagnerite but had no patience with anti-Semitism. In the face of anti-Semitic attacks in Parliament he defended the award of a literary prize to Arthur Schnitzler. Despite his bespectacled academic exterior, he was known for his wit in the salons of the "second society," where men of affairs and intellectuals still met and mingled freely. Cf. A. Engelbrecht, "Wilhelm Ritter von Hartel," *Biographisches Jahrbuch für die Altertumswissenschaft*, XXXI (1908), 75–107.

but even her postage stamps and currency were designed by
Secessionists.*35 The arts project dearest to Hartel, however, and
one vigorously pressed by the Secession from its inception, was
the creation of a Modern Gallery. It was ratified by the emperor in
June 1902, and opened its doors in April 1903. Meanwhile, Hartel
actively collected by purchase and gifts the artworks for the state's
modern collection. Such was the policy context in which Klimt's
University paintings were received.

Alas for Klimt and the government's intentions, official patronage
of the Secessionists did not pass unchallenged. The language of the
new art, far from softening the antagonisms of a divided nation, fed
fuel to the flames. From the halls of the University, they spread to
the press, and soon to the political arena. It was one thing for the
government to cope with professors who scented a subversive
counterculture in Klimt's first ceiling painting—Minister von Hartel
and his Arts Council simply ignored their petition.36 It was quite
another to cope with the opposition of Catholic conservatives and
the New Right. The most strident note amid the din against
"Philosophy" from the philistine press was sounded by the *Deutsches
Volksblatt*, organ of Mayor Lueger's Christian Socials, and it was
the cry of anti-Semitism. The *Volksblatt* found a way of identifying
Klimt and Wickhoff with the Jews, though both were Gentiles—
through the Philosophical Society. Not only had the Society invited
Wickhoff to speak on Klimt's behalf, but it had greeted his defense
with "prolonged and frenetic applause." Such adulation of "immoral"
art was not surprising, the *Volksblatt* reporter opined, for in that
stronghold of liberal activism, "the membership cards were made of

* Otto Wagner's Postal Savings Office and his church at the Steinhof Hospital
were perhaps the most radically modern monumental buildings built by a
European state since the erection of the Eiffel Tower in 1889. Koloman Moser
designed the postage stamps of the series 1908–1913. Alfred Roller became the
stage designer of the Court Opera under Gustav Mahler. The Secessionists—
notably the vigorous Otto Wagner—frequently complained of their failure to
win competitions or state posts, but they did remarkably well considering the
hostility to their art from a broad sector of the public. The teaching institution
which, from 1899 on, was the principal stronghold of the Secessionists was the
Arts and Crafts School. The architect Josef Hoffmann, the painters Koloman
Moser, Alfred Roller and Felician von Myrbach (Director), and the sculptor
Arthur Strasser—all Secessionists—got faculty appointments.

yellow cardboard . . . alas without . . . the triangular form of the patches by which, in earlier and happier times, Jews were distinguished from Christians."[37]

Undaunted by the attacks on his work, and fortified by Baron von Hartel's quiet but firm rejection of the professorial protest, Klimt went on to complete the companion piece to "Philosophy." On the Ides of March 1901, "Medicine" was shown for the first time at the House of the Secession (Figure 46). Again Klimt confronted the culture of scientific progress with an alien and shocking vision. He presented medicine's field of action as a phantasmagoria of half-dreaming humanity, sunk in instinctual semi-surrender, passive in the flow of fate. Death dwells centrally within this river of life, his black veil swirling strong among the tangled bodies of the living. As in "Philosophy," there is a priestess figure at the forefront to mediate between the spectators and Klimt's existential *theatrum mundi:* Hygeia. A proud, tall, powerful female, Hygeia is the last of the androgynous protectrix types that marked Klimt's middle period (1897–1901). Like most of the others before her—two of the three Athenas, *Nuda veritas* and *Wissen*—Hygeia confronts the beholder frontally, imperiously, as though forcing from us a recognition of the existential vision behind her. The spectacle of suspended lives over which Hygeia presides is marked by a contrast between the discrete, molded substantiality of the individual figures and the formlessness of their relations in space. The figures drift at random, now locked together, now floating apart, but almost always impervious to each other. Although the bodies sometimes unite, no communion exists among them. Thus the individual psycho-physical experience of sensuality and suffering is abstracted from any metaphysical or social ground. Mankind is lost in space.[38]

Klimt made no attempt to represent the science of medicine as its practitioners conceived it. The reviewer for the *Medizinische Wochenschrift* could with justice complain that the painter had ignored the two main functions of the physician, prevention and cure.[39] His Hygeia merely proclaims in her hieratic stance, through the symbols Greek tradition gave her, the ambiguity of our biological life. In Greek legend, Hygeia is ambiguity *par excellence;* accordingly, she is associated with the snake, the most ambiguous of creatures. Along with her brother Asclepius, Hygeia was born a snake out of the tellurian swamp, the land of death. The snake,

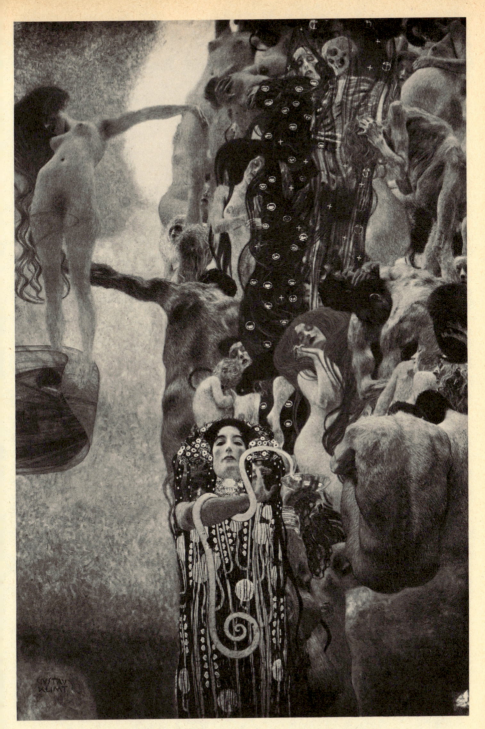

Figure 46. Medicine, University ceiling painting, 1901.

amphibious creature, phallic symbol with bisexual associations, is the great dissolver of boundaries: between land and sea, man and woman, life and death. This character accords well with the concern with androgyny and the homosexual reawakening of the *fin de siècle:* expressions of erotic liberation on the one hand and male fear of impotence on the other. Wherever dissolution of the ego was involved, whether in sexual union or in guilt and death, the snake reared its head. Klimt had exploited its symbolism defensively with Athena, aggressively with *Nuda veritas,* seductively with his watersnakes. Now he employs it philosophically with Hygeia, goddess of multivalences. Hygeia, herself an anthropomorphic transformation of the snake, offers to the serpent the cup of Lethe, to drink of its primordial fluid.[40] Thus Klimt proclaims the unity of life and death, the interpenetration of instinctual vitality and personal dissolution.

Such symbolic statement can be apprehended without being rationally comprehended, as Klimt's contemporaries showed. While Hygeia evoked aggressive reactions, Klimt's most hostile critics had no understanding for the meaning of the snakes and Hygeia's stern play with them. Their indignation found focus and expression rather in the "indecency" of the figures in the background. Nudity had, in the great tradition, been legitimized by idealizing its representation. What offended in Klimt was the naturalistic concreteness of his bodies, their postures and positions. Two figures particularly outraged conventional sensibilities: the female nude at the left of the picture, floating with her pelvis thrust forward, and the pregnant woman in the upper right.[41]

With "Medicine," the thunder that had rumbled at "Philosophy" broke into a violent storm, with crucial consequences for Klimt's self-consciousness both as man and as artist.[42] No longer was it mere professors who attacked his work, but powerful politicians as well. The public prosecutor ordered the confiscation of the issue of *Ver Sacrum* containing drawings of "Medicine" on the grounds of "offense against public morals." A legal action was successfully taken by the Secession's president to lift the censor's ban, but the atmosphere remained heavy with anger.[43]

At the same time, a group of deputies of the Old and New Right, including Mayor Lueger, put pressure on Minister von Hartel, call-

ing him to account in the Reichsrat. In a formal interpellation, they asked the minister whether, through the purchase of "Medicine," he intended to recognize officially a school of art that offended the aesthetic sense of a majority of the people. Thus the Koerber government's policy of using modern art to heal political cleavages began to deepen them instead. Von Hartel, out of his personal commitment to the new art, originally drafted a defiant response to his critics, praising the Secession for revitalizing Austrian art and restoring its international standing. "To oppose such a movement," his draft speech concluded, "would be evidence of total failure to understand the responsibilities of a modern policy in the arts; to support it I regard as one of our finest tasks."[44]

By the time he reached the floor of the House, however, the minister had allowed political prudence to soften his straightforward rhetoric. He shifted his position to a more neutral ground; namely, that it lay beyond the power of the Ministry of Culture to give any artistic tendency an official stamp of approval. Art movements, the minister told the Reichsrat, stemmed from "a continuing progressive development of material and intellectual life in its totality." They could neither be made nor broken by governments. They could thrive only in freedom and survive only with the support of the artistically sensitive public.[45] Hartel thus denied any special place to the Secession in state patronage.

While the minister did not yield to the pressure to reject Klimt's "Medicine," his interpellation marked a turning point in the government's attitude toward Klimt. Through the ceiling paintings, the hoped-for political asset of modern art had become a political liability, and von Hartel's cautiously modified utterance made this clear.

Other signs of an official cooling appeared thereafter in quick succession. When Klimt was elected to a professorship in the Academy of Fine Arts, the Ministry, contrary to all expectation, refused to confirm him.[46] At the same time, Friedrich Jodl, Klimt's chief University antagonist, was appointed to a new chair of aesthetics at Vienna's Technical University. Jodl's inaugural address reads like a cry of triumph over Klimt and the Secession. He attacked modern artistic tendencies for their subjectivism and their use of Mycenaean and other primitive forms. He proclaimed the necessity

for a scientific criticism to restore the objective spirit to art. Finally, Jodl reaffirmed the past as the only proper school for both critic and artist.[47]

One more academic career, in quite another sphere, was positively affected by the politics of the Secession: that of Sigmund Freud. Although, so far as we know, Freud remained as untouched by Klimt and his struggles as by other modern painting, yet he owed the final approval of his professorship to Minister von Hartel's involvement with the new art. The story of Freud's long-delayed promotion is too complex to recount fully here.*[48] It would carry us far from Klimt, into the dense web of personal connections in the intellectual-bureaucratic élite which Freud reluctantly resolved to exploit for his own advancement in the fall of 1901. Yet a swift side glance into the thicket seems justified to show how lives and careers could be intertwined in Vienna's "second society" where politics and culture converged.

For four years after 1897, when the medical faculty of the University of Vienna had first recommended Freud for a professorship, the promotion had lain dormant in the Ministry of Culture. No reasons for the delay were given at the time, nor have they been discovered since. In the autumn of 1901, Freud prevailed upon his faculty sponsors to reopen the case. Freud also went himself to the Ministry of Culture. There he consulted a former teacher, Sigmund Exner, who served as an official under von Hartel. (Still a professor, Exner had co-sponsored Jodl's faculty petition against Klimt's "Philosophy.") Exner gave Freud to understand that some personal intervention with the minister would be necessary to get action on his promotion. Freud turned first to a patient of fifteen years' standing, Elise Gomperz. She was the wife of a famous liberal classicist, Theodor Gomperz, who had been Hartel's colleague at the University.[49] In 1879, when still a student, Freud had worked for Gomperz, translating John Stuart Mill's "The Subjection of Women" and other essays for Gomperz's German edition of Mill's collected works.[50] Gomperz himself was not involved in the intervention for Freud's promotion. His wife interceded personally with the minister, but produced no results.[51]

* For its place in Freud's intellectual development, see Essay IV.

Freud then sought and found another "protectrix," as he called his well-connected Athenas. She was the Baroness Marie Ferstel, wife of a diplomat and daughter-in-law of Heinrich Ferstel, architect of the new University. Through a mutual friend, the baroness approached Hartel on her analyst's behalf, sweetening her plea with a promise to arrange a contribution of a painting for one of Hartel's favorite projects, the Modern Gallery, soon to be opened. She apparently had in mind a painting by Arnold Böcklin. This mid-century artist was both accepted by the traditionalists as a classical realist and revered by the Secessionists as a pioneer of modernity for his paintings on themes of instinctual life and death. His work thus bridging the factions so bitterly arrayed over Klimt's University paintings, Böcklin was a painter well suited to Hartel's needs in 1901–2. Alas, the baroness failed to secure the Böcklin from its owner, her wealthy aunt. Yet Hartel had started the action on the Freud promotion. The baroness, for her part, sent to Hartel, in place of the Böcklin, a painting by Emil Orlik, one of the more conservative Secessionist painters.[52] The minister kept his promise to the baroness that she would be the first to hear when the emperor had approved Freud's promotion. One day in March 1902, Freud tells us, Baroness Ferstel came to his office "brandishing an express letter from the minister" with the good news.

The circle of academic politics was complete. Hartel was too chastened by the politics of the University paintings to permit Klimt's appointment to the Academy of Fine Arts. But his patronage of modern art was still strong enough for the promise of an acquisition for his Modern Gallery to spur him to raise Freud to his coveted professorship. Perhaps Freud, despite his apparent indifference to modern painting and its politics, understood Hartel's new cautiousness when he wrote to his best friend, "I believe that if a certain Böcklin had been in her [Baroness Ferstel's] possession and not in that of her aunt . . . I should have been appointed three months earlier."[53] The world of Vienna's élite was small; word of the minister's moods did get around. The same wind of political fortune that had battered Klimt blew fair for Freud.

⋺ V ⋵

THE EXPERIENCE of public obloquy and professional rejection meanwhile struck Klimt with stunning force. The evidence of the depth of his reaction lies not in literary sources—Klimt was given to almost no verbal utterance—but in his art. After 1901 his painting manifested two diametrically opposed emotional responses, both symptomatic of a wounded, weakened ego: rage and withdrawal. For each of these responses, during four years of painful oscillation between fight and flight, Klimt developed a separate visual language. We know too little of his personal life to be able to trace his psychological development with clear biographical evidence. That he was in his forties when the crisis broke in earnest may have added private personal ingredients to his public misfortune. What can be said is only what his painting suggests: that Klimt underwent a "reshuffling of the self." For he created an art of anger and allegorized aggression that dissolved his earlier organic style. This in turn yielded place to an art of withdrawal and utopian abstraction. The external event which formally sealed his break with public authority was a suit for the repurchase of his controversial University paintings from the Ministry in 1905.[54] But his counterattack against his critics began in his painting as early as 1901 in the wake of the crisis over "Medicine." In the third and last of his University ceiling paintings, "Jurisprudence," Klimt gave his rage its most vehement expression.

During the controversy over the first two paintings, "Jurisprudence" had not progressed beyond the preliminary form of an oil sketch submitted in 1898. When Klimt turned to execute it in 1901, he was ready to invest the work with all his indignation and his sense of injury. The subject—law itself, the most revered feature of Austria's liberal culture—lent itself well to his seething will to subversive statement. One is reminded of the similar counterpolitical spirit with which Freud invested his revelations of the world of instinct in *The Interpretation of Dreams*. Klimt could well have appropriated for his "Jurisprudence" the menacing legend from the *Aeneid* that Freud had placed on the title page of his dream book two years before: *"Flectere si nequeo superos, Acheronta movebo"* (If I cannot bend the higher powers, I shall stir up hell). Like Freud

in similar circumstances in the late 1890's, Klimt pressed his own frustrating experience of social authority—academic, political, and bureaucratic—into the service of socio-psychological insight through personal self-revelation.

When Klimt set to work on "Jurisprudence" in 1901,[55] he had before him the composition study (Figure 47) which he had submitted to the Kunstkommission in May 1898. That sketch differed both in spirit and in style from its companion pieces, "Philosophy" and "Medicine." The priestess of "Philosophy" and Hygeia in "Medicine" were mysterious, mantic types, in solemn, static postures, while the figure of Justice was at first conceived as active and alive, swinging her sword as she swept through the air to ward off the threat of a shadowy octopus of evil and crime below. Klimt clearly idealized Justice in this version, treating her with the lucent, energetic brush strokes of a Whistler woman-in-white. The spatial ambiance also differs from that of "Philosophy" and "Medicine"; instead of the heavy, viscous atmosphere of the latter, "Jurisprudence" has a bright and airy one. Thus Klimt originally saw Justice as free of the ambiguities of Philosophy and Medicine. To set it off from these, he employed the same contrast in style and technique as in the two panels for the Nikolaus Dumba music room, "Music" and "Schubert" (see above, pages 220–1). Where he had conveyed a psycho-metaphysical reality by means of a substantialist, naturalistic technique, he used evanescent, impressionistic means to portray an ideal. We may thus conclude that in 1898 Klimt assigned Jurisprudence to the same ideal realm as Schubert's *Hausmusik*—a fitting option for a still-loyal son of the culture of law.

When he resumed work on "Jurisprudence" in 1901, after the University controversy, Klimt drastically altered his conception. The new version (Figure 48) must be viewed in relation to the earlier sketch of "Jurisprudence" as well as to "Philosophy" and "Medicine" to appreciate just how drastic was his change in view. The scene has moved from the breeze-swept Heaven of version I to an airless Hell. No longer is the central figure a soaring Justice but rather a helpless victim of the law. In working out the new image, Klimt incorporated three suggestions which the commissioners of the paintings had made for the improvement of the 1898 version. But he did so ironically, so that each change increased the element of terror in his rendering of the law. The commissioners had asked

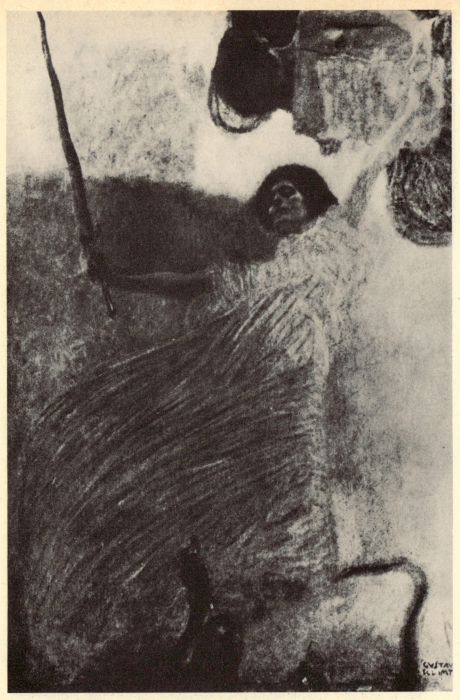

Figure 47. Jurisprudence, composition study for the University ceiling painting, c. 1897–8.

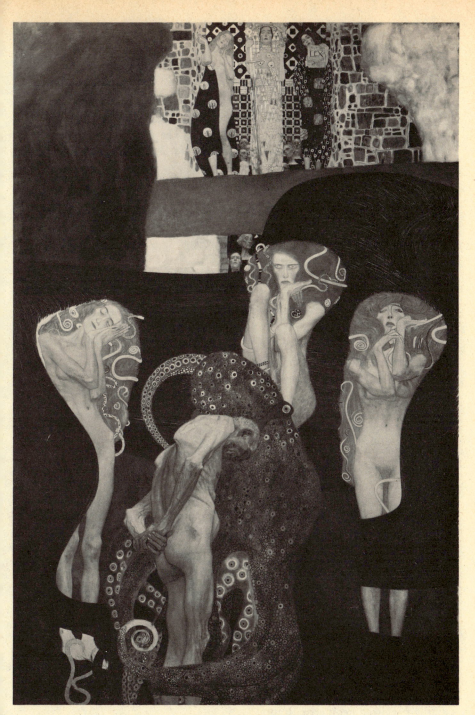

*Figure 48. Jurisprudence (final version), University
ceiling painting, 1903–7.*

for (1) a "clearer characterization of the central figure"; (2) "greater calm in the tone of the picture"; and (3) a "corresponding improvement to the painting's noticeable void in the lower half." In reply to the first request, the male in the tentacles of the law replaced in all-too-concrete realism the sheer, diaphanous impressionism of Justice in version I. Klimt replaced the fresh and agitated sky of version I with the static, clammy "calm" of society's execution chamber. And the "noticeable void" was now filled with the frightening spectacle of the law as ruthless punishment, consuming its victims. Thus the painter obeyed all three of his clients' injunctions in a strict literal sense, while flouting their values more aggressively than ever before.

In relation to the two completed panels, Klimt in "Jurisprudence" broke connections too. He transformed the space, inverted the structure, and radicalized the iconography. The fictive space of "Philosophy" and "Medicine" was still conceived like a proscenium stage in three receding vertical planes. The viewer's perspective was from the audience's side of the footlights. The allegorical figures, *Wissen* and Hygeia, stood in a second plane, stage front, below, mediating between the spectators and the cosmic drama; the drama itself occupied the third, deepest spatial plane, and dominated the whole. In "Jurisprudence," the entire space is raked in a unified, receding perspective, but also bisected laterally into an upper and a nether world. Where in version I the focus was celestial, in version II it is infernal, subterranean, even submarine. In the upper world, far removed from us, stand the allegorical figures of Jurisprudence: Truth, Justice, and Law. Iconographically they are the equivalents, the sisters, of Hygeia and the philosophic priestess. But unlike the latter figures, they perform no mediating role to bring us closer to the mysteries of their sphere. On the contrary, in their withdrawal to their lofty perch they abandon us to the realm of terror to share the nameless fate of the victim. Thus only the pretensions of the law are expressed in the ordered upper portion of the picture. It is the official social world: a denatured environment of masoned pillars and walls ornamented in mosaic-like rectilinear patterns. The judges are there with their dry little faces, heads without bodies. The three allegorical figures are impassive too, beautiful but bloodless in their stylized geometric drapes.

The reality of the law, however, lies not in that upper realm of

stylized regularity and static decorum, but in the vacuum-like space beneath, where justice is carried out. No crime is recorded here, only punishment.* And the punishment is sexualized, psychologized as an erotic nightmare in a clammy hell. The iconography, rich in allusion, cathects classical and modern images and ideas. "The loins," said Blake, "are the place of the last judgment." Castration anxiety governs Klimt's focal scene: the male victim—passive, depressed, impotent—is caught in a carnal trap, a womb-shaped polyp which englobes him. The furies who preside over the execution are at once *fin-de-siècle femmes fatales* and Greek maenads. Their sinuous contours and seductive tresses were probably inspired by the female figures of the Dutch *art nouveau* painter Jan Toorop.[56] But Klimt has endowed them with the cruel, Gorgon-like character of classical maenads. Not the idealized figures above, but these snaky furies are the real "officers of the law." And all around them in the hollow void of hell thick swirls of hair entangle and envelop in a terrible sexual fantasy.

Klimt's bisected world of law, with its three graces of justice above and its three furies of instinct below, recalls the powerful resolution of Aeschylus' *Oresteia*, where Athena establishes Zeus' rule of rational law and patriarchal power over vendetta law and matriarchal vengeance. When Athena builds her court of socialized justice, the Areopagus, she persuades the Furies to become its patrons, and subdues their power by integrating them into her shrine. Reason and civilization thus celebrate their triumph over instinct and barbarism.[57] Klimt inverts this classic symbolism, restoring the Furies to their primal power, and showing that law has not mastered violence and cruelty but only screened and legitimized it. From "deep, deep in the first dark vaults of earth" to which, in Aeschylus' version, Athena has consigned the "daughters of night," Klimt in his anger and anguish has called them up again. After his affirmation of instinctual power as stronger than politics, Klimt could no longer have "worshipped the humble and mutilated remnant of the Temple of

* Karl Kraus, in one of his many hostile criticisms of Klimt, sardonically observed that the artist, "who had already painted over the pale cast of his thought with luminous colors, wanted to paint 'Jurisprudence' and [instead] symbolized criminal law." Thus Kraus caught the truth of Klimt's painting but completely missed its critical intention. *Die Fackel*, No. 147, Nov. 21, 1903, 10.

Minerva" as Freud did. (See pages 202–3.) Athena, whom Klimt had so often painted in so many roles, is simply absent for him from the theater of justice that was uniquely hers. The return of the repressed is marked by the disappearance of the goddess. Thus in the final panel of his series that was to celebrate "the victory of light over darkness," Klimt unequivocally proclaimed the primacy of darkness, "stirring up hell" as he exhumed and exposed through the symbol of the furies the power of instinct that underlay the political world of law and order. In Aeschylus, Athena had enthroned justice over instinct; Klimt has undone her work.

Although Klimt's "Jurisprudence" was an aggressive exposé, it also bore the character of a *cri de coeur*. The very mode of the indictment, with its stress on the individual sufferer, involved a shift from public ethos to private pathos. There is no Nietzschean *amor fati* in Klimt's aging victim of the law—only marks of weakness, marks of woe. Alone of the University paintings, "Jurisprudence" has a male as the central figure. But he is very different from the previous male allegorical figure Klimt had painted, the Theseus of the first Secession poster, symbolic hero of the artists' oedipal revolt (Figure 37). There the vigorous youth plunges his sword into the Minotaur of tradition. Now the aging victim suffers a punishment peculiarly appropriate to oedipal crime: castration, reduction to impotence. One may conjecture that Klimt is expressing not only pain and anger here, but another feeling characteristic of the weakened ego, guilt. Was not Klimt's offense against the fathers, as his academic and political opponents saw it, sexual licentiousness? For rebellion in favor of erotic liberation, the fantasies of sexual punishment visited by Klimt's furies were altogether fitting.* Thus the iconography suggests that Klimt, under the lash of criticism, even while he fought back, partially internalized as personal guilt the rejection of his artistic mission to act as liberator of the instinctual life from the culture of law. His very defiance was tinctured by the spirit of impotence.

Other paintings of the years 1901 to 1903 expressed the defiant mood that dominated "Jurisprudence." From "Medicine" Klimt

* In Greek mythology, the Furies are by their very origins associated with sexual violence. They sprang from the scattered seed of their castrated father, the Titan Ouranos.

lifted as subjects for independ-
dent paintings the two figures
that had most offended moral-
istic opinion. With a deliberate
will to shock, he developed
their frank sensuality even fur-
ther. One, entitled "Goldfish"
(Figure 49), showed a nude
impudently displaying her lus-
cious bottom to the viewer.
Klimt had planned to call it
"To My Critics" until friends
dissuaded him.[58] The other
painting, "Expectancy" (Hoff-
nung), presented in more fin-
ished form the pregnant woman
who had so scandalized the
public in "Medicine." Klimt
rendered his subject with a
maximum of sensitivity for the
ambiguous feelings of a woman
in the last heavy weeks before
delivery. Both pictures in-
creased the tension between the
painter and the Ministry of Cul-
ture. In 1903 Baron von Hartel
persuaded the reluctant Klimt
not to exhibit "Expectancy"
lest he should jeopardize the
acceptance of his University
murals.[59] The Ministry also
tried to prevent the showing of
"Goldfish" in an exhibit of
Austrian art in Germany.[60]
Then it refused to allow Klimt's

Figure 49.
Goldfish, 1901–2.

"Jurisprudence" to be the central work of the Austrian exhibit at the St. Louis Fair of 1904.[61] The gulf between the assertiveness of the artist and his friends and the caution of the bureaucrats was growing wider.

<div style="text-align:center">

❧ VI ☙

</div>

IN 1902, while still at work on his defiant "Jurisprudence," Klimt became involved in one more large-scale mural project equally important to his artistic evolution. It was a vast frieze celebrating Beethoven and his setting in the Ninth Symphony of Schiller's "Ode to Joy." As "Jurisprudence" was Klimt's boldest expression of narcissistic rage, the Beethoven frieze was its opposite: a manifestation of narcissistic regression and utopian bliss. Fight here found its analogue in flight. Where politics had brought defeat and suffering, art provided escape and comfort. In style as in idea, the Beethoven frieze marked a turning point in Klimt's art.

The occasion for this work was the exhibition in Vienna of a much-fêted contemporary statue of Beethoven by the Leipzig artist Max Klinger (Figure 50). The Secession artists decided to transform their whole building into a temple to consecrate Klinger's statue. Surely this was the high point of one of the Secession's tendencies noted earlier: to provide in art a surrogate religion offering refuge from modern life. In the Beethoven show, all the major Secession artists contributed their time and labor to celebrate Klinger as he exalted Beethoven, an aesthetic Prometheus who held the vultures of life at bay. If ever there was an example of collective narcissism, this was it: artists (Secessionists) celebrating an artist (Klinger) celebrating a hero of art (Beethoven). The catalogue of the show spoke of the Secession's "longing for a great task"; hence "the idea of undertaking what our age challenges the artist to provide: the purposive development of interior space [*Innenraum*]." The Beethoven show was indeed a *Gesamtkunstwerk* of aestheticized inwardness.

The architect Josef Hoffmann, taking advantage of the flexible space of the Secession building, transformed it into a pseudo-primitive, rough-textured labyrinthine shrine. His interior was truly a pioneering work, foreshadowing the new brutalism (Figure 51). Through solemn corridors, ornamented here and there by ceramic

plaques and neo-primitive sculpture, the votary of art proceeded until he reached a vestibule from which he saw the *sanctum sanctorum* where Beethoven sat enthroned. "Having been prepared by every available means for reverence [*Andacht*]," wrote the *Neue Freie Presse*, "one arrives before [the statue] in a kind of hypnosis." For the opening of the show, Gustav Mahler added luster with a performance of Beethoven's Ninth in a special condensed arrangement.[62]

Klimt contributed a frieze, an allegory in three panels to illustrate the power of art over adversity. Although this theme is close to that of Klinger's "Beethoven," Klimt drains all Prometheanism from it. The first panel, entitled "Longing for Happiness," shows the weak appealing to "the well-armed strong one" (Figure 52). But the strong figure is no longer the aggressive Theseus who slew the Minotaur in

Figure 50. Max Klinger, Beethoven, as displayed at the Secession, 1902.

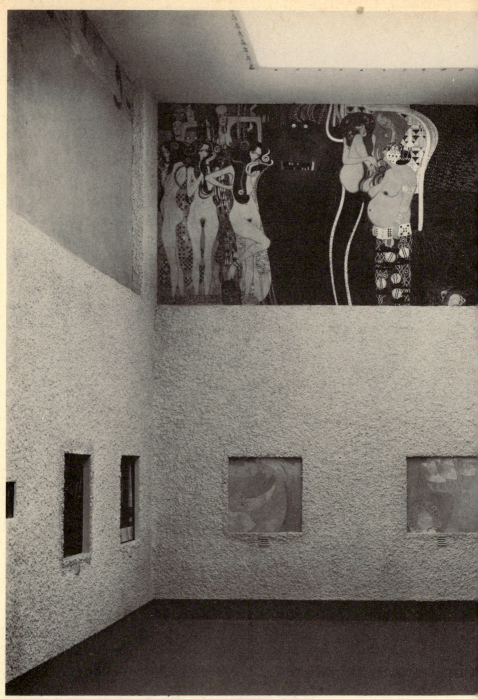

Figure 51. Josef Hoffmann, Secession interior, Beethoven exhibit, showing the Klimt frieze, 1902.

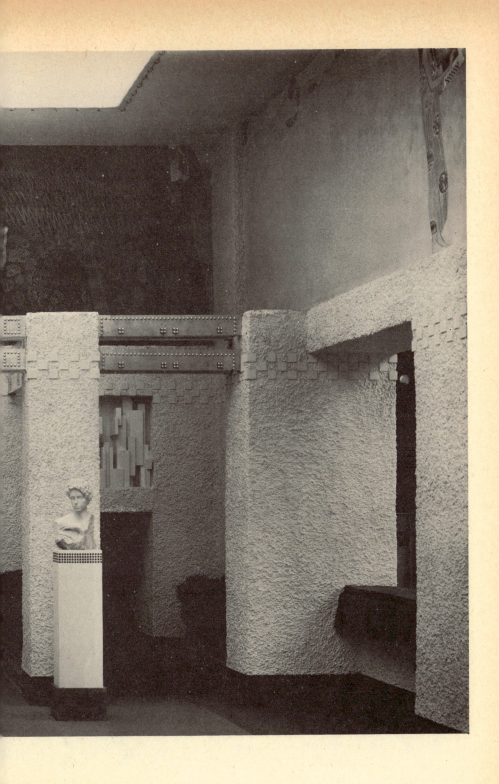

Klimt's first Secession poster. The knight steps forth from a womb-shaped tower, encouraged by two female spirits to win the crown of victory. "The Hostile Forces" of the second panel (Figure 53) are all female, except perhaps for the ape-like winged monster at the center. They stand between the sufferers and happiness. There is no heroic encounter, no equivalent to Beethoven's fierce Turkish battle music in the Ninth. As the catalogue specifically states, "the longings and wishes of mankind fly away over them [the Hostile Forces]." This psychological posture is classic for the weakened ego finding in fantasy a substitute for power over reality: wish is king; encounter is avoided. One can see the wishes in their horizontal flight above the figure of Music (Figure 54)—long-gowned dreamy spirits, sublimated sisters of Klimt's sensual watersnakes.

The last, most interesting panel represents fulfillment (Figure 55). It bears the legend: "The longing for happiness finds its surcease in poetry." Here, says the catalogue, art "leads us into the ideal realm, wherein alone we can find pure joy, pure happiness, pure love." Klimt conceived this last panel around a phrase from Schiller's "Ode to Joy": "This kiss to the whole world." For Schiller and for Beethoven, the kiss was political, the kiss of the brotherhood of man —"Be embraced, ye millions"* was Schiller's universalistic injunction. Beethoven introduces the line through male voices only,

* "Seid umschlungen ihr Millionen."

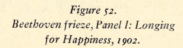

Figure 52.
Beethoven frieze, Panel I: Longing
for Happiness, 1902.

Andante maestoso, with all the strength and dignity of fraternal fervor. For Klimt, the sentiment is not heroic but purely erotic. More remarkable still, the kiss and the embrace take place in a womb. The high "flight" so characteristic of narcissistic omnipotence fantasies terminates in erotic consummation in a womb. And even in that

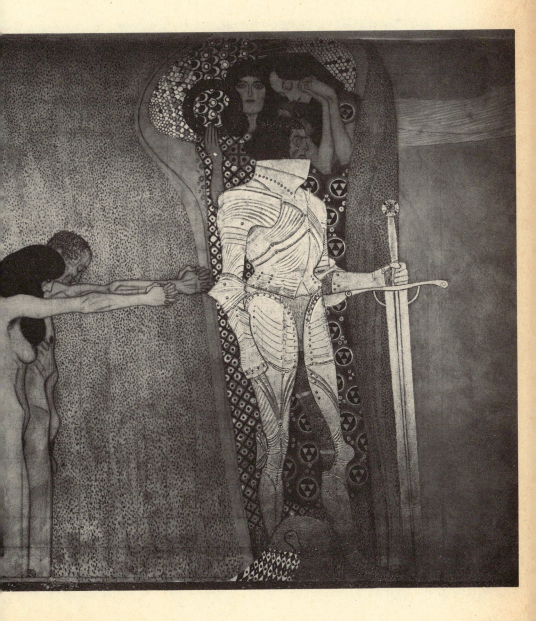

heaven, the woman's hair encircles her lover's ankles in that danger-
ous way we have come to know so well in Klimt. Even in Arcadia,
sex ensnares.

 To assess the full significance of Klimt's crisis of 1901, and the
separation of politics from art implied by it, the scene of victimiza-

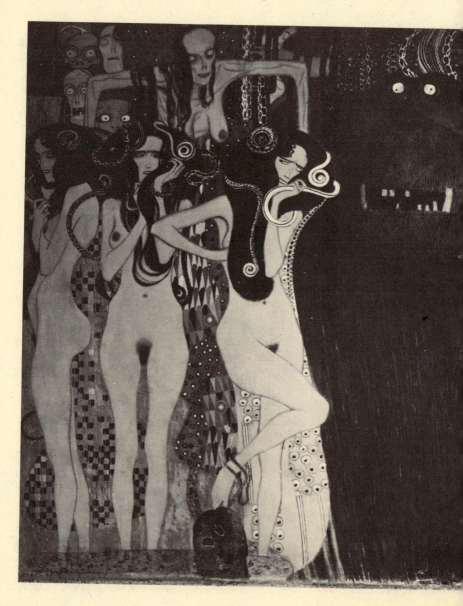

tion in "Jurisprudence" and the scene of fulfillment in the Beethoven frieze should be viewed together. They relate to each other as paired opposites, each with a style appropriate to its idea. The central symbol in both allegories is the womb and the male's relation to it. The womb-shaped polyp of the Law with its menacing

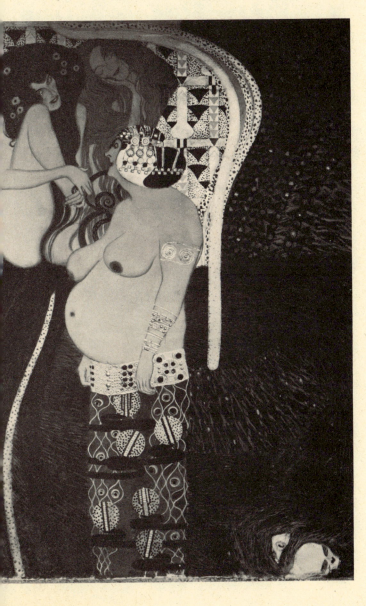

Figure 53.
Beethoven frieze,
Panel II: The
Hostile Forces,
1902.

tentacles contrasts with the womb-shaped arbor of Poetry with its gentle tendrils in the third Beethoven panel. The suction cups of the first become blossoms in the second. The central figures in both

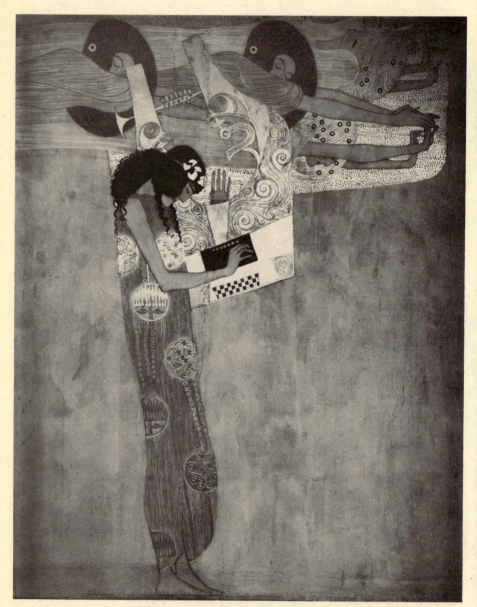

Figure 54. Beethoven frieze, detail of Panel III: Music, 1902.

cases are male. In the first, the victim of justice—an old man bowed, gripped in a carnal trap; in the second, the victor of art—a young man in transport, framed with his mate in a column shaped unmistakably like an erect penis within Art's uterine bower of bliss. The two styles used in these presentations bring a new level of antithesis to the distinction observed earlier between a two-dimensional, linear treatment of ideas not yet realized and a three-dimensional, molded naturalism to represent reality. The supervising agents of the male's destiny in politics, the furies, are organically presented, as substantial, fleshly hell-cats. They are real. In contrast, the heavenly choristers who sing Schiller's "kiss to the whole world" are the most abstract two-dimensional group Klimt had yet painted. The undulating vibrations of their flower-spangled gowns echo Klimt's more sensuous representations of female ecstasy; but their stylized flatness suggests incorporeality, like a Byzantine band of angels.[63] The contrast extends to spatial placement: the furies are irregularly and dynamically poised in space, while the angels of art are statically arrayed in ranks, even their *frissons* creating a metered, linear rhythm. At every level the two works dramatize the negative relationship between reality and ideality, between the realm of law and power and the realm of art and grace. That the ambiguity of sex, as punishment and fulfillment, should have provided the symbolic link for both spheres was appropriate to the instinctual substance of Klimt's liberating quest and its public fate.

As "Jurisprudence" marked the height of Klimt's critical defiance of the culture of law in pursuit of modern truth, so the Beethoven frieze was his fullest statement of the ideal of art as refuge from modern life. In "Beethoven," the dreamer's utopia, wholly abstracted from that life's historical concreteness, is itself imprisonment in the womb, a fulfillment through regression. The Orphic inversion of the Promethean tradition is complete. The tomb that Klimt had opened in his "Music" in the name of truth has claimed its own once more in the name of beauty.

⇒ VII ⇐

AFTER THE UNIVERSITY CRISIS, Klimt gave up philosophical and allegorical painting almost entirely. His withdrawal

into the temple of art in the Beethoven show had its analogue in a kind of social withdrawal to a narrow élite. In his previous phases—whether as purveyor of the values of Ringstrasse historicism or as the Secession's philosophic seeker after modernity—Klimt had been a public artist. He had addressed his truths to what he assumed to be, at least potentially, the whole society. He had wanted and received contracts from public authorities to formulate universal messages. Now he shrank back to the private sphere to become painter and decorator for Vienna's refined *haut monde*. Perhaps the greatest achievements of Klimt's last fifteen years lay in his portraiture of women, most of them members of wealthy Jewish families. Cheerful landscapes, especially well-ordered gardens, likewise provided subjects for his later painting. The organic dynamism of his style in the *art nouveau* period disappeared, in favor of a static, crystalline ornamentalism. In stance as in style, transcendence replaced engagement.

Klimt's evolution after 1902—social, personal, and artistic—bore all the characteristics which Yeats immortalized in "Sailing to Byzantium." As Yeats left Irish politics behind, so Klimt withdrew from all attempts to work with Hartel and the government. "I want to get out [*Ich will loskommen*]," Klimt cried, explaining in a rare interview his decision to retract his University paintings in

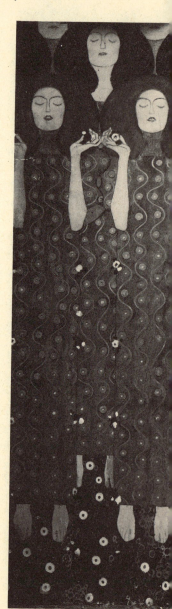

Figure 55. Beethoven frieze,
detail of Panel III:
The Longing for Happiness Finds
Surcease in Poetry, 1902.

April 1905.* That a sense of aging was also part of Klimt's new de-

* In the interview, Berta Szeps-Zuckerkandl elicited from Klimt a full sense of the oppression he felt under the Ministry's multiple signs of disapproval and

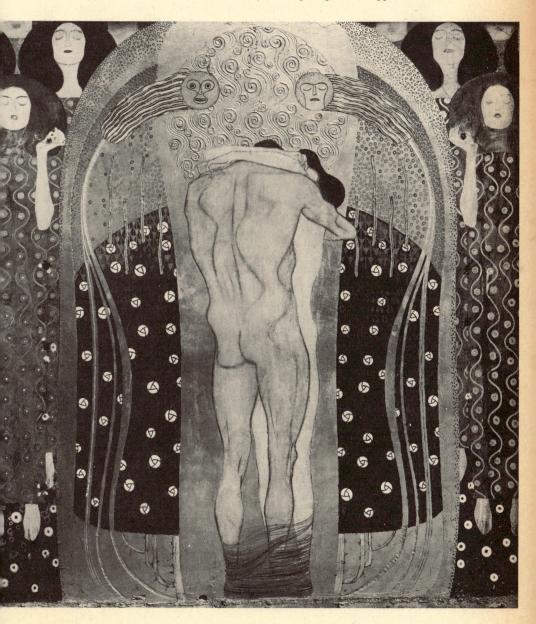

velopment is suggested by the degree to which—with rare excep-
tions*—he abandoned his sexual explorations in large works in favor
of oblique symbolic statement. Like Yeats leaving Ireland behind
("no country for old men"), where all are "caught in [a] sensual
music," and "neglect monuments of unageing intellect," Klimt tried
to transcend temporal vitality in "the artifice of eternity." Klimt cer-
tainly did not abandon his concern with the erotic life. But he
turned, as did Yeats, to Byzantium to find new forms to attenuate
the pressures of Eros, both for pain and for bliss, and to freeze in
form the instincts he had once struggled so boldly to liberate. From
nature to stylized culture, from direct presentation of psycho-
physical experience to formal symbolization: thus the journey ran.[64]

In 1903 Klimt, though normally no traveler, journeyed twice to
Ravenna, where he viewed the mosaics of San Vitale.[65] Meanwhile
the ablest of his Secession colleagues, those turning to interior design
and crafts, had since 1899 been experimenting with mosaics and with
gold leaf. In his architecture and decor Josef Hoffmann had taken
the lead in replacing the curvilinear thrust of *art nouveau*, with its
organic lines and shapes, by rectilinear geometric forms, which soon
became the hallmark of Viennese architecture and crafts. In the
Wiener Werkstätte—the highly successful crafts workshop of the
Secession—the best artists pioneered after 1903 in art deco, with its
metallic and crystalline forms.[66]

Klimt was swept into this crafts current in 1904, when he joined
Hoffmann and other artists of the Wiener Werkstätte in designing
a luxurious villa in Brussels, the Stoclet house.[67] In his frieze for the
Stoclet dining room, Klimt pushed to its conclusion the break he had
begun in "Beethoven" from the spatial illusionism of his previous
architectural painting. He now treated the wall truly as wall, bring-
ing out its flatness by rich, two-dimensional ornament. In the Stoclet
frieze he conceived his huge Tree of Life in the Byzantine manner,
while adopting the stylized dress of Byzantine religious figures to
clothe his own erotic ones.[68] The Stoclet frieze was Klimt's cooled-

embarrassment. His complaints culminate in the will to disengagement: "Enough
of censorship. I am having recourse to self-help. I want to get out." Strobl,
Albertina Studien, II, 161–3.

* Notably "Danae" (1907) and "Salome" (1909). See below, pages 271–2.

off, sublimated version of the erotic utopia of his third Beethoven panel, decently draped to serve as decor for the well-to-do.

Although he entered his so-called golden period as part of the wider movement toward geometry and art deco on the part of the Secession's applied artists, Klimt, when he turned to gold and metallic colors and forms, was also reattaching himself to his personal past. Both his father (now dead) and one of his brothers were gold engravers. That he should have done this in his time of troubles is characteristic of the ego crisis of a middle-aged male.[69] Personal history thus added its weight to the artistic influence of Klimt's Secession colleagues in pressing him toward the abstraction and formalism that filled his need when a new way of relating to his social reality was at its most urgent.

The painter who, like Freud and Nietzsche, had pursued his quest for modernity against classical bourgeois convention by summoning the buried instinctual powers of archaic Greece—Dionysus, Hygeia, the Furies—now turned to the other end of Greek history and culture, to Byzantium. There he found the forms of visual language to close Pandora's box again. In Byzantium's stiff, inorganic order the instincts and the threat of social change could be held at bay. Again, Yeats's words serve to express the new direction which Klimt took as artist:

> Once out of nature I shall never take
> My bodily form from any natural thing,
> But such a form as Grecian goldsmiths make
> Of hammered gold and gold enamelling
> To keep a drowsy Emperor awake;
> Or set upon a golden bough to sing
> To lords and ladies of Byzantium
> Of what is past, or passing, or to come.

For five years after 1903, Klimt refrained from exhibiting in Vienna. His passion for work remained unabated, however, and by 1908 he revealed to the public the products of his reconstituted vision. He presented his new work in a show called *Kunstschau 1908*, a comprehensive exhibition of the achievements of Klimt and his colleagues both as fine artists and as stylists of the life beautiful. Ten years before, in the first issue of *Ver Sacrum*, Hermann Bahr had de-

clared the Secession's war on "actionless routine and ossified Byzantinism."[70] *Kunstschau 1908* showed how far the creators of the élite's visual culture had clarified their purposes, scope, and style away from movement toward abstract, static order.

The very pavilion that Josef Hoffmann designed for the Kunstschau reflected the change in the nature and function of art that ten years of political erosion and economic prosperity had wrought (Figure 56). Instead of the solemn, a-historical cubic radicalism of the Secession temple of art, the Kunstschau pavilion was conceived as a gracious *Lustschloss* from the era of Maria Theresa. The whole exhibit—in ceramics, garden design, book design, clothes, and

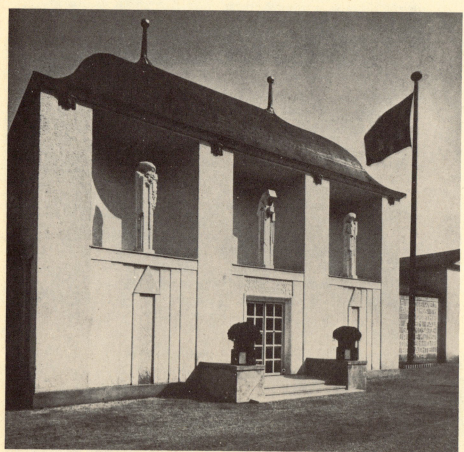

Figure 56. Josef Hoffmann, Kunstschau Pavilion, 1908.

furniture—bore the stamp of neo-classicism, however stripped and contemporary in treatment, that marked a return from the organic naturism of *art nouveau* design to a static rationalism and tradition. Although the inscription on the Kunstschau pavilion's entrance echoed the Secession's 1898 call, "To the Age its Art," the catalogue used as its motto for the painting section a quite different sentiment from Oscar Wilde: "Art never expresses anything but itself."[71] Not "the face of modern man" then, but the face of art itself. What could that be?

In a rare speech to open the show, Klimt himself defined the limits of the aesthetic subculture which now bounded his world. What the Kunstschau aspired to, he said, was an "Artist-Community [*Künstlerschaft*]," the ideal community of those who create and those who enjoy. Klimt sorrowfully complained that "public life was predominantly preoccupied with economic and political matters." Thus artists could not reach the people through the preferable route of "performing public artistic tasks," but had to resign themselves to the medium of the exhibition, "the only road that remains open to us."[72] Here again one feels the contrast with the Secession, which had set out to regenerate Austria by creating a whole *Kunstvolk*. The social circle, never objectively wide, had narrowed in the mind of the Klimt group to the artist-decorator and his customers; an aesthetically schooled élite became their world.

The Kunstschau was called by one critic "a festive cloak around Klimt."[73] For here the artists celebrated their leader almost as much as the Beethoven show had fêted Klinger. Near the center of his building Hoffmann placed an elegant room, like a chaste, satin-lined jewel box, to house the great retrospective of Klimt's work of the previous half-decade. That gallery enables us to sample his art in its swift post-crisis development.

It was fitting that, in his resocialization as painter to the élite, Klimt should have bent his talents to portrait painting. His subjects, be it noted, were always women. (Even in his anonymous figure painting before 1903, where men occur at all, their faces are almost always averted.) In a series of three portraits painted between 1904 and 1908, Klimt progressively extended the dominion of the environment over the person of the subject. Yet the environment itself —always a fantasized interior—became ever more denatured and abstract, its elements of design serving now as purely ornamental, now

as symbolically suggestive. In the portrait of Margaret Stonborough-Wittgenstein, daughter of a rich Secession patron and sister of the philosopher (Plate IV), the subject's face and hands bespeak a perfected serenity and an ideal of refinement. Yet there is little character. In conformity with an older tradition of portraiture, the subject's body is completely lost in the clothing; the dress itself still has the dreamy impressionist quality we observed in the Schubert scene of 1898. The background, however, is treated in a wholly novel way, as a hermetic, stylized space, a beautiful but unreal frame for the subject's life. The figure, itself molded and substantial, seems caught in the artifices of two-dimensional design. The formalistic invention of the walls endows the habitat with an autonomy more powerful than the personality of its inhabitant.

In the portrait of Fritza Riedler, the stylization of the environment has extended its power further over the human subject (Plate V). A radical geometricity, from which all literary meaning is banished, proclaims solidity and stability, but of a strangely encapsulating kind. The mosaic-like window behind Frau Riedler refracts the outer world of nature into design, which frames the subject's face as if it were a headdress.* She is crafted into her ideal floating castle, with a stylized yet detached allusion to aristocratic history.

Klimt's a-social portraiture achieves its fullest intensity in the painting of Adele Bloch-Bauer (Plate VI). Frau Bloch-Bauer is shown not only as wholly cut off from nature, but as imprisoned in the stiff Byzantine opulence of her environment. The house dresses the lady, while the lady adorns the house. Clothes and habitat are melded into a single continuum of design, and both flatten her body to two-dimensionality. Only the subject's sensitive face and blue-veined hands bespeak the tensely delicate soul swathed in the cloth of gold. The hieratic, metallic quality of the setting, and the detail of kaleidoscopic symbols—circles, volutes, rectangles, and triangles—recall the three priestesses of "Jurisprudence." But where in 1901 Klimt had struck through their mask of beauty from the netherworld perspective of instinctual truth, here he accepts the denatured surface of civilized beauty as legitimate. Thus Klimt's radical cultural

* The resemblance of the headdress effect to that of Velasquez's portrait of Queen Mariana of Austria (1646) has been pointed out by Alessandra Comini, *Gustav Klimt* (New York, 1975), p. 15.

mission died as his narcissistic rage subsided. The painter of psychological frustration and metaphysical malaise became the painter of an upper-class life beautiful, removed and insulated from the common lot in a geometric house beautiful.

Klimt's portraits constitute a social analogue to the aesthetic-erotic utopia of the Beethoven frieze. For what is sybaritic high style but a socially conventionalized aesthetic assertion of gratified wishes? Yet it would be a mistake to equate Klimt's social retreat and psychological withdrawal with artistic decline. On the contrary, his reshuffled self devised new forms of art to serve as his armor against the pain of life. The two central features of Klimt's new painting, emerging with ever-greater prominence in the portraits we have considered, were abstraction and symbolism. Abstraction liberated the emotions from concrete external reality into a self-devised realm of form, a heuristically posited ideal environment.[74] Yet within these larger, rigid, tectonic forms, the small, shimmering particles served symbolic as well as ornamental functions. Thus in the Bloch-Bauer portrait, Klimt could suggest abstractly, through the particles, conflicting psychological states without directly representing what such states felt like as he had formerly done. The tension between actively coiled volutes and composed mosaic cells, between suggestive eye-shapes, vulva-like parted ellipses, and neutralizing triangles—all these formalized individual elements produce in juxtaposition a suggestion of explosive power suspended, immobilized within their abstract frame. As in Byzantine art, organic force is neutralized by the combination of crystallized fragments and the two-dimensional symmetry of the whole.

When Klimt turned to allegorical or figure painting in his later phase, as he occasionally did, he muted and even cosmeticized the agonistic elements in his themes. Or, to state his accomplishment more positively, he neutralized their anguishing potential through an aesthetic distancing. The same trajectory from ornamented naturalism to aesthetic transcendence that he traversed in the three portraits (Wittgenstein, Riedler, and Bloch-Bauer) can be seen in three idea-paintings: "Danae," "The Kiss," and "Death and Life." Because each was related to themes we have seen Klimt explore thoroughly before, they can serve us well in grasping the changed relationship between style and existential stance in his late painting.

In the "Danae" (Plate VII), Klimt once more invoked the gods

of Greece to express the state of modern man. This last of Klimt's Greek women has nothing in common with her predecessors— Athena, Niké, Hygeia, or the furies, androgynous phallic females all. Klimt seems to have overcome his fear of woman. Rarely have the lineaments of gratified desire been more glowingly rendered than in his Danae, her flesh suffused to honeyed hue by Zeus' golden stream of love. Klimt has found his peace—with woman no longer threatening in insatiability, but blissfully curled in receptivity. Again Klimt contraposes two media of expression. While he employs naturalism to present Danae's passive passion, symbolism dominates the action. To the golden shower of the myth, Klimt assigns chromosome-like biological shapes, finally adding a symbol all his own: the vertical rectangle as male principle, uncompromisingly angular and black as death. It is a powerful dissonant detail in the harmony of eros and wealth in coition.

"The Kiss" (Plate VIII) carried Klimt's golden style to its apex. The most popular of Klimt's paintings at the Kunstschau and ever since, it escalates the intensity of the sensuous effect by expanding the symbolic at the expense of the realistic field. In the "Fulfillment" panel of the Beethoven frieze (Figure 55), and even more in "Danae," the erotic effect was conveyed by molded nude bodies; in "The Kiss," the flesh is covered, yet the sensuous effect is heightened by the gestural, caressing line. In the clothing, as in the flowery base on which the lovers kneel, the ornamental elements serve also as symbols. The drapery of both male and female stands uncompromisingly distinguished by its ornamental designs. The single rectangle that, in "Danae," is Zeus' phallic symbol, proliferates in "The Kiss" on the male's cloak; while the woman's dress is alive with symbols at once ovular and floral. These are not traditional symbols, but inventions drawn from the reservoir of Klimt's unconscious. The two defined fields of sexual symbols are brought into a union of opposites by the vibrant cloth of gold that is their common ground. Having passed from an art of movement and literary allusion to one of static abstraction, Klimt has in "The Kiss" adapted the indirect statement of symbolic collage to portray once more a strong, if now harmonious, erotic feeling.

In "Death and Life" (Plate IX), Klimt grapples yet again with the kind of philosophic theme that had concerned him ever since *Nuda veritas* held up her mirror to modern man.[75] In structure as in

theme, "Death and Life" resembles "Medicine," with a mass of humanity grouped on the right against a dominating solitary figure on the left (cf. Figure 46). In "Medicine," the somnolent pregnant drifter is on the left. Humanity in its tortuous, tangled flow finds Death in its midst, radiating havoc. In the Kunstschau painting, it is Death that is separated out from the mass. He looks across at a blissfully sensuous humanity. It is static now, bedded down in a colorful blanket of flowers. Love is in humanity, Death outside it, an alien force. The bright bonbon colors of Klimt's painted mosaic resolve the structural tension into pleasing contrast. Where in the University murals Klimt had created a mysterious atmospheric depth, here he offers only an ornamental two-dimensionality, itself an index of the utopian complacency to which his "adjustment" to reality had led him. Terror yields to decorum, existential truth to Pollyanna beauty.

By 1908, recoiling from the trauma of his encounter with society as psycho-philosophical subversive, Klimt had returned to the painter-decorator's function in which he began his career on the Ringstrasse. But the break he had made with history as the source of meaning, and with physical realism as the proper mode of representation, remained permanent, for him as for the class whose expectations of history and nature had played them false. He had passed irrevocably from the realm of history, time, and struggle to that of aesthetic abstraction and social resignation. In his Secessionist *voyage intérieur*, however, with Greek myth serving often as his iconographic pilot, Klimt had opened up new worlds of psychological experience. It remained for the younger spirits of the Expressionist movement to carry to new depths the explorations which Klimt had abandoned when he made his aesthetic retreat to the fragile shelter of the Viennese *haut monde*.

❧ NOTES ☙

[1] Christian M. Nebehay, *Gustav Klimt: Dokumentation* (Vienna, 1969), pp. 84, 88, 97–8. (Hereafter cited as Nebehay, *Klimt: Dok.*)

[2] *Ver Sacrum*, I, No. 1, January 1898, 1–3.

[3] The best analysis of the Secession building and its architect is that of Robert Judson Clark, "Olbrich and Vienna," *Kunst in Hessen und am Mittelrhein*, VII (1967), 27–51.

[4] J. M. Olbrich, "Das Haus der Sezession," *Der Architekt*, V, January 1899, 5.

[5] Wilhelm Schölermann, "Neue Wiener Architektur," *Deutsche Kunst und Dekoration*, III (1898–99), 205–10.

[6] On the wide currency of Nietzsche in the Viennese avant-garde intelligentsia, see William J. McGrath, *Dionysian Art and Populist Politics in Austria* (New Haven, 1974), *passim*.

[7] Friedrich Nietzsche, *The Birth of Tragedy and the Genealogy of Morals*, tr. F. Golffing (Garden City, 1956), p. 52.

[8] The new version was executed as a full-length painting for Hermann Bahr's study in 1899. See Nebehay, *Klimt: Dok.*, pp. 198–9.

[9] Fritz Novotny and Johannes Dobai, *Gustav Klimt* (Salzburg, 1967), p. 70.

[10] The most detailed analysis of the controversy is by Alice Strobl, "Zu den Fakultätsbildern von Gustav Klimt," *Albertina Studien*, II (1964), 138–69. Hermann Bahr, *Gegen Klimt* (Vienna, 1903), provides a valuable collection of documents.

[11] Nebehay, *Klimt: Dok.*, p. 208.

[12] Peter Vergo, "Gustav Klimt's 'Philosophie' und das Programm der Universitätsgemalde," *Mitteilungen der Oesterreichischen Galerie*, XXII / XXIII (1978–9), 94–7.

[13] Mahler originally called his Third Symphony, after Nietzsche's essay, "Die fröhliche Wissenschaft." For a most illuminating analysis of the work, and of Mahler as "metamusical cosmologist" in the context of the Austrian Nietzsche cult, see McGrath, *Dionysian Art*, pp. 120–62. See also Henry-Louis de La Grange, *Mahler* (New York, 1973), I, 806–7.

[14] Friedrich Nietzsche, *Also Sprach Zarathustra*, Part IV, "Das trunkene Lied," especially sections 8 and 10. The Midnight Song is repeated in Section 12.

[15] The text of the petition is partially reproduced in Strobl, *Albertina Studien*, II, 152–4.

[16] *Ibid.*, p. 153.

[17] Emil Pirchan, *Gustav Klimt* (Vienna, 1956), p. 23.

[18] *Neue Freie Presse*, March 30, 1900; March 28, 1900, reproduced in Hermann Bahr, *Gegen Klimt*, pp. 27, 22–3.

[19] Otto Neurath, *Le Développement du Cercle de Vienne* (Paris, 1935), p. 40.

[20] Albert Fuchs, *Geistige Strömungen in Oesterreich, 1867–1918* (Vienna, 1949), pp. 147–55.

[21] *Die Fackel*, No. 36, March 1900, pp. 16–19.

[22] ". . . [N]icht gegen die nackte und nicht gegen die freie Kunst, sondern gegen die hässliche Kunst." The interview, along with another with Franz Exner, is reproduced in Bahr, *Gegen Klimt*, pp. 22–3. Franz Exner, a physicist, and his more eminent brother Sigmund, a physiologist, two sons of a famous Austrian educational reformer of 1848, were also opponents of Klimt, presumably out of liberal-rationalist conviction.

[23] Bahr, *Gegen Klimt*, pp. 27–8.

[24] Max Dvořak, *Gesammelte Aufsätze zur Kunstgeschichte* (Munich, 1929), p. 291. Dvořak's necrological essays on Riegl (pp. 277–98) and Wickhoff (pp. 299–312) offer excellent assessments of their significance.

25 Franz Wickhoff, "Die Bibliothek Julius II," *Jahrbuch der preussichen Kunstsammlungen*, XIV (1893), 49–64.

26 "Was ist hässlich?" The lecture was not reprinted in Wickhoff's collected papers. My discussion of it is based on the extensive report which appeared in the *Fremdenblatt* for May 15, 1900, reprinted in Bahr, *Gegen Klimt*, pp. 31–4.

27 Richard Charmatz, *Oesterreichs innere Geschichte von 1848 bis 1907* (2nd ed., Leipzig, 1911–12), II, 153, 195.

28 For a general survey of Koerber's administration, see *ibid.*, II, 139–59. The political background and constitutional character of the Ministry are most fully dealt with in Alfred Ableitinger, *Ernest von Koerber und das Verfassungsproblem im Jahre 1900* (Vienna, 1973). Particularly interesting for the origins and economic aspects of the program are the memoirs of Rudolf Sieghart, *Die letzten Jahrzehnte einer Grossmacht* (Berlin, 1932), pp. 34–51, 56–60. Alexander Gerschenkron, *An Economic Spurt That Failed* (Princeton, 1977) sees the promising economic program of Koerber as sabotaged by Boehm-Bawerk. It ignores the cultural side.

29 Berta Szeps-Zuckerkandl, *My Life and History*, pp. 142–3; *idem*, "Wiener Geschmacklosigkeiten," *Ver Sacrum*, I, No. 2, February 1898, 4–6.

30 Allgemeines Verwaltungsarchiv, *Protokoll des Kunstrates*, Feb. 16, 1899.

31 *Jahrbuch der kunsthistorischen Sammlungen des Allerhöchsten Kaiserhauses*, Beilage zum XV. and XVI. Band, 1895. Wickhoff's contribution has been translated: *Roman Art; Some of Its Principles and Their Application to Early Christian Painting*, tr. and ed. S. Arthur Strong (New York, 1900).

32 Wickhoff in an unidentified letter to Riegl, quoted in Dvořak, *Ges. Aufsätze*, p. 309.

33 Hans Ostwald, *Otto Wagner. Ein Beitrag zum Verständnis seines Aufsätze, lerischen Schaffens*. Diss. ETH Zurich (Baden, 1948), p. 24.

34 See, e.g., Allgemeines Verwaltungsarchiv, *Protokoll des Kunstrates*, 1899, p. 4; *ibid.*, 1900, pp. 9–10.

35 The protocols of the Arts Council contain striking examples of the energy and candor with which Wagner, Moll, and Roller pressed the interests of modern artists. Cf. e.g., Allgemeines Verwaltungsarchiv, *Protokoll des Kunstrates*, Feb. 16, 1899; May 12, 1900; Memorandum of Alfred Roller to Minister of Culture von Hartel, October 1901, on the development of the Modern Gallery and its collection. For the Secession's public pressure on behalf of modern artists in the Council, see *Ver Sacrum*, III (1900), 178. One of the ministry's lesser bureaucrats has provided in his memoirs a somewhat jaundiced view of log-rolling and division of spoils in the Council; but he amply confirms the success of the modern movement as a pressure group within the state apparatus. Cf. Max von Millenkovich-Morold, *Vom Abend zum Morgen* (Leipzig, 1940), pp. 203–5. On teaching appointments, see Peter Vergo, *Art in Vienna, 1898–1918* (New York, 1975), pp. 129–30.

36 Strobl, *Albertina Studien*, II, 153.

37 Quoted in Bahr, *Gegen Klimt*, p. 35. On the position of the *Deutsches Volksblatt* between German nationalist and Christian Social anti-Semitism,

see William A. Jenks, *Vienna and the Young Hitler* (New York, 1960), pp. 126ff.

[38] For a fine reading of "Medicine," see Franz Ottmann, "Klimt's 'Medizin'," *Die Bildenden Künste*, II (1919), 267–72.

[39] Quoted in Bahr, *Gegen Klimt*, p. 59.

[40] See J. J. Bachofen, *Versuch über die Gräbersymbolik der Alten, Gesammelte Werke* (Basel, 1943 et seq.), IV, 166–8. Whether Klimt developed his careful iconography of Hygeia and the snake out of Bachofen, I do not know.

[41] Bahr, *Gegen Klimt*, pp. 41–59.

[42] A sample of press criticisms is given in *ibid.*, pp. 41–59.

[43] *Ibid.*, pp. 47–9.

[44] Quoted in Strobl, *Albertina Studien*, II, 168, n. 87. Von Hartel proudly cited Klimt's winning a gold medal for "Philosophy" at the Paris Exposition of 1900.

[45] *Ibid.*, p. 154.

[46] *Kunstchronik*, XIII (1901–2), 191–2, announced that confirmation was expected, but it evidently never came. See also Novotny and Dobai, *Gustav Klimt*, p. 386.

[47] Friedrich Jodl, "Über Bedeutung und Aufgabe der Aesthetik in der Gegenwart," *Literaturblatt, Neue Freie Presse*, April 20, 1902, 36–40.

[48] The fullest treatment of the final phase of the promotion, whose essentials I have followed here, is Kurt R. Eissler, "Ein zusätzliches Dokument zur Geschichte von Freuds Professur," *Jahrbuch der Psychoanalyse*, VII (1974), 101–13.

[49] Theodor Gomperz. *Ein Gelehrtenleben im Bürgertum der Franz-Josefs-Zeit*, ed. Heinrich Gomperz and Robert A. Kann, Oesterreichische Akademie der Wissenschaften, Philosophisch-historische Klasse, Sitzungsberichte, vol. 295 (1974), 15, 70–2.

[50] Ernest Jones, *The Life and Work of Sigmund Freud* (New York, 1953) I, 55–6.

[51] Letters of Freud to Elise Gomperz, November 25, 1901, and December 8, 1901; and to Wilhelm Fliess, March 11, 1902, *Letters of Sigmund Freud*, ed. Ernst L. Freud, tr. Tania and James Stern (New York–Toronto–London, 1964), pp. 241–5. Eissler, *Jahrbuch 1974*, p. 104. What Freud probably did not know was that Theodor Gomperz's own relations with Hartel were somewhat tarnished by early academic rivalry, and that, however much Gomperz may have valued Freud's work as a translator, he was distrustful of Freud's therapeutic methods in the treatment of his wife. See, on the first point, Gomperz, *Gelehrtenleben*, pp. 70–1, 309–10, and the somewhat cool eulogy that Gomperz wrote on Hartel's death for the *Neue Freie Presse*, Jan. 16, 1907, quoted in Gomperz, *Gelehrtenleben*, pp. 412–13; for Gomperz's mounting concern about Freud's hypnotic and talk-therapies in 1893 and 1894, *ibid.*, pp. 170, 234–7, 251. These doubts were not shared by Mme.

Gomperz, who interceded for Freud, but they could, through her husband, have affected the Minister.

[52] I follow here the cogent account of Eissler, *Jahrbuch 1974*, VII, 106–8.

[53] Letter to Fliess, March 11, 1902, *Letters of Freud*, p. 245.

[54] See Strobl, *Albertina Studien*, II, 161–3; Nebehay, *Klimt: Dok.*, pp. 321–6.

[55] The date as established by Dobai on the basis of the style, Novotny and Dobai, *Klimt*, p. 330.

[56] On Toorop at the Secession show of 1900, see Hevesi, *Acht Jahre*, p. 241; on "Jurisprudence" as a whole, pp. 444–8; on Toorop and Klimt, pp. 449–50. See also the article on Toorop in *The Studio*, I (1893), 247, with its illustration of Toorop's "The Three Brides."

[57] See the luminous introduction to Aeschylus, *The Oresteia*, tr. with intro. by Robert Fagles (New York, 1975), *passim*, esp. pp. 3–13, 60–85.

[58] The figure in "Medicine" on which "Goldfish" was based was painted over in the final state reproduced in Figure 46. See Novotny and Dobai, *Klimt*, Pl. 124, p. 325; Nebehay, *Klimt: Dok.*, p. 260.

[59] Hevesi, *Acht Jahre*, p. 446.

[60] Novotny and Dobai, *Klimt*, p. 325.

[61] Nebehay, *Klimt: Dok.*, p. 346.

[62] Kurt Blaukopf, *Gustav Mahler*, tr. Inge Goodwin (New York, 1973), pp. 163–4.

[63] The influence of Ferdinand Hodler is usually adduced to account for Klimt's conception of the chorus. See Vergo, *Art in Vienna*, pp. 74–5; Nebehay, *Klimt: Dok.*, p. 334 and figs. 406, 408.

[64] I am grateful to Professor Ann Douglas for pointing out the Yeats parallel. For the development of the late Yeats and its expression in "Sailing to Byzantium," see the fine analysis of Richard Ellman, *Yeats: The Man and the Masks* (New York, 1948), ch. XVI.

[65] Nebehay, *Klimt: Dok.*, p. 495.

[66] Rupert Feuchtmüller and Wilhelm Mrazek, *Kunst in Oesterreich, 1860–1918* (Vienna, 1964), pp. 109–22; Oesterreichisches Museum für Angewandte Kunst, *Die Wiener Werkstätte* (catalogue) (Vienna, 1967), pp. 11–16.

[67] The Stoclet house is one of the few Viennese buildings of the period to have been comprehensively analyzed. See Eduard I. Sekler, "The Stoclet House by Josef Hoffmann," *Essays in the History of Architecture Presented to Rudolf Wittkower* (London, 1967), pp. 228–44.

[68] The Mycenaean inspiration of the volutes and gold in the Stoclet frieze has been stressed by Jaroslav Leshko, "Klimt, Kokoschka und die mykenischen Funde," *Mitteilungen der oesterreichischen Galerie*, XII (1969), pp. 21–3, but he recognizes the overall primacy of the Ravenna example.

[69] I am indebted for this observation to Dr. Charles Kligerman in a discussion of Klimt at the Kohut Symposium on History and Psychoanalysis, Chicago, June 2, 1973.

[70] *Ver Sacrum*, I, No. 1 (January, 1898), 5.

[71] *Katalog der Kunstschau 1908* (Vienna, 1908), p. 23.

[72] *Ibid.*, pp. 4, 3.

[73] Josef-August Lux, in *Deutsche Kunst und Dekoration*, XXIII (1908–9), 44: "... A glorification of Klimt which seems to me just. Klimt is the artistic apex."

[74] For an illuminating discussion of a related development in Symbolist painting, see Robert Goldwater, "Symbolic Form: Symbolic Content," in *Problems of the 19th and 20th Centuries. Studies in Western Art.* Acts of the International Congress of the History of Art, IV (1963), 111–21.

[75] The date of conception of this painting is not known. Dobai's catalogue places it "before 1911, revised 1915." See Novotny and Dobai, *Klimt*, pp. 357–8. In the other philosophic paintings of his last ten years, such as "The Maiden," 1913; "The Bride," 1917–18; "The Baby," 1917–18; "Adam and Eve," 1917–18, Klimt likewise represses the unpleasant sides of life. His final style, marked by cheerful ornamental color and sturdy floral, plant, and human forms, lies beyond our scope.

VI

THE TRANSFORMATION OF THE GARDEN

"IT IS HARD to grapple with an existing social order, but harder still to have to posit one that does not exist."[1] These words of Hugo von Hofmannsthal carry the ring of the twentieth century, when the European mind lost its capacity to project satisfying utopias. Earlier, in the wake of the French Revolution, most writers would have inverted Hofmannsthal's judgment. They found it harder to grapple with the existing social order than to draft the lineaments of an ideal one.

As long as the artist knew what his values were, and knew these to have sanction and support from his society, if not pervasive power in it, social reality could serve as the anvil against which he created his literary artifacts. When historical expectations were defeated by events, however, or when the artists' values, bereft of social support, became abstract, Hofmannsthal's difficulty in positing a social order that did not exist acquired primacy over the more traditional problem of wrestling with the existing society. Inevitably, the role of the artist became redefined: he had not merely to articulate the rela-

tionship of traditionally accepted values to social reality, but to express truths for a mankind despairing of social order as such. The stages in the emergence of this function of literature in relation to the social order provide my theme; the culture of liberal Austria, its setting.

Wherever European artists made the difficult attempt to grapple with an existing order, as they so often did in the nineteenth century, social realism emerged as a dominant literary mode. A secure image of society's nature and movement, of its strengths and vulnerabilities, was the necessary prerequisite to wrestling with it in the pursuit of happiness and dignity. Depending on the critical stance of the author, his hero might be locked in deadly struggle with his society, like Stendhal's Julien Sorel, or shaped and imprisoned by it, like Émile Zola's Nana; in either case social realism implied an integration of character and milieu. Concern for the human condition illuminated the state of society; careful delineation of the social milieu explicated the state of humanity. The interpenetration of character and scene, of individual and contemporary environment, is, as Erich Auerbach so concretely demonstrated, the hallmark of realism.[2] The more specific and far-reaching the author's emphasis upon social structure, the more appropriate the term "social realism" becomes. In the nineteenth century, this tendency in the novel, as in Zola, finally approximated the character of pure sociological inquest.

Compared to other countries of high literary productivity, Austria in the nineteenth century remained singularly unaffected by the social realist movement. Most of the authors who can be classified in this school remain virtually unknown outside Austria itself. Both the power of the baroque tradition of fantasy and the failure of the Austrian middle class to develop independence of the aristocracy weakened the development of social realism. Yet Austrian literature found other media to refract the problem of relating cultural values to a social structure in transition. The image of the garden was one such medium. Since ancient days the garden has served Western man as a mirror of paradise to measure his temporal state. As it appears at crucial points in Austrian literature, it helps us to mark stages in the developing relationship of culture and social structure, utopia and reality. Within its narrow confines, the garden captures and reflects the changing outlook of Austria's cultivated middle class as the ancient Empire approached disintegration.

I N 1 8 5 7 Adalbert Stifter published his novel *Der Nachsommer (Indian Summer)*. Generally regarded as the masterpiece of Austrian realism, it was conceived as an answer to the socio-political problems of his age. Yet these problems are never openly stated in the book; nor is the historical movement of society described, except in the most allusive and remote fashion. Stifter offered no symptomatology of society's ills; he went directly to the cure. The cure is *Bildung*, the training of the character in a holistic sense. *Der Nachsommer* is a utopian *Bildungsroman* built of realistic elements.

Born in 1806, Stifter acquired his values and outlook in the quiet years before the storm of 1848. For him, a relatively unpolitical Biedermeier liberal, *"ein Mann des Masses und der Freiheit,"**[3] the revolution proved a decisive experience, a crisis of confidence in the nature of man. Like so many of his contemporaries, Stifter at first welcomed the revolution, then recoiled in horror at the collapse of order. Conceiving of politics as a branch of ethics, he understood the destruction of order not as the result of historical or social "forces" but as the consequence of human passions unleashed. In classical Kantian fashion, Stifter regarded order, control of passion, as indispensable and integral to freedom in both the individual and the state: "genuine freedom demands the most self-control, the constraint of one's desires. . . . The foremost and only enemies of freedom therefore are all those people who are possessed by powerful desires and urges [*Begierden und Neigungen*], which they wish to gratify by any means. . . ."[4] Stifter's political analyses are indistinguishable in form and content from moral homilies. As he disdained romantic poets who unleashed strong human emotions, so he feared political radicals:

Distrust your hotspurs, who promise to overwhelm you with immeasurable freedom and eternal gifts of gold; they are mostly men corrupted by

* "A man of measure and independence."

the power of their emotions, who are driven by their emotions to win a wide field of action and great gratification [for themselves]; and when they have won them, they will fall still lower and drag down all who trusted them.[5]

Political chaos was the product of personal passion; its remedy must be personal self-discipline. Only moral individuals could sustain free institutions, Stifter maintained. Because men had not acquired the moral maturity to be capable of freedom, the revolution destroyed the very freedom it aimed to realize. Stifter thus drew the lessons from the revolutionary experience in the traditional language of German humanism, of Friedrich Schiller and of Wilhelm von Humboldt. Although "the ideal of freedom [was] destroyed for a long time to come" by the revolution, Stifter did not despair: "Whoever is morally free can be politically free and always is so; not all the powers of the earth can make the others free. There is but one power which can do so: *Bildung*."[6]

Bildung was no empty phrase with Stifter. As citizen and as artist, he devoted himself after 1848 to spreading it among his fellow men in order to prepare them intellectually and morally for freedom. Where before the revolution Stifter had served as private tutor to wealthy families (including Metternich's), after it he turned to public education. He participated actively in the great reform of the school system under Count Leo Thun*, in 1848 and 1849 as a contributor to public discussion and policy planning, thereafter as a school inspector. His commitment to education, though liberal, also bore the stamp of the Benedictine tradition in which he had been schooled: Stifter strove for a unity of mind and heart, of knowledge and practice, of reason and grace. His old-fashioned, politically conservative humanism produced paradoxically democratic consequences in his educational theory. For him the major pedagogic task of the state—indeed, its most vital function in any sphere—was the education of the masses. Stifter perceived and criticized the growing tendency of modern society, fostered by the intellectuals themselves, to divide men into *die Wissenden* and *die Nichtwissenden*, the knowledgeable and the ignorant. Education should weld together,

* For Leo Thun and his role in University reconstitution, see above, pp. 38–40.

not separate, mankind. Stifter's very fears of the masses led him to the democratic conclusion that the elementary school had more immediate importance than either secondary school or university. In elementary education the *Volk* could and should be trained morally as well as intellectually. The personally fulfilled life and the socially useful life grew out of the same stalk. "What we need is character," Stifter wrote a friend in June 1848. "I believe that rock-solid truthfulness . . . and rock-solid thoroughness . . . would have stronger and longer effectiveness today than learnedness and knowledge."[7] Education must accordingly foster not merely the life of the mind but a comprehensive development of character.

Surely the virtue of learning was not as important as the learning of virtue. *Bildung,* a term increasingly denoting that acquired high culture which accorded a mark of social substance if not of social grace to its possessor, still meant to Stifter a richer complex of attributes composing the well-formed and integrated personality.

To illustrate and propagate his concept of *Bildung,* compounded of Benedictine world piety, German humanism, and Biedermeier conventionality, Stifter gave to the world his novel *Der Nachsommer.* As his dedication to a career in public education had grown out of his political concern, so his commitment as an artist represented an extension of his educational concern. Stifter left no doubt of his didactic intention in *Der Nachsommer:* "I have probably made the work on account of the rottenness [*Schlechtigkeit*] which in general and with a few exceptions prevails in the political conditions of the world, in its moral life and in the literary arts. I wanted to contrapose a great, simple, ethical force [*sittliche Kraft*] against the wretched degeneration [of the times]."[8]

In his negative intention—to fight "the wretched degeneration" of his times—Stifter was at one with his great French contemporary, Gustave Flaubert. The latter published his bitter *Bildungsroman, L'éducation sentimentale,* in 1869, only twelve years after *Der Nachsommer.* To the modern reader, however, a century of social history would seem to lie between the two works. Flaubert's strategy in his warfare against social reality is not only to reveal the chaotic, unstable movement of society but also to show how it corrodes all idealistic resistance. The "education" of Frédéric Moreau is an education in disenchantment: the intelligent perception destroys what the heart owns, and the experienced understanding ratifies the futility

of all ideals. Flaubert's "realism" indicts society by depicting it directly and concealing from the reader his own normative ideals. Stifter's strategy is the opposite: he indicts the chaos of contemporary reality not by describing it but by ignoring it. Out of recognizably real social materials he constructs a well-ordered milieu in which an immanent ideality is slowly made plain to the hero. By a careful, generous training of habit, head, and heart, Stifter's hero grows into a life of fulfillment. In Stifter's fictional society, as in his *gebildeter Mensch,* intelligence and sentiment, truth and goodness are synthesized, not mutually exclusive as in Flaubert's.

The realistic novel revolves around the integration of character and milieu. The opening of Flaubert's *L'éducation sentimentale* adumbrates that integration for the hapless child of illusion, Frédéric Moreau. A Seine River steamer about to depart belches "great whirlwinds of smoke" as people rush aboard, jostling each other "in breathless haste." Traffic is obstructed by cargo and cables strewn in every direction. "The sailors answered nobody." As the steamer casts off, the chaotic, mobile, commercial society it represents will sweep Moreau up too. His moorings cut, he will attach himself to the world of illusory love, specious art, and corrupt politics that will drag him down. On the clanging, hissing steamer he confronts all these aspects of the world for the first time, appropriately enough in motion, in transit. In just a few brisk opening pages Flaubert shows the malleable, romantic Frédéric already being embraced and molded by the strong and slippery tentacles of the modern French milieu.[9]

To posit a "great, simple, ethical force" against the times, Stifter integrated hero and milieu no less than Flaubert. In the first chapter of *Der Nachsommer* the hero, Heinrich Drendorf, describes his positive responses to his early education, but Stifter allowed its title, "The Household," to reflect the primacy of the milieu. As in the opening of Flaubert's novel, the description of the economic environment serves as basic clue to the social and spiritual conditions that will form the hero. The clangorous, vaporous river steamer of Flaubert, symbol of mobile, speculative, capitalist society, has a contrasting analogue in Stifter's novel: the composed ménage of the elder Drendorf. In this household, old-style commercial enterprise and an upright family life are felicitously united under the sober justice of the father-master. The atmosphere is the very opposite of

Flaubert's riverboat: solidity, stability, serenity, and orderliness. The social and physical milieu serves Stifter's hero as vestibule to the good life, and his reader as a kind of concrete *preparatio evangelii*.

Heinrich Drendorf begins his story with the lapidary sentence, "My father was a merchant." Domicile and shop were under the same roof. The employees ate at the master's table as members of an enlarged family. The ethic of fatherhood governed the elder Drendorf's behavior as entrepreneur. The obverse was equally true: Drendorf's early capitalist ethic informed his exercise of paternal authority. He managed his family and his household, one might say, like a business in an era when probity, thrift, simplicity, and strict personal accountability were the principal economic virtues. Every person had his appointed duties in the household. Time and space were precisely subdivided and organized in such a fashion that every segment fulfilled a specified function. Heinrich's mother, a warm and good-natured soul who would have allowed her children a more spontaneous life, enforced "out of fear of Father" the appointed tasks laid down by the master of the household. The well-ordered environment was the key to the well-ordered soul, and together they composed the well-ordered world.

Heinrich's father summarized his view of life in the principle: "Everything and every person can be but one thing; this, however, he [or it] must be to the full." On the basis of this principle of specialization, there was inculcated into the children the spirit of "strict exactitude" which became the basis of a character formation leading to a life of personal fulfillment. Greatness in this view lay not in the exceptional or outstanding but in the regular and perfected.

Self-discipline and self-reliance were the principal virtues the father inculcated in his son. Classical bourgeois virtues, transmitted in a Biedermeier setting, they constituted for Stifter the characterological core of *Bildung*. They were the very virtues that Robinson Crusoe, by ignoring the sound advice of his father, had had to acquire, as he said, through "a life of misery."[10]

Drendorf, through filial devotion and willingness to make his father's values his own, did not merely enter his father's station; rather, he prepared himself for a more comprehensive self-fulfillment and a wider culture. Indeed, Stifter wished to show that there was a better life than that of the upright bourgeois of the old school: a life of science, art, and higher culture. Heinrich was trained and

encouraged to transcend his father, but to do so by building on his paternal inheritance rather than rejecting it.

Der Nachsommer stands at a crossroads in the relationship between generations within the Austrian bourgeoisie of the mid-nineteenth century. Are the sons to enter the patrimony of the fathers or to create a new world of their own? The very existence of such a question implies a social crisis. Not until the 1880's did it become a burning issue, and, when it did, the nature and function of higher culture were also thrown into question. Stifter was the first to pose the problem, albeit gently. He could delineate a convincing solution in a perspective wherein utopian and realistic elements could still be satisfactorily unified.

In the life of the Drendorfs, social mobility was still identified with intellectual growth, and *Bildung* was an extension of bourgeois virtue. Drendorf the elder, though clearly without formal education, manifested strong intellectual interests. He acquired culture in the same spirit and manner as he acquired property, and the author respects him for it. Thus Drendorf kept his books in a case the glass doors of which were hung with green cloth, lest the exposure of the gilt-decorated bindings suggest vain display. When his fortunes allowed him to purchase a more cheerful home in the suburbs, Heinrich's father became less reticent in manifesting his commitment to higher culture. Not only did he install a large library (the green curtains seem to have been forgotten when the family left "the old, gloomy city house"), but he set aside a separate room to house his paintings. Indulging his nineteenth-century taste for the private museum, he set up an easel in a well-lit position, upon which each painting could be placed in order to be studied, read. One is reminded of St. Augustine's maxim: "To use, not to enjoy": Heinrich's father valued art not as a source of pleasure but as an instructional medium, closely bound to science, teaching one of light and shadow, rest and motion. At the same time he prized his paintings as a sound investment. "He said that he bought only old ones which had a certain value, which one could always realize if one were ever compelled to sell. . . ."[11]

In his self-assured integration of moral, cultural, and economic values, Heinrich's father might have served his creator as the very model of the cultural philistine. Stifter did not see him thus. Unlike his immediate successors, Stifter maintained an unbroken faith in the

pre-industrial bourgeois value complex, and he wished to make clear how modest were the social foundations of the good life. Where intellectuals of the next generation would see puritanical repressiveness, Stifter saw *Sittlichkeit und Ernst* (morality and sobriety), like a moralist of the eighteenth century. Where his successors would see *petit bourgeois* narrowness, he found civic uprightness; where they complacency, he solidity; where they pallor and weakness, he clarity and purity.

Only once did Stifter allow a rift to appear between the Drendorf household and the bourgeois society in which it was anchored. The issue concerned, significantly, the relationship of culture and society, *Bildung* and *Besitz*. Heinrich, who had flourished under the excellent tutors provided by his father, asked permission to become a scientist. In assenting, Heinrich's father evoked sharp criticism from "many people." They argued that he should have dedicated his son to "an estate . . . useful to civil society," so that he might "one day end his days with the consciousness of having fulfilled his obligations." Heinrich's father withstood this pressure not by justifying the utility of science but by asserting the principle that human beings existed for their own sake, and not for society's. He buttressed this radical individualism with his confidence that each man would serve society best if he followed the inner urge that God placed in him as a guide to his true vocation. This incident made it clear that, in the pursuit of pure science, Heinrich had to leave the society of his birth and transcend the culture of his father. In supporting his request, the elder Drendorf exemplified paternal generosity to the point where his bourgeois independence became independence of the prevailing bourgeois code.[12]

Stifter invests the episode with little tension in the telling (his limpid prose always flows as smoothly as the lives he holds to view), but its significance is nonetheless great. Maturity would bring Heinrich no necessary break from his father, but neither did his initiation into manhood imply entry into the father's vocation. The father trained Heinrich for financial independence, and a fortuitous inheritance solidified the economic foundation of his vocational independence. Only filial piety remained to tie son to father. As a *rentier* and a scientific intellectual, Heinrich was ready to pass out of the older commercial milieu and enter the utopia of the mid-century Austrian middle class.

"Even as a boy," Heinrich tells us, "I was a great friend of the reality of things." His growth as a scientist ran from the exact observation of the details of "things" to the comprehensive description of nature. Scientific research as Stifter described it was essentially classificatory. The spirit of fastidious orderliness dominating the Drendorf household reappeared, without explicit notice by the author, in Heinrich's approach to nature. He collected botanical or mineral specimens, described each "with strict exactitude" according to its nature, and "progressed to ever more composite [*zusammengesetzteren*] and ordered descriptions."[13] The *petit bourgeois* zeal for acquisition and precise ordering was thus elevated to the intellectual sphere and applied to the understanding of nature. "Through the collection of many small facts in the most varied places," Heinrich could broaden himself out "into the great and sublime whole."[14]* God's house of nature appears almost as an ideal magnification of the modest, well-ordered Drendorf household.

Science took Heinrich out of his limited urban environment into a wider realm. The second phase of his *Bildungsweg*, begun as wandering physiographer, brought him into the countryside where he first came to sense the beauties of God's vast creation. While he studied nature's inner structure as scientist, he awoke to art through watching nature's outer form.

His independent existence as a naturalist prepared Heinrich for the third and most important phase of his education: the unification of "nature" and "culture" in the perfected life of a country gentleman. To a description of this life and its setting in a model rural estate most of *Der Nachsommer* is devoted. Indeed, the estate, the *Rosenhaus*, is the central symbol of Stifter's social ideal, a Paradise Regained.

Heinrich discovers the *Rosenhaus* when he is seeking refuge from a threatening storm. (In accordance with Stifter's method of ex-

* The special philosophic character of the traditional Austrian conception of the world, with its stress on the immanence of spirit in earthly reality, and with its resistance to the dualism of German philosophic idealism, has been brilliantly explored by Roger Bauer in *La réalité, royaume de Dieu, études sur l'originalité du théâtre viennois dans la première moitié du XIXᵉ siècle* (Munich, 1965). Stifter absorbed this world-view from his Benedictine teachers, its chief exponents.

purgating the chaotic from life, the storm never breaks.) He sees the house gleaming high on a hill under the black clouds and makes his way to it like a romantic wanderer approaching an enchanted castle. The house is covered with roses. They "seem to have spoken the word to each other to burst into bloom at the selfsame time, in order to swathe the house in a cloak of the most charming hues and in a cloud of the sweetest scents."[15] Neither Stifter nor his meticulously intellectual hero allows us to linger long in the spell of this beauty. Romantic illusion is not punctured, but explained. Swiftly and coolly, Heinrich penetrates the magical effect, revealing it to be a triumph of human industry, of artful horticulture. The floral web has been carefully plaited of rose trees, trained to varying heights, and trimmed so that no gap might appear in the solid bank of blooms. By scientific husbandry the innocent forces of nature are organized to create a setting of beauty for the flowering of the human spirit.

The *Rosenhaus* and its ideal life reveal much concerning the sociological properties and intellectual content of *Bildung* in mid-nineteenth-century Austria. Sociologically, the *Rosenhaus* represented the life of a higher social stratum than that to which Heinrich was born. Its owner, Freiherr von Risach—who becomes Heinrich's mentor and surrogate father—was a cultivated nobleman, yet no aristocrat of the blood. Born of a poor peasant family, Risach had risen by the most usual route for the Austrian commoner to acquire eminence, one that continued to accord high social status until the end of the monarchy: the civil service.* Despite a career that had brought him not only a patent of nobility but the friendship of his sovereign, Risach had turned his back on politics and power. Purchasing an estate in the country, he retreated to contemplation and practical activity on his own circumscribed domain, enriching his understanding and imparting, to those who would learn, his formula for a perfected and harmonious existence. The ideal of Risach and the *Rosenhaus* was that of a nobleman of the spirit, a seigneur be-

* Hugo von Hofmannsthal pointed to Josef Sonnenfels under Maria Theresa and Baron Kübeck under Francis I as enlightened bureaucratic statesmen of the social type that Stifter had in mind—men whom everyone would view as "having achieved great heights, [but] not as climbers." See "Stifters 'Nachsommer,'" in Hugo von Hofmannsthal, *Selected Essays,* ed. Mary Gilbert (Oxford, 1955), pp. 58–9.

yond any *libido dominandi*, who could enhance the traditional rural aristocrat's life with the scientific, ethical, and aesthetic culture of the bourgeoisie.

Risach conducted his utopian estate on principles combining the practical prudence of Daniel Defoe with the classic sublimity of Johann Winckelmann. He integrated nature and culture into a single continuum. The *Rosenhaus* garden, central symbol of this integration, was designed not merely for aesthetic effect. Unlike the gardens of the country houses of city people, "where one cultivates unfruitful shrubs or at best bushes bearing only ornamental fruit," Risach's garden mingled flowers with vegetables to produce "feelings of domesticity and usefulness."[16] Nature was perfected by science into art: purged of weeds and insects, the *Rosenhaus* garden bloomed "clean and clear." Risach's estate was thus no parturient paradise for a pleasure-seeking *homo ludens*. *Nature naturante* was curbed and perfected in accordance with God's intention that Adam fulfill a task in the Garden of Eden: "to dress and to keep it." Utility and beauty result from man's self-conscious and disciplined effort to activate nature's bounty.

As he cultivated his garden to elicit the more edifying beauties of nature, so the master of the *Rosenhaus* designed his house as a setting for the flowering of the human spirit. The *Rosenhaus* made possible an ordered, expurgated life and a harmonious disposition of the feelings. Where its garden exemplified nature transfigured by culture, its interior revealed a culture vitalized by nature. Into the building's design and decor, nature's sustaining presence was physically incorporated. Indeed Risach achieved an almost Japanese interpenetration of indoors and outdoors. Great sliding windows brought in the cheerful view of birds and flowers. Silk screens allowed pure air to circulate in the sitting room "as in a quiet forest." Huge skylights in the ceiling above the stairwell introduced the variety of nature's lights to glorify a Grecian statue. Risach employed native woods and marbles (only the richest, of course) to achieve an atmosphere of what Winckelmann would have called "noble simplicity and quiet grandeur."

A second noteworthy characteristic of the culture of the *Rosenhaus* was the commitment of its master to the past. To furnish the *Rosenhaus*, Risach maintained a workshop for reclaiming old furniture and art objects from the ravages of time. Risach's devotion to

restoration and recovery transcended by far his love of creation or discovery. The ideal life could not risk spontaneity; it had to feed the feelings on the works of the dead. For Risach, time was rather a foe that might sweep one away than a force that would carry one forward, as the progressives believed. Hence Risach devoted himself to keeping the past alive in both its practical and ideal aspect. The line between arts and crafts, artistry and artisanship, scarcely existed. In old use-objects Risach recognized "the charm of the past and of the vanished bloom." He sought to recapture it: we "snatch [old utensils and furnishings] from decay, put them back together, clean them, polish them, and try to restore them to domestic use."[17] Risach accorded the same treatment to works of fine art (as did Stifter himself), restoring Greek sculpture or Gothic ecclesiastical art, removing the overlay of later ages—especially of the frivolous *Zopfzeit* (the age of the pigtail), the eighteenth century—to purify the works that could edify the spirit. In the garden Risach pruned away the sickly plant to make way for the healthy. In the house and in culture he showed the same passion for maintenance, but, significantly, none for new growth.

Thanks to its master's piety toward the moral-aesthetic achievement of a vanished past, the *Rosenhaus* partook of the character of a museum. In this character, the nature and function of *Bildung* for the educated middle classes in the mid-century come to focus. Partly consciously, partly unwittingly, Stifter here disclosed the social content and the problematical character of his utopian ideal. As private museum the *Rosenhaus* reveals three features: the transposition of *petit bourgeois* parsimoniousness into aesthetic fastidiousness; the substitution of art for religion as the source of the highest meaning in life; and the tendency of social mobility and cultural acquirement to destroy the democratic ideal of a single, universal, ethical culture.

The first of these features shows itself in Risach's passion for maintaining the *Rosenhaus* and its internal contents. Though he was a wealthy *rentier*, his custodial zeal was of the same stuff as the insistent orderliness of the elder Drendorf. Risach personally supervised the restoration of furniture in the shop. Lest one scratch his parquet floors, one had to don felt slippers. Never might a book be left out of its case. The classical purity of the *Rosenhaus* thus shows itself to be but an elevated form of *petit bourgeois* cleanliness. Differences

in *Bildung* aside, the aesthete's *Reinheit* betrays its affiliation to the Hausfrau's compulsive *Reinlichkeit*. What waste and functionlessness were to the merchant Drendorf, the abuse of beautiful things and the loss of the treasures of the past were to the new aristocrat Risach. Property and *objets d'art*, both painstakingly acquired, deserved to be protected against the inroads of human carelessness and the erosions of time. The man of property who acquired aesthetic culture became not a creator but a curator.

The *Rosenhaus* was itself a work of art, an ideal setting to dramatize the art of life. Heinrich could appreciate its nature because his educational journey had equipped him with a moral foundation and an intellectual-scientific outlook that seasoned him for entry into the complete life of the spirit which found its ultimate expression in art. Only gradually did he come to appreciate that in the *Rosenhaus* every element, though discrete and self-justified, contributed to a single harmonious whole. Heinrich reached the end of his learning process only when he finally felt and understood the impact of Risach's prize possession: a lifesize Greek statue. The statue symbolizes the unifying, sublimating, and disciplining function of art that the *Rosenhaus* represents. Even its dangerous subject, the naked female form, expresses repose, *Ruhe:* "that many-sided composure of all parts into one whole . . . that ordering vision . . . [which prevails] no matter how strongly feelings or [the urge to] actions may rage within."[18] Man's aesthetic power unites him to the creativity of God; it lets him perceive even in movement and passion that measure and order which so enchant us. Art expresses the highest stage of *Bildung*, for it presents the world not only to the mind, but to the soul, as religion had done. The man of science could understand the rational structure of the world of things, yes; but only the man of art could apprehend it as formed feeling. When Heinrich finally achieved the state in which he could appreciate God's universe aesthetically, he was ready to enter the world of adult love. His father had disciplined his feelings with correct ethical norms of behavior; Risach had cultivated and sublimated them in art. Here, too, art took on a burden once performed by religion: the canalizing of the passions and the refinement of feelings. Coming to love—and marriage—by the route of art, Heinrich never had to endure the pains and disorders of passion.

Risach had turned to the horticultural and aesthetic pursuits of

the *Rosenhaus* in order to build a life of order. Only at the close of the novel do we learn that behind Risach's ideal life in the *Rosenhaus* lay an earlier one of disorder and sorrow. Storms of amorous passion had brought him close to disaster, and his attempt to order the political world through civil service had yielded only frustration. The ordered ideality of Risach's *Rosenhaus* was a deliberate work of art, its ideal culture reminding one of the dictum of Stifter's more sophisticated contemporary, Charles Baudelaire, that "art is the best thing of all for veiling the terrors of the pit."[19]

The content of Risach's culture, as well as the relation its pursuit had to his earlier direct experience of life, could truly be called *Nachsommer*. For it consisted of elements from the past, all of which were losing their vitality even as Stifter built his utopian culture of them: the simple bourgeois Biedermeier ethic, the self-contained, rural-aristocratic economic entity, the purified Hellenic and medieval ideals of art, and the concept of the family as the primary social unit. Stifter presented Risach's Indian summer as though it were Heinrich Drendorf's spring. History did not honor the claim. Stifter's *Bildungsideal*, based on social withdrawal and a cultural orientation toward the past, would rapidly reveal its incapacity to serve even as a utopian vision for late-nineteenth-century society.

The ultimate viability of Stifter's utopian ideal, however, is no fair standard by which to judge his success. Let us rather ask whether Stifter had achieved his own aim: to "contrapose a great, simple, ethical force against the wretched degeneration" of the times. If we concentrate on the hero's progress in *Bildung*—successively in morals, science, and art—then surely Stifter provided a model for personal fulfillment in a cultivated and refined life of ethical perfection. But if we turn to the relation of this *Bildungsweg* to the social structure, the power of the "simple, ethical force" becomes enfeebled, nay, deeply problematical. Heinrich's road to ideality implied, on the one hand, social mobility; on the other, social withdrawal. Heinrich does not so much become a model for modern urban society as rise beyond it, socially and culturally. He climbs, however innocently, from a Viennese bourgeois background into an aristocratic way of life. If he succeeded in maintaining his ties with his father, it was because he carried his bourgeois morality into the higher social stratum that he entered. Risach, his substitute father, incarnated the principle of social withdrawal, which a truly pure, higher culture seemed to

imply for Stifter despite his own intention. For Risach left behind a
society where politics and passion ruled. If he achieved, in the
ordered realm of his ideal country seat, the unity of ethics, science,
and art, he devoted all three to the cultivation of his own garden.
Moreover, the social prerequisites that the realist Stifter showed to
be necessary to his utopia drastically limited its accessibility as model.
The Arcadia of the *Rosenhaus* was open, as Stifter made clear in
innumerable passages, only to the man of independent wealth.
Bildung is grounded in *Besitz*. Thanks to fortunate inheritances and
prudential habits, Heinrich could mount the social ladder from his
father's workaday world into Risach's pseudo-aristocratic heaven,
where leisure was the necessary prerequisite of the good life, and
work was but an instrument of self-perfection. The good life itself,
consisting of learned culture, suited only an élite, the élite of *die
Wissenden*, whose separation from *die Nichtwissenden* Stifter had so
feared and deplored.

Stifter did not merely posit a utopia that unwittingly implied a
widening gap between educated and uneducated. His social realism
broke through his utopian intent to reveal the crack in his golden
bowl. By his own account, the cost of progress in higher culture was
deeper cleavage in the social structure. As we proceed from the
simple and upright Drendorf household to the refined atmosphere of
the *Rosenhaus*, the relationship between master and men deteriorates.
In the elder Drendorf's old bourgeois household, the ethic of labor
and duty governed both employer and worker; both served each
other in an integrated familial and economic unit. In the more exalted
milieu of the *Rosenhaus*, the master, through no fault of his own,
learned to distrust most of his men, held them in intellectual con-
tempt, and regarded any effort at social integration as hopeless. At
the Drendorfs' the employees had taken their meals with the family;
in the *Rosenhaus*, the master dined alone or with his social equals.
Risach had once had his staff at meals, for he believed that it would
benefit them morally and make them love their service more. But he
had given up the custom, as "the gulf between the so-called culti-
vated and the uncultivated [had grown] ever wider." Once the
"natural" relation between master and servant had gone, Risach
concluded that the attempt to restore it would only make the workers
lose their freedom.[20] Whatever his regrets, Risach held most of the
people who worked for him in low esteem. He regarded his gardeners

as incapable of learning how to water the plants in relation to the weather and he controlled their work by direct orders and the threat of discharge if they should disobey. His stern patriarchal rule over his furniture restorers and his high craft standards occasioned a high turnover in Risach's labor force.[21] The handicraft methods of the past seemed uncongenial to the worker of the present, and Stifter portrayed the worker as generally impervious to the moral and technical culture Risach required for his restorative work. Thus Stifter showed that the social structure grew more radically stratified and less integrated as *die Wissenden* progressed in the realization of their cultural ideal.

Heinrich's *Bildungsweg* equipped him with the character, patrimony, and culture to lead a fruitful personal life. It did not, however, provide what Stifter had set out to offer his society: a usable utopian model to set against the age. *Der Nachsommer*, reasserting the unity of art, science, and ethics, turned all three inward toward self-cultivation. It left the scene of contemporary social action for an idealized rural-aristocratic past. Stifter projected an ideal of life that implied a social withdrawal and a cultural élitism ultimately incompatible with his redemptive intent. To the degree that his highly cultivated, composed, and sublimated personality ideal became embodied in an actual social type in the next generation, its adherents proved unable to engage in social action. The man of high culture lost the psychological stability, the ethical responsibility, and the sense for the interdependence of all things that Stifter sought to rescue from a vanishing past to restore order in an uncongenial present. The powerful social reality, which Stifter had found so hard to grapple with, would one day penetrate the fastnesses of the *Rosenhaus* and undermine the cultural ideal he had sketched with such admirable security of line.

❧ II ❧

THE HISTORICAL fortunes of the high middle class of Austria in the mid-century were strangely compounded of unearned successes and undeserved failures. After the defeats of 1848, the Austro-German burghers slowly developed their strength in the economic and intellectual spheres, but they owed their rise to political power in

1860 and 1867 less to their intrinsic strength than to the defeat of the absolutist régime at the hands of Italians and Prussians. Neither fully supplanting the aristocracy as a ruling class nor successfully fusing with it, the upper middle class found ways of coming to terms with it, especially in culture. We have seen (Essay II) how, in building the Ringstrasse after 1860, the liberals projected into architectural monuments the values of their secular counterculture to compete with, if not to replace, the churches and palais of the religious-aristocratic order. While Parliament building and Rathaus proclaimed the victory of law over arbitrary power, a series of edifices expressed the *Bildungsideal* of liberal Austria: university, museum, theater, and, grandest of all, the opera. In ways that Stifter would have heartily approved, the culture once confined to the palace had poured into the market place, accessible to all. Art ceased to serve only as an expression of aristocratic grandeur or ecclesiastical pomp; it became the ornament, the communal property, of an enlightened citizenry. The Ringstrasse thus bore massive witness to the fact that Austria had replaced despotism and religion with constitutional politics and secular culture.

The high value placed on *Bildung* in the public ethos of liberal Austria penetrated deeply into the private sphere as well. Scientific and historical cultivation were valued for their social utility as the key to progress. But art held a position almost equal in importance to that of rational knowledge. The reason for the high place of art in the scale of bourgeois values was obscure even to its devotees. Art was closely bound up with social status, especially in Austria, where the representational arts—music, theater, and architecture—were central to the tradition of a Catholic aristocracy. If entry into the aristocracy of the genealogical table was barred to most, the aristocracy of the spirit was open to the eager, the able, and the willing. Museums and theaters could bring to all the culture that would redeem the *novi homines* from their lowly origins. Learned culture could serve, as it had for Stifter's Heinrich, not only as an avenue to personal development, but as a bridge from a low style of life to a high life of style. The democratization of culture, viewed sociologically, meant the aristocratization of the middle classes. That art should perform so central a social function had the most far-reaching consequences for its own development.

The economic growth of Austria created the basis for an increasing

number of families to pursue an aristocratic style of life. Wealthy burghers or successful bureaucrats, many of whom acquired patents of nobility like Stifter's Freiherr von Risach, established urban or suburban variants of the *Rosenhaus,* museum-like villas that became centers of a lively social life. Not only gracious manners but also intellectual substance were cultivated in the salons and soirées of the new élite. Increasingly, from the age of Grillparzer to the age of Hofmannsthal, poets, professors, and performing artists were valued guests, in fact, prize catches of the hosts and hostesses. The gap in values between bourgeois and artist, so marked in the Empire of Napoleon III, was but faintly adumbrated in that of Francis Joseph. Men of affairs—political and economic—not only mixed freely with intellectuals and artists, but single families might produce both types. Thus the Exners were now bureaucrats, now professors; the Todescos and Gomperzes produced bankers, artists, and scholars. Intermarriage provided the new wealth with high cultural status and the intelligentsia with firm economic support. (When the philosopher Franz Brentano, a bearded man of imposing stature, courted the wealthy Jewess Ida Lieben, some cultivated wag observed that "a Byzantine Christ . . . was in search of his gold background.")[22] The integration of *Bildung und Besitz* thus became a surprisingly concrete social reality in the brief era of liberal ascendancy. Action and contemplation, politics and economics, science and art—all were united in the value system of a social stratum secure in its own present and confident in the future of the humanity it championed. In the new plan of the city, in the life of the salon, in the ethos of the family— everywhere the hopeful integrating creed of a rationalistic liberalism found concrete expression.

Most important for our concern, art occupied a place of increasing centrality in this culture. The ambiguity of its function in the middle-class ethos has already been alluded to. In Stifter, art had served as vehicle of metaphysical truth and refiner of personal passion. In the more common, garden-variety liberal culture, art was seen as expressing ideals for the society and bringing grace to the individual. Soon these two functions of art—the social and the individual—were to separate in the face of fundamental political and social changes, but not before a deep sense of the value of art had been instilled in a whole generation of upper bourgeois children.

The fathers who created the brave new world of sober rectitude

and economic success in the mid-century longed for the graces that would ornament their lives.

> When Adam delved and Eve span
> Who was then the gentleman?

The question had ironic relevance for the *arrivé* in general, but especially for the bourgeoisie of Vienna, a capital where visible grace, a personal style of sensuous charm, a theatrical and musical culture were the well-established marks of social distinction. Where performances at Burgtheater or opera provided the subjects of polite conversation—those topics of discourse which in Britain would be offered by the political reviews—we can hardly wonder that the fathers introduced their children to aesthetic culture early in life. Beginning roughly in the 1860's, two generations of well-to-do children were reared in the museums, theaters, and concert halls of the new Ringstrasse. They acquired aesthetic culture not, as their fathers did, as an ornament to life or as a badge of status, but as the air they breathed.

Where the fathers had been educated like Stifter's Heinrich Drendorf for a vocation, the sons were reared to absorb high culture for its own sake. The two children of the Wertheimsteins, one of Vienna's wealthiest intellectual society families, were privately tutored to be artists, and the "artistic natures" of these melancholy neurotics were the subject of general appreciation.[23] The great psychiatrist Theodor Meynert encouraged his son to a career in painting, his daughter tells us, "as if all those talents and inclinations which, passed on for generations, germinated in [the] father, . . . now broke through energetically in the son."[24] The great pathologist Carl von Rokitansky had his paternal dreams of glory fulfilled when he could boast of his four sons that they were divided in their careers between singing and medicine: "Two howl and two heal."[25]

The devotion to the arts implanted in the young Austrian in the home found reinforcement in the peer group at the Gymnasium and the University. Literary circles and aesthetic friendships formed in the school years frequently determined the life orientations of their members.[26] Such influences only added to the development by 1890 of a high bourgeoisie unique in Europe for its aesthetic cultivation, personal refinement, and psychological sensitivity. What had been

acquired in Stifter's time as "learned" culture became living spiritual substance for the next generation. Aestheticism, which elsewhere in Europe took the form of a protest against bourgeois civilization, became in Austria an expression of that civilization, an affirmation of an attitude toward life in which neither ethical nor social ideals played a predominant part.

Ferdinand von Saar (1833–1906), perhaps the nearest Austrian approximation to the social realist as known in England, France, or Russia, bore witness as critic and artist to the changing relationship of art to society over half a century. Born of a bureaucratic family, he early joined the circle of the Wertheimsteins, serving their salon as one of its most treasured court poets. Sharing the views of the liberal élite of the 1860's, Saar employed art as a vehicle for the perfection of society and the realization of human dignity:

> Yea, art! Spread your powerful rosy wings;
> Brightly span the whole wide world!
> Help to banish the crude and the vulgar,
>
> Win us freedom and human dignity
> Which still lie prisoned deep in night and fear!
> Then *all* will raise a *single* song of praise!*[27]

In support of the Liberals' fight against the Austrian concordat, Saar composed a dramatic trilogy extolling Henry IV's historic struggle against the papacy. He celebrated in verse Anton von Schmerling's crusade for constitutional government and sang the praises of many a leader in liberal political and intellectual life.[28]

The anticipated transformation of the world, in which art would play its part, failed to materialize. Instead, Saar witnessed in shocked astonishment the spread of ruthless social climbing on the one hand, and of social misery on the other. Saar never became a Socialist, but he participated in a developing consciousness of the need for social reform that marked the Austrian scene in the 1880's. In song and

* Ja! breite, Kunst, die mächt'gen Rosenschwingen
 Hellrauschend über diese Erde aus!—
Und hilf Gemeinheit—Roheit zu bezwingen!—

Die Freiheit und den Menschenwert erringen,
 Der jetzt noch schmachtet tief in Nacht und Graus!
Dass *alle* Stimmen dir—*ein* Loblied singen!

story Saar recorded the misery of the workers' lot, at first with the moral lesson that individual generosity could alleviate misery *(The Stone Breakers*, a short story of 1873), later with the pessimistic sense that the problem was too large to solve. In a poem entitled "The New Suburb" he recorded the appearance of jerry-built workers' quarters, complete with rickety children. The spectacle transformed Saar's growing social pessimism into total resignation:

> Consoling myself that I am old,
> I take shuddering comfort
> In the thought:
> After me, the deluge![29]

Saar drew small comfort from the spread of aesthetic education when art was losing its ideal functions. Where in his own youth, "the world consisted of philistines, today it consists of nothing but aesthetes." In a poem, "Enkelkinder," ("Grandchildren") of 1886, Saar derides the way in which all children are made into artists:

> When parents, in solicitous search,
> Detect in their child the smallest spark
> Of talent, however unpromising,
> It is nourished and nurtured with pride.
> Higher schools and academies
> Can hardly contain the hosts of disciples;
> Honors, prizes, and traveling fellowships
> Guide them to all the shrines of art
> Where the burgeoning Raphaels,
> Buonarottis and Winckelmanns,
> Male and female, wander in hordes:
> Painting, sculpting, writing volumes.[30]

To what end is this schooling in art? Only to serve social climbing, answers Saar: for "honor and profit."[31]

Social climbing, Saar showed in three realistic novelettes, collected under the title *Schicksale (Destinies)*, could bring ruin to the climber or his victims. He explored with particular skill the psychological problems of shifting interclass relations. "Lieutenant Burda" deals with an officer of bourgeois origin falling in love with an aristocratic

girl and developing the crippling illusion that his suit is succeeding. "Seligmann Hirsch" describes a rich but crude Jew rejected by his cultivated *rentier* son. "Die Troglodytin" shows how the socially induced rejection of a poor rural girl's honest love casts her back into the moral swamp of her *Lumpen*-proletarian origins. Saar deals freely with all social strata in pursuing the moral and psychological consequences of social mobility.[32] His realism casts into question a basic postulate of the liberal creed, that of the integral connection between personal advancement and social progress, a connection fundamental to Stifter's model.

Under the changed social circumstances of the 1880's, where art had been compromised as an instrument of status, and the growth of wealth had only deepened the cleavage between the classes and the masses, Saar lost his hope of the 1850's that art's "powerful rosy wings" would help humanity "to banish the crude" and to win "freedom and human dignity." Society, ceasing to be a scene of moral triumph in which art would play a worthy part, became instead a field of psychological frustration and ethical despair. Art could either record gloomy truths or provide a temple of beauty as a refuge from reality. Saar stood before the alternatives, aware of both, convinced of neither. His heart remained in the world of Stifter, where art could join with science and ethics in a progressive and redemptive function. His head led him to record the trauma of the modern social scene.

In 1891 Saar expressed his dilemma, and that of the declining liberal-idealist tradition, in his poem "Kontraste."[33] The scene is central to the message: an elegant city street in midsummer, "all its houses deserted and empty, where in the winter wealth is enthroned." Under the broiling noonday sun, a street gang is at work repairing the pavement while the fortunate residents relax in the country. Only those "driven by need" labor on such a day. Like Gustave Courbet's stone breakers, the workers are faceless, heavy, crude. Dripping sweat, their senses dulled, they sit down at last to eat their coarse midday bread. Suddenly, when the weariest have fallen asleep on the hard stones, a chorus of women breaks into glorious song. High above the street an opera school is rehearsing Beethoven's setting of Schiller's "Ode to Joy." "Be embraced, ye millions": the hope-filled, revolutionary verse rings out "in fiery unison," but it cannot reach

the exhausted sleepers below. "*Alle Menschen werden Brüder*." The singers strive for aesthetic perfection. Today is rehearsal, tomorrow again, until the artists will win their reward: applause. Their redeeming message is not for the people of the street for whom it was written, but for the concert audience.*

Saar put his lesson crudely but forcefully in "Kontraste": the world of art, though still singing of the brotherhood of man, had lost touch with social reality. The masses were too depressed to pay heed to art, while the upper classes confined art to their own enjoyment. All communication between classes was broken. Oppressed by the increasing irrelevance of literature to the problems of the social structure, Saar lamented the death of an aesthetic ideal in an elegy to Stifter: "I revere the memory of the poet who opened an Eden for me—an Eden, alas, which I've lost."[34] Like Stifter before him, Saar died by his own hand.

III

IN THE 1890'S, Saar's hypercultivated *Enkelkinder* came of age and brought back the garden as a central image of the good life. Theirs was a final variant of the *Rosenhaus:* once more art served as the crown of a perfected humanity; once more the aristocratic tradition served the bourgeois as inspiration for an elevated mode of existence. For the new generation, however, Stifter's unification of art and science, of culture and nature as aspects of an ordered cosmos had lost all vitality. Where Stifter devised his utopia as a model for a society to be perfected, the new artists created a garden to which the elect could withdraw in retreat from an uncongenial reality. For Stifter, art was a crown to be earned by moral purity and bourgeois probity, a reward of effort. For his spiritual grandchildren, art was a legacy to be enjoyed: noble simplicity gave place to elegant composure, *Vornehmheit.* Ethics yielded its primacy to aesthetics, law to grace, the knowledge of the world to the knowledge of one's feelings. A hedonistic self-perfection became the center of aspiration,

* We have not yet reached the stage where the "Ode to Joy" is interpreted as an aesthetic-erotic utopia, as in Klimt's Beethoven frieze of 1902. But Saar has shown the direction of development. See Essay V, pp. 254–63.

and Stifter's "Garden of Virtue" became transformed into a "Garden of Narcissus."

By origin or, more rarely, by adoption, the artists who built this new garden belonged to the well-to-do upper middle class or to the lower nobility into which so many talented bourgeois had risen. Since the 1860's the situation of that class had greatly changed. In the 1890's the economic position of this stratum was more enviable than ever: it was a prosperous class, part *rentier*, part professional or bureaucratic. But its political position had ceased to correspond to its economic eminence. The liberals had conjured up new forces and new claimants to political participation: Slavic nationalists, Socialists, Pan-German anti-Semites, Christian Social anti-Semites. They neither integrated these new movements into the legal order nor could they satisfy their demands. The conflicting groups may have had different heavens, but they shared the same hell: the rule of the Austro-German liberal middle class. In the 1890's, utilizing now the ballot box, now parliamentary obstruction, now mass demonstrations and street brawls, the anti-liberal movements paralyzed the state and extruded the liberals from the positions of power they had acquired only three decades before.

The position of the liberal *haute bourgeoisie* thus became paradoxical indeed. Even as its wealth increased, its political power fell away. Its pre-eminence in the professional and cultural life of the Empire remained basically unchallenged while it became politically inpotent. Thus the Viennese upper middle class became one which, even more than the emperor it so loyally served, reigned though it could not rule. A sense of superiority and a sense of impotence became oddly commingled. The products of the new aesthetic movement reflect the ambiguous compound formed of these elements.

The aesthetic movement was, of course, no Austrian creation, and its Austrian protagonists, both in poetry and in painting, drew inspiration from their western European predecessors, French, English, and Belgian. The Austrians readily captured the languorous sensibility of a Baudelaire or a Paul Bourget,[35] but they achieved neither the searing, self-lacerating sensuality of the French decadents nor their vision of the cruel beauty of the urban scene. The English Pre-Raphaelites inspired the *art nouveau* movement (under the name of "Secession") in *fin-de-siècle* Austria, but neither their pseudo-medieval spirituality nor their strong social reformist impulse

penetrated to their Austrian disciples.* In brief, the Austrian aesthetes were neither as alienated from their society as their French soul-mates nor as engaged in it as their English ones. They lacked the bitter anti-bourgeois spirit of the first and the warm melioristic thrust of the second. Neither *dégagé* nor *engagé*, the Austrian aesthetes were alien-ated not *from* their class, but *with* it from a society that defeated its expectations and rejected its values. Accordingly, young Austria's garden of beauty was a retreat of the *beati possidentes*, a garden strangely suspended between reality and utopia. It expressed both the self-delight of the aesthetically cultivated and the self-doubt of the socially functionless.

Two lifelong friends—Leopold von Andrian zu Werburg and Hugo von Hofmannsthal—may serve us as representatives of the new aestheticism. Not only do they embody in their writings the values and spiritual problems of the young generation of the 1890's; they are socially representative as well. By lineage and assent, they belonged to that Viennese élite which continued to reign after it had ceased to rule. Both could qualify as grandchildren of the leading characters of Stifter's novel; both were as though born and raised in the *Rosenhaus*.

From politics to science to art: such was the evolution of three generations of Andrian-Werburgs in the nineteenth century. The poet's granduncle Viktor had, like Risach, been a high state official. A political leader of the liberal aristocracy in the 1840's, he had championed the revitalization of Austrian politics through emulation of England. His influential pamphlet, issued under the title *Österreich und dessen Zukunft (Austria and Its Future)*,[36] urged the nobility of Austria to join with the urban middle classes to provide the bureau-cratic monarchy with a foundation in representative government. Viktor's nephew Ferdinand, father of the poet, turned from the practi-cal politics of his family to the scientific study of man in society. He became one of Austria's outstanding anthropologists, an ideal type of the liberal nobleman-scholar. As president of the Vienna Anthro-pological Society, Ferdinand contributed substantially to sustaining

* The architect and designer Josef Hoffmann, who was a staunch admirer of William Morris in his youth, told me that he read Morris's writings on the social question with interest, but that he and his companions regarded such problems as "for the politicians to solve," not the concern of artists.

general scientific and humanistic *Bildung* in an era of increasing specialization. Like so many intellectuals of the mid-century, Ferdinand reached out for the graces of art to complement the truths of science. The sturdy gentile aristocrat married the daughter of the Jewish composer Giacomo Meyerbeer. Though ill-matched, the couple could agree to nurture the aesthetic gifts of their son Leopold, who was born in 1874. They committed him at the age of thirteen to the tutorial care of Dr. Oskar Walzel, later a renowned literary scholar. It was at Walzel's home in Vienna that Leopold met the young poet Hofmannsthal, destined to be his aesthetic soul-mate and lifelong friend.[37]

Hofmannsthal's social lineage was only slightly less distinguished than Andrian's. His great-grandfather Isaak Löw was, like Heinrich Drendorf's father, a successful merchant. Though a Jew, Isaak's services to the state won him the title Edler von Hofmannsthal, in 1835. Thereafter his descendants rapidly completed the *cursus honorum* leading to the most cultured stratum of Austrian society in the *fin de siècle*. Isaak's son abandoned the faith of his fathers to marry an Italian Catholic. His son in turn attended the University, acquired a law degree, and rose to the position of director in a major Austrian bank.[38] Hermann Broch has shown how the value that this banker placed upon aesthetic culture affected the nature of his son's outlook as poet.[39] Hugo's father did not, like Mozart's, focus upon his son's vocation or career. What was important was that he be a man of culture. *Bildung* itself had changed its stress since Stifter's day. It meant not so much a characterological education as an aesthetic one. Thus the poet's father did all he could, through exposure to theater, museums, and so forth, to develop his son's aesthetic learning and poetic powers. Not professional proficiency but pleasure in appreciation, not active engagement but passive enrichment: such were the aims of education in the high Viennese circles in which the Andrians and Hofmannsthals had their being. The scions of both houses, one suspects, would have identified the art of life with the life of art even if neither had had strong creative urges. Such aesthetic culture, drained of the metaphysical and social functions assigned it by Stifter and Saar, became the spiritual hallmark of the small but exalted milieu to which Hofmannsthal and Andrian belonged.

The two young poets moved in the charmed circles where higher

literati and lower aristocrats converged. They met in the Café Griensteidl with the élite of the literary world of the 1890's: Arthur Schnitzler, Peter Altenberg, Hermann Bahr, and other writers of the innovative literary group loosely called "Young Vienna." Andrian introduced Hofmannsthal to another circle, the nucleus of which had apparently been formed in the *Schottengymnasium* among young members of the well-to-do aristocratic intelligentsia. The members of this circle were destined for assured places in élite society. One was a naval officer; two were budding diplomats; another a future conductor; still another a future art patron.[40] All were linked by a strong sense of caste, as much social as cultural. The ideal of the English gentleman as synthesis of grace and action strongly attracted them. They took pride in their riding, their tennis, and the club they called, in English, the "First Vienna Athletic." But they also read English poets together, even on their holidays at Altaussee, where each would pursue the aesthetic activity most congenial to his nature.[41]

"Art is art and life is life, but to live life artistically: that is the art of life." This motto, devised by Peter Altenberg for his journal *Kunst*,[42] might well have served the Hofmannsthal-Andrian circle. Their youthful mission became the pursuit of beauty and the escape from the "common" lot. Without wholly rejecting a social role, they made of life a stylized play, a search for the delicate emotion and the refined sensibility.

In his prologue to Schnitzler's *Anatol*, the young Hofmannsthal expressed one side of his generation's sense of life through the image of a rococo garden. From Stifter's hated *Zopfzeit*, Hofmannsthal invoked a utopia in which beauty was associated not with virtue but with a self-indulgent hedonism. Separated from the world by "lofty railings, formal hedges," the poet and his friends re-create the elegant, playful atmosphere of Canaletto's Vienna. Near quiet pools "smoothly edged in gleaming marble," cavaliers exchange gallantries with daintily perfumed ladies, "with them, violet monsignori." In this classic garden of delight the young aesthetes have "fleetingly erected" a stage to act out plays of their own making: "the commedia of our spirit," "early ripe and sad and tender." Their theater offers them a life substitute, in which serious concerns are not so much evaded as trivialized through beautification. "Pretty formulas" speak "evil things." Feelings, furtive and half-felt, find outlet in the refined conventions of the tolerant hedonistic community.

Some are listening, but not all . . .
Some are dreaming, some are laughing.
Some are eating ices . . . others
Utter very gallant sayings. . . .*43

Such was the gracious garden scene that the young poet evoked to
introduce Schnitzler's compulsive sensualist, Anatol. Hofmannsthal's
prologue was to his friend's play as the aesthete to the playboy, the
man of sensibility to the man of sensuality, the spirit to the flesh in
a generation that made of beauty a screen against truth and of art a
substitute for ethics. The image of the garden—this time that of the
Belvedere, near Hofmannsthal's own house—served as the artificial
preserve wherein the functionless and cultivated could live sundered
from a world they neither made nor cared to know.

Was this garden truly a utopia? Yes and no. Like a utopia, it was
posited against an unsatisfactory reality. But where, in Stifter, utopian
house and garden served as model for life, in Hofmannsthal it was a
refuge from life. In the playlet *The Death of Titian (Der Tod des
Tizian)* (1892), Hofmannsthal showed his concern that the disciples
of art were cut off from reality in their master's garden retreat, and
disdainful of the darkly pulsating vitality outside the pale. He saw
his generation as "altogether without energy [*Kraft*]. For the
strength to live is a mystery. The stronger and more spirited [*hoch-
mütiger*] one is in daydreams, the weaker one can be in life. . . .
Incapable of ruling and of serving, incapable of giving love or receiv-
ing it . . . he wanders like a ghost among the living."44

Although he found life in the insulated preserve of high culture
problematical, Hofmannsthal saw some possibilities in the early 1890's
for projecting his aesthetic utopia into reality. In 1895 he weighed
the prospects in a letter to Richard Beer-Hofmann: "I still believe
that I shall be in a position to build my own world into the [outer]
world itself. We are too critical to live in a dreamworld like the
romantics. . . . The problem is admittedly always one of setting up
Potemkin villages on the periphery of our own horizon, but [villages]
of the sort that one can personally believe in."45 But even if one

* Manche hören zu, nicht alle . . .
 Manche träumen, manche lachen,
 Manche essen Eis . . . und manche
 Sprechen sehr gallante Dinge. . . .

had the confidence and sense of sovereignty *(Herrschaftlichkeit)* to press one's illusions into reality, the resultant empire of the imagination would not endure: "an empire like Alexander's, just as great and so full of events as to fill all thought . . . then falling apart with [our] death—for it was an empire only for this one king."[46] Desirable as it was, young Hofmannsthal's ephemeral, projective utopia was still purely personal: "for this one king." No community ideal was implied; no social reality affected. Hofmannsthal accordingly defined as the condition of his personal utopia the willingness to "let life slide."[47] The existential side of utopian dreaming was drifting. Indeed, one might well view drifting and dreaming as the objective and subjective aspects of introversion, of preoccupation with the self, its nature, and its boundaries. Aesthetic utopianism, with its stress on self-cultivation, fed a narcissism in which utopianism could survive no better than social realism.

Not Hofmannsthal but his friend Andrian produced the classic novel of the *fin-de-siècle* identity crisis, *The Garden of Knowledge (Der Garten der Erkenntnis)* (1895). At the head of the work stands the motto: "Ego Narcissus." We remember the classical Narcissus as the self-infatuated one, the auto-erotic, drowning in the attempt to merge with his own reflected image. Let us not forget that outraged Eros, whose favors Narcissus had rejected, had imposed the curse upon him for spurning that union with "the other" that is love. For his crime against Eros and the world, the seer Tiresias had predicted a fitting fate: Narcissus would die if he should come to know himself. These mythological motives pervade *The Garden of Knowledge:* self-preoccupation, the incapacity to love another, the inability to distinguish the inner self from the outer world and to separate illusion from reality. If knowing himself spelled death to the mythical Narcissus, knowing the world only as a projection of the self was the fate of Erwin, his modern descendant. Erwin died, the last line of the novelette tells us, "without knowledge." The "Garden of Knowledge" was in fact co-extensive with the psyche of the hero: too small and too arid a plot to yield the fruit even of good and evil. Erwin never reached the world; like the cultivated class to which his creator belonged, he was, half by necessity, half by choice, removed from reality.

When Stifter, four decades before, had traced the *Bildungsweg* of Heinrich Drendorf, he had etched the elements of reality that his

hero encountered in sharpest outlines. Household, landscape, *Rosenhaus*, workers, art, and history: all were treated, in the spirit of objective realism, as elements composing an orderly world to which the individual must adapt himself. The solid outer world provided the frame for the proper disposition of the individual. The utopian dimension in Stifter consisted essentially in the purity and clarity with which the immanent order of the world was realized as milieu. This order once made plain, man could achieve fulfillment within it, as Heinrich did. Stifter's assumption was not unlike that of Rousseau and his *Émile:* the rightly ordered world provided the key to, and a model for, the well-ordered soul.

Andrian's *The Garden of Knowledge*, despite its title, barely touched upon the concrete environment of the hero. Andrian's realism was the opposite of Stifter's: it concerned not the outer world of social and physical reality but the inner scene of psychic life. The social and physical world exist merely as stimuli to or symbols of the hero's feelings. Both Erwin and Heinrich seek entry into and connection with a world larger than themselves. Both see that world as multifaceted and composite. But Heinrich masters it step by step and comes to understand it as an essentially static harmony of elements from which man, by his labor, eliminates the dissonance. Its unity is a clarity of articulated parts. For Erwin, the world is a flow—now viscous, now torrential—whose liquid elements blend into each other and into the self. Its unity is an elusive flux. For Heinrich, truth lies in clarity; for Erwin, in mystery: "deep, dark, manifold."[48] Erwin cannot find the way to the world because he sees rational self, outer reality, and personal feeling as an undifferentiated continuum. Subjective and objective experience were painfully and dizzyingly confounded. Hofmannsthal expressed the fluid sense of relationship between the "I" and the world more succinctly than Andrian: "And three are one: a man, a thing, a dream."[49] Such pan-psychism was a complete inversion of Stifter's individuated and defined universe: "Everything and every person can be but one thing," said Heinrich's father; "this, however, he must be to the full."

The liquidity of the boundary between self and other meant that the search for "the other" was condemned to futility. Even scientific knowledge Erwin drew into the vortex of self-infatuation. After a year of scientific study, it . . . "became clear to him that he should not search for his place in the world, for he was himself the world,

equally great and equally unique. . . . But he studied on, for he hoped that if he knew the world, out of its image his own would look back."[50] Erwin's hopes went unrealized. Separated from the world, he could not use it as a mirror. Merging with it, or ingesting it, he felt his selfhood threatened. Only in ceremonial or aesthetic experience were ego and world bound together in a rhythmic unity of feeling. But this unity lacked both strength and durability. The shudder at the poetic word, in which Heaven and Hell flowed together in an ambiguous, sublimated ecstasy, "full of trembling glory," brought neither clarification to the understanding nor satisfaction to the instincts. Life, which began for the sensitive Erwin as "an alien task," ended without the direct and meaningful experience of engagement. The aesthetic aristocrat remained the devitalized Narcissus, hoping as a dying man that a dream might give him what life had failed to provide: contact with "the other."

As Stifter and Andrian differed in defining the relationship between the ego and the world, they exploited the image of the garden for radically different purposes. For Stifter, the garden symbolized the marriage of nature and culture. There man, through science and art, completed the work of God. There he purged nature of disease and chaos, brought out its potentiality for an order blending usefulness and beauty. For Andrian, the actual cultivation of the garden would of course be wholly irrelevant. Life knows no such thing as labor. The garden served only to stimulate the sensibilities. It symbolized the strangely mixed and transient fragrances of life, the passing experience of beauty. There is no one garden, only gardens. They reinforced those sensuous thoughts and intellectualized sensations that marked the self-infatuated ones. For a generation that felt itself to be outside the mainstream of life, perceiving it only dimly through the refracting medium of art—"because a play is more to us than is our fate"[51]—gardens symbolized the evanescent beauty that one might capture as one drifted will-lessly through life. Erwin's mother, his only true soul-mate, expressed the psychological function of the garden for the disengaged generation: "We go through our lives as through the pleasure gardens of strange castles, guided by strange servants; we retain and love the beauties they have shown us, but which ones they lead us to and how fast they take us through depend on them."[52]

The aesthetic attitude reinforced the severance from the common

lot which was its social basis, and hence nurtured a vicarious rather than a direct experience of the world. The aesthetic experience, as Susanne Langer has reminded us, is virtual, not actual. It gives form to the feelings arising out of experience, but not to the experience itself. By the very fact of standing for life, art separates us from it. That is why, when art became detached from other values and became a value in itself, it produced in its devotees that sense of eternal spectatorship which in turn nurtured introversion. Andrian's Erwin, unable to find the secret of life by direct engagement, turned inward and "bent deeper and more anxiously over his past." His recollections of past experience became not merely moving but "exalting and priceless." As in Marcel Proust, Erwin's remembrances became his life. Again, desocialization accompanied internalization. Human beings acquired worth for Erwin only insofar as they contributed to his memories; that is, "they moved him only because he had lived of them."[53] The past recalled became more significant than the present experienced. Thus the narcissistic hero imperceptibly shifted not only from a life of engagement to imprisonment in the self, but also from a life not yet lived to a life lived out. When death came for Prince Erwin, he was ready for it, despite his young years. It came not, as to Narcissus, as moral retribution, but as psychological necessity.

﹥ I V ﹤

HOFMANNSTHAL deeply admired *The Garden of Knowledge*.* Yet he could not leave the problem of the new Narcissus unresolved as Andrian had done. He sought to return art to ethics, aesthetic culture to society, and his cultivated class to fruitful participation in the body social. Andrian wrote for his generation alone; Hofmannsthal linked its problems more closely to tradition, more deeply to the psyche, and more widely to society.

* As late as 1900 Hofmannsthal gave *The Garden* to Maurice Maeterlinck and strongly urged Andrian to resume his literary activity, both for his own sake and "so that the [artistic] powers that produced it should not turn completely . . . to dust." (Hugo von Hofmannsthal, *Briefe, 1890–1901* [Vienna, 1937], I, 306–7.)

From the first, Hofmannsthal saw Andrian's *Garden* as built on a terrain fraught with dangers of which the author had been unaware. "Your book," Hofmannsthal wrote his friend, "is just like the young goddess Persephone, who . . . picks many narcissus on a meadow and is suddenly overcome with anxiety. You know, it is the same meadow where Pluto then rises up to abduct her to [the land of] the shades."[54] And what modern force, in this antique parable, did Pluto represent? Hofmannsthal groped for an answer to his own question, seeking it now in individual instinct, now in the threatening masses.

Hofmannsthal's earliest concern, however, was for the moral consequences of the aesthetic attitude. From these he was led to psychological and social interests. In *The Fool and Death (Der Tor und der Tod)* (1893), a playlet in verse dealing with the same problem as Andrian's *Garden*, Hofmannsthal indicted the young aristocrat who, in pursuit of his own refined sensations, ruined mother, friend, and sweetheart. Where Andrian pursued the psychological development of the aesthetic attitude, Hofmannsthal examined its moral implications. Death came as judge to the Fool, as in a medieval morality play, to punish the transgression. In this respect, Hofmannsthal was a traditionalist, trying to re-establish the connection between art and ethics. But, as Richard Alewyn has shown, the figure of Death was no medieval skeleton. He appears in the play as musician, as a Dionysian ally of life. He represents the unconscious instincts that have been repressed in a hypertrophy of individual self-cultivation.[55] Thus morality, unlike in Stifter, takes the form of vitality and appears in dialectic unity with it in Death become music.

The setting for *The Fool and Death* is reminiscent of Risach's Rosenhaus: an elegant classical villa, in the 1820's. It evokes a Biedermeier order from which, however, all life has been drained. For the house is a purely personal museum of the memories and cultural mementos of the hero—one who, unlike Stifter's Risach, has never lived a committed life. Gustav Klimt, in his paintings for the Dumba music salon, would also contrapose Biedermeier nostalgia and Dionysian instinctuality, but without questioning the moral implications of the aesthetic attitude as Hofmannsthal did.*

* See above, pp. 220–1, and Figures 40 and 41.

Hofmannsthal's attempt to break out of the solipsism and cultured isolation of the life of art was then two-pronged: on the one hand, he returned to revitalize a traditional morality of personal responsibility; on the other, he thrust forward toward depth psychology and the affirmation of instinct.

To Hofmannsthal's moral and psychological critique of the *Gefühlskultur* of his class, we must add yet a third dimension: the sociological. Even as a young man, Hofmannsthal began to worry about the hollowing out of social responsibility in the upper classes. His poem "Manche freilich . . . ," written in 1892, reasserted the unity of the cultivated and the common strata, whose separation Saar had so deplored in "Contrasts." Hofmannsthal's statement of the problem, to be sure, took the form of a reminder that there was such a thing as a tie between the high and the lowly, the fortunate and the hapless—an indication of how attenuated it had become. The poet expressed it as a hidden bond of interdependency, in the image of the galley slaves below decks, from whose lives a shadow falls on the lives of those above.

> Many destinies with mine are woven;
> Living plays them all through one another,
> And my part is larger than this slender
> Flame of life or narrow lyre.*

Thus Hofmannsthal suggested the will to a stronger social involvement.

In a verse playlet called *The Little Theater of the World (Das kleine Welttheater)* (1897) Hofmannsthal set forth in veiled but unmistakable terms the whole direction of the interrelationship of art and society for his generation.[56] He chose as form for his statement the baroque masque. In a cast of characters who appear in only the loosest relations, the first of importance is the Gardener. A former king, he has put aside his worldly diadem of power to cultivate his

* Viele Geschicke weben neben dem meinen,
 Durcheinander spielt sie alle das Dasein,
 Und Mein Teil ist mehr als dieses Lebens
 Schlanke Flamme oder schmale Leier.
—Hugo von Hofmannsthal, *Poems and Verse Plays*, ed. Michael Hamburger (New York, 1961), pp. 34-5.

flowers. The Gardener's poetic vision enabled him, as king, to see that the care of human subjects and the care of plants are essentially the same: only that the latter is "cooler." Hofmannsthal here recapitulates *in parvo* the withdrawal of Risach in *Der Nachsommer* from the frustrations of politics to the satisfactions of the *Rosenhaus*. Did he also wish to allegorize the more general and less voluntary withdrawal of the Austrian upper middle class from politics to culture? The evidence is too scanty to judge. But clearly Hofmannsthal asserted a principle of correspondence between kingship and horticulture, one that set up a seductive equivalence, in "childish innocence and majesty," between the realm of politics and the garden of art, between civil and aesthetic order.

Contraposed to the Gardener-monarch, as the final and dominating figure in the masque, is the Madman. He is a scion not of royalty but of wealth: "the last of the rich, the last of the powerful—helpless." The Madman's father, a mighty entrepreneur, had been unable to tame a son who shared his arrogant spirit but had no sense of responsibility. Like many actual parvenus' sons in Hofmannsthal's society, this one sought and won the company of noblemen, charmed the world, squandered his wealth, and wasted his person. But, like the best of the functionless, the Madman turned inward, sought solitude. Again we encounter Narcissus, identified now as *rentier*-squanderer. The Madman shut himself in a tower, turning his bold, rapacious spirit upon his inner soul to become the poetic explorer of his own depths. There he found "monstrous masses of inchoate" forces. The self-centered attitude of the functionless rich, transferred from the world of action to that of contemplation, led to his discovering inside himself monstrous instinctual forces. Through this the Madman came to a recognition of analogous inchoate energies outside himself.[57] As the Gardener found a correspondence of order between the realm of politics and the garden of beauty, so the Madman found a correspondence of energy between inner instinct and external life forces. Individuation begins to transcend itself, and the Madman, apostrophizing his reflection in a mirror, *en bon Narcisse*, proclaims: "The illusion [of the self-contained individual] will not last much longer; the voices multiply which call me to the outer world."[58] He announces a mission that will be Hofmannsthal's: to create a dynamic unity between the individual and the world. The

abstract, static fashion of kings and poets before him can no longer serve either the modern psyche or modern society:

> But what are palaces, and what are poems?
> The dreamlike image of reality!
> The real no mortal tracery can catch:
> To lead the *whole* dance, the *whole* round,
> The real, can you begin to grasp this task?*

A bold but sane man could "grasp this task"; only a madman would be determined like Dionysus "to lead the *whole* dance, the *whole* round." The Madman had to be restrained from plunging into the river beneath, the torrent of primal life energy which was also death.

By 1897 Hofmannsthal was convinced that the Gardener was but a relic, and he devoted himself, however tentatively, to taming the Madman. The problem was to find an order that was not sterile, to find an energy that was not fatal, to re-establish the ties between art and instinct on the one hand, art and society on the other. He turned toward the lower orders not only because the problem lay there but also because life seemed to be strong in them. Like Sigmund Freud, Hofmannsthal saw the lower classes as uninhibited, living directly by instinct. Half in envy, half in fear, he sought the social sources of vitality in the ill-defined "folk," while he gingerly approached its psychological sources in sex. Both tendencies are clear in *Der Tod des Tizian*, where the Great God Pan inspires art, but where the artist is drawn by the magnetism of the city to leave the pale of art. Accordingly, at the turn of the century, Hofmannsthal passed from poetry to drama, out of the narcissistic reservation into the street.

It was characteristic of the sheltered perceptions of his class that Hofmannsthal should first have been impressed by abject social misery not in his native Vienna, where there was much of it, but in

* Was aber sind Paläste und die Gedichte:
 Traumhaftes Abbild des Wirklichen!
 Das Wirkliche fängt kein Gewebe ein:
 Den ganzen Reigen anzuführen,
 Den wirklichen, begreift ihr dieses Amt?
Ibid., pp. 262–3.

Galicia during his military service in 1896. From his billet in the wretched Jewish village of Tlumacz, he wrote to a friend, "I am correcting my concept . . . of what life is for most people: it is more joyless, more depressed than one likes to think: much more. . . ."[59] Amid this dreadful "spectacle of so many miserable human beings . . . their stench and their voices," Hofmannsthal became captivated by the dramatic form. Thomas Otway's Restoration drama on the Popish Plot, *Venice Preserv'd*, which Hofmannsthal read in his dank and stinking billet, stimulated his new turn. "A very peculiar art form," he wrote to Andrian of drama, "and I suspect that if one produces it, one simultaneously connects oneself with life—and simultaneously frees oneself from it."[60] Here was Hofmannsthal's deepest need, both as poet and as citizen.

Eight years later Hofmannsthal published his powerful reworking of Otway's play under the title *Das Gerettete Venedig*. This somber social-psychological drama deals with political decadence and the personal passion that is unleashed as a consequence of misrule. An insurrectionary mob contributes its murky and threatening power to the action. Characteristically, the principal figure is a waverer, vacillating between the old powers and their angry challengers.[61] He is the most humane figure, yet too weak for the situation he confronts. His human understanding is of no avail when he does not know how to apply it in socio-political crisis where passion is unleashed.

The poet wavers and trims like his major character. Though his play was redolent with the problems of modernity, Hofmannsthal avoided, as in most of his writings, any direct social realism or a contemporary *mise en scène*. Like so many Austrian pioneers of twentieth-century thought and art—Gustav Klimt, Gustav Mahler, Otto Wagner, Sigmund Freud—he used traditional language to convey modern messages. Not without justice did Andrian invoke for him the motto: *Sur des pensers nouveaux faisons des vers antiques*.[62]

Yet Hofmannsthal would not commit himself, as Stifter or Saar had done, to history. It seemed to have lost its exemplary value for him. Although his setting was Venetian, he fought hotly against the producer's tendency to make sets and costumes historically "realistic." Hofmannsthal demands "atmospheric" and "suggestive" costumes appropriate to "a conservative-reactionary period rotten at the roots . . . like pre-March [1848] Austria" (the period before liberalism's

first breakthrough!). Above all, the mob should "for God's sake" not be Venetian, but rather "uncanny, threatening," like a contemporary mob *(Gesindel)*.[63] Both in the play and in the form of its production, then, Hofmannsthal approached contemporary social reality cautiously and evasively. He wished neither an escape into history and myth nor a direct representation of modern society and its problems. By using a suggestive, rather than a literal, historical milieu, he realized in this frightening drama of social disintegration the promise he had seen in drama as a literary form when he wrote Andrian from squalid Galicia. Drama, he said, would both connect one to life and free one from it.

The combination of engagement and distance that Hofmannsthal found in drama made possible his redefinition of the poet's function in modern society. His "road into the clear" had been a long one. First he escaped the hedonistic garden of Narcissus, with the futility that Andrian had rendered in his *Bildungsroman*. He had clarified the still graver dangers that he had allegorized in *Das kleine Welttheater:* the soul-satisfying illusion of the Gardener, that art was a substitute for politics; and the drastic conclusion of the rich Madman, that the only true participation in life was a suicidal merging with the formless irrational forces of the world. Slowly Hofmannsthal shaped a synthesis between lifeless illusion and formless vitality, between Gardener-king and Madman. Out of it emerged the poet, not as legislator, not as judge, not as sympathizer, but as reconciler.

In 1906 Hofmannsthal defined the poet's role with a new clarity: "It is he who binds up in himself the elements of the times."[64] In a society and a culture that he saw as essentially pluralistic and fragmented, Hofmannsthal set literature the task of establishing relationships. The poet must accept the multiplicity of reality, and, through the magic medium of language, bring unity and cohesion to modern man. The poet "is the passionate admirer of things of eternity and the things of the present. London in the fog with ghostly processions of unemployed, the temple ruins of Luxor, the splashing of a lonely forest spring, the roaring of monstrous machines: the transitions are never hard for him . . . everything is simultaneously present in him."[65] Where others saw conflict or contradiction, the poet would reveal hidden ties and develop them by bringing out their unity through rhythm and sound.

Was there room for utopianism in Hofmannsthal's new conception

of literature? Not in the senses in which we have thus far encount-
ered it. There was here no Stifterian model of an expurgated reality,
no abstract social ideal in the manner of Saar, no resurrected rococo
garden of delight, not even Hofmannsthal's earlier Potemkin village.
For the poet now accepted reality as it was: insistently incoherent.
The assertively centrifugal character of society and culture in-
hibited the constructive fancy. Emerging from his cultivated social
isolation, Hofmannsthal had learned "to grapple with an existing
social order"; but as he did so, he found it less and less possible "to
posit one which does not exist."

In *Der Turm (The Tower*, 1927), written over a period of
twenty-five years, Hofmannsthal nevertheless struggled once more
to point the way to utopia. I say "point the way," no more, for
Hofmannsthal no longer tried to project one. The action in *Der
Turm* almost reverses, at a deeper level, that of *Das kleine Welt-
theater*. The hero, Prince Sigismund, begins as the irrational prisoner
in the self, like the Madman. By way of his own dream of a just
world, he attempts to pass from Madman to Gardener to king—
from instinctual visionary to civic actor. In the process he associates
himself with the needy and energetic but irrational mass. As in
Calderon's Christian drama *Life Is a Dream*, which Hofmannsthal
adapted to his modern purposes, the oedipal revolt of the poet-
prince becomes identified with a political revolution against the
father-king. But in Hofmannsthal, the result is not divine comedy but
human tragedy. The work of harmonizing the disparate components
through the language of mutual respect breaks down. As in the
Austrian Empire, the forces of social and psychological disintegration
prove too strong. Yet the poet-prince dies in the conviction that his
message of love, drawn up from the lonely well of Narcissus where
dream and reality had merged, will yet be understood one day: "Bear
witness that I was here—even if no one knew me."[66] The prince not
known by the world: he is the opposite of Andrian's Prince Erwin,
who dies without knowing the world.

Hofmannsthal had rescued the function of art from the hedonistic
isolation into which his class had carried it and had tried to redeem
society through art's reconciling power. But the rifts in the body
social had proceeded too far. Society could tolerate tragedy or
comedy, but not redemption through aesthetic harmonization. It was

left to a new generation to formulate the intellectual consequences of that cultural fact.

❧ NOTES ☙

1 Hugo von Hofmannsthal, "Buch der Freunde," *Aufzeichnungen, Gesammelte Werke in Einzelausgaben*, ed. Herbert Steiner (Frankfurt am Main, 1959), p. 59. Unless otherwise indicated, translations are mine.

2 Erich Auerbach, *Mimesis*, tr. Willard Trask (Princeton, 1953).

3 *Stifters Werke*, ed. I. E. Walter (Salzburg, n.d.), II, 905.

4 Stifter, "Über das Freiheitsproblem," *ibid.*, 921, 923.

5 *Adalbert Stifters Sämtliche Werke*, eds. Gustav Wilhelm *et al.* (Prague and Reichenberg, 1904–39), XVI, 58–9; cited in Eric Albert Blackall, *Adalbert Stifter* (Cambridge, Mass., 1948), p. 254.

6 Letter to Gustav Heckenast, March 6, 1849, *Stifters Sämtliche Werke*, XVII, 321.

7 *Ibid.*, 292; cited in Blackall, *Stifter*, p. 249.

8 *Stifters Sämtliche Werke*, XIX, 93.

9 Gustave Flaubert, *Sentimental Education*, tr. Brentano (New York, 1957), pp. 1–14.

10 Daniel Defoe, *Robinson Crusoe*, Everyman ed. (London, 1906), p. 2.

11 *Stifters Sämtliche Werke*, VI, 9.

12 *Ibid.*, 10–14. For an actual instance of a similar relationship between father and son in the choice of a scientific vocation, see the geologist Eduard Suess, *Erinnerungen* (Leipzig, 1916), pp. 115, 139.

13 *Stifters Sämtliche Werke*, VI, 23–4.

14 *Ibid.*, 40.

15 *Ibid.*, 44.

16 *Ibid.*, 58–9.

17 *Ibid.*, 99.

18 *Ibid.*, VII, 94.

19 Charles Baudelaire, "Short Poems in Prose," in *The Essence of Laughter*, ed. Peter Quennell (New York, 1956), p. 147.

20 *Stifters Sämtliche Werke*, VI, 143–4.

21 *Ibid.*, 129–31, 103–4.

22 Dora Stockert-Meynert, *Theodor Meynert und seine Zeit* (Vienna, 1930), p. 150.

23 Felicie Ewart, *Zwei Frauenbildnisse* (Vienna, [1907]), *passim*.

24 Stockert-Meynert, *Theodor Meynert*, p. 99.

25 *Ibid.*, pp. 50–1.

26 See, e.g., Georg von Franckenstein, *Diplomat of Destiny* (New York, 1940), pp. 14–17; Stefan Zweig, *The World of Yesterday* (London, 1943), pp. 39–55.

[27] "Die Kunst," unpublished early work, in *Ferdinand von Saars Sämtliche Werke*, ed. Jacob Minor (Leipzig, [1909]), III, 49. (Translation mine.)

[28] Jacob Minor, "Ferdinand von Saar als politischer Dichter," *Österreichische Rundschau*, XXXII (July–Sept. 1912), 185–203.

[29] Undated and unpublished in Saar's lifetime. *Saars Sämtliche Werke*, ed. Minor, III, 26–7; see also "Proles," *ibid.*, II, 145.

[30] *Ibid.*, 168–9.

[31] *Ibid.*, 167.

[32] Ferdinand von Saar, *Schicksale* (Kassel, 1889 [republished in *Saars Sämtliche Werke*, ed. Minor, IX]).

[33] *Ibid.*, II, 175–6.

[34] "Stifter-Elegie," *ibid.*, III, 77.

[35] Geneviève Bianquis, *La poésie autrichienne de Hofmannsthal à Rilke* (Paris, 1926), pp. 8–17.

[36] Viktor von Andrian-Werburg, *Österreich und dessen Zukunft* (Hamburg, 1843–7). See also the discussion of Andrian in Karl Eder, *Der Liberalismus in Altösterreich* (Vienna, 1955), pp. 95–8; Georg Franz, *Liberalismus* (Munich, 1955), pp. 32–3.

[37] *Leopold Andrian und die Blätter für die Kunst*, ed. Walter H. Perl (Hamburg, 1960), pp. 11–12.

[38] *Hugo von Hofmannsthal*, ed. Helmut A. Fiechtner (Bern, 1963), pp. 5–6.

[39] Hermann Broch, "Hofmannsthal und seine Zeit," in *Essays*, ed. Hannah Arendt (Zurich, 1955), I, 111–13.

[40] See Franckenstein, *Diplomat of Destiny*, pp. 14–17, 113–16; Hugo von Hofmannsthal, *Briefe, 1890–1901, 1900–1909* (Berlin, 1935; Vienna, 1937), I, 59–60, 208, 212–13, 291, 293; and esp. *idem* and Edgar Karg von Bebenburg, *Briefwechsel*, ed. Mary E. Gilbert (Frankfurt am Main, 1966), *passim*, in which poet and naval officer explore together the nature and pursuit of the gentlemanly ideal.

[41] Hofmannsthal, *Briefe, 1890–1901*, pp. 208, 291.

[42] *Kunst* (No. 1, 1903), II.

[43] Hugo von Hofmannsthal, *Poems and Verse Plays*, ed. Michael Hamburger (New York, 1961), pp. 64, 65.

[44] Hugo von Hofmannsthal, *Prosa, Gesammelte Werke in Einzelausgaben*, ed. Herbert Steiner (Frankfurt am Main, 1950), I, 273.

[45] Hofmannsthal, *Briefe, 1890–1901*, I, 130.

[46] *Ibid.*, p. 131.

[47] For Hofmannsthal's connection of the imaginary empire with drifting, see *ibid.*

[48] Leopold Andrian, *Das Fest der Jugend: Des Garten der Erkenntnis erster Teil* (Graz, 1948), p. 33.

[49] Hofmannsthal, "Terzinen," *Poems and Verse Plays*, ed. Hamburger, p. 30.

[50] Andrian, *Fest*, p. 46.

[51] *Ibid.*, p. 35.

[52] *Ibid.*, pp. 42–3.

[53] *Ibid.*, p. 34.

[54] Hofmannsthal to Andrian, *Briefe, 1890–1901*, pp. 125–6.

[55] Richard Alewyn, *Über Hugo von Hofmannsthal* (Göttingen, 1958), pp. 75–6.

[56] Hofmannsthal, *Poems and Verse Plays*, ed. Hamburger, pp. 224–63.

[57] *Ibid.*, p. 256.

[58] *Ibid.*, p. 260.

[59] Hofmannsthal to Fritz Eckstein, May 2, 1896, Hofmannsthal, *Briefe, 1890–1901*, I, 182.

[60] Hofmannsthal to Andrian, May 4–5, 1896, *ibid.*, pp. 184–6.

[61] ". . . Jaffier makes the mistake of joining the indignant ones, though he probably belongs really to the lackeys: a consistent main motif. . . ." (Hofmannsthal to Otto Brahm, Sept. 15, 1904, Hofmannsthal, *Briefe, 1900–1909*, II, 163.)

[62] Leopold Andrian, "Erinnerungen an meinen Freund," *Hofmannsthal*, ed. Fiechtner, p. 52.

[63] Letters to Brahm, December [?], 1904, Hofmannsthal, *Briefe, 1900–1909*, II, 184, 192–3.

[64] Hugo von Hofmannsthal, "Der Dichter und diese Zeit," *Selected Essays*, ed. Mary Gilbert (Oxford, 1955), p. 132.

[65] *Ibid.*, p. 133.

[66] Hugo von Hofmannsthal, *Dramen, Gesammelte Werke in Einzelausgaben*, ed. Herbert Steiner (Frankfurt am Main, 1948), IV, 207.

VII

EXPLOSION
IN THE GARDEN:
KOKOSCHKA AND
SCHOENBERG

LOOKING BACK on his life as an artistic rebel, the Expressionist Oskar Kokoschka recalled an episode of his childhood.[1] Kokoschka came from an artisan background, and grew up in a recently annexed outer suburb of Vienna as it was passing from traditional rural village to nondescript urban fringe. Near his modest home was a public park where the little boy played. Once the Galitzinberg Park had been part of an aristocratic estate. No longer a private preserve of gallants and their ladies, or of violet monsignori, it was now a place where Viennese urchins came to play among the marble statues. An old veteran of the Austro-Prussian War served as watchman; he seemed to Oskar much like the sculptured Hercules standing beside the fountain. The allegorical figures "lived on the same basis as the lords of the palaces" in the Viennese folk imagination, which was peopled with "tragicomic figures who wished to climb so much higher in society that they bumped into the world of spirits [*Geisterreich*]."*

* Kokoschka refers here to the fairy realism of the popular nineteenth-century dramatist Ferdinand Raimund. Cf. also Hofmannsthal's imagined garden in the Vienna of Canaletto, pp. 306–7 above.

Not only gamins like Kokoschka frequented the garden, but better folk too. Oskar made friends with two little girls who came with their mother to play. He disliked that mother with her cultivated airs: she read French novels, insisted on proper manners, and served tea *à l'anglaise* promptly at five. Oskar learned in scorn that the lady's father had been just a good bourgeois Viennese coffee drinker, but she had married an "Edler von," and now drank tea.

Despite his distaste for their mother, the boy rejoiced in the girls. One he admired for her mind and her grace. The other, who swung on the swing with her clothes disarrayed, occasioned his sexual awakening. Here, in a rococo garden, the lower-class boy awoke to the "abrupt and naked facts" revealed by an upper-class girl. Sexual instinct broke raw through the veneer of a stylish civilization. For Kokoschka, coming of age meant not the initiation into culture, as for his predecessors, but the affirmation, at once tortured and joyous, of our animal nature.

In school young Oskar had learned of the two great simultaneous inventions that ushered in modern times: printing and gunpowder. Since the first resulted in the hellish invention of the textbook, he turned, he tells us, to explore the second. One day, equipping himself with homemade gunpowder, Oskar went to the palace garden where his friends were at play. Beneath the tree where the swing was hung was a huge ant colony. Under it Oskar placed his explosive charge. When all was prepared, at five o'clock, the hated hour of tea, Oskar "cast the torch into the world."

The explosion was immense, far beyond the destroyer's expectations. The burning city of ants flew into the air with a great clap of thunder. "How hideously beautiful!" Singed bodies and severed limbs of ants fell writhing over the well-kept lawn. And the innocent temptress was found unconscious beneath her swing.

The forces of civilization rallied. The mother summoned the guard of the park. Oskar was "banished from the Garden of Eden."

Unlike Adam, young Oskar—modern, lower-class, self-willed— refused to accept his banishment as final. Although the old guard barred the gate "like the angel Gabriel," the young rebel would find a way. Behind the garden lay a city dump, with a bluff that Oskar might scale to enter the garden from the rear. He climbed the bluff; but disaster awaited him. He lost his footing.

Only the expressionistic fantasy could have contrived what fol-

lowed. Plunging back into the dump, Oskar landed upon the bloated carcass of a rotting pig. A swarm of vicious flies rose from its body, stinging the hapless boy. Oskar went home to bed with a serious infection.

Lying in bed, the fevered second Adam had psychological experiences that have the tortured glow of the Expressionist's painterly vision: At the root of his tongue sat a fly that incessantly turned round itself, leaving its grubs as it went. The wallpaper burned with revolving suns of green and red. The victim felt his brain dissolve into a vile gray fluid. In "The Red Stare" (*Der rote Blick*) (Plate X), Arnold Schoenberg captured a state of psycho-physical anguish of the sort that Kokoschka described.

<div align="center">I</div>

WITH UNCANNY EXACTITUDE, Kokoschka's biographical parable reflects his place in the birth of Expressionist culture. Particularly appropriate was his choice of a garden as the scene of his outrage and his banishment. The Viennese élite of *Bildung und Besitz* until about 1900 had proudly expressed its urban character by residing in the great Mietpalast (or rental palaces) of the Ringstrasse (see Essay II, pages 47–54). But with the completion of the Ringstrasse development, new upper-class housing was displaced to the outer districts. The best young modern architects perforce did not design great apartment houses as Otto Wagner and other older masters had done, but suburban villas. The leading intellectuals and artists themselves, once prosperity crowned their public successes, withdrew to the peripheral districts of Vienna. Hofmannsthal and Hermann Bahr, Otto Wagner and Gustav Mahler, the painter-designers Karl Moll and Kolo Moser—all were among the new suburbanites.[2]

With the turn to the suburbs came, so the poet Hofmannsthal observed in 1906, "a heightened delight in gardens." "We are gradually returning to where our grandfathers were: to feel the harmony of the things of which a garden is composed," Hofmannsthal wrote in a moment of Biedermeier nostalgia. The poet-critic noted that the new gardens, questing for simplicity, achieved it through "the geometrical elements of beauty."[3] Architectural magazines and house-and-garden journals amply confirmed his judgment.[4] The new garden cult re-

jected the English romantic tradition of the garden as a cultivated adaptation of nature, turning instead to a radical classicism. The garden was conceived as architecture, as an extension of the house. Ideologically, this tendency was associated with the decline of the idealization of the proud self-made man in favor of pre-industrial social models: the eighteenth-century nobleman on the one hand, the Biedermeier burgher on the other. Aesthetically, formalism and the new garden cult were reinforced by the shift from *art nouveau* to art deco, from organic and fluid forms to crystalline and geometric ones. Artists who in the 1890's, under the name of "Secession," had engaged in a dynamic search for new instinctual truth, now turned away from their unsettling findings to the more modest and profitable task of beautifying daily life and the domestic environment of the élite.* By the time young Kokoschka began his artistic training in the Arts and Crafts School *(Kunstgewerbeschule)* in 1904,[5] he had a group of teachers who had completed this change, turning also as they did so away from fine arts toward applied arts and design. In the Wiener Werkstätte, the arts-and-crafts cooperative inspired by English example (minus the socialism), the artists created a superb workshop and a commercial outlet for their products. Even the imperial postage stamps of 1908 were designed by a Wiener Werkstätte artist, Kolo Moser, as the new art acquired almost official status in its harmless, decorative phase.†

In 1908, the neo-classical, art-deco phase of the Viennese aesthetic movement celebrated its greatest triumph in the public exhibition called simply *Kunstschau 1908*. The artists arranged their works and wares under the principle of unifying the fine and applied arts. Functional objects became museum pieces, while even the most serious painting and sculpture was reduced to decorative functions. Gustav Klimt, as president of the Kunstschau, proclaimed in his

* See Essay V, especially pp. 266–9.

† The postage stamp series designed by Moser was issued in commemoration of the 60th Jubilee of Francis Joseph. The art-deco style of the new series contrasts strikingly with the Biedermeier classicism of all previous Austrian stamps. Moser exhibited postage stamp designs "commissioned by the Royal Imperial Ministry of Commerce" at the Kunstschau. See *Katalog der Kunstschau 1908*, (Vienna, 1908), pp. 75–6. The stamps, with Moser's name in the lower margin, are pictured in *Scott's Standard Postage Stamp Catalogue* (124th ed. New York, 1968), II, 54.

opening address his group's conviction that "the progress of culture consists only in the ever-increasing permeation of all of life by artistic purposes."[6]

The architect Josef Hoffmann gave the building the character of a *Lustschloss* from the era of Maria Theresa such as might once have stood on Kokoschka's Galitzinberg (Figure 56). Lean and modern in its exterior facade, Hoffmann's pavilion was, like an aristocratic pleasure lodge, intimate and elegant within. Individual rooms devoted to the several arts and crafts were grouped around courts so as to maintain a feeling of residential space. Attached to the whole—as the special contribution of the city of Vienna—was a garden.[7] The authors of the Kunstschau catalog cited William Morris to convey their idea of the nature and function of a garden:

Large or small, the garden should look well ordered and rich; it should be closed off from the outer world; it should in no way imitate the purposes or accidents of nature, but rather look like something which one could see nowhere else but in a human dwelling.[8]

Hoffmann added a garden theater. Here in the summer of 1908 Vienna's élite could attend *al fresco* performances of Friedrich

Figure 57. Oscar Wilde's Birthday of the Infanta *performed in the Kunstschau Garden Theater, 1908.*

Hebbel's *Genoveva* and Oscar Wilde's *Birthday of the Infanta*. The first of these plays celebrates the recognition of Divine Justice in the suffering inflicted on demonic passion—that kind of passion which the Klimt group had earlier tentatively sought to liberate in their art, but had now abandoned. Wilde's play, performed in Velasquez-like costumes (Figure 57), reflected the new commitment of the visual artists to life as refined gesture.

Whatever was vital in Austrian culture ultimately had to express itself in theater. It was fitting that the most comprehensive statement of Vienna's modern visual culture should be made through these two plays, produced for the *haut monde* in the formal, stylized garden of Hoffmann's house beautiful.

<p style="text-align:center">⋙ II ⋘</p>

ASSOCIATED WITH the cultural ideal of *homo aestheticus* was the Kunstschau group's special concern for the child as artist. This provided the basis for Kokoschka's participation in the show, giving the mischievous young artist the opportunity to lay his cuckoo's eggs in the aesthete's garden of delight. Through Kokoschka, the late liberals' solicitous cultivation of childhood creativity paradoxically issued forth in The Expressionist explosion.

"The Art of the Child" had pride of place in *Kunstschau 1908*, occupying the first room of the exhibition space. Professor Franz Cizek, who organized the show, headed the department of education in the Arts and Crafts School where Kokoschka was studying to be an art teacher. The modesty of the young man's choice deserves our notice. Had Kokoschka aspired to the less secure but more prestigious career of painter, he would have attended the Academy of Fine Arts. He took instead the lower road, one more appropriate to the artisan class from which he sprang.

Professor Cizek, an associate of the Secession from its inception, projected the ideology of aesthetic liberation back to childhood and became Austria's leading progressive educator in the plastic arts. Where earlier generations had emphasized the induction of the child into adult aesthetics by means of imitative drawing, Cizek encouraged free creative activity. The child, he said, could show us "revelations of elemental creative power, *ur*-primitive art, on a new

terrain in our own homeland."[9] Youngsters of five to nine years came
to Cizek's classes once a week "to express themselves."[10] "Every-
thing elemental, subconscious and unconsumed is fostered and pro-
tected. . . . Only the uninhibited, the instinctual, becomes luminous
here as [the] essentially human," said a sympathetic reporter of
Cizek's school.[11]

Fortunately for the rambunctious Kokoschka, his professors
showed toward him as a vocational student the same tolerance that
they saw as essential for cultivating the artist in a child. When he
balked at the size and formality of the still-life class, he was given
a private room and the right to employ members of a circus family
as models for his action drawings. Even the jury of the Kunstschau,
headed by Gustav Klimt, indulged Kokoschka's confrontationist
whims. When he refused to show the jury the works he wished to
exhibit unless they ratified his entries in advance, they acceded.[12]

Kokoschka's teachers developed both art and crafts products de-
signed specifically for children (book illustrations, tapestries, and so
on), styling them in a kind of folk-art formalism. They believed that
the naïve art of the child "recapitulates atavistically the childhood of
peoples and the childhood of art."[13] Accordingly, Kokoschka did not,
like traditional art students, go for ideas and inspiration to what he
called "*die Grossen*," "the greats" (the German word also means
"grown-ups") whose works hung in the Museum of Art History.
Instead, he went across the way to the Museum of Natural History,
there to study the primitive art in the rich Ethnographic Collection.[14]
Kokoschka showed his early mastery of the child and folk-art idiom
in a poster for *Kunstschau 1908* (Plate XI), which conformed
well with the current ornamental formalism of his teachers and
fellow students.

In this artistic and educational context Kokoschka produced a
startlingly original work, *The Dreaming Boys (Die Träumenden
Knaben)*, a poetic fairy tale conjoined with a series of color litho-
graphs conceived like cartoons for tapestries.[15] The book, beautifully
printed under the auspices and guidance of the Wiener Werkstätte,
had all the surface characteristics of a Klimt group product. One of
the plates seems to portray in appropriate formal appliqué design the
tea-sipping mother of Kokoschka's girl companions in the garden
(Figure 58). Like his poster, his lithographs are informed by the sort
of literary-visual fantasy with which one enlarged the imagination

of the young and ratified the contemporary childhood image of the old. But beneath this conventional surface much lay concealed. Embracing the fashionable aesthetic idiom with its two-dimensional Persian garden quality, Kokoschka at twenty-one adapted it to project in archetypal symbols his own tormented experience of puberty. In effect, Kokoschka reversed the development which, only

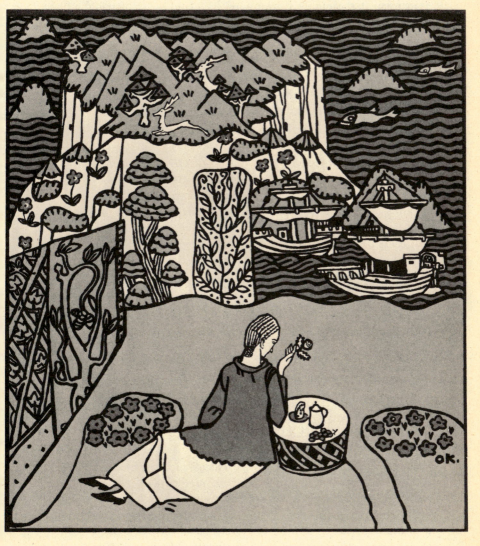

Figure 58. Oskar Kokoschka, from The Dreaming Boys, *1908.*

half-consciously, his elders had undergone as they passed from the fine arts to careers in the arts and crafts. They had drained the Secessionist art of the nineties of its original function—to speak psychological truth—and adapted its visual language to purely decorative purposes. Kokoschka took his teachers' mature ornamental idiom and developed its symbolic potential once more by attaching it to a searing poetic rendering of a youth's psychic state. He thus transformed the childish dreams of fairyland so fashionable among his elders into adolescent nightmares. Out of a combination of mischief and a strong instinct for the power of the symbolic, Kokoschka appropriated conventional decorative motifs as images to render a quasi-hallucinatory, erotic dream experience.

The poetry of *The Dreaming Boys* combines the childlike style of folk song (one thinks of "*Röslein rot*") with modern stream of consciousness. It opens with a fantasy of self-mutilation:

red fishling / fishling red	*rot fischlein / fischlein rot /*
with a triple-bladed	*stech dich mit dem drei-*
knife I stab you dead	*schneidigen messer tot*
with my fingers rend you	*reiss dich mit meinen fingern*
in two /	*entzwei /*
that there be an end	*dass dem stummen kreisen*
to this soundless circling	*ein ende sei /*
red fishling / fishling red /	*rot fischlein / fischlein rot /*
my little knife is red /	*mein messerlein ist rot /*
my fingers they are red /	*meine fingerlein sind rot /*
in the dish there falls a	*in der schale sinkt ein*
fishling dead /	*fischlein tot /*

This bloody child-chant is followed by the first of a series of dreams. The verse subtly changes to an undulating, free-flowing rhythm, broken occasionally by fitful changes of pace to convey the irregular image-sequences of dreaming:

and I fell down and	*und ich fiel nieder und*
dreamt / fate has many	*träumte / viele taschen hat*
pockets / I am waiting	*das schicksal / ich warte bei*
by a Peruvian tree of stone /	*einem peruanischen steiner-*
its many-fingered	*nen baum / seine vielfingri-*
branches grasp like	*gen blätterarme greifen wie*

anguished arms and fingers	*geängstigte arme und finger*
of thin / yellow figures / who	*dünner / gelber figuren / die*
in the star-flowered thicket	*sich in dem sternblumigen*
touch one another unnoticing	*gebüsch unmerklich wie*
like the blind /	*blinde rühren /*

So far the lithograph relates to the text in the margin beside it (Plate XII). The torn fish lie on the greensward, if not in a dish as described in the poem; the Peruvian trees show their many-fingered, leafed arms.*

But soon a gap opens between picture and verse. The embracing men central to the litho have no place in the poem. Images important to the text—blue birds hanging from the mast, ship with luffing white sails pulled by chains—are missing from the pictures, while the vivid color images of both text and litho rarely correspond.

The artist has treated text and pictures not in the tradition of an illustrator, but after the fashion of a Lieder composer, for whom words and music are reciprocally evocative rather than subordinative. By establishing a relationship of alienated complementarity between the visual and the verbal, Kokoschka widens the hallucinatory range of his singular opus. The pictures as a whole reinforce the peaceful psalmodic rhythm of the verse, in contrast to the ejaculatory stream of consciousness of the words. Yet the pictures intensify the terror through minute pictorial detail, such as tiny fish rent in half, or trees composed of human hands—features which, without the text, the observer might never notice.

The same semi-detached quality which subsists between pictures and text appears within the poem itself. Kokoschka's verse has on its surface the quiet, ambulatory rhythm of the Psalms. But he undermines the innocence of this language. With rhythm, as with line and color, Kokoschka works with a delayed fuse. By widely varying the length of the line and by breaking the phrase with slash marks at unsuspected nodes, he injects a breathless, eccentric music into a visual-verbal field already suffering from dissociation. Thus he com-

* At the entrance to the Ethnographic Collection of the Museum hung a picture of an ancient Peruvian temple city which may have provided Kokoschka with this motif. See Eugen Guglia, *Wien: Ein Führer . . .* (Vienna, 1908), p. 65.

municates the defiant breakthrough of subversive instinct within the highly formal frame.

In his dreaming, the poet reveals himself to the comfortable society of his elders as a werewolf:

and I fell and dreamt the sick night /	*und ich fiel* *und träumte die kranke* *nacht /*
blue-mantled men / what are you doing asleep / under the boughs of the dark walnut trees by moonlight?	*was schlaft ihr / blauge-* *kleidete männer / unter den* *zweigen der dunklen nuss-* *bäume im mondlicht?*
you gentle ladies / what springs and stirs in your red cloaks / in your bodies the expectation of swallowed members since yesterday and always?	*ihr milden frauen / was quillt* *in euren roten mänteln / in* *den leibern die erwartung* *verschlungener glieder seit* *gestern und jeher?*
do you feel the excited warmth of the trembling / mild air—I am the were- wolf circling round—	*spürt ihr die aufgeregte* *wärme der zittrigen / lauen* *luft—ich bin der kreisen-* *de wärwolf—*
when the evening bell dies away / I steal into your garden / into your pastures I break into your peace- ful corral /	*wenn die abendglocke ver-* *tönt / schleich ich in eure* *gärten / in eure weiden /* *breche ich in euren fried-* *lichen kraal /*
my unbridled body / my body exalted with pig- ment and blood / crawls in- to your arbors / swarms through your hamlets / crawls into your souls / festers in your bodies	*mein abgezäumter körper /* *mein mit blut und farbe* *erhöhter körper / kriecht in* *eure laubhütten / schwärmt* *durch eure dörfer / kriecht* *in eure seelen / schwärt in* *euren leibern /*
out of the loneliest stillness / before you awaken my howling shrills forth / I devour you / men / ladies / you drowsily hearkening	*aus der einsamsten stille /* *vor eurem erwachen gellt* *mein geheul /* *ich verzehre euch / männer /* *frauen / halbwache hörende*

children / the ravening / lov- ing werewolf within you /	*kinder / der rasende / lieben- de wärwolf in euch /*
and I fell down and dreamt of unavoidable change /	*und ich fiel nieder und träumte von unaufhalt- baren änderungen /*

The secretly destructive werewolf is in fact, as the beginning of the poem made clear, a self-lacerating sufferer. He knows his state as adolescence:

not the events of childhood move through me and not those of man- liness / but boyish- ness / a hesitant desire / the unfounded feeling of shame before what is growing / and the stripling state / the over- flowing and solitude / I per- ceived myself and my body / and I fell down and dreamt love /	*nicht die ereignisse der kindheit gehen durch mich und nicht die der mann- barkeit / aber die knaben- haftigkeit / ein zögerndes wollen / das unbegründete schämen vor dem wachsen- den / und die jünglings- schaft / das überfliessen und alleinsein / ich erkannte mich und meinen körper / und ich fiel nieder und träumte die liebe /*

In his search for escape from his solipsistic imprisonment, the poet falls from dream to dream, from self-injury to injuring others, those of the adult world, until at last his dream of destruction is metamorphosed into a dream of love. Finally, the virginal tenderness of a nubile waif, vague and delicate of outline, quenches his fire and quells his shame. In this resolution, text and illustration can converge once more and rest in concord (Figure 59).

Shame—let us make no mistake about it—is central to the young Expressionist's anguish. The previous Viennese generation of adolescents, the *fin-de-siècle* aesthetes such as Hofmannsthal and Leopold Andrian, had a sexual awareness so attenuated that neither shame nor guilt arose.* Their problem lay not in mastering or shaping intensity of feeling, but in the weakness of feeling, in the feebleness of the sense of self. For them, a diffuse oceanic consciousness blurred

* See Essay VI.

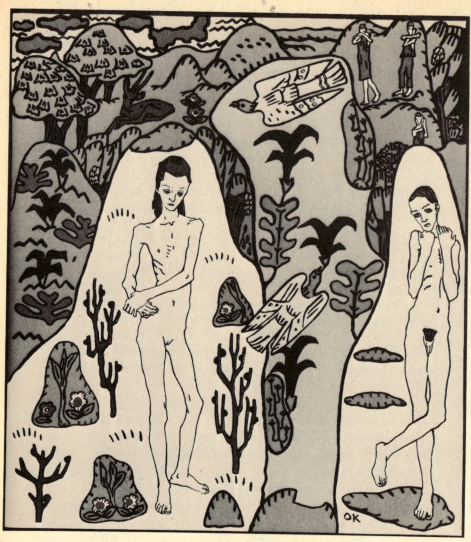

Figure 59. Oskar Kokoschka, from The Dreaming Boys, *1908.*

the border between self and other, between inner and outer, blending dream and reality. In *The Dreaming Boys* Kokoschka burned through this undifferentiated surface of the panpsychic consciousness to affirm the primary reality of sex as interior personal experience; but this affirmation involved the most searing sense of shame. Despite its subversive and aggressive thrust against an excessively

sublimating culture, the poem therefore remains essentially confessional; not even the deceptive plural of the title—*The Dreaming Boys*—is allowed to cover the identity of the poet, who utters his stream of consciousness in the first person.

From the terrible impasse of sexual tension, Kokoschka saw the possibility of release in two directions: in wooing, or in subduing. *The Dreaming Boys* culminated in the first; consummated love reestablished both self and world. Kokoschka explored the other solution in a playlet called *Murderer, Hope of Women (Mörder, Hoffnung der Frauen)*, which he staged in the Kunstschau garden theater in 1909. Here eros becomes pure aggression. The introspective dreamworld of *The Dreaming Boys* gives place to a stark primitive love combat between the sexes. "Frightening, passionate human nature with its capacity for experience appears as our own experience."[16]

The theme is simple: "Man," leading a band of soldiers, meets "Woman" with her retinue before a fortress. Man has Woman branded with his mark; she stabs and imprisons him. Ensnared in a kind of love-hate, she releases him. But Man, who is near death, still can release irresistible force: at the touch of his outstretched hand, Woman dies. Not *Liebestod*, but *Liebestöten* is proclaimed here: a passion in which love and murder are indissolubly bound together. Death is not something to which the lovers surrender in the tradition of Tristan and Isolde, but which they inflict upon each other in the bitterness of a passion that contains aggression and love as indistinguishable ingredients. Kokoschka translated his powerful feeling from dramatic into visual language in a poster for the play (Plate XIII). It has the same bold two-dimensional color composition as his poster for the Kunstschau of the year before (compare Plate XI). But whereas Kokoschka had conveyed the static composure of beautiful girlhood in flat color planes, he now projected the aggressive agony of a female killer's *Pietà* with a powerful, sweeping brush.

Heinrich Kleist had already resurrected the ancient co-mingling of love and war in his *Penthesilea*—itself a landmark in the return of the repressed to European high culture. Kokoschka discovered this play as a schoolboy, and based his playlet upon it. Tearing off the decent draperies of Homeric mythology, he compressed Kleist's classic drama into a short, stark, archetypal action. In a play crassly

entitled *Murderer, Hope of Women*, no Greek heroes are needed:
Achilles and Penthesilea are stripped down to *Mann* and *Weib*.
Kleist's sonorous poetic diction shrinks to knifelike utterance. Stark
color reinforces percussive poetry in reducing character to archetype.
Shading and half-tones have no place here. The opening stage direc-
tions suggest a poster: "The Man: White face, blue armor, head-
bandage covering a wound" (presumably red-stained). The Woman
appears in contrasting primary colors: "Red clothing, open yellow
hairs [sic], large, loud." The warrior-following of the Man identifies

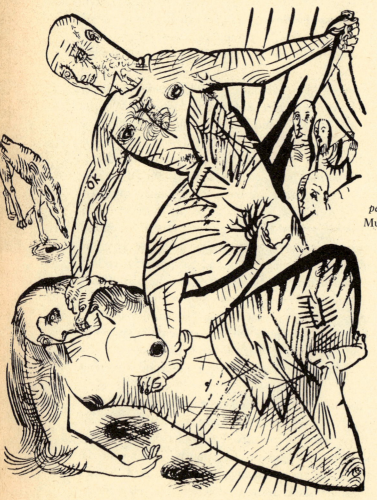

*Figure 60.
Oskar Kokoschka,
pen-and-brush drawing for
Murderer, Hope of Women,
1908–10.*

itself in opening lines whose blatant visual imagery strengthens their dithyrambic throb:

> *Warriors*: We were the flaming wheel around him.
> We were the flaming wheel around you, stormer of
> secret bastions!

> *Warriors*: Lead us, pallid one.*[17]

Both the verbal and the visual language of *Murderer, Hope of Women* seem to aspire to a primitive, athletic directness: they bespeak powerful muscles now unbearably contracted, now springing with deadly energy. Figure 60, one of the pen-and-brush drawings which the artist executed as illustrations for the first publication of the play (in *Der Sturm*, 1910), shows figures of solid metallic contour, their limbs molded with steely nerve-like lines. If we compare this picture of deadly war between the sexes with that of an early Secessionist, Ernst Stöhr (Figure 61), we can see how Kokosch-

*Figure 61. Ernst Stöhr,
untitled, 1899.*

ka's generation began to free its art from literary language to achieve a direct visual statement of sado-masochistic experience. Kokoschka's drawing, like the wide-spanned music of Schoenberg, opens up a world of fire and ice that could not previously have been formulated so directly. In *Murderer*, as in *The Dreaming Boys*, Kokoschka remains indifferent to the literal correspondence between

* *Krieger*: Wir waren das flammende Rad um ihn.
 Wir waren das flammende Rad um dich, Bestürmer
 verschlossener Festungen!
 Krieger: Führ' uns, Blasser!

picture and text. Only reciprocal intensification is the dramatist's aim, and that he achieves in abundance.

That such a work should have been performed in the charming Kunstschau garden! An audience which had just learned to refine its sensory and psychological receptors to respond to the delicate nuances of Oscar Wilde's *Birthday of the Infanta* had now to conjure with the raw savagery of Kokoschka's play. The painter—then already known as the "chief wild man" of the Kunstschau—has written that a storm of protest broke over him on opening night; but this recollection has been challenged by Peter Vergo with some solid evidence to the contrary.[18] Even though the play may not have aroused so much fury as its author claimed, it must nevertheless have been easier to ignore the internalized and allegorically formulated puberty crisis of *The Dreaming Boys* than the direct, destructive revelations of *Murderer, Hope of Women*. The differences between the lithos for the poem and the artwork for the play dramatize the enormous visual range within which young Kokoschka could formulate his feeling. His febrile psychological truths could no longer be uttered in the aesthete's grammar of assent. For a new message Kokoschka was devising a new language.

Kokoschka's provocative explosion produced the eviction from the garden that he might have expected—with momentous consequences both for himself and for Austrian art. At the instigation of the Ministry of Culture and Instruction, the director of the Arts and Crafts School, Alfred Roller, took away Kokoschka's stipend.* Happily, the explosion also drew the attention of the coolest and most determined critic of Viennese aestheticism, the architect Adolf Loos. He stepped forward to offer the young artist a helping hand. Within a year he had provided Kokoschka not only with numerous commissions for portraits, but also with an intellectual milieu that opened new vistas for Kokoschka's development as artist. Kokoschka saw him as a Virgil to his own Dante, "decisive not only for my career but also for my life."[19]

The friendship that developed between the forty-eight-year-old architect and the young painter symbolized a wholly new relation-

* Roller, a charter member of the Secession, had made his fame as stage designer for Gustav Mahler at the Court Opera.

ship between fine and applied art. What the Secession group had joined together in the interest of the life beautiful, the new generation rent asunder in the name of truth.

Loos had participated in the Secession movement in its early days, sharing its revolt against historical style. In 1898, he had formulated in the Secession's *Ver Sacrum* the most vigorous indictment of Ringstrasse Vienna for screening its modern commercial truth behind historical facades.[20] The Secession artists and architects sought redemption from historical styles by developing a "modern" style, to sheathe modern utility in new beauty. Loos sought to remove "style" —ornamentation or dressing of any sort—from architecture and from use-objects, in order to let their function stand clear to speak its own truth in its own form. Along with his friend and fellow moralist Karl Kraus, he relentlessly condemned the "penetration of life with art" and the stylization of the house as work of art that reached its apogee in the Kunstschau. As Kraus sought to restore the purity of the linguistic environment of man by removing all aesthetic pretensions from expository prose, so Loos tried to purify the visual environment—city, housing, dress, furniture—by abolishing all embellishment. Architecture, he said flatly, was not art: "Whatever serves a purpose must be excluded from the realm of art. . . . We shall have an architecture for our time only when the mendacious slogan, 'applied art,' is banished from the vocabulary of nations."[21]

In 1909—perhaps under the spell of young Kokoschka's rebellion, certainly in its spirit—Loos defined with unprecedented sharpness his polaric conception of art and architecture:

The work of art is the private affair of the artist. The house is not. . . . The work of art is answerable to no one; the house, to everyone. The work of art wants to shake people out of their comfortableness [or complacency: *Bequemlichkeit*]. The house must serve comfort. The artwork is revolutionary, the house conservative.[22]

In a partnership of opposites, Kokoschka and Loos in effect assaulted the Kunstschau's aesthetic synthesis of painting and architecture on both flanks. Loos banished the decorative elements from architecture in favor of severely neutral rationality. Kokoschka, on the other hand, proceeded from the abstract explorations of the erotic life of his Kunstschau works to concretely characterological

painting. True to Loos's principle of privatism in painting, Kokoschka hurled himself with the caricaturist's passion into a new kind of psychological portraiture. He would capture the spirit of his subjects through dialogue. By thus penetrating deeply into another's soul, he aimed to "find through my painting a basis of self-knowledge."

In retrospect, Kokoschka described his new kind of painting as born of a feeling of alienation: ". . . to confront the problem, I started painting portraits."[23] His strategy with his sitters was to keep them moving and talking, to summon up their vitality, so that their faces would become luminous as consciousness, as spirit. "A person is not a *still* life," Kokoschka insisted.[24] Faces dispose of a "delegated power" of the consciousness, which allows them to select images expressing some—though never all—of the soul's nature and movement. The face (and body, gesture) is to the spirit as the wick is to the oil. The artist's consciousness in turn becomes the vision of his subject, "sustained and nourished" by the overflow of vitality transmitted by the person before him. Otherness is overcome, illusion penetrated, by a kind of "real presence" of life, transmitted through the subject's face and the artist's consciousness into the portrait—into image.

The artist, though a "man without rules" *(regelloser Mensch)* in an uncharted sea of life, can thus give form to a portion of the boundless through his consciousness of faces and visions *(Bewusstsein der Gesichte).** That consciousness is at once dynamic and static: "letting the current run and the visions be."[25] It does not "represent" human or natural reality as painters had done until now, but "presents" it as the willed creation of an in-formed consciousness.

The portraits that Kokoschka produced in the years 1908 to 1915 surely showed their subjects as "real presences" in an almost theological sense. Incarnate spirits, the very tone and gesture of their bodies expressed the essential, vital character that the painter saw in them. Even as he moved toward an intense three-dimensional realism, Kokoschka treated the body as the voice of the psyche. Concomitantly, he banished environment from his portraits, or left it at best a shadowy existence. For, after the explosion in the garden,

* The German word *Gesicht* denotes both "vision" or "image" and "visage" or "face," thus embracing both the subjective and the objective side of visual perception. The double meaning is integral to Kokoschka's conception of the artist's consciousness, but compels us in English to stress now one side, now the other, of the complex.

neither external nature nor the external symbols of dress, status, and occupation could give access to the de-culturated, essential human being that became the Expressionist's concern. When reality lay in the active spirit, psyche would create its own ambience, a radiant emanation of the persona of the subject, where once external environment had served as clue to his nature.

Kokoschka's double portrait of the art critics Mr. and Mrs. Hans Tietze (Plate XV) demonstrates the power of his vision. Kokoschka called his image of the husband "the Lion"; of the wife, "the Owl." A kind of crackling light seems to spring from the head of the male partner. From his back rise sharpened, finlike scorings suggesting radiating energy. They seem to make him symbiotic with a similarly energized surround, a field of life, where electric currents crisscross at random in the cloudily undulating atmosphere.

In the making of this portrait, according to Mrs. Tietze, the artist seated his subjects before the window, framed in light coming from behind. But in the painting Kokoschka inverted the pair's relation to the light, letting them become its principal source.[26] The couple's hands, each pair so different from the other in shape and flesh and bone, are aligned and nearly touch, but they do not reach for each other—as though to do so would unconsciously break the privacy or predicament of personality.

In his portrait of his Berlin friend Herwarth Walden (Plate XIV), Kokoschka recorded on canvas the qualities it took to be an avant-garde editor. Walden was a man who dared. It was he who published Kokoschka's *Murderer, Hope of Women*—text and drawings—and took the young artist on his staff. The sharpness of Walden's profile and the sturdy brow convey Kokoschka's own "vision-consciousness" of a critical intellect. The steady eye combines cool vision with an intense alertness, an eye ready for the enemy, equally quick to blaze into righteous anger. Behind the sensuous mouth we know the jaw is firmly set; yet the whole face is suffused with the fatigue that strenuous critical engagement brings. The hand reassures: it is warm, strong, relaxed. Its jaunty set upon the hip suggests that, however great the strain shown by the face, the fight goes on.

Most astonishing in the Walden portrait is the wide variety of brush strokes and lines that compose the clothing of the wiry body. There is no single texture to the coat; Kokoschka has used as many lines straight and curved, as many surfaces clean and splotched, as

there are ideas and attitudes in the chaotic avant garde. Walden wears lightly his multi-shaded mantle. He keeps the whole coherent by the clear direction of the light he radiates: forward. The light-lines of the shoulder point forward and down; the lines of the forearm sleeve forward and slightly up. Thus the painter suggests the determined, springy, upright posture that gives Walden the power to be a light-bringer within and despite the chaos.

In 1914, in a painting he called "The Tempest" (Plate XVI), Kokoschka returned to the theme of love with which he had burst upon a startled Vienna in 1908. But now he presented the problem entirely demythologized, as candid, visual autobiography. Like his double portrait of the Tietzes, this painting of Kokoschka and his mistress, Alma Mahler, presents the individuals both in their uniqueness and in their mutual relationship. The hands of the Tietzes, of the Lion and the Owl, did not touch, but their spirits joined in the sharp yet warm electric field of a shared intellectuality. In "The Tempest," the bodies of the lovers lie together, but Kokoschka's "vision-consciousness" tells us how impossible is this love. Alma's smoothly textured body sleeps in eloquent contentment on her lover's passion-corruscated breast. Oskar lies tensely awake, his jaw clenched, his head as rigid upon his neck as if he stood erect. The tired eyes, wide open, stare fixedly into the void; the seared and swollen hands, entwined uncertainly over his groin, bring to a focus his tumescence of the spirit, so hopelessly out of phase with Alma's serenity. Out of the dissonance, the aphasic disjuncture, of these two beings of embodied spirit, the whirlwind arises. Up from their moon-lit sea of lunar love, the tempest bears them like a bark. Is it a cloud of hope, a sturdy vehicle of baroque fantasy to draw them upward? Or is it the trough of a wave of despair that will engulf their fated love? The ambiguities in the setting reinforce the ambiguities of this powerful erotic experience, in which neither partner could possibly distinguish between the physical and the psychological, but in which the solipsistic predicament could never be transcended.

Looking back upon the first works in which Kokoschka had addressed the problems of sexual experience, one can see how swiftly he consolidated his own aesthetic revolution. Even *Murderer, Hope of Women*, cast as it was as dramatic allegory and graphic abstraction, was closer in spirit to Klimt's psychological painting than to "The Tempest." It was Klimt, after all, who had broken through

the conventions that had restrained the artist from too frank an exploration of the erotic life. Yet his subversive work had remained allegorical and, above all, impersonal. Anonymous models could be used to "represent" the pains and pleasures of the instinctual life, but no portrait of an identifiable client would be permitted to carry its marks. Indeed, the more "psychological" Klimt became, the more he cloaked his messages in the jeweled raiment of symbolism. "The Kiss" (Plate VIII), Klimt's most popular painting at the Kunstschau, was a masterpiece of sensuous surface and sublimated instinctual substance, from which all semblance of personal identity had been expunged.

Kokoschka's first revolution was the restoration of rawness to the portrayal of instinct—basically a continuation of the psychological probing Klimt and the Secession had so daringly begun. His second revolution, exemplified in all his portraits, linked the psychological revelation with concrete personal experience. He restored the third dimension to portrait painting, not in order to reintroduce the scientific spatial perspective of the Renaissance, but to restore the body as the primary expressive vehicle of psychological experience. By the same token he dared, in "The Tempest" and in other portraits, to widen the force of his culture's increasing consciousness of man's psycho-physical aloneness by presenting it as personal experience: the painful, spiritual underside of bourgeois individualism.

A comparison of Kokoschka's portrait of Adolf Loos (Plate XVII) with Klimt's nearly contemporaneous portrait of Fritza Riedler (Plate V) will suggest the wider import of the Loos-Kokoschka alliance. Klimt painted his client in an ideally stylized interior, its walls and moldings ornamented in the style of the Wiener Werkstätte. The environment extends from wall to furniture to dress, framing the human person in her formal environment. In this aesthetic sanctuary—even the window is of stained glass, denaturing light as it enters the enclosed space—Frau Riedler's cultivated physis stands forth in idealized relief. She graces the interior as it frames her, a reciprocal play of personal *Bildung* and beautified *Besitz*. Such a portrait belongs in an art-deco room; and such a room deserves as its centerpiece a portrait so sublimely stylized.

Kokoschka's portrait of Loos obviously speaks another language. The artist uses no iconic guides, no interior environment to provide a background for his subject. Nor could he have done so for this

"conservative" protagonist of Reason. A Loos house is an extremely rational, geometric structure, from which any visible sign of the complex, nervous quality of modern life is ruthlessly excluded: a building in which space is clear and unclouded, line secure, strong, and definite. If an ordered environment can be said to produce a sense of security, surely Loos's strict and lucid interior style achieved its creator's aim. Kokoschka, in his Expressionistic portrait, achieves the opposite effect. Here the rationality of Loos's architectural conceptions is adapted to present his psyche, the strong but suffering psyche of *l'homme machine*. Against a background not of geometric architecture but of space charged with the electric atmosphere of blue weather-lighting, the stern, reflective face of Loos stands forth. The hands are meshed into each other like two toothed wheels. The face is built of irregular planes locked in tension. Only the irrational force of an iron will seems to subdue and hold together the all-too-rational elements of this powerful personality. Where space in Loos's architecture is pure and clear, the spatial ambience of his personality as seen by Kokoschka is surcharged with a heavy, explosive energy. It is surely a painting that fulfills Loos's injunction to the artist: "to shake us out of our complacency and comfort [*Bequemlichkeit*]."

Such a portrait could not well hang in a patterned interior conceived by Josef Hoffmann, who had designed the Kunstschau pavilion in the spirit of sybaritic aestheticism. On the bare white wall of a Loos room, however, the painting could show forth its disturbing vision of the human condition, of modern man wracked by inner tension—in the words of Sartre, of man *"condamné à être libre."* Against the combined flank attack of Loos's astringent, puritan rationalism in architecture and Kokoschka's desublimated psychological realism in painting, the Kunstschau ideal of the life beautiful, so well symbolized in the formal, denatured garden, could not stand.

III

WHILE KOKOSCHKA was touching off the explosion in the garden in painting, Arnold Schoenberg—in that same year, 1908—was laying the powder train for the explosion in music. Like Ko-

koschka, Schoenberg worked almost unconsciously with camouflage, using traditional aesthetic forms to screen his subversive work, even while he exploited the dissociative potential of those forms. Again like Kokoschka, Schoenberg took his initial step into a new world of feeling within the framework of lyric poetry, but then quickly broke into the open with a radical turn to theater. The dramatic mode, by providing overt justification for a new kind of musical expression, released the composer from traditional musical inhibitions, just as the harsh psycho-dramatics of *Murderer, Hope of Women* helped the painter to liberate himself from the visual language of the Kunstschau group. That literature should have served both men as midwife suggests how crucial was the role of ideas in their respective language revolutions.

It seems almost too pat that Schoenberg too should have accomplished his breakthrough to atonality on the theme of an adolescent sexual awakening placed in the setting of a garden. Yet it was so. Both formally and psychologically, Schoenberg's song cycle, *The Book of the Hanging Gardens*, is a close musical analogue to Kokoschka's *The Dreaming Boys*.

Older by twelve years than Kokoschka, Schoenberg had been more deeply involved than the painter with the aesthetic movement of the *fin de siècle*. He shared with his older contemporaries, intellectual pioneers of Vienna's élite—Hofmannsthal, Freud, Klimt, and Ernst Mach—a diffuse sense that all is flux, that the boundary between ego and world is permeable. For him as for them, the firm traditional coordinates of ordered time and space were losing their reliability, perhaps even their truth. Pan-naturism and pan-psychism —the objective and the subjective sides of the same continuum of being—found expression in music as in other fields of art and thought. Together, the two tendencies accelerated a process that had been under way since Beethoven: the erosion of the old order in music, the diatonic harmonic system. Schoenberg's most revolutionary act, accomplished in *The Hanging Gardens*, was the rejection of tonality, an act which he himself called, significantly, "the emancipation of dissonance."*

* To emancipate dissonance was not the same as to construct a new system to replace the tonal one. Schoenberg achieved his serial, or twelve-tone, system only after World War I, but this lies beyond the scope of the present study.

What was the old order in music, and what was the nature of Schoenberg's liberating act?[27] Since the Renaissance, Western music had been conceived on the basis of a hierarchical tonal order, the diatonic scale, whose central element was the tonic triad, the defined key. The triad was the element of authority, stability, and, above all, repose. But music is movement; if consonance is perceived only as a frame at rest, all movement is dissonance. Our system of music-making firmly subsumed movement under key, so that all movement took its rise from the tonic triad and returned to it. Dissonance was legitimized as a dynamic element—departure in the context of key—by having always to refer to it. Modulation—the passage from one key to another—was a moment of permitted illegitimacy, a heightened state of ambiguity, to be resolved by a new orientation in a new key, or a return to an older one. Thus the pianist Alfred Brendel has identified the uses of chromaticism, a principal solvent of key, made by Liszt, in his "Variations" on Bach, and by Haydn: "Chromaticism stands for suffering and insecurity, while 'pure' diatonic harmony, introduced at the conclusion of the piece, represents the certainty of faith. . . . [In] the opening of Haydn's *Creation* . . . Chaos and Light follow each other in a comparable way."[28] Dissonance—dynamic excursion from the tonic—gave excitement to music, and was the primary source of its expressiveness.

The task of the composer was to manipulate dissonance in the interests of consonance, just as a political leader in an institutional system manipulates movement, canalizing it to serve the purposes of established authority. In fact, tonality in music belonged to the same socio-cultural system as the science of perspective in art, with its centralized focus; the Baroque status system in society, and legal absolutism in politics. It was part of the same culture that favored the geometric garden—the garden as the extension of rational architecture over nature. Not for nothing was Rameau, the court musician of Louis XV, the clearest and most uncompromising theorist of the "laws" of harmony. The tonal system was a musical frame in which tones had *un*equal power to express, to validate, and to make bearable the life of man under a rationally organized, hierarchical culture. To make all movement fall in the end into order (the musical term is "cadence") was, appropriately, the aim of classical harmony in theory and in practice.

The nineteenth century saw itself generally as "a century of movement," in which "the forces of movement" challenged "the forces of order." Such was the case in music, too. Hence it was the century of the expansion of dissonance—the medium of tonal movement— and the erosion of the fixed key, the center of tonal order. In music as elsewhere, time moved in on eternity, dynamics on statics, democracy on hierarchy, feeling on reason. Richard Wagner, who was both a political and a sexual revolutionary, became Public Enemy Number One of traditional tonality, of key. In his *Tristan und Isolde*, Eros returns in surging rhythms and chromatics to assert its claims against the established political and moral order of the state expressed in rigid meter and diatonic harmony. Chromatic tones— half-tones—are all of a single value, and constitute an egalitarian universe of sound. To one accustomed to the hierarchical order of tonality, such democracy is disturbing. It is the language of flux, of dissolution. Of liberty or death, depending on your point of view.

Like Richard Strauss and many another young composer of the era, Schoenberg found in Wagner a medium appropriate to his own *Lebensgefühl*. Always a musician of ideas, Schoenberg was inspired to his first three major works by literary texts on the favored *fin-de-siècle* themes of erotic affirmation and the dissolution of boundaries. The three tonal poems in praise of love asserted against the conventions of society, *Verklärte Nacht* (1899), *Gurrelieder* (1901), and *Pelléas und Mélisande* (1903), are truly pan-erotic period pieces.* Their poets—Richard Dehmel, Jens Peter Jacobsen, and Maurice Maeterlinck, respectively—dwelt in that ambiguous neo-romantic realm where symbolism was born out of disintegrating naturalism. As these poets generally proceeded to their new communications out of the formal poetic structures of tradition, so Schoenberg, in adapting their new ideas to music, approached his task from a formal, structural base provided by his revered Brahms. But it was from his second hero, Wagner,[29] that he found the musical means to erase boundaries in a densely textured web of ever-transforming motifs; boundaries between man and nature, psyche and environment, ethics and instinct, above all between man and woman. In their surges of

* So strong was the appeal of Maeterlinck's *Pelléas* to the musicians of the time that four major composers devoted works to it: Fauré (1901), Debussy (1902), Schoenberg (1903), and Sibelius (1905).

liquid sound and rhythmic flux, Schoenberg's early works have the true *fin-de-siècle* ring, conveying the same sense of cosmic amorphousness one finds in Klimt's "Philosophy" or in Schnitzler's drifters borne along by nameless instinctual pressures.[30] Yet even as Schoenberg created a rootless world by the use of modulation-in-permanence and the expansion of chromatic elements, he did not yet break from key or even from the obligations of sonata form. He showed in *Verklärte Nacht* that, as he said, the "impassable gulf [between Brahms and Wagner] was no longer a problem." On the one hand, Schoenberg constructed his sextet as a pair of sonatas that firmly reflected the structure of Dehmel's text. On the other, he used Wagnerian harmonic devices to weaken the sense of tonal center, such as evading the dominant, which normally provides us with tonal location. Schoenberg thus created within sonata form the ambiguity of direction, sensuous flow, and uncertainty of meaning that sonata form traditionally aimed to dominate.[31]

As he looked back on this Impressionist phase in Europe's music and his own, Schoenberg stressed what in fact was his own special characteristic in that world of flux: the subjective, responsive element in the continuum between the "I" and the world. "The organ of the Impressionist is a . . . seismograph which registers the quietest movement," he wrote in his *Theory of Harmony* in 1911. Because the Impressionist is tempted to follow up the slightest tremors, he becomes an explorer of the unknown. "He is drawn to the still, the scarcely audible, therefore mysterious. His curiosity is stimulated to taste what has never been tried." To him who demands, the answer is given. It is "the tendency of the seeker to find the unheard of . . . in this sense, every great artist is an Impressionist: [his] refined reaction to the faintest impulse reveals to him the unheard of, the new."[32] This exploratory sensibility was not only outward-oriented; it also had subjective implications. "What counts is the capacity to hear oneself, to look deep inside oneself. . . . Inside, where the man of instinct begins, there, fortunately, all theory breaks down. . . ."[33] This exploration—at once of his interior world and of a world of fragments not yet heard in a sonic unity—Schoenberg began in *The Book of the Hanging Gardens.*

It was fitting that for his gentle revolution in song Schoenberg the neo-romantic should have chosen verses by Stefan George, the high

priest of German aestheticism at the turn of the century and a one-time friend of Hofmannsthal. George offered much to attract Schoenberg: an absolute devotion to Holy Art, and a mystical sense for the unity of man and cosmos. George's poetry had the synesthetic characteristics appropriate to the artist-priest's mystical unifying function: a language magical in sonority and an imagery rich in color. Beyond its ideational and aesthetic attractions for Schoenberg, George's verse peculiarly lent itself to the bold musical task upon which the composer now embarked: the dissolution of tonality as the cohesive structural center of music. The verse had the simple, formalistic clarity of the classical garden itself. Sturdy in meter as in sound, it provided a firm poetic frame within which to create a music appropriate to a world in which, to the composer, the ontic hierarchy had lost its meaning and its truth.

In *The Book of the Hanging Gardens*,[34] George sets up a tension, ideal for Schoenberg's purposes, between the socially ordered nature of the garden and the eruptive passion of an initiate to love. The love affair moves from the shy entry of the lover into the quiet garden to consummation in an inner floral bed, a kind of sanctum of love. Then the lovers part, and the garden dies. The fifteen verses that compose the cycle thus chart the transformation not only of the lover, but also of the garden. The trajectory is from the autonomy of garden and lover, through their integration, to the disintegration of both. The first verse describes the rococo park as a well-structured outer scene with sculptures around a pond, as in Kokoschka's childhood paradise on the Galitzinberg. The lover appears as outsider, a dreaming boy. Then love awakens, finds an object, and consecration begins. The central group of verses sees the lover rejecting the outer world in favor of his suit, the rise of his passionate desire in all its anxiety and hope, and his imperious insistence on fulfillment. The garden, which had been completely forgotten as love awoke, returns in verse 10 as a "beautiful bed hedged with blackish-purple thorns," at once symbol of the loved one's sexual organs and scene of the lover's erotic fulfillment. Three final verses bring the dénouement: the lovers part; the garden dries and dies. There is no banishment from the garden here, rather the disintegration of the garden itself, of the very image of ideal bliss. In the last verse—a marvelous reprise of the whole, of which Schoenberg takes the fullest musical

advantage—the abandoned lover stumbles through the ponds turned swamp and over the seared grasses; sultry winds drive hissing clouds of brittle leaves around the ashen walls of desiccated Eden.

Schoenberg develops the duality of external order and personal feeling as two interacting musical tensions: one between word and context, another between traditional musical shapes (especially in the piano) and a new, erratic psychological expression which pantonality makes possible.[35] Through both, he transforms George's stylized lyrics to amorous devotion into a subtly muted yet intensely piercing cry of sexual awakening. In the process he lifts the whole autonomous status of external reality (the garden), integrating it with the lover in an experiential realm of being beyond subject-object distinction. The seismographic consciousness of Schoenberg the Impressionist was still at work. But now, freed from the obligation of tonality, it could catch and record both the subtlest tremors and the most wide-arced terrors dwelling in the depths of the psyche, not merely those that rippled, in the manner of program music, on the surface of the senses.

In his setting of the poem cycle, Schoenberg remained faithful to its fundamentally conservative spirit through one major device: the establishment of a *Gesamtstimmung*, a single atmosphere. The first song sets the tone, the mood of the rococo park at evening (see Figure 62). In the piano introduction a profoundly serene series of slow, single-toned phrases conveys the soundless stillness of the garden pond. The lack of key produces in us only expectancy. We are in an open universe, we soon become aware. The movement is no longer through harmonic progression, but in a kind of gestural shaping and reshaping. Thus in the first two bars of the first song, four opening quarter-notes are clustered close in pitch, then the phrase reaches in a wider sweep upward and comes to rest. This motif, four times restated before the voice enters, is freed of formal order in time; it expands and contracts like breathing. Rhythm crosses the bar line, ignores the meter—a free pattern of quarter notes—first four, then two, then five, before they sweep upward and subside again. Thus melody becomes melodic gesture, *shape*; because each note has an enlarged autonomy, and can go anywhere, the sequence works aphasically, as it were—for the singer as for us. A tone will break into a privileged position, but disappear again into the mass, like a stone cast into the dark pond.

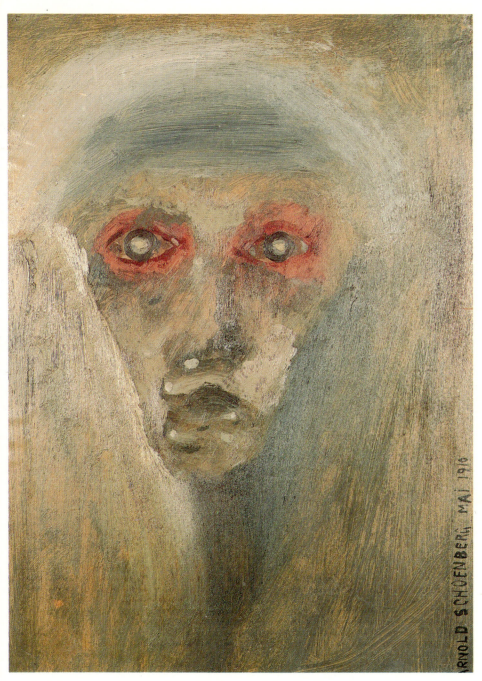

Plate X. Arnold Schoenberg, The Red Stare, 1910.

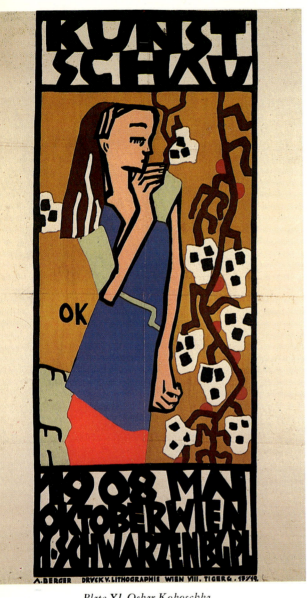

Plate XI. Oskar Kokoschka,
Kunstschau poster, 1908.

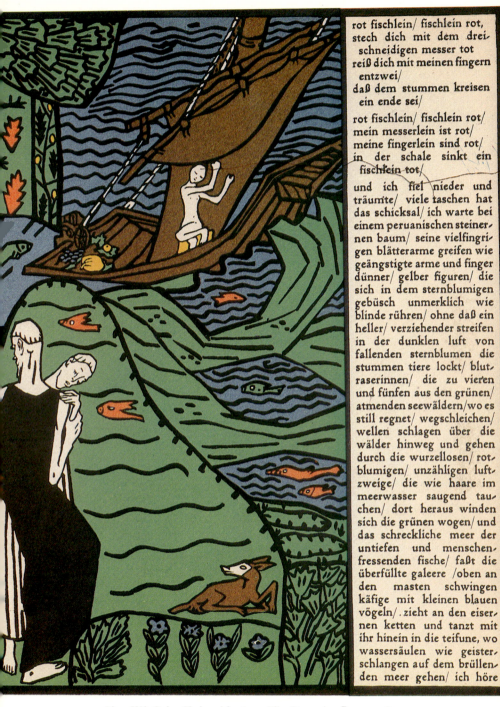

rot fischlein/ fischlein rot,
stech dich mit dem drei
schneidigen messer tot
reiß dich mit meinen fingern
entzwei/
daß dem stummen kreisen
ein ende sei/

rot fischlein/ fischlein rot/
mein messerlein ist rot/
meine fingerlein sind rot/
in der schale sinkt ein
fischlein tot/

und ich fiel nieder und
träumte/ viele taschen hat
das schicksal/ ich warte bei
einem peruanischen steiner-
nen baum/ seine vielfingri-
gen blätterarme greifen wie
geängstigte arme und finger
dünner/ gelber figuren/ die
sich in dem sternblumigen
gebüsch unmerklich wie
blinde rühren/ ohne daß ein
heller/ verziehender streifen
in der dunklen luft von
fallenden sternblumen die
stummen tiere lockt/ blut-
raserinnen/ die zu vieren
und fünfen aus den grünen/
atmenden seewäldern/wo es
still regnet/ wegschleichen/
wellen schlagen über die
wälder hinweg und gehen
durch die wurzellosen/ rot-
blumigen/ unzähligen luft-
zweige/ die wie haare im
meerwasser saugend tau-
chen/ dort heraus winden
sich die grünen wogen/ und
das schreckliche meer der
untiefen und menschen-
fressenden fische/ faßt die
überfüllte galeere /oben an
den masten schwingen
käfige mit kleinen blauen
vögeln/. zieht an den eiser-
nen ketten und tanzt mit
ihr hinein in die teifune, wo
wassersäulen wie geister-
schlangen auf dem brüllen-
den meer gehen/ ich höre

Plate XII. Oskar Kokoschka, from The Dreaming Boys, *1908.*

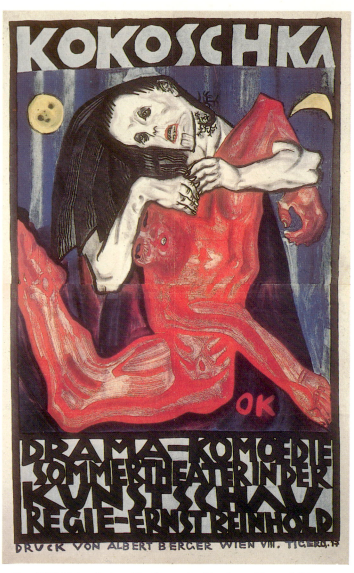

Plate XIII. Oskar Kokoschka, Poster for Murderer, Hope of Women
(Pietà), 1909.

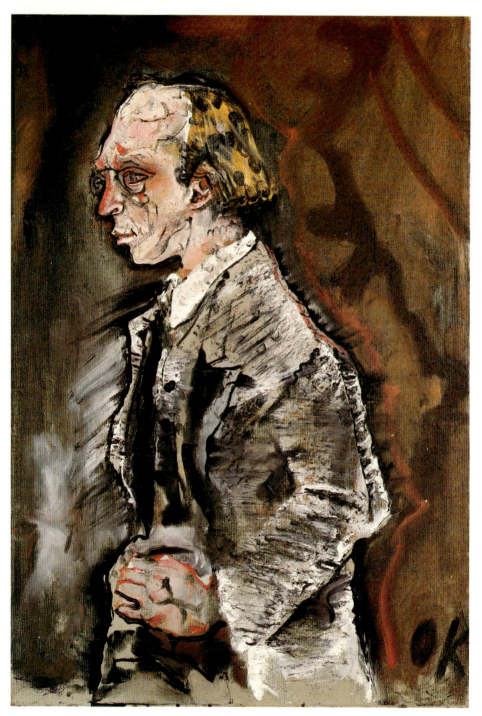

Plate XIV. Oskar Kokoschka, Portrait of Herwarth Walden, 1910.

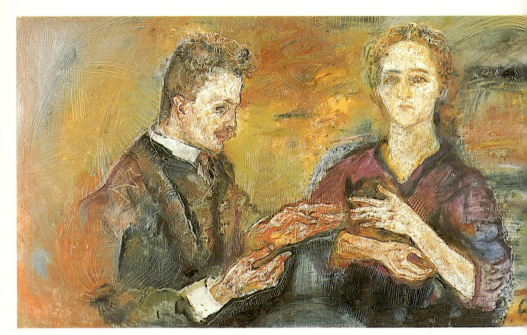

*Plate XV. Oskar Kokoschka, Portrait of Hans Tietze and
Erica Tietze-Conrat, 1909.*

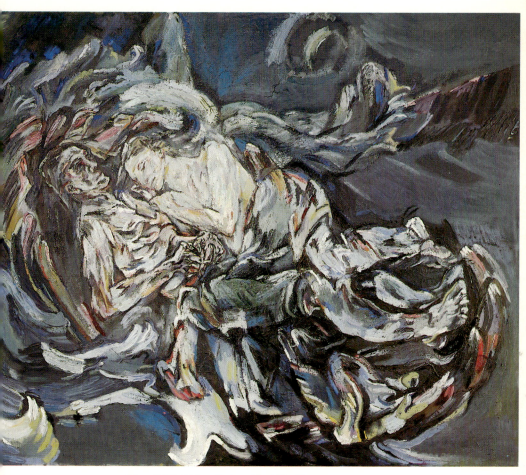

Plate XVI. Oskar Kokoschka, The Tempest, 1914.

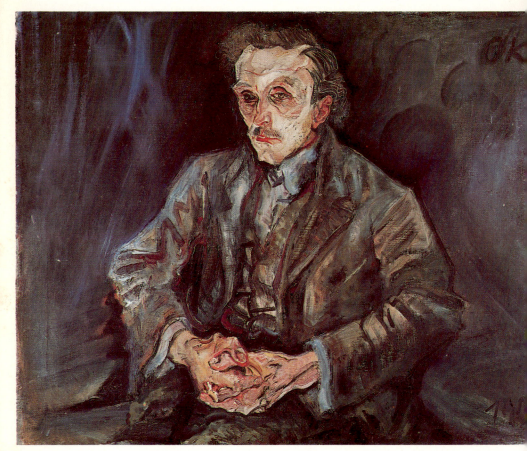

Plate XVII. Oskar Kokoschka, Portrait of the architect Adolf Loos, 1909.

The singer at first is as caught as we are in the stillness. Only when she reaches the water-spewing "fabled animals" in stone (bar 13) does new life come into the music—carried more in the piano than in the voice, which still is that of an expectant observer. Then— a surge of intensity as candles suddenly light up the bushes like will-o'-the-wisps (bar 17). Here the absence of harmonic constraint shows its potential for conveying feelings. Schoenberg whipsaws us upward out of the crepuscular calm to share with the singer a startled perception of the lights, only to drop us into a space of suspense as the "white forms" appear (bar 19)—an anticipation of the intense and swiftly oscillating feelings of the lover in the verses that follow.

In *The Hanging Gardens*, thematic form lies close to the surface in the early part, where the garden setting is presented as the defined field of psychic action to come. As the dialectic of the cycle unfolds between garden and lover, and progresses to the victory of the logic of the lover's passion, the declamatory speech rhythm absorbs and in effect pulverizes the last resistance of the garden, ordered symbol of outer reality and hierarchical culture. As it does so, the more chaotic musical elements bury the well-shaped remnants of traditional musical form.

The "emancipation of dissonance" has done more here than destroy harmonic order and cadential certainty. By establishing a democracy of tones, it has vastly enlarged *all* the expressive possibilities, thematic and rhythmic as well as coloristic and tonal. The composer can create any community or cluster of tones he wishes, now crowding them into confined musical space, now associating them across distances that are positively astral. The tonal relations, clusters, and rhythms expand and contract "like a gas," as Schoenberg said. The awesome demand on the constructive power of the composer in this world of infinite space and atomized matter, of macrocosm and microcosm, is nothing short of godlike.

Wer die Wahl hat, hat die Qual, runs a German proverb. "He who has choice has torment." In the next work in which Schoenberg explored the vast realm of possibilities he had opened, he created a terrifying psycho-drama, *Erwartung (Expectation)*. It exactly parallels—again in 1909—Kokoschka's *Murderer, Hope of Women*. It chronicles a murderous love, only this time in the form of the search of a deranged woman for her lover—murdered by her, or by

I

Figure 62. Arnold Schoenberg, The Book of the Hanging Gardens, *Song I.*

a rival for his love? We do not know. We follow the solitary's hallucinatory quest as she stumbles through a tangled wilderness, incapable of ordering her reality, unable to find the way. The whole piece is a clear sequel to *The Hanging Gardens*. It begins where the latter ended, outside the dried-up garden:

> Go in here? . . . I can't see the way. . . .
> How silvery the trees glisten . . . like birches!
> oh—our garden.
> The flowers for it must surely be faded.
> The night is so warm. I am afraid . . .
> what sultry air beats out from there . . .
> Like a storm standing still . . .
> So gruesomely quiet, so empty.*[36]

As Schoenberg passes from the *Liebestraum* of George to the *Angsttraum* of *Erwartung*, he abandons George's strongly metered poetry for an agitated free verse—part speech, part song, part simply cry. All cohesive thematic remnants are expunged from the music: here freedom is to madness close allied. The anti-structural potential of a democracy of tonal atoms is horrifyingly employed, reinforced by rhythm and orchestral color.[37] Schoenberg's *Liebestöten* is, if anything, harsher than Kokoschka's, because it is portrayed not as a heroic battle of the sexes but as inner distintegration, psychopathology. And as the disordered psyche becomes the primary focus of the music, the composer replaces the old metaphor of outer order, the garden, with a new one, the wilderness.

Behind *Erwartung* lay a shattering personal experience which Schoenberg projected into his work: abandonment by his wife in favor of one of his best friends, the artist Richard Gerstl, who shortly thereafter committed suicide. Personal anguish cannot, of course, explain artistic creation, but Schoenberg's desperation must

* Hier hinein? . . . Man sieht den Weg nicht. . . .
Wie silbern die Stämme schimmern . . . wie Birken!
oh—unsern Garten.
Die Blumen für ihn sind sicher verwelkt.
Die Nacht ist so warm. Ich fürchte mich . . .
was für schwere Luft heraus schlägt . . .
Wie ein Sturm, der steht . . .
So grauenvoll ruhig und leer . . .

surely have lent its force to the radical expansion of musical expression—in this case to encompass a wild oscillation of feeling between tenderness and terror—upon which the composer had already embarked. The more radical his music became in giving voice to derangement, the more his social isolation and inability to reach the public increased. Thus, his very achievement in finding a form of aesthetic expression adequate to the full range of psychic possibilities brought desocialization of the artist as its consequence.

Twice rejected—once as lover, once as artist—Schoenberg developed his music around ideas of the failed self, the artist isolated and unrecognized. The theme of double failure appeared first in *Die glückliche Hand (The Golden Touch)**** (1910–13), a dramatic piece for which Schoenberg wrote his own text and which he considered making into a film with Kokoschka as set designer.† Kokoschka had in fact already turned his attention to the theme of self as artist-victim. In a poster for the lecture "On the Nature of Visions," in which he presented the theory of portraiture discussed above, Kokoschka had graphically caricatured himself in blue outlines against a blood-red background, pointing with his left hand, like an exhibitionistic Christ, to a gaping wound in his side (Figure 63).‡[38] But despite their simultaneous espousal of this common theme, the collaboration of the two artists never came to pass.

In *Pierrot lunaire* (1912), the chamber song cycle which must be accounted one of his masterpieces, Schoenberg established the identification of the artist and Christ by a related religious symbolism: that of the Mass. Selecting twenty-one poems from Albert Giraud's poetic cycle on Pierrot, Schoenberg organized them into three groups of seven, suggesting roughly the three principal parts of the Mass. The second part, equivalent to the consecration, is replete with hallucinated killings. At the very center of this section,

* The title suggests the equivalent of a "green thumb," a gift of productivity; but it is used ironically to suggest the fated frustration of the creative artist.

† Failing Kokoschka, Schoenberg hoped to enlist either Wassily Kandinsky or Alfred Roller. Cf. Willi Reich, *Arnold Schoenberg*, tr. Leo Black (New York and Washington, 1971), p. 84.

‡ The lecture was sponsored by the Akademischer Verband für Literatur und Musik, in which Schoenberg participated. There is no evidence that he attended the lecture or knew the poster, although, given his interests, the likelihood of both is high.

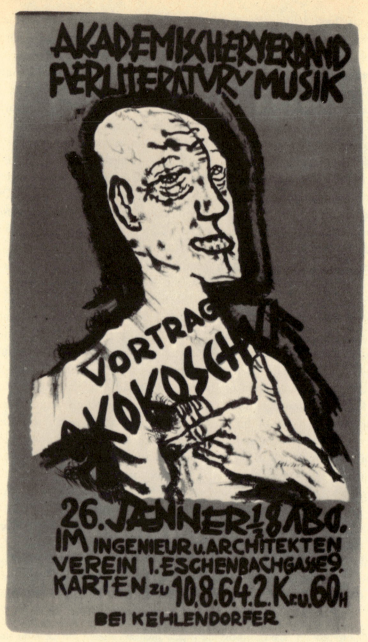

*Figure 63. Oskar Kokoschka, Poster
(self-portrait), 1912.*

and thus of the whole cycle, is a song (no. 11) entitled "Red Mass." In it Pierrot climbs upon the altar, "rends the priestly raiment," then "shows to the frightened souls the dripping red host: his own heart, in bloody fingers, for (their) gruesome communion."[39]

Though self-pitying in its exposure of personal craziness and *Angst* ("sentimental, modern," the text says), Schoenberg's treatment of Pierrot's surreal martyrdom lifts the popular tragic-clown theme to a more general level as the fate both of traditional art and of the modern artist. In his prime of life as commedia dell'arte figure, Pierrot had known how to confront life's hard realities with a mixture of wit and illusion. Now, in the moon-drenched world of the rootless modern mummer, his artist's power of formative illusion survives only as hallucination and surrealist vision. Small wonder that, in the end, Pierrot takes refuge in reminiscence. His final illusion, very Viennese, is intoxication with "the old fragrance of once-upon-a-time."*

In *Pierrot lunaire* Schoenberg thus identified the psyche in dissolution not with the end of love and the garden, as in *Erwartung*, but with art and the artist. Yet the artist who stated the truth of dissolution fully, even when ignored or vilified, would speak for Everyman. "Art is the cry for help [*Notschrei*] of those who experience in themselves the destiny of men," Schoenberg wrote in 1910, in the midst of his radical work of destructuring traditional tonality. Even as he sought a music to express the disintegration of love and the rejection of his art, Schoenberg's allusion to "the destiny of men" pointed beyond the purely personal, psychological realm: Art is the cry

not of those who will accommodate themselves to [that destiny], but of those who will wrestle with it; not of those who blandly serve "the dark powers," but of those who throw themselves into the machinery to grasp its construction; not of those who avert their eyes to protect themselves from emotion, but of those who open them wide to tackle what has to be tackled.[40]

What had to be tackled? It was here that Schoenberg connected his *cri de coeur* with cultural criticism, and fulfilled the revolutionary

* "O alter Duft aus Märchenzeit
 Berauschest wieder meine Sinne!"

function of art as his admired friend Adolf Loos had defined it: "to shake us out of our complacency and comfort." Like Loos a moral rather than a social revolutionary, Schoenberg leveled his critique not against the social system but against its self-deceiving culture, its illusion of order and the screens of beauty that sustained it. "Our age seeks much," Schoenberg wrote in his *Theory of Harmony*. "What it has found above all is: *Comfort*. That penetrates full-scale even into the realm of ideas and makes it too comfortable [*bequem*] for our own good."[41] "Comfort as *Weltanschauung!*" he cried again. "As little movement as possible, no upset!" Schoenberg associated the idea of beauty as an independent value with this complacency of spirit: "Beauty exists only from that moment when unproductive people begin to find it lacking . . . the artist has no need of it. For him truthfulness is enough."[42] Comfort, intellectual complacency, the static, and the cult of beauty—all were associated in Schoenberg's mind. Against them he posited movement, responsiveness to the inner dictates of mind and instinct *("Geistes- und Triebsleben")*,[43] and, above all, truth.

In this critical spirit Schoenberg worked from 1912 to 1914 on the plan of a large symphony to celebrate the death of the Bourgeois God. The symphony was never completed, for war intervened. The work begins with a movement entitled "Change of Life (looking backward, looking to the future; gloomy, defiant, withdrawn)." Two movements are dedicated to the "Beautiful Wild World," one of which associates the Bourgeois God with nature in a Festival of Creation. The text of this section, conceived by Richard Dehmel in the spirit of the *fin de siècle*, is a kind of paean to nature parturient under the sign of Eros.

Schoenberg had shared Dehmel's pan-naturistic vision in his early years. Now he assimilates it into his plan only to subvert it. In the fourth movement he introduces a contrary idea: "The Bourgeois God does not suffice." The symphony's whole second part, entitled "Death Dance of Principles," dramatizes the burial of and funeral oration for the Bourgeois God. The death dance brings the slim hope that the death of meaning is only a dream, for "man likes to live and believe; to be blind!"

> The darkness yields—
> But the sun is without strength.

Schoenberg presents his dying bourgeois world as on the edge between surfeit and void. "A terrible amount of order is in the whole. And just as much disorder. That is, if one asks for sense. All is simultaneously order and disorder." One cannot distinguish; one cannot decide. Cognition becomes equated with decision. Schoenberg's text asks the question of cosmic unity in musical terms as well: "One tone? Or is there no tone? Or are there many tones? Is it infinite or nothing? Multiplicity was easier to grasp before than unity is now. It is overwhelming."[44]

Stephen Spender once observed that the politics of the artist are the politics of the unpolitical, decided on for the sake of life and not of politics. His finding has particular force for Schoenberg in the last years of the Habsburg era. In a letter to Dehmel in 1912, Schoenberg explained the genesis of his symphony project in ways that stressed the bankruptcy of politics. The work was to deal "with the man of today, who has passed through materialism, socialism, anarchy; who was an atheist, but preserved a remnant of his old belief (in the form of superstition). . . ."[45] By virtue of the collapse of all these categories, Schoenberg's modern man seeks God again: but his own, metaphysical God, who stands for the mysterious, unitary plenitude of reality, which no principle can comprehend. Like his contemporary Robert Musil, novelist of the disintegration of Austrian hierarchical society and liberal-rational culture, Schoenberg felt driven to find "what differentiates a world-view [*Weltanschauung*] from a true view of the world."*[46] In the symphonic sketch, Schoenberg called the fifth section "The faith of the 'disillusioned one'; the union of objective, skeptical consciousness with faith: In the simple is concealed the mystical."[47] He thus articulated his passage from the fractured bourgeois order to a faith in a hard vision of the world that could both accept a pulverized reality and posit in it an order that was not inherent to it. As composer of this complex of ideas, Schoenberg took an initial step toward his second musical revolution, the creation of the serial system. To introduce a scherzo entitled "Cry of Joy" in the Death Dance Symphony, he wrote his first twelve-tone theme.[48] Just as his earlier liberation of

* The German more forcefully sunders the subjective and ideological distortion of reality from the objective vision thereof: "Was die Weltanschauung von der Anschauung der Welt unterscheidet."

dissonance was connected, in *The Hanging Gardens* and *Erwartung*, with the psychology of love experiences, so his warfare on bourgeois "comfort," political ideologies, and illusory principles of cosmic order led him, on the eve of World War I, to explore the possibility of a projective tonal order consonant with both the creative power of man and the inscrutable, manifold nature of the world.

Like Kokoschka, Schoenberg had early developed a profound trust in his feelings and his instincts, assigning to his own psychological suffering paradigmatic value as moral and metaphysical truth. As a determined bourgeois individualist, he fought for the rights of the psyche against society and its confining art forms, just as a political radical would fight for social or legal rights. In his rock-solid affirmation of alienation lay both his revolutionary power as artist and his unwillingness as philosopher to envisage any scene of human realization except the wilderness. The truth of the wilderness —atomized, chaotic, indifferent, yet open and bracing—became Schoenberg's substitute for the utopian beauty of the garden.

It was not until after the collapse of the Empire that Schoenberg formulated in art his mature indictment of the protagonists of beauty. This he did fully in the opera *Moses und Aron* (1926–32), in which he not only castigated those who trusted the seductive power of art but found the new musical forms to convey his message. He dramatized Truth and Beauty respectively in the persons of Moses and Aaron, a fraternal alliance that failed. The brothers stood between two great forces which they were ordained to connect: on the one side, God, the "unrepresentable," absolute spirit; on the other, the people, corruptible flesh. The people cannot receive God's abstract truth except as art, wherein truth is incarnate. Moses, the prophet of truth, can speak but does not sing: too pure for art, he cannot reach the people. Hence he commits to Aaron the communication of the Word through the senses. Art's hull of sensuousness distorts the purity that is truth; the appetite of the people corrupts it further, debasing the sensuosity of art into the sensuality of the flesh. Thus the Golden Calf replaces the Decalogue. The hero Moses reaches for song only in one line, then to express his most anguished moment of despair at the failure of the Word.[49] It was the highest irony that the composer's hero should be the anti-artist, incapable of song except *in extremis*.

Once again, Schoenberg vents his wrath at the corruption of truth

by art. Within the indictment resonates a comprehensive rejection of all the major formative forces in the Austrian tradition: the Catholic culture of grace, wherein the Word is incarnate and made manifest in the flesh; the secular adaptation of the culture of grace by the bourgeoisie to supplement and sublimate its own primary culture of law; and finally, the turning to art as itself the source of value, as religion-substitute in liberalism's crisis of the *fin de siècle*. The weight of all are felt in this prophet's opera written against opera, the queen of Catholic Austria's arts. It is present too in Moses' words to Aaron, where he condemns the garden as a false theater of human realization in terms that would seem to combine the values Schoenberg most detested, beauty and comfort:

> Then you desired physically, actually
> to tread with your feet an unreal land,
> where milk and honey flow.[50]

The aesthetic-utopian ideal had once been Schoenberg's, too. From it he had painfully detached himself through the series of traumas that had followed the erotic affirmation of *Verklärte Nacht* and other early works: first as the desolated lover in *The Hanging Gardens* and *Erwartung;* then as the rejected artist of *Die glückliche Hand* and *Pierrot lunaire;* and finally as the misunderstood philosophic prophet of the Word in *Moses und Aron.* Thus Schoenberg's personal sequence of rejections and frustrations led him ever away from the flesh to the spirit, from art to philosophy, from the sociohistorical world to the realm of Being-as-such. As his Moses enjoined the Jews, so did Schoenberg exhort the human race, to renounce forever the cultivation of the garden in favor of his counter-ideal, the acceptance of the wilderness:

> . . . whenever you left the wilderness where you were free of desire
> And your gifts brought you to the loftiest heights,
> Ever again you would be cast down from the success of their
> misuse, back into the wilderness.

> But in the wilderness, you are invincible and will achieve the goal:
> Unity with God.

Was there then no place for art, no way of ordering life in the wilderness once the garden had been destroyed? Schoenberg ans-

wered the question positively, by organizing the liberated chromatic world into the twelve-tone system. It was a system as pure in its rationality as a house by Adolf Loos. Yet it allowed for all the expressiveness of a Kokoschka portrait or a Schoenberg cry of agony in the garden. Above all, it allowed the artist to do what God had done before: To place deep, deep in the world of his creation an infrastructure, a set of relations too subtle to be grasped immediately by the senses but accessible under the laws of logic to the inquiring mind. The system Schoenberg thus devised was no return to the hierarchical, privileged order of the diatonic system. Yet its democracy of twelve tones would cohere again in a systematic way: in a hidden order, created by the composer—one in which above and below, forward and back, were related visibly to the analytic mind, even though not generally accessible to the listening ear.

Traditional Western aesthetic culture until the turn of our century had placed structure on the surface, to control nature and the life of feeling that pressed up from below. Schoenberg as psychological Expressionist confronted his listener with an art whose surface was broken, charged with the full life of feeling of man adrift and vulnerable in the ungovernable universe; yet beneath it he posited out of his own powers a subliminal, inaudible world of rational order that would integrate the chaos. Here liberated dissonance became a new harmony; psychological chaos, a meta-sensuous order. Here the garden, buried alive, gave a sustaining structure to the wilderness confronted above. Thus Schoenberg the artist, even as he turned back to the faith of his fathers and submission to God, became man the creator, what Goethe would have called "der kleine Gott der Welt."

It was a prophetic *Lebensgefühl* that produced the explosion in the garden: a humanism unfamiliarly mixed with nihilism. Kokoschka and Schoenberg recognized each other as engaged in the same dangerous, lonely work, at once of liberation and of destruction. Both men revolted against the aesthetic culture in which they were reared, the work of the first Viennese modernists of the *fin de siècle*, at the moment when that culture lost its critical thrust, and when, as in the Kunstschau, it became the ruling conventional culture of the *haute bourgeoisie*. The major older artists—Klimt in art, Hofmannsthal in literature, and Otto Wagner in architecture—had come

to speak for the educated upper middle class as it adapted to the curbing of its political power by expanding its aesthetic culture. The younger artists, however, Expressionists like Kokoschka and Schoenberg, allied themselves with the last puritans, rationalistic critics like Adolf Loos and Karl Kraus, who rejected the use of art as a cultural cosmetic to screen the nature of reality.

Kokoschka and Schoenberg asserted in direct visual and musical language disturbing instinctual and psychological truths which their precursors had discovered, but had learned to express only in the indirect form of allegory. The shock the newcomers caused produced social rejection; that rejection reinforced their alienation. Alienation in turn became the basis for their adventure into new realms, spiritual and artistic. The two anti-bourgeois bourgeois, Kokoschka and Schoenberg, found the forms to express the soul of men whose culture had prevented their irrational private experience from finding public expression. As critics, prophets, and creators of a new art, the Expressionists gave it voice.

Both Kokoschka and Schoenberg grounded their innovative power on a clear acceptance of their egocentric predicament. Kokoschka, in the autobiographical parable with which this essay began, shrewdly linked the essentially private nature of modern life with both the necessity and the impossibility of formulating social visions: "Isolation compels every man, all alone like a savage, to invent his idea of society. And the knowledge that every doctrine of society must remain a utopia will also drive him into solitude. This solitude swallows us in its emptiness. . . ."[51] Schoenberg, in the text of his cantata *Jacob's Ladder*, echoed Kokoschka's sentiment in a single cry: "Erlöse uns von unserer Einzelheit! (Redeem us from our isolation!)."

In their prewar work, both artists found the means to render their *cris de coeur* in forms which destroyed the conventions of order in a traditional art that had inhibited such expression. For both, the appropriation, then disintegration, of the garden as the image of order served as the liberating vehicle. Kokoschka's explosive impulse found a creative outlet in the unification of psyche and corporal reality in portraiture. He made no attempt to reconstitute the destroyed garden except in intra-personal terms. Schoenberg, as subverter of the garden of beauty, though he could find no social ideal or reality to lift the curse of his profound sense of alone-

ness, did not let the problem drop as easily as Kokoschka. Out of the depths of his extraordinary being he generated the power to present the wilderness as the proper metaphysical analogue and metaphoric ideal for psychological man. To those who could listen, he showed how it might be organized in sound to replace the garden he had done so much to destroy.

❧ NOTES ❧

[1] Oskar Kokoschka, "Aus der Jugendbiographie," *Schriften, 1907–1955,* ed. Hans Maria Wingler (Munich, 1956), pp. 21–46.

[2] For a succinct treatment of the new villa culture and the work of its principal architects, see Peter Vergo, *Art in Vienna* (London, 1975), pp. 142–77, *passim.*

[3] Hugo von Hofmannsthal, "Gärten," *Gesammelte Werke, Prosa,* ed. Herbert Steiner (Frankfurt am Main, 1959), II, 176, 178, 181.

[4] *Hohe Warte,* a journal named after the principal intellectuals' district, was dedicated to "the artistic, intellectual and economic interests of city culture" (1904 ff.). It is a particularly illuminating source, for it includes urban modernists like Otto Wagner, neo-classicists like Josef Hoffmann, and petit-bourgeois revivalists (*Heimatkunde* ideologists of architecture and town life) like Schultze-Naumburg and Sitte's followers. See, e.g., the serial articles, "Die Kunst des Gartenbaues," *Hohe Warte,* I (1904–1905), nos. 5, 7, 12, 14.

[5] Oskar Kokoschka, *My Life,* tr. David Britt (New York, 1974), p. 219.

[6] *Katalog der Kunstschau, 1908* (Vienna, 1908).

[7] The Kunstschau was financed by contributions from the Imperial government, the Lower Austrian administration and the Vienna municipal government. Private underwriters established a guarantee fund. *Katalog,* p. 6.

[8] *Ibid.* Unable to locate the original in Morris's writings, I have here retranslated the German into English.

[9] L. W. Rochowanski, *Die Wiener Jugendkunst. Franz Cizek und seine Pflegestätte* (Vienna, 1946), p. 20.

[10] *Ibid.,* p. 28. The German, "sich auszusprechen," not only adumbrates Expressionism, but also suggests psychoanalytic talk-therapy.

[11] *Ibid.,* p. 29.

[12] Oskar Kokoschka, *Mein Leben* (Munich, 1971), p. 55. For his own description of his teachers and training at the School of Arts and Crafts in general, see *ibid.,* pp. 49–52; J. P. Hodin, *Oskar Kokoschka: The Artist and His Time* (London, 1966), pp. 62, 221; Josef Hoffmann, "Die Anfänge Kokoschkas," in J. P. Hodin, ed., *Bekenntnis zu Kokoschka* (Berlin and Mainz, 1963), pp. 65–7.

13 *Deutsche Kunst und Dekoration*, XXIII (1908–9), 53.

14 Kokoschka, *Mein Leben*. The contents of the collection in 1907 are briefly described in Eugen Guglia, *Wien, Ein Führer* . . . (Vienna, 1908), pp. 65–7.

15 Oskar Kokoschka, *Die träumenden Knaben* (Vienna, Munich, 1968).

16 Kokoschka record, *Oskar Kokoschka erzählt sein Leben*, Deutsche Gramophon Gesellschaft, 1961.

17 Kokoschka, *Schriften*, p. 141; translation mine.

18 For Kokoschka's own description of the alleged tumult, from which he claimed to have been saved by Karl Kraus' influence with the chief of police, see Kokoschka, *My Life*, p. 27. See Vergo's evidence in his *Art in Vienna*, p. 248, *n.* 16.

19 Kokoschka, *My Life*, p. 35.

20 Adolf Loos, "Die potemkinische Stadt," *Ver Sacrum* I (1898), 15–17.

21 Adolf Loos, "Architektur" (1909), *Trotzdem* (Innsbruck, 1931), p. 109.

22 *Ibid.*

23 Kokoschka, *My Life*, pp. 36–7.

24 *Ibid.*, p. 33.

25 While he describes his practical approach to portrait-painting only in retrospect in *My Life*, chapter III, he first recorded his theory of it in a lecture of 1912: "Von der Natur der Gesichte," on which the above discussion is based. See Kokoschka, *Schriften*, pp. 337–41.

26 According to Mrs. Tietze's account of sitting for Kokoschka, he quickly threw away his brush and painted with his fingers, using his nails for scoring. E. Tietze-Conrat, "Ein Porträt und Nachher," in J. P. Hodin, ed., *Bekenntnis zu Kokoschka* (Berlin and Mainz, 1963), p. 70.

27 The most lucid analysis of the traditional tonal order and Schoenberg's relation to it is by Charles Rosen, *Arnold Schoenberg*, in the series Modern Masters, ed. Frank Kermode (New York, 1975, paperback), especially ch. II.

28 Alfred Brendel, *Musical Thoughts and Afterthoughts* (Princeton, 1976), p. 83.

29 For the "double nature"—Brahmsian and Wagnerian—of Schoenberg's early work, see Willi Reich, *Schoenberg: A Critical Biography*, tr. Leo Black (New York, Washington, 1971), pp. 5–8.

30 See pages 13–15, 226–31.

31 See the penetrating analysis of Richard Swift, "I-XII-99: Tonal Relations in Schoenberg's *Verklärte Nacht*," *19th Century Music*, I (July, 1977), 3–14.

32 Arnold Schoenberg, *Harmonielehre* (Vienna, 1911), pp. 449–50.

33 *Ibid.*, p. 443.

34 Stefan George, *Die Bücher der Hirten und Preisgedichte, der Sagen und Sänge und der hängenden Gärten* (Berlin, 1904), pp. 103–12.

35 For a full technical analysis of the work, see Karl Heinrich Ehrenforth, *Ausdruck und Form. Schoenberg's Durchbruch zur Atonalität in den George-Liedern, Op. 15* (Bonn, 1963).

36 Translation mine. For Marie Pappenheim's complete text and a translation, see pamphlet accompanying Columbia Records Masterworks, M2S 679, *The Music of Arnold Schoenberg* (New York, n.d.), II. The same pamphlet

includes an excellent discussion of the dramatic structure of *Erwartung* by Robert Craft.

[37] See the illuminating discussion of the attempts to find the theoretical unities of the work in Rosen, *Schoenberg*, pp. 38–49.

[38] Kokoschka had devised the self-portrait first for a poster for Walden's *Der Sturm* in late 1909 or early 1910. See Hans Wingler, *Oskar Kokoschka. Das druckgraphische Werk* (Salzburg, 1975), pp. 75–7.

[39] Text in Columbia Records, Masterworks, *The Music of Arnold Schoenberg*, I.

[40] Cited from "Aphorismen," 1910, in Arnold Schoenberg, *Schöpferische Konfessionen*, ed. Willi Reich (Zurich, 1964), p. 12.

[41] Arnold Schoenberg, *Harmonielehre*, p. 281. (Italics his.)

[42] Quoted from *ibid.*, n.p., in *die Reihe*, II (Eng. ed., 1958), 6.

[43] Schoenberg, *Harmonielehre*, p. 443.

[44] For the scenario and portions of his text, see Arnold Schoenberg, *Texte* (Vienna, 1926), pp. 23–8. The outline of the whole symphony is given in Josef Rufer, *The Works of Arnold Schoenberg* (London, 1962), pp. 115–16.

[45] Arnold Schoenberg, *Briefe*, ed. Erwin Stein (Mainz, 1958), Letter 11, to Richard Dehmel, Dec. 13, 1912.

[46] Robert Musil, "Aufzeichnungen eines Schrifstellers," *Gesammelte Werke* (Reinbek bei Hamburg, 1978), VII, 919–20.

[47] Rufer, *Works*, p. 116.

[48] *Ibid.*, p. 117.

[49] See the excellent essay by George Steiner, "Schoenberg's Moses and Aaron," *Language and Silence* (New York, 1970), pp. 127–39.

[50] All passages are from Act III. See original text in booklet accompanying Columbia Records Masterworks K3L–241, Arnold Schoenberg, *Moses and Aaron* (New York, 1957). (Translation mine.)

[51] Kokoschka, *Schriften*, p. 44.

Index

Academy of Fine Arts, 75, 82, 243, 245, 327
Adler, Victor, 119, 126 *n.*; and Freud, 195–7
Akademische Lesehalle, 149
Akademisches Gymnasium, 135 *n.*
Allgemeine Oesterreichische Baugesellschaft, 54
Altenberg, Peter, 225–6, 306
Andrian-Werburg, Ferdinand von, 304–5
Andrian-Werburg, Leopold von, 304–6, 308–12, 316–18, 333–4
Andrian-Werburg, Viktor von, 304
anti-Semitism, 6, 90, 116–46 *passim*, 148, 151–2, 158–63, 168–9, 238 *n.*, 239; in France, 153–62; and Freud, 6, 185–8, 191–2; and Klimt, 208–9, 227; and Schnitzler, 11–14; Society for Defense against, 160, 168–9; and University students, 126–8, 132–3,

151; *see also* Herzl, Theodor; Lueger, Karl; Schönerer, Georg von
architectural styles: historical and ideational, 36–43, 49, 62–3; modern, emergence of, 74, 82–110; *see also individual architects and buildings*
architectural training, 65–6, 75, 82–3
army: counter-insurgency planning, 29–31; and University, 38–9; *see also* Ringstrasse
arsenal, 30 *n.*
art and social mobility, 8–9, 280, 284–295 *passim*, 297–303; in domestic architecture, 46–62 *passim*; Hofmannsthal and Andrian-Werburg families as examples, 304–6
art deco, 325, 343
artisans, 5, 47, 65–8, 117–18, 120, 126, 128, 132–3, 139–40, 142, 146, 327;

368 ·

Permissions Acknowledgments

THE FOLLOWING illustrations and excerpts have been reproduced with the kind permission of the individuals, institutions, and firms indicated:

Figure 1: Courtesy of the Map Division of the Princeton University Library.

Figures 2, 9, 10, 15, 35, 37, 47: Courtesy of the Historisches Museum der Stadt Wien.

Figures 5, 23, 25, 29, 34, 46, 49: Courtesy of the Oesterreichische Nationalbibliothek, Bildarchiv und Portrait-sammlung, Vienna.

Figures 11, 12, 13, 18, 19, 20, 24, 33, 39: Courtesy of Johanna Fiegl, photographer.

Figures 14, 21: From Renate Wagner-Rieger, *Wiens Architektur im 19en Jahrhundert* (Vienna, 1970).

Figures 16, 17: Courtesy of Bruno Rieffenstein, photographer.

Figure 22: From Geretsegger & Peintner, *Otto Wagner, 1841–1918* (Residenz Verlag, Salzburg, 1964).

Figure 32: Courtesy of the Oesterreichische Galerie, Vienna.

Figure 36: Courtesy of the Kunsthistorisches Museum, Vienna.

Figures 37, 40, 41, 43, 44, 45, 47, 48, 52, 53, 54, 55, 58, 59, 60, 63: Courtesy of the Galerie Welz, Salzburg.

Figure 62: Courtesy of Belmont Music Publishers, Los Angeles, and Universal Editions A.G., Vienna.

Plates I, II, III, IV, V, VI, VII, VIII, IX, XI, XII, XV: Courtesy of the Galerie Welz, Salzburg.

Plate X: Courtesy of the Städtische Galerie im Lenbachaus, private collection.

Plate XIII: Courtesy of the Staatsgalerie, Stuttgart.

Plate XIV: Collection, the Museum of Modern Art, New York (oil on canvas, 30 ⅛ x 53 ⅜", Abby Aldrich Rockefeller Fund).

Plate XVI: Courtesy of the Kunstsammlung, Basel.

Plate XVII: Courtesy of the Nationalgalerie, Bildarchiv Preussischer Kulturbesitz.

The stanza from "Sailing to Byzantium" by William Butler Yeats is reprinted courtesy of M. B. Yeats and Macmillan Publishing Co., Inc. From *Collected Poems* © 1928 by Macmillan Publishing Co., Inc., renewed 1956 by Georgia Yeats.

The lines from *Die Träumenden Knaben* by Oskar Kokoschka are reprinted by kind permission of Professor Oskar Kokoschka.

The quotations from *The Interpretation of Dreams* by Sigmund Freud are used with the permission of Basic Books, Inc. *The Interpretation of Dreams*, translated from the German and edited by James Strachey, published in the United States by Basic Books, Inc., by arrangement with George Allen & Unwin Ltd. and The Hogarth Press Ltd., London.

ABOUT THE AUTHOR

CARL E. SCHORSKE was born in New York City and attended Columbia College and Harvard University. He is Dayton-Stockton Professor of History and has served as Director of European Cultural Studies at Princeton University. He has also taught at Wesleyan University and at the University of California, Berkeley. He is a member of the American Academy of Arts and Sciences. His previous books are *German Social Democracy, 1905–1917* and *The Problem of Germany*.

VINTAGE CRITICISM: LITERATURE, MUSIC, AND ART